POSTER TO POSTER

Railway Journeys in Art Vol. 5: London & the South-East

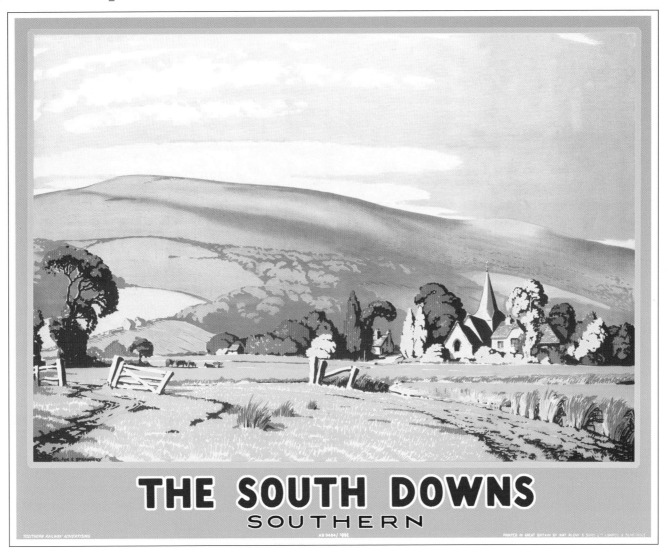

THE SOUTH DOWNS
SOUTHERN

Richard Furness

Foreword by The Hon. Sir William McAlpine Bt.

Published by JDF & Associates Ltd

Unit 19, Space Business Park, Quedgeley

GLOUCESTER GL2 4AL Gloucestershire

First Published MMXII

This Book is produced under licence for the National Museum of Science and Industry Enterprises Ltd. of London. Royalties from the sale of this product help fund the National Railway Museum's exhibitions and programmes.

ISBN Number 978-0-9562092-5-2

A catalogue record for this book is available from the British Library

Layout/Graphic Design: Amadeus Press (Steve Waddington)/Richard Furness

Printed in England by

The Amadeus Press, Cleckheaton, West Yorkshire BD19 4TQ

Bound in Scotland by

Hunter & Foulis, Haddington, Midlothian EH41 3ST

"The *Cunader* leaves Southampton for London" by Norman Elford (1931-2007)
Authors Collection and Copyright

All views and opinions contained within this book are solely those of the Author and do not represent the views of NMSI Enterprises Limited or The National Railway Museum.

The National Railway Museum, York is the largest railway museum in the world. Its permanent displays and collections illustrate over 300 years of British railway history, from the Industrial Revolution to the present day. The NRM archive also includes a fabulous collection of railway advertising posters charting the history of rail.

Visit www.nrm.org.uk to find out more.

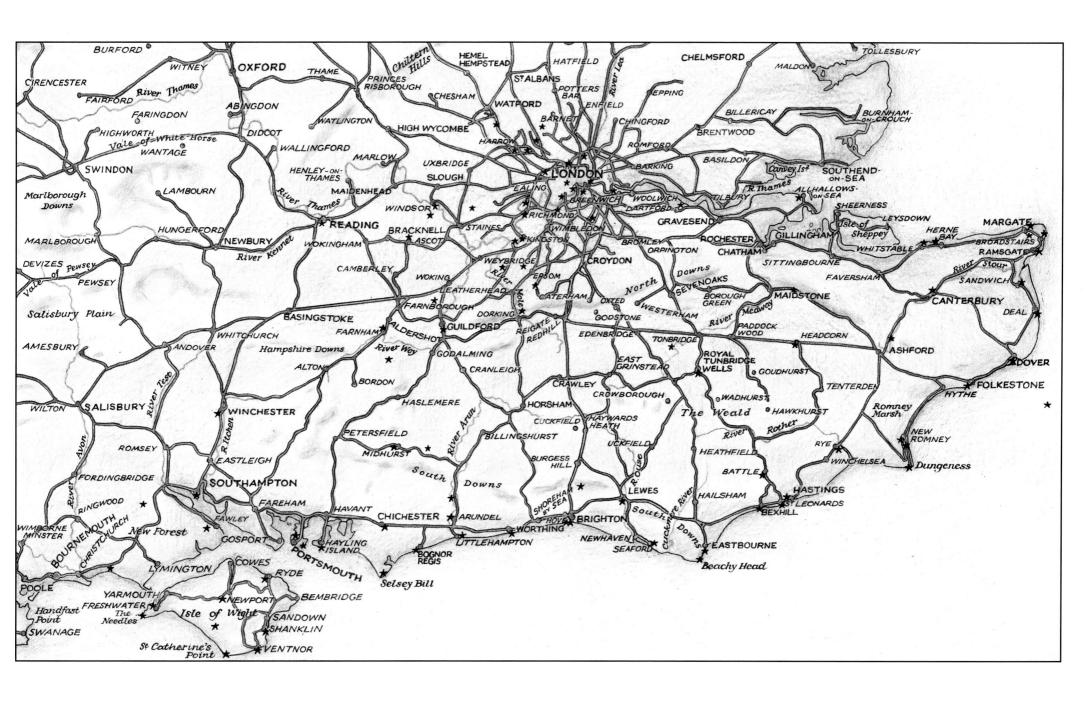

Map of London and the South-east Region by Alan Young

Maps Indicating the Poster Locations

At the start of each of the first seven chapters, readers will find a poster location map to help us on the route. The **red stars** on each map refer to posters included in that part of the journey: the **black stars** refer to posters used in other chapters. The aim was to try to cover the entire region in art, as summarized by Alan Young's hand-drawn map of the whole area featured at the start of this Volume. Some of the posters have not yet been located exactly: therefore some of the stars may have been placed slightly incorrectly. The majority however are correct.

Abbreviations

Throughout this book, abbreviations are used aplenty. Many of the railway fraternity are well versed with these, but maybe the poster art market is less so. This short list explains these; with only those relevant to the area covered being included.

AONB	Area of Outstanding Natural Beauty (Norfolk Broads for example)
BR	British Railways (formed 1st January 1948)
BR (CAS)	Central Advertising Services (of British Railways)
BR (CPU)	Central Publishing Unit (of British Railways)
BR (ER)	Eastern Region (of British Railways)
BR (SR)	Southern Region (of British Railways)
ECML	East Coast Main Line (Kings Cross-Edinburgh via Grantham, York, and Berwick)
FGW	First Great Western (Formed 1998)
GER	Great Eastern Railway (Pre-1923)
GNR	Great Northern Railway (Pre-1923)
IOWR	Isle of Wight Railway (Pre-1923)
KESR	Kent & East Sussex Railway (Pre-1923 and current Heritage Company)
LBSCR	London, Brighton and South Coast Railway (Pre-1923)
LCDR	London, Chatham & Dover Railway (Pre-1923)
LMR	London Midland Region (of British Railways)
LMS	London Midland & Scottish Railway (1923-1947)
LNER	London North Eastern Railway (1923-1947)
LSWR	London and South Western Railway (Pre-1923)
LT	London Transport
MR	Midland Railway (Pre-1923)
NER	North Eastern Railway (Pre-1923)
NRM	National Railway Museum, York
RAS	Railway Air Services (Formed 1934, ceased 1947)
RHDR	Romney, Hythe and Dymchurch Railway (Formed 1927)
SECR	South East & Chatham Railway
SSPL	Science and Society Picture Library, London

Poster Sizes: Quad Royal (50" x 40") = QR	Double Royal (24" x 40") = DR

APPENDIX A Artist Portraits

APPENDIX B Poster Database for London and the South-East

ACKNOWLEDGEMENTS

This has been a little more difficult volume to write than previous books in the series, due to the number of posters available for inclusion. Layout and planning took 30% longer than any of the previous volumes, as the route of the journey changed several times. Many people have assisted in the overall production, some throughout and others at key stages in the book's development. It would not have been possible at all without the long-term commitments from staff at the National Railway Museum, York and the Science Museum, London. At York, the first stimulus was given by former Curator of Collections **David Wright** who afforded me access to the amazing collection in 2002. This privilege has been further extended by **John Clarke** and **Ed Bartholomew**. In London, Publishing Executive **Wendy Burford** has given excellent project support, with Image Executives **Debbie Jones** and **Jasmine Rodgers** providing the bulk of the SSPL picture files. As with the first four volumes, **Patrick Bogue** of Onslows has provided continuous encouragement and guidance throughout the project and provided some poster images.

It was a real honour that **Sir William McAlpine Bt** agreed to write the Foreword. Sir William has been a champion of the railways for most of his life and is responsible for some of our iconic locomotives being in UK collections. His Foreword shows a unique connection with the railways: being able to travel around Britain in your own coaches really is <u>the</u> way to travel. His kind words about our production of these books are very much appreciated and he supported us during our Gloucester poster exhibition in 2011.

The database information in Appendix B, the first of its type ever attempted for this region, is literally down to thousands of hours spent by **Valerie Kilvington**, son **Simon** and myself over many years. We have gone through hundreds of auction catalogues, trawled the Internet, spoken to experts and collectors alike to amass as much data as we could on this region's posters. We are continually updating and amending the database as new information surfaces, or unseen posters appear. My sincere thanks go to them for continuous support going back almost a decade. **Greg Norden** has helped with artists' data and with carriage print images from his unique collection. **Alan Young**, who assisted with the 'Book of Station Totems" and the first four volumes, has again hand-drawn the maps that open each chapter. He has also provided excellent editorial guidance.

Pictures and information came from many other sources, as detailed in Appendix C, but I should mention **Charlotte Heyman,** Account Manager at the Bridgeman Art Library, in London and **Elizabeth Pepper-Darling** and **Robyn McLean** from Morphets of Harrogate kindly allowed image usage from the Malcolm Guest Collection. **Simon** and **Val Kilvington** gave images freely from their own extensive collection. The proof reading and checking has been undertaken by the **Rev. Gordon Savage** from Dumfries and by **Alan Young**, and independently by **Ed Bartholomew** from the NRM**.** In the railwayana world, I have to mention **Tony Hoskins** & **Simon Turner** at GWRA, Pershore, **David Jones** & **Mike Soden** at GCRA, Stoneleigh, **Chris Dickerson** at SRA, Derby and **Nigel Maddox** at Solent Railwayana. Amadeus Press provided us with endless support: **Richard Cook**, **David Crossland** and anchor man **Steve Waddington** (who undertook all the digital cleaning) take full credit for the finished quality of this fifth Volume in the series. **Nick Jones** from the Photo-Studio in Tewkesbury produced all the images of those posters from my own collection.

The final and greatest thanks go to my wife **Judi,** who has patiently put up with my long hours on the computer, both in the office and at home over many years. Her critical eye and influence is always there. The chapter layouts benefitted greatly from her input and she reviewed all the images for colour balance: this is her book as well!

Sincere thanks to all of you for helping to make this Volume a real pleasure to write.

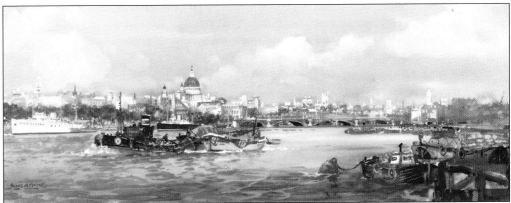

Artwork for King's Reach, London by Frank H. Mason (Author's collection)

FOREWORD The Hon. Sir William McAlpine Bt.

I was delighted to be asked by Richard Furness to write a foreword to Volume 5 of *Poster to Poster*, as it gives me an opportunity to thank him for producing these magnificent volumes. I find as a collector of all things railway that one starts to think that one has a representative collection of some items only to discover that this is just the tip of the iceberg; also often one has no idea of the number that were produced, or why. A collector of posters immediately runs into the problem of how to display and store them. Wall space is usually limited and if stored in cabinets they are not easy to view. Now, thanks to this wonderful series of books, we can see the amazing range of posters that the railways produced and in a digestible form.

I have a joint LMS/LNER poster and have always wondered why, when competition between them was so great. Now I read that the railways saw that the real competition was Road Transport. The high point of posters and publicity was between the amalgamations of 1923 and effectively 1939: barely 16 years; but everyone has heard of the great locomotives and the named trains. They used the best artists: many of whom also became famous. I knew Claude Muncaster and Terry Cuneo well.

I have always loved railways: literally from the pram! I have had the opportunity to indulge my love of all things on rails ancient and modern, and am so pleased to see a resurgence of railways, when forty years ago, they were thought to be dying. But the railways once had such style: it is so sad to see the decline, especially the demise of the restaurant car, which made journeys such a pleasure.

Collecting is addictive and the amazing amount of railway material is astonishing. I have been remarkably lucky in my collecting. I started in the 60's, when things were very cheap. Cast iron signs, clocks and even director's free passes, although these were claimed by British Railways as being their property. They have relented now and I have a collection. Of course all railway property was marked and empties had to be returned to depot. Materials were expensive and labour was cheap, the opposite of today. I even have a machine for measuring the length of string in a ball or reel to make sure that maker was not cheating.

My family built railways in Scotland and England, and had locomotives for earth moving and internal site transport. I still have the last one, bought new by the company. It will be 100 years old in 2013: 45 years with me. By coincidence, it was used at the construction by Sir Robert McAlpine of Wembley Stadium and Exhibition in 1923/1924. Exhibited there were *Pendennis Castle*, GWR and *Flying Scotsman* LNER, both of which I subsequently owned. *Pendennis Castle* was sold to Australia and I thought that they would never meet again so I commissioned a painting of the two together: now that would have made a wonderful poster!

Then, of course I took *Flying Scotsman* "down under" to celebrate the Centennial and they met in Perth - and now *Pendennis* is back in Britain, so who knows, someone may make a poster of a day out with *Scotsman* and *Pendennis* and it may end up in a future edition of this series!

In the 1970's I obtained a sleeper from the Royal Train, and Great Eastern No.1, which has a balcony at the rear. I was able to attach these to service trains or a locomotive to travel all over Britain. To me it was the ultimate luxury to sit on the open balcony and see our beautiful scenery appearing, just like an ever-changing poster.

Fawley Hill, Henley-on-Thames **January 2012**

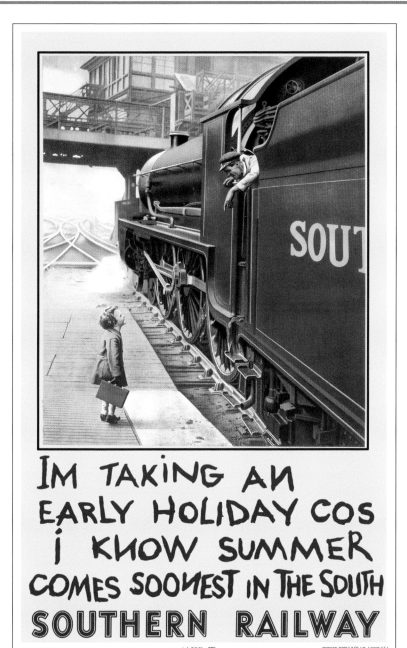

A famous Southern Railway poster to set the scene by Charles E. Brown

The Flyer by Cy Warman (1855-1914)

Across the hill and down the dell,
Past station after station;
The muffled music of the bell
Gives voice to each vibration.

Out o'er the prairie, cold and gray,
There falls a flood of fire,
While orders flash for miles away:
"Take siding for the flyer."

The engine seems to fairly float,
Her iron sinew quiver,
While swift, beneath her throbbing throat,
The rails rush like a river.

Upon the seat the engineer,
Who knows her speed and power,
Sits silently without a fear
At sixty miles an hour.

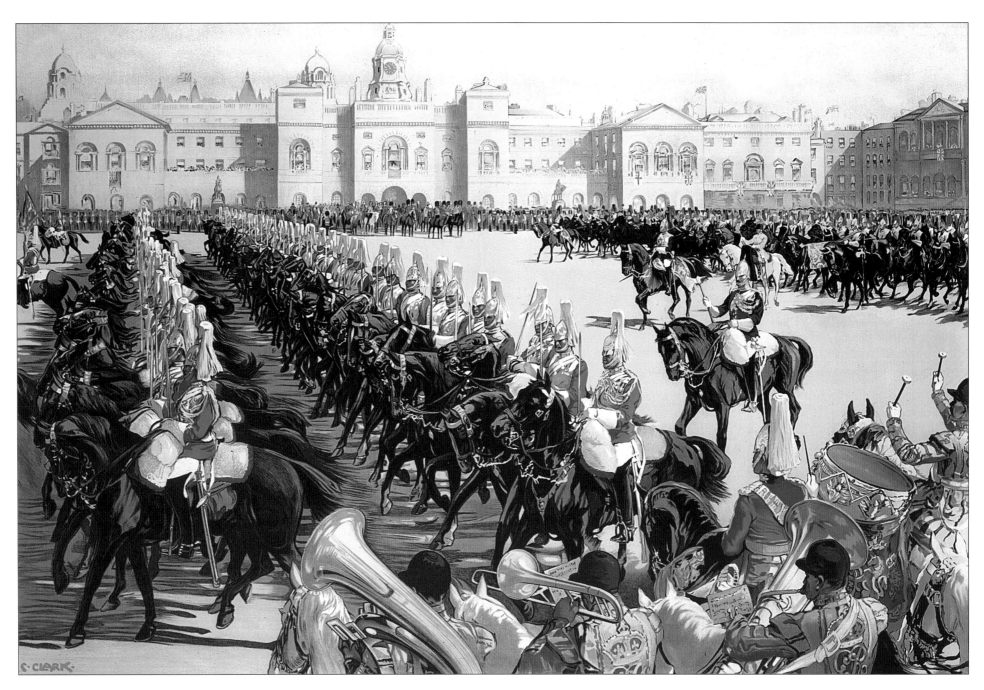

Pomp and ceremony in London in 1932: original painting used on an LMS poster of Trooping the Colour on Horseguards Parade by Christopher Clarke (1875-1942)

Opening remarks

For the first time in the series we are venturing to the southern part of England. Records show that the pre-grouping companies, the LBSCR, LSWR and SECR, were all major producers of promotional materials, as their large passenger market generated healthy advertising budgets. When they were combined in 1923 to form the Southern Railway, the extravagance of their advertising work continued, even though the SR subject matter (towns, events and activities) had previously been extensively covered. One of the features of this area's publicity, even before 1923, was the production of holiday and travel guide books. After grouping, the LNER and LMS copied both the SR and the GWR, who had also been producing some fine books. The SR took some time to 'weld together' their constituent companies in both style and content. Being based at Waterloo, the new SR Publicity Department employed a majority of ex-LSWR people; inevitably their influence shaped ongoing SR advertising policy.

Naturally, with London included in the area, the number of railway posters produced for travellers and residents was high - indeed the area database is close to one thousand entries - and this does not include a huge number of letterpress and general advertisements. This book therefore has been difficult to plan and lay out because of the abundance of potential images. Wherever possible, I have selected illustrations that have not featured in previous books. Little London Transport artwork (most of which I greatly admire) is included, as many have been beautifully depicted in some recent books (see Appendix C). This volume is therefore a complement to the excellent work of David Bownes and Oliver Green of the LT Museum.

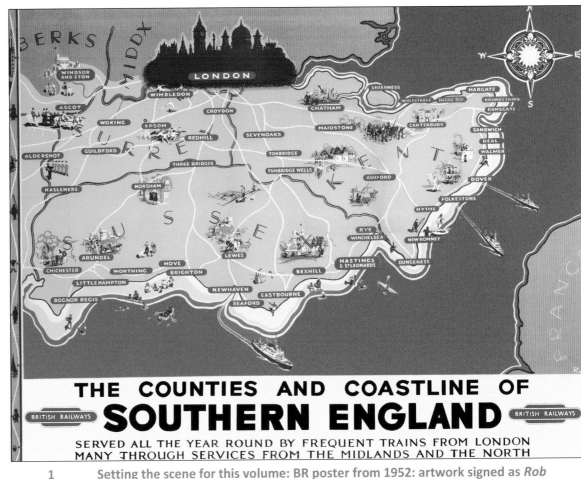

1 Setting the scene for this volume: BR poster from 1952: artwork signed as *Rob*

Railways in the region

Compared to the railway building that took place in the north (e.g. the Stockton & Darlington or Liverpool & Manchester railways), the first tracks arrived in this region some years later: the exception was the Canterbury & Whitstable Railway (opened in 1830). The first main constituent Southern Railway company was the London & Southampton Railway (later the LSWR) formed in 1834, followed shortly afterwards by the SER (1835). There were many small companies, such as the London & Greenwich (1833) or London & Croydon (1835) which were absorbed well before the major 1923 grouping.

Our first poster, issued in 1952, shows the route network for the south-east corner of England, with the lines radiating from London. With a few exceptions this network is Victorian, and it was not until HS1 was built in 2007 (Channel Tunnel high speed line from St Pancras) that the system was enlarged. This poster was one of a series covering the whole of the southern portion of England and illustrates many of the places to be visited in this volume. Railway building really took off from about 1840, when lines across Kent and Sussex were installed. The famous London to Brighton railway line opened in two sections: Norwood Junction to Haywards Heath in July 1841, followed two months later by the more difficult Brighton to Haywards Heath section, which cuts through the South Downs. The prominent Redhill to Ashford line, which runs west-east in the poster above, opened in 1842.

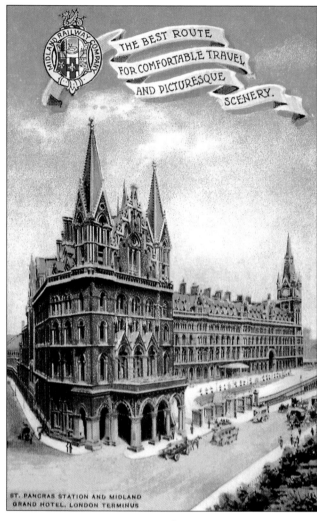

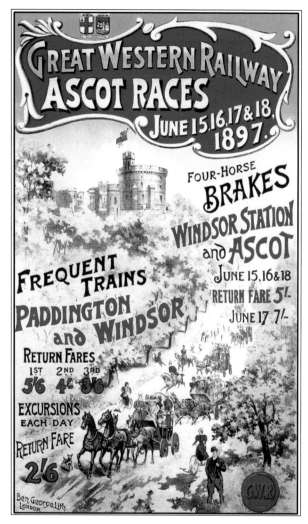

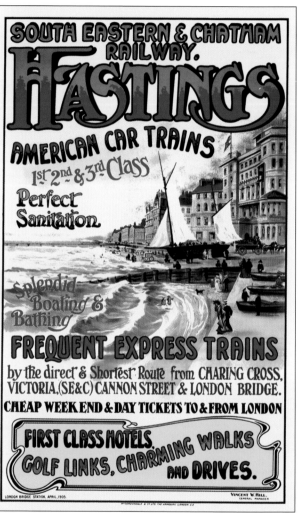

2, 3 & 4 Victorian and Edwardian marketing for parts of this region: artwork for all three posters is unsigned

One of our greatest railway stations, St Pancras (depicted above left), was opened in 1868 by the Midland Railway. Other London termini serving southern destinations had more complex histories, with Waterloo appearing in 1848, and Victoria in the 1860s. Indeed, if we take greater London as a whole, some 357 stations are listed, and reference to railway maps shows the incredible planning necessary to build and operate such a myriad of tracks. This does not include the vast network of underground lines required to keep the capital running smoothly. It is little wonder therefore, that railways have featured prominently in the development of London, as a place both to work and to live. Clapham Junction on the south side of the river is where lines from London's two busiest termini, Victoria and Waterloo, converge and funnel through, whilst on the northern side of the Thames, Willesden Junction is also an exceptionally busy complex, with the West Coast main line plus tracks to Kew, Kensington and Broad Street all merging and crossing.

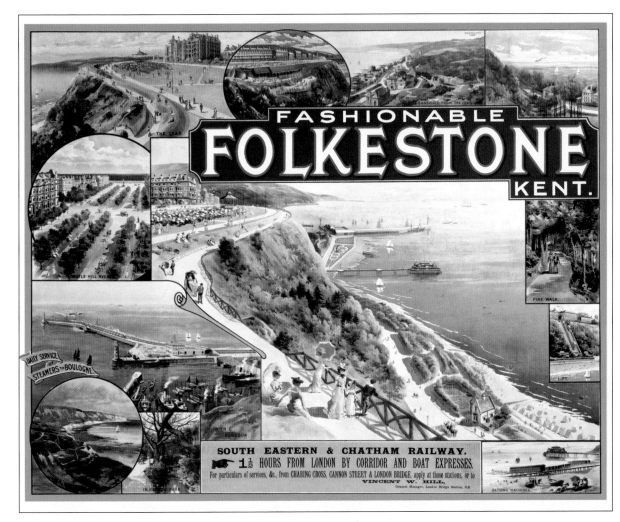
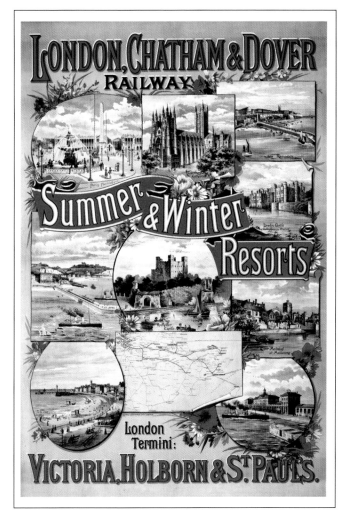

5 and 6 Early 20th century posters for trips to the coast: both pieces of artwork are unsigned

During the frenzied years of railway expansion, lines appeared all over this area. The South Eastern Railway had built the important Redhill-Tonbridge-Ashford line in 1842, and this was extended to Folkestone a year later. The London, Chatham & Dover built lines through Faversham to Canterbury (1860), Whitstable (1860) and Margate (1863) to link up the 1846-built line from Canterbury to Ramsgate and on into Margate. It was many years later that the two posters above appeared to advertise what had been achieved in the early Victorian period. The Folkestone poster portrays the fashionable side of the Kent coast, with vignettes juxtaposed to produce a cluttered image that detracts somewhat from the quite lovely main painting. The general fussiness of Edwardian posters is illustrated in the right hand poster above, where Rochester Castle, Dover, Canterbury and Maidstone are some of the places advertised on the LC&DR route map. Trains from London to the Kent coast were very popular at this time, and the various companies produced many posters of this type.

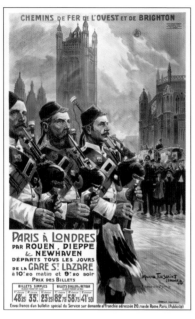
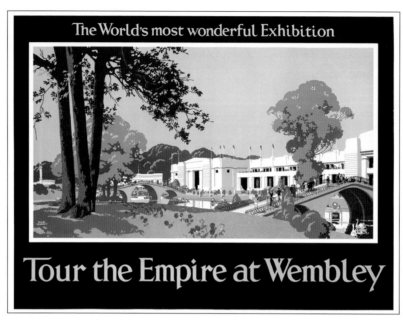

7 to 12 Selection of railway artwork for the south-east region of England up to 1930 (see page iii for details)

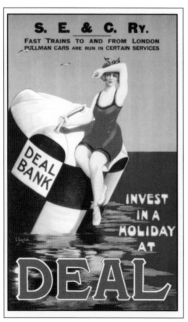

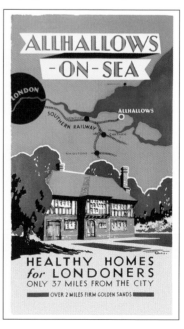

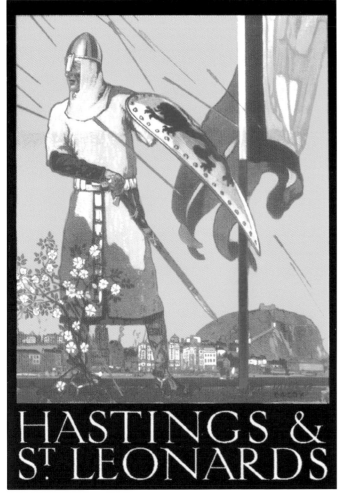
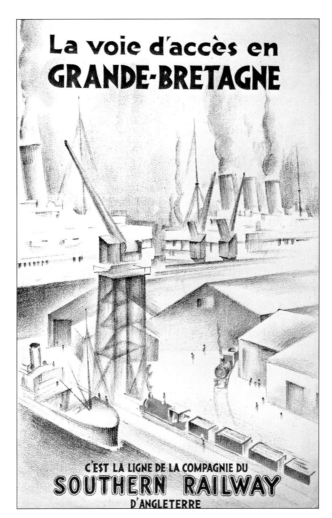
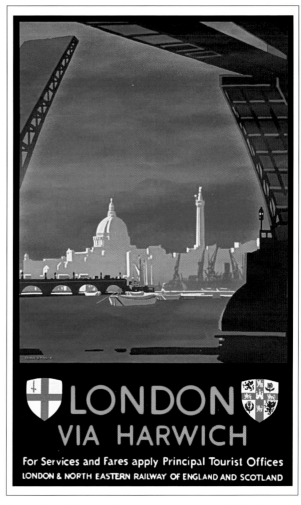

13, 14 & 15 Marketing south-eastern England destinations during the 'Big Four' era: artists are E A Cox (left), unsigned (centre) and Frank Mason (right)

The nine posters and paintings displayed on these two pages show the types of advertising found at stations all over the southern part of England and beyond our shores. Early in the 20th century, there was a strong connection between the British and French railway companies, so posters were produced identifying the collaborating parties, sometimes of English destinations for use in France and, in other cases, of French destinations to be used in England. Naturally the major cities of London and Paris featured prominently, but cross-Channel ferry services and through-train timetables, using some lovely artwork, graced many stations. With so many major ports, copious shipping posters were produced, and throughout this volume a large proportion will be shown for the first time. The Southern Railway was the first to electrify its main lines, so commuting service posters promoted the benefits. The history of our nation changed significantly in 1066, so that Hastings was a town that appeared often in railway advertising. The item above left is an example of classic SR marketing.

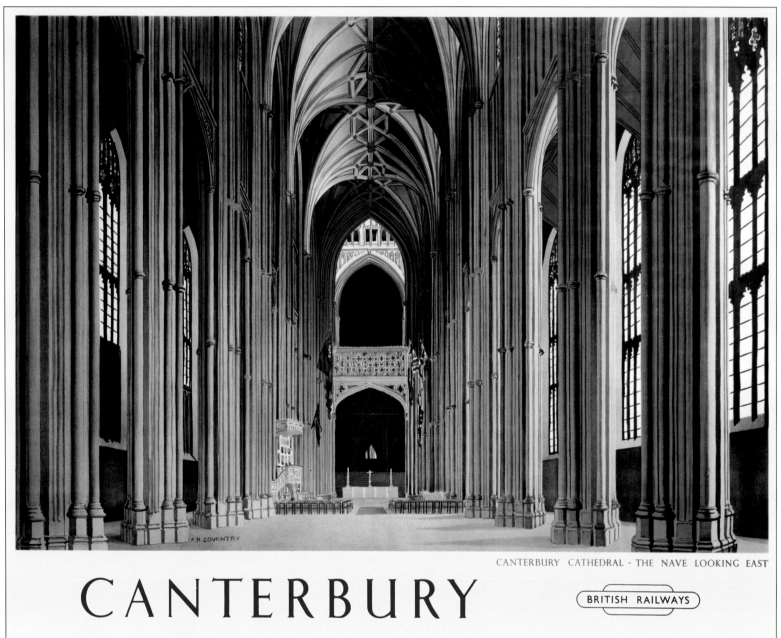

CANTERBURY CATHEDRAL - THE NAVE LOOKING EAST

CANTERBURY

BRITISH RAILWAYS

16 The wonderful interior of Canterbury Cathedral in a 1948 British Railways poster by Frank Coventry

Styles of marketing the South-East

What is noticeable during the production of this series of books is the development of poster style during the whole of the 20th century. But as well as the style, the subject matter also changed from that used in the so-called 'Golden Period' between the war years through to the end of the last century. From now until the end of this chapter, a short potted history of southern poster development is presented because, although they did not employ the prominent artists associated with the LNER and LMS (such as Mason, Wilkinson, Purvis, Newbould, Cooper or Gawthorn), they nevertheless produced some bold classic designs.

Irrespective of artist and style, when a number are displayed together, as on page 4, an enhanced marketing message is given; the LNER recognized this, but so did the SR. Photographs of Victoria and Waterloo stations show large poster boards which were probably filled with colour - the NRM pictures I found were black and white - over many years. The addition of continental destinations and posters for the famous *Golden Arrow* express only added to the impact that the railways had on their passengers, such as the poster here. This shows the wonderful nave at Canterbury Cathedral, a subject ideally suited to the scale of a quad royal. This is one of BR's first posters issued in 1948 and harks back to LNER Cathedral posters of the 1930s.

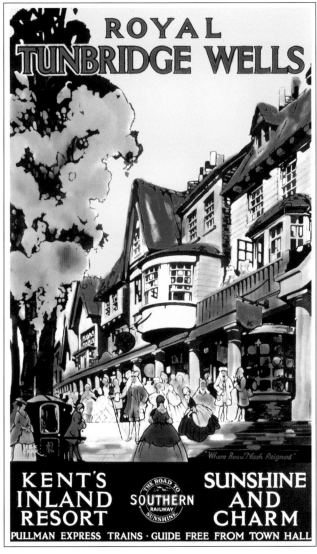 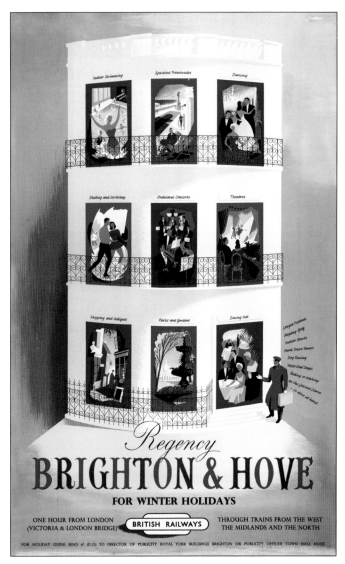 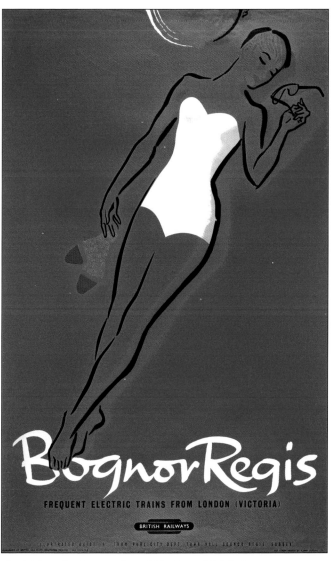

17, 18 and 19 Marketing comparison for the 1920s, 1950s and 1960s: Artists are Leslie Carr (left), Reginald Lander (centre) and Unsigned (right)

Advances in railway marketing and advertising methods in the middle of the 20th century were due in part to social and economic developments, but were also enabled by technical advances in printing and photography. The trio here span a generation, but the style might suggest a longer time period. The bold direct use of colour in the Bognor poster is an example of good commercial art, harking back to the 1930s, when Tom Purvis was active. This artwork (and the Hastings poster from the display on page 5) causes the eye to stop and look for a longer period than the other two, and demonstrates the essence of a good poster. The other two here are attractive posters, but possibly not bold enough.

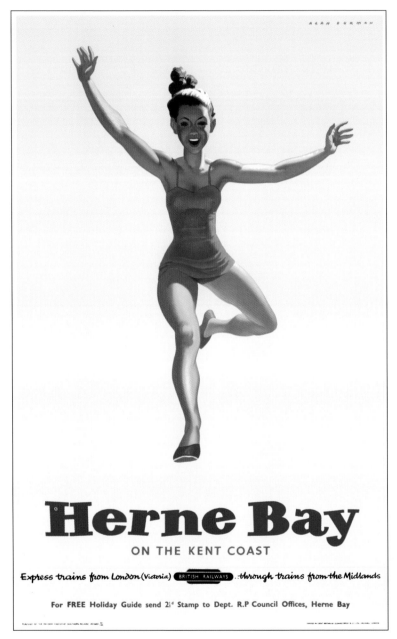

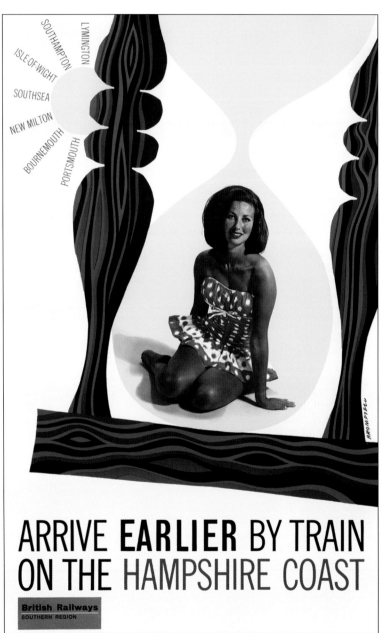

Alan Young's map at the front of the volume shows that there were resorts all along the coast, from the north Kent area down to Hampshire and the Isle of Wight. These places were ideal to advertise, and naturally every borough and town clamoured to be included in the list of places featured each year by the railway companies. Sometimes they were even proactive and offered financial incentives to be part of the annual summer poster campaign. The two examples here are rarely seen and illustrate Kent and Hampshire, the latter being one of a 1963 series that highlighted all of the southern counties. The Herne Bay poster was part of a set that also featured the other north Kent towns of Whitstable and Margate. British Railways recognized the importance of seaside advertising, and a good proportion of the promotional budget was spent here, as the weekday commuter trains could be utilised for holiday makers and day-trippers each weekend. As early as 1948 they introduced the *Thanet Belle*, later called the *Kentish Belle*, which was an all-Pullman train between London and Ramsgate. The railway down to the Hampshire coast had been electrified in 1937, part of Sir Herbert Walker's efforts to apply modern technology, so the message on this 1963 poster is a direct result of some visionary investment nearly thirty years before.

20 and 21 Advertising the southern seasides: Alan Durman from 1952 (left) and Kenneth Bromfield from 1963

By the time the 1960s arrived, BR advertising was often very colourful. These two posters are testament to that and, shown together, they illustrate how BR tried to portray the capital in different ways. The 1960 collage (near side) shows ceremonial London, where state occasions are organised and executed better than anywhere else, and in Chapter 3 some magnificent quad royals reinforce this strong statement.

In 1980, at a time when photo-posters had largely superseded artwork, the series produced by Reginald Lander showed all the southern counties in a new way. This one for London uses purple and turquoise as the primary colours - very unusual in railway advertising - but the design is bright and bold: whether the prospective traveller would stop and read all of the text is open to debate. Notice that in the 1960s the branding was *British Railways*, but in the 1970s, this had been regionalised to just *Southern* with the corporate BR Inter-City logo alongside. This area did not seem to suffer the in-roads that road transport had made in other areas and, even today, it is best to go to London by train.

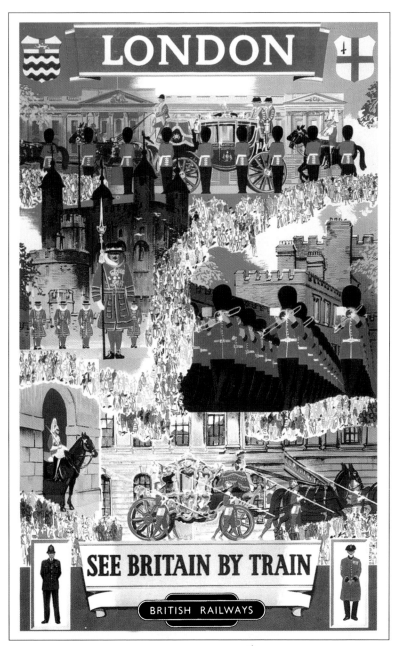

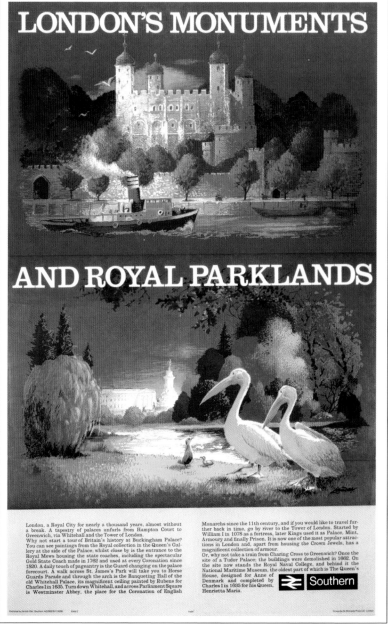

22 and 23 Colourful 20th century poster artwork for London: Blake from 1960 (left) and Lander from 1980 (right)

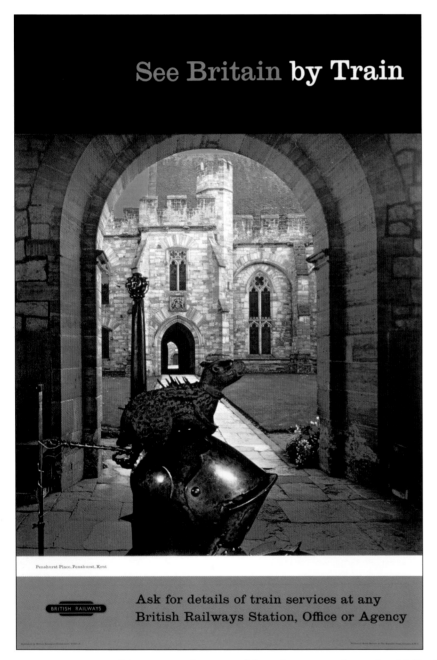

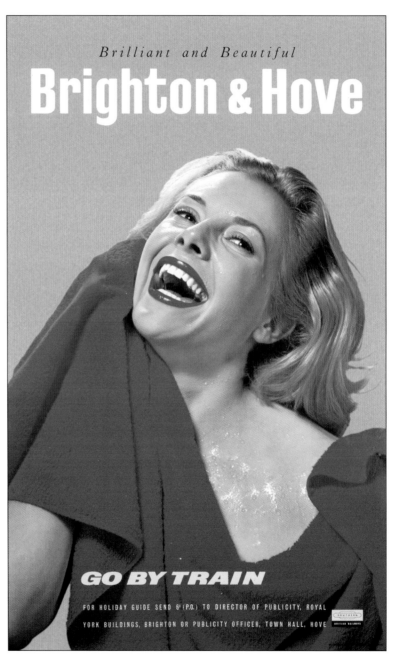

Photographic poster images did appear early on Southern stations, and the two examples shown here are typical of the material produced. Penshurst Place has an interesting history but, for many, is not on the 'A-list' of places to visit. In contrast Brighton has for two centuries been a main resort, and the poster database (Appendix B) shows many images of the town produced throughout the 20th century. This one is certainly colourful, but somehow does not have the appeal of an artwork-based poster.

The posters on pages 11 and 12 take us towards the end of the 20th century. These often carried images of commuter services, as the highest concentration of new multiple electric units appeared in the south-east. The Leeds Castle image on page 12 is a strange one, because the castle is stunning in its own right, yet here the superimposed EMU takes the eye away from the beautiful building and is too prominent. Neiland's offering on page 12 of the roof of the Eurostar terminal at Waterloo is a return to more artistic ways and was part of a set of posters commissioned in 1996.

24 and 25 Photographic style posters from the 1960s: Penshurst Place, Kent (left) and Brighton & Hove (right)

The layout of this book

This has proved to be the most difficult of the five books written so far in this series. The database pages in appendix B list nearly 1000 regional posters, but space has restricted the number used to around 40% of those listed. This region also shows the greatest concentration of railway stations, so the sheer number of posters produced must have been considerable. The Southern Railway also kept customers informed of their many developments, and this continued beyond 'Southern' territory in BR years, when major upgrades in the 1960s at Euston and 1970s at King's Cross, were promoted via posters.

During the planning of the series it was clear that, as we move south, industrial images became ever scarcer, so that there are few in this volume. What we lack in industrial drama, we make up in pageantry and colour, and a whole raft of seaside posters from all across this region. Southampton Docks was given prominence via many lovely quad royal shipping posters, as the railway joined forces with some major shipping lines.

Initially the journey was planned to begin in London, but fitting Berkshire and Middlesex into the journey in a logical way became troublesome. We therefore start at Windsor, which, because of the royal residence guarding the town, had posters produced throughout the 20th century. Our **Chapter 1** journey begins on page 14, and advertising images from the LSWR, GWR, BR and Network SouthEast are included, to clearly show how poster art for Windsor developed from Edwardian times.

Chapters 2 and 3 are devoted to London and its environs. The database shows hundreds of posters produced for this area, so selection was prioritized to show some of the rarer items. **Chapter 2** looks at the main stations that served all destinations from north-west England, Scotland and eastern Britain: Euston, Marylebone, St Pancras, King's Cross and Liverpool Street all feature in this unashamedly 'train-biased' chapter. **Chapter 3** looks at central London, with its history, pageantry and wonderful buildings all prominent, before we see Greenwich and a small selection of the posters produced for south London.

Then it is off to the coast, first in **Chapter 4** through Kent, the Garden of England, taking in the resorts and towns along the north coast. Whitstable, Margate, Ramsgate, Deal and Dover were towns where tourism was strongly encouraged. Some classic Southern Railway posters were published for these towns, and, for the first time, the whole of Kent is covered in a single section.

Neighbouring Sussex was not to be outdone, and once the railways developed in the early years of Victoria's reign, millions of travellers left London for the coast at Brighton, Worthing, Eastbourne and many other towns; **Chapter 5** covers this area.

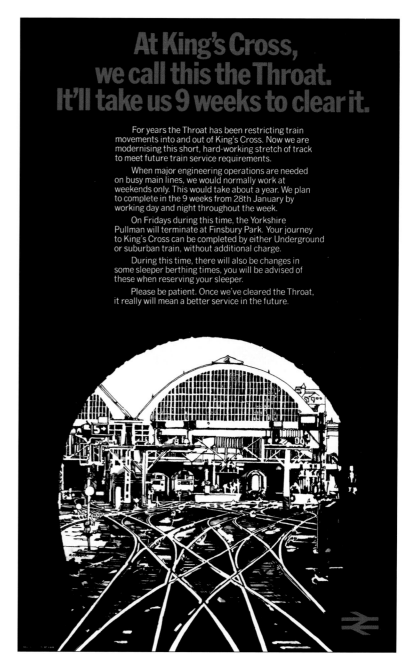

26 Upgrades: photo-style informative poster from the 1970s

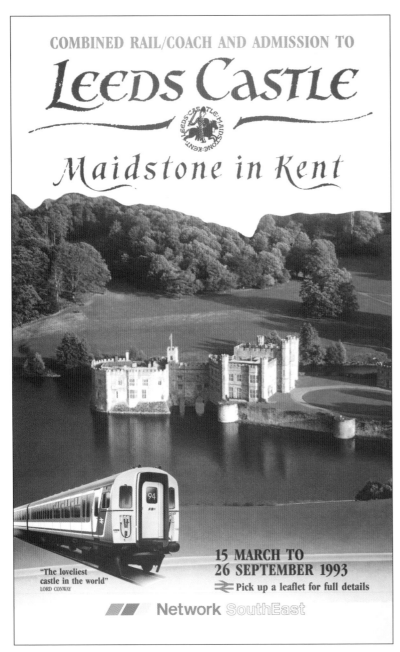

27 Beautiful Leeds Castle reached by EMU in 1993

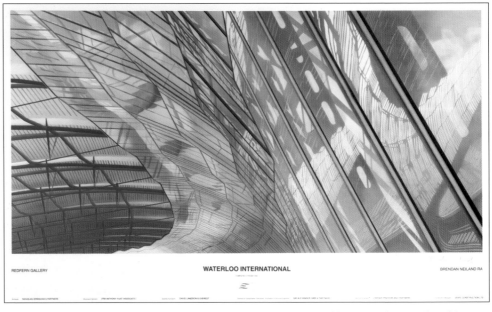

28 Artistic view of the Waterloo Eurostar terminal roof by Brendan Neiland in 1996

Posters from inland Sussex and Surrey are found in **Chapter 6**. This area saw concentrated commuting into London, or travelling south to the coast, but relatively fewer posters were produced for local tourism in this part of the journey. However the chapter features advertising for Guildford, Farnham, Kew, Lewes and Arundel, plus several uncommon railway promotional works that are lodged in the NRM archives.

Chapters 7 and 8 cover Hampshire and the Isle of Wight respectively. Here history and sailing activities are found in equal measure. **Chapter 7** covers mainland Hampshire, featuring historic Winchester, a former English capital, plus major naval and shipping facilities in the cities of Portsmouth and Southampton. The lovely New Forest and Hampshire coast are also covered, before we go off the English mainland, taking a ferry to the Isle of Wight, for the **Chapter 8** visit. This lovely island was a favourite of Queen Victoria, and the journey around the south-east finishes with a strong sailing theme.

Chapter 9 gives a chance to include many other posters covering the whole area. In this chapter the impact of the railways and its advertising on the south-east of England is assessed. Being both the capital city and the hub of the British Empire, London has dominated travel in the region. Railway posters have played a major role in both the city's and area's growth.

Chapter 1 Royal Connections
Royal Berkshire and Middlesex

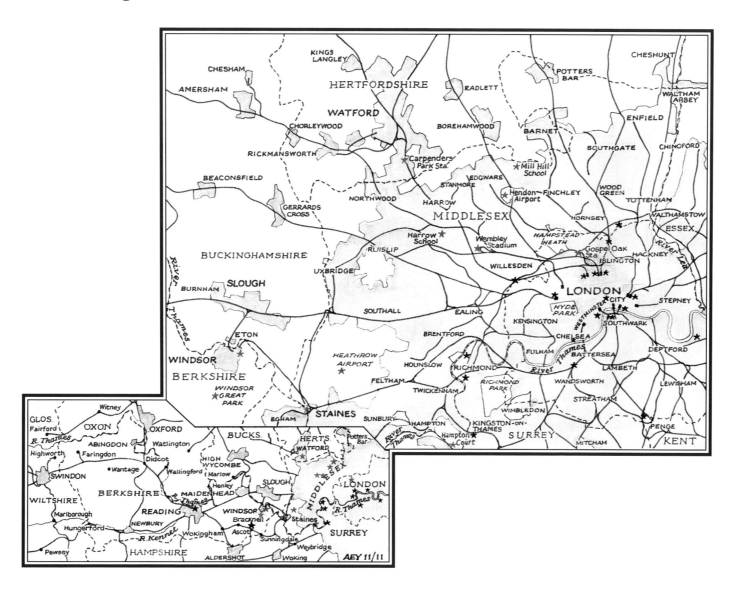

Chapter 1 — Royal Connections

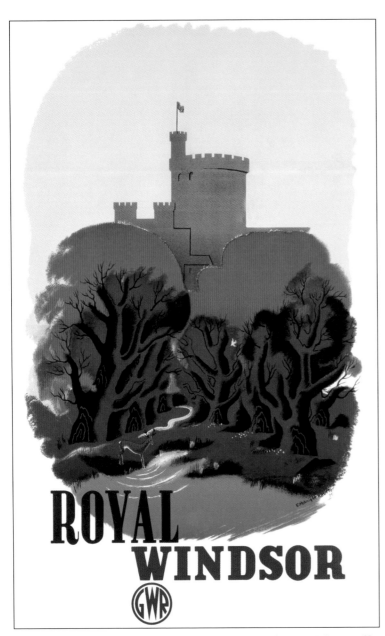

29 Famous poster for a famous place: Edward McKnight Kauffer

One of England's most famous castles

Royal Berkshire, which gained that distinctive title in 1957, is regarded as one of the Home Counties and, in railway terms, is host to the two main companies featured in this volume, the Great Western and the Southern Railway companies. Abingdon was the county town for many centuries, but as Reading grew, it superseded its smaller northern neighbour in 1867. The original Berkshire coat of arms shown below was granted in 1947, with the supporters being added 14 years later, but in 1974 the arms shown below right were adopted, until Berkshire was abolished as an administrative county. The early coat of arms shows a rampant white horse. When the county boundaries changed in 1974, the Vale of White Horse to the west, along with historic Abingdon in the north, were moved into Oxfordshire; the new Berkshire coat of arms subsequently carried a black horse.

The coats of arms for Berkshire: 1947 (left) and 1974 (right)

The county is one of England's oldest, dating from the 9th century, when *Beaurucsir* was first noted in official records. Reading lies almost exactly in the middle, on the banks of the river Thames, which forms the northern boundary. Moving westwards, the Thames Valley gives way to rolling downs around West Ilsley and Lambourn, while to the south, the land rises towards the border with neighbouring Hampshire. Much of the eastern part of Berkshire is wooded, with major towns at Slough, Bracknell, Maidenhead and Windsor, where we now begin.

Situated some 25 miles west of central London, Windsor is known worldwide for its wonderful castle, a main residence of the British Royal Family. The posters on this pair of pages from two eminent artists show instantly recognizable images. Along with the castles at Edinburgh, Warwick, Stirling and Bamburgh, Windsor Castle has always been an important focus for railway promotion, and the following four pages indicate how advertising for the town has developed. In nearly all of the images selected, the distinctive castle, with sections dating from the 11th century, is present. Windsor is the oldest and largest inhabited castle in the world, and over the centuries it has been enlarged and developed into a quite magnificent tourist attraction, as well as being a working residence.

It has, in the past century, seen some tumultuous events, joyous as well as disastrous, with royal ceremonies at regular intervals and a serious fire that destroyed many unique artefacts on 20th November 1992. St George's Hall, the Crimson and Green Drawing Rooms, and the Queen's Private Chapel (where the fire started) were either gutted or badly damaged. A unique Willis chapel organ and several historic paintings and pieces of furniture were lost, but all the damage has since been repaired, and the grandeur that was Windsor can once again be enjoyed by present and future generations.

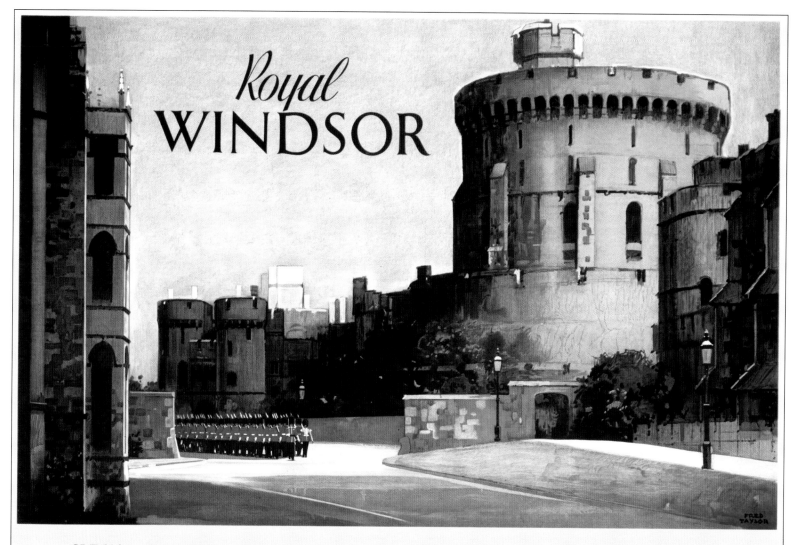

30 Ceremony at Royal Windsor: BR (LMR) quad royal poster from the 1950s by Fred Taylor (1875-1963)

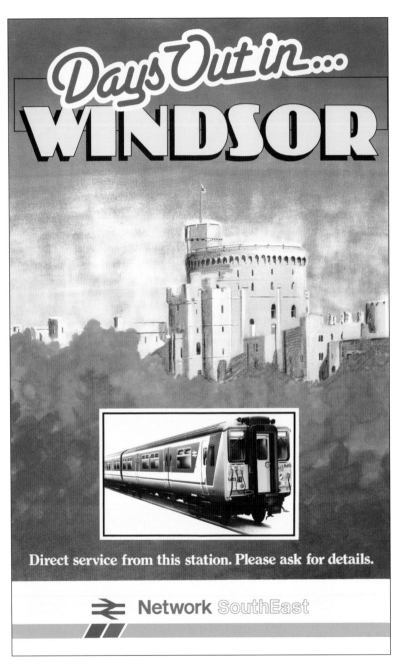

These two posters, published more than sixty years apart, show the enduring popularity of day trips to Windsor. The Great Western poster, issued years before the enlarged GWR was formed, advertised visits to the State Apartments: the unsigned artwork illustrates the internal grandeur as well as an external view from the river. At this time, visitors could have taken the LWSR service from Waterloo via Staines, or the GWR service from Paddington, via Slough. This is still the case today, and we will look at the two stations shortly. The poster here from the 1970s advertises the service to Riverside station, a short walking distance from the castle.

Visiting Windsor by either route has always been popular, and today almost three million passengers use the two small termini; many come to see the castle and its State apartments. These are a collection of rooms created between 1675 and 1678 for King Charles II and Catherine of Braganza, decorated gloriously in the baroque style of that period. They include the magnificent St George's Hall, which is used for state banquets, and two drawing rooms housing famous paintings by Rubens and Van Dyke. George IV built the Semi-State Apartments in an extravagant style; they all suffered badly in 1992.

31 & 32 Windsor's magic down the years: posters from 1908 (unsigned left) and the 1970s (photographic right)

The pair of posters on this page show pageantry on the river in a 1962 season image and a poster from 1982 advertising the exhibition held by Madame Tussaud's that relives Queen Victoria's 1897 Golden Jubilee. Gordon Nicoll's image shows one of the popular events of the Hanoverian period, when concerts and socialising took place along the Thames, and is an unusual choice of poster subject for the town. The 1980s poster held at Windsor & Eton Central station shows a replica locomotive *The Queen* as the centrepiece of the staged exhibition. This station opened in October 1849 on the branch from Slough. It became Windsor & Eton Central in September 1949, and shortly afterwards carried chocolate and cream Western Region totems. The station is approached on a 2,000 yard brick viaduct, Brunel's oldest surviving bridge. When first opened, the station had a simple trainshed. It was rebuilt in 1897 with a grand frontage and an interior similar to that of Paddington. Initially there were four platforms, but in 1968, two were taken out of service and a year later a third was decommissioned. In 1982 the Tussaud's exhibition was staged and this lasted until the late 1990s. Today the station is rebranded yet again, this time as Windsor Royal Shopping, a far cry from the grandeur that once existed here.

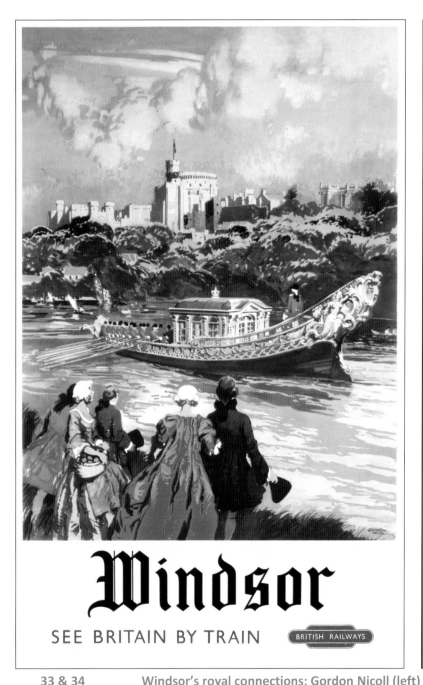

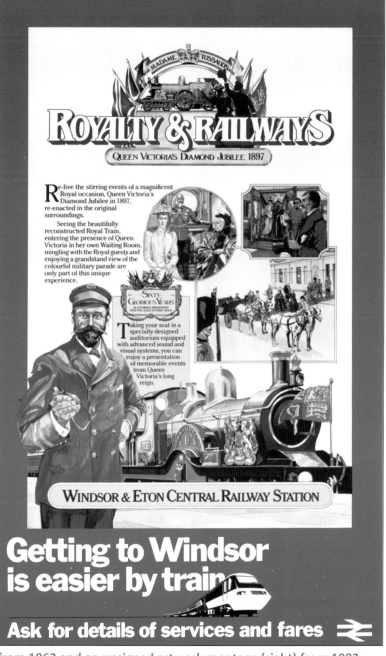

33 & 34 Windsor's royal connections: Gordon Nicoll (left) from 1962 and an unsigned artwork montage (right) from 1982

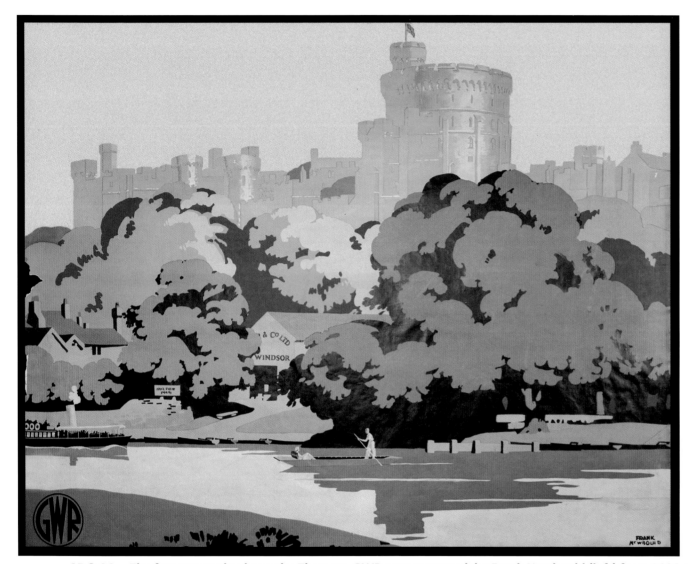

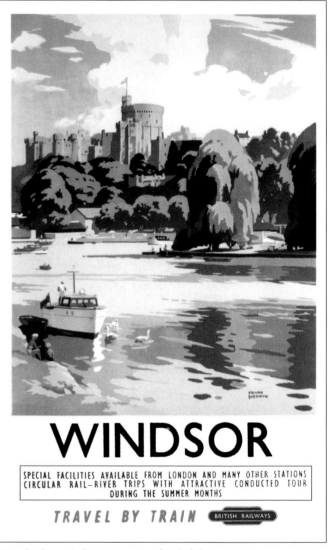

35 & 36 The famous castle above the Thames: GWR poster artwork by Frank Newbould (left) from 1936 and Frank Sherwin's BR poster (right) from 1955

These two posters are the more traditional views of the castle as seen from the Thames. Windsor's other station, Windsor & Eton Riverside (once adorned with green Southern Region totems), is located nearby. This opened in December 1849, designed by eminent architect Sir William Tite. The Datchet Road frontage is built in stone with mullioned windows and gables, and is quite different from the GWR trainshed. Queen Victoria's royal waiting room is found at this station, and today the two platforms are managed by South West Trains. Frank Newbould's famous quad royal painting for the GWR in 1936 shows the immense size of the castle, whereas Sherwin's more distant and colourful painting from 1955 indicates the lovely setting the castle possesses. At this time, Frank Sherwin was being used by British Railways to produce advertisements of famous places, including seaside towns, all over Britain.

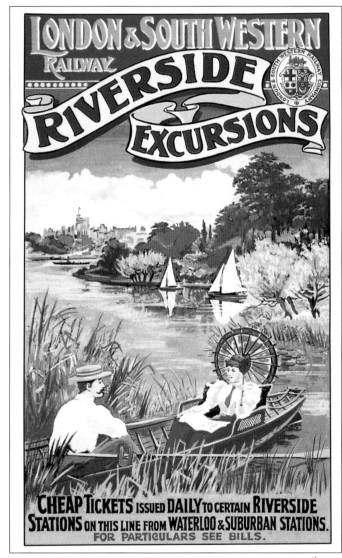
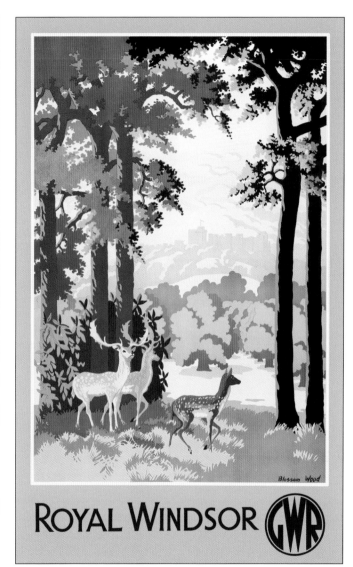
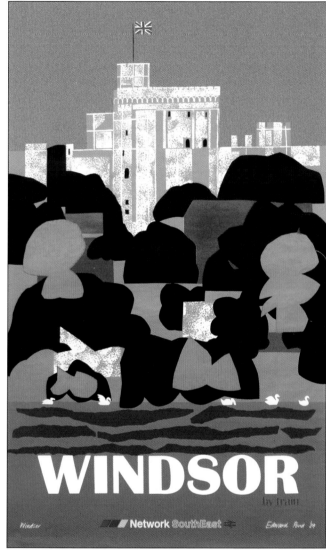

37, 38 & 39 Windsor through the 20th century: unsigned artwork from 1910 (left), Blossom Wood from 1934 (centre) and Edward Pond from 1989 (right)

This final trio shows contrasting images of Royal Windsor from three different railway companies. On the far left is an Edwardian LSWR poster advertising their riverside excursions that included Windsor. At this time the British Empire was at its zenith, so the day trip from Waterloo proved very lucrative. The unsigned artwork is one of the LSWR's more eye-catching posters. Also easy on the eye is Blossom Wood's poster for the GWR of the famous Windsor Great Park. This 5,000 acre pleasure ground, dating from the 13th century and south of the castle, was where royalty formerly hunted deer. Today is it open to the public, and its many famous lodges and ancient oak trees are reached from a series of named gates around the perimeter. The right hand poster is Edward Pond's 1989 bold and colourful rendition for Network SouthEast, showing the castle in contemporary style.

THAMES VALLEY

40 The tranquil Thames valley: joint GWR/SR Poster from 1946 by Walter E. Spradbery (1889-1969)

In the Lower Thames valley

Travelling down the Thames from Windsor towards London is an absolute delight. The railways thought so too and produced a few posters to show the beauty of the many willows and other trees reflecting in the waters of the Thames. For much of the 19th and 20th centuries it was polluted by man's effluent but, thanks to modern water treatment, the waters are clean again. This joint GWR/SR poster was issued in 1946.

There never seemed to be the rivalry and animosity between these two companies that occurred between the LMS and LNER, and right from the formation of the 'Big Four' in 1923, there were varying degrees of co-operation between them, even for destinations in Cornwall and Devon, where there might have been reason for the GWR and SR to battle each other for passenger business.

Walter Spradbery had undertaken much work for the GWR, SR and LNER before WWII, and he also produced a series of posters during the war to depict the pride and suffering that London felt during the hostilities. This poster is one of several he made jointly for the railways, and it was almost certainly painted in the late 1930s, (but issued after WWII) during his most active commercial period.

There are several small islands in the Thames, so it is difficult to pin-point the exact location of the Spradbery poster. These 'eyots' formed when the river split and altered its course slightly over countless millennia. Passing downstream from Windsor and Eton we soon come to Staines. This used to be in the County of Middlesex, but boundary changes in 1965 (when much of Middlesex was absorbed into Greater London) now place Staines in Surrey. As the 1912 poster alongside shows, this has been popular destination for riverside days out: being on the line from Waterloo, reaching here was easy. Rather interestingly, the poster shows a vignette of the London Stone, which marks the western extremity of the City of London's jurisdiction in former times. Staines has always been an important Thames crossing point, and the main picture shows the famous bridge. It is only three miles from Heathrow Airport so the poster on the far side is placed here to show the huge contrast in style in three generations, but also to acknowledge the famous airport with its important railway links. This poster was one of a series issued in the 1980s to highlight the railway's role in international travel. It appears to show a Lockheed Tri-Star L-1011, which British Airways was promoting at that time, as their airline 'flagship'.

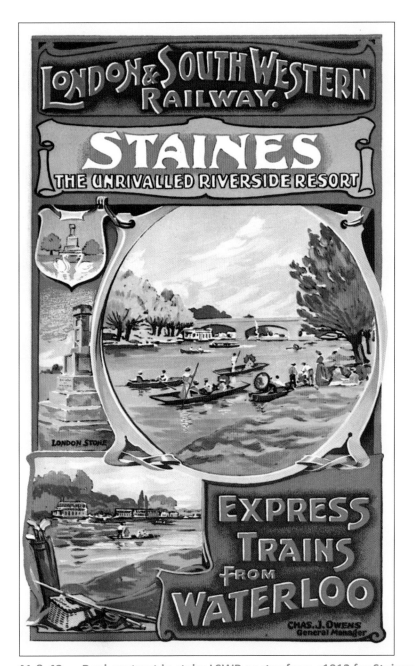

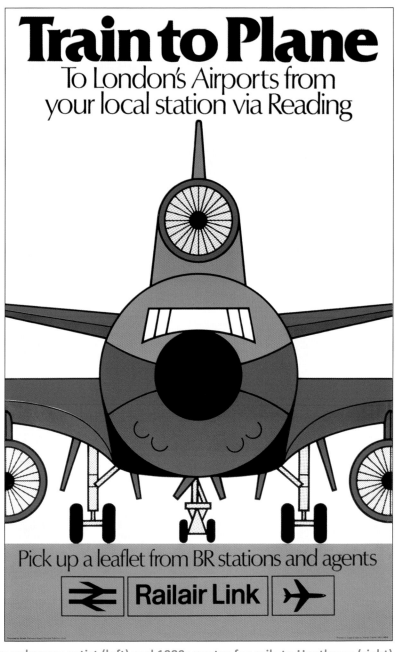

41 & 42 Real contrast in style: LSWR poster from c1912 for Staines by unknown artist (left) and 1980s poster for rails to Heathrow (right)

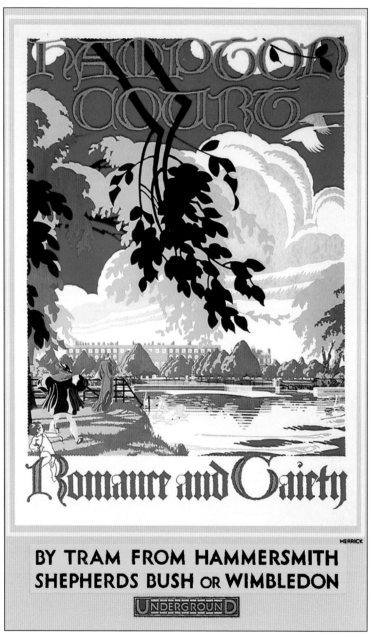

It is not far from Staines to the second main royal connection in this chapter, the wonderful Hampton Court Palace. This has been a royal palace since the 16th century, having been developed by Cardinal Wolsey, and later by Henry VIII. It had previously been in the hands of the Order of St John, but when Wolsey acquired it in 1514, he spent years and large sums of money producing one of England's great houses. Much of what is visible today was of Wolsey's making.

The wonderful architecture, internal grandeur and exquisite gardens of Hampton Court are not done justice by the railway posters. They are certainly colourful, but something is lacking, and none of them really show the palace's beauty. This pair suggests the easiest mode of travel in the 1920s was by tram, from at least three nearby locations. Wolsey is shown in his colourful robes in Taylor's poster and, alongside, Frederick Herrick shows the scale of the former Court buildings. Wolsey did not enjoy his sumptuous house for very long, because the King, and his enemies, were plotting his downfall. In 1528 he gave Hampton Court to Henry VIII, but a year later he was dead. Henry VIII continued the expansion and soon it was far larger than the original buildings.

43 & 44 Tram posters for Hampton Court, Middlesex: artists Fred Taylor (left) and Frederick Herrick (right)

The Great Hall was added from 1532, and Ann Boleyn's Gate in 1540, during a decade of courtyard expansion. Henry VIII made Hampton Court his main residence, as it became large enough to accommodate his considerable entourage. Anne Boleyn's apartment complex, above the gate that bears her name, was still being developed when the king became tired of her, and it was 'off with her head'! After Henry's death in 1547, a succession of Tudor, then Stuart, owners continued the building work. First Inigo Jones, and then Sir Christopher Wren were called upon to enlarge the structure. George I and George II became the last monarchs to use Hampton Court as their home, though even in their times, rooms and furnishings were still being added. The grounds were developed in the late 17th century and are today largely as originally conceived. The Royal Chapel, with its superb stained glass windows, is not to be missed.

In the nearside illustration, produced in 1989 for Network SouthEast, Edward Pond tries to convey the scale of the buildings. At this time he had been commissioned to produce many posters of places in and around London, and his artwork was some of the last to be sanctioned by the English railway companies. His poster is juxtaposed against Gregory Brown's 1929 image of the nearby Thames.

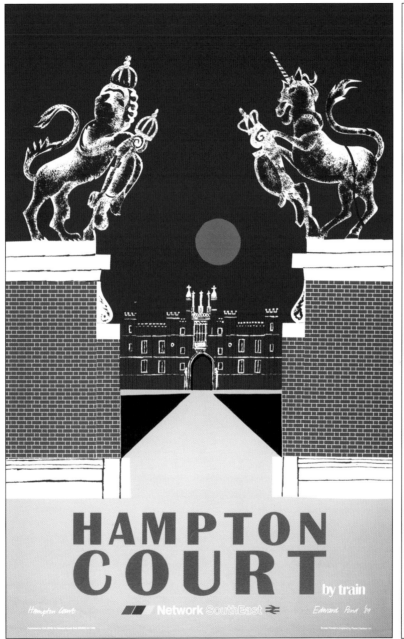 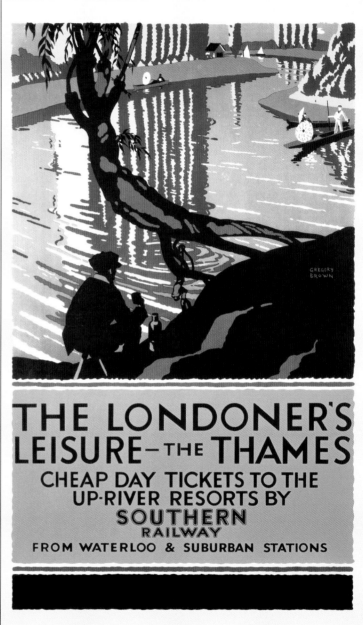

45 & 46 Attractions in the lower Thames valley: Edward Pond from 1989 (left) and Gregory Brown from 1929 (right)

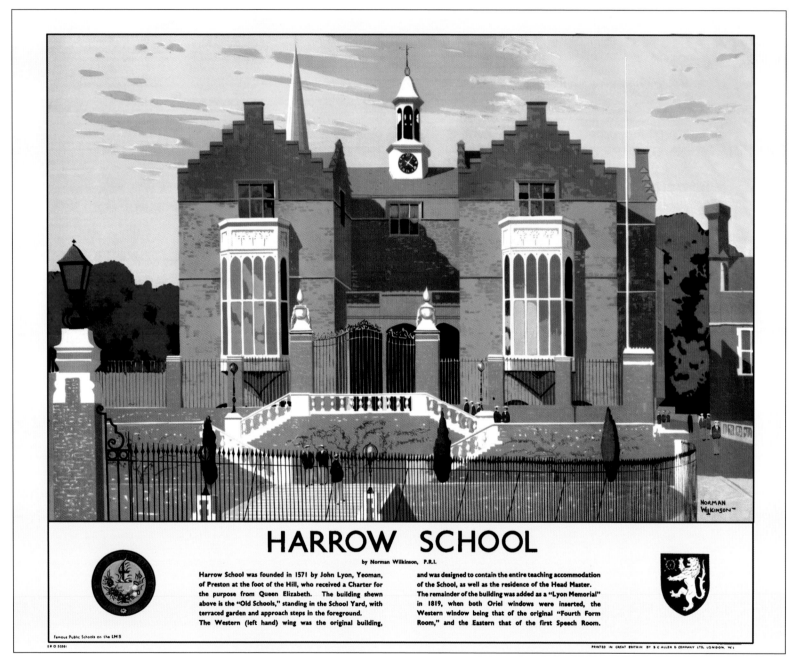

HARROW SCHOOL

by Norman Wilkinson, P.R.I.

Harrow School was founded in 1571 by John Lyon, Yeoman, of Preston at the foot of the Hill, who received a Charter for the purpose from Queen Elizabeth. The building shewn above is the "Old Schools," standing in the School Yard, with terraced garden and approach steps in the foreground. The Western (left hand) wing was the original building, and was designed to contain the entire teaching accommodation of the School, as well as the residence of the Head Master. The remainder of the building was added as a "Lyon Memorial" in 1819, when both Oriel windows were inserted, the Western window being that of the original "Fourth Form Room," and the Eastern that of the first Speech Room.

Famous Public Schools on the LMS

47 A famous painting of a famous school: Norman Wilkinson for the LMS in 1927

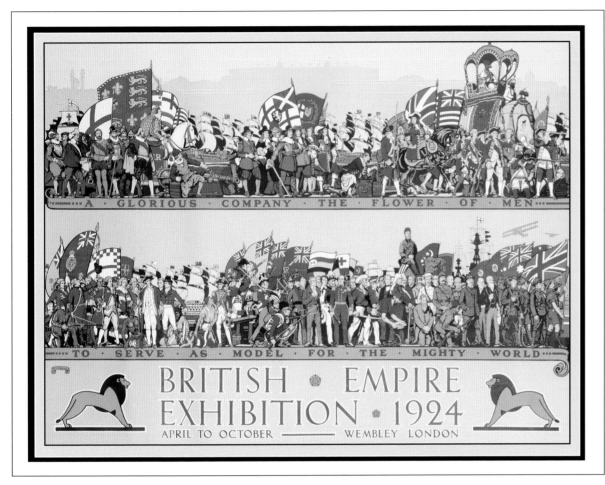

48 Richard Cooper's amazing artwork for the Great 1924 Exhibition at Wembley

Wembley, here we come!

Leaving the Thames, we swing northwards to an area of London much favoured by the railway companies. Wilkinson's painting of Harrow School contrasts with the two posters on this page for nearby Wembley. Harrow was founded in 1572, under a charter from Elizabeth I, but educational facilities have existed here since the late 13th century. The impressive list of alumni includes royalty, several British Prime Ministers (notably Winston Churchill), and other famous Britons, including many from the aristocracy. The poster depicts the frontage of the Old School buildings. Harrow to Wembley is a short journey, and the railway companies have over the years produced almost two dozen Wembley posters; two of the most famous are shown here. The 1924 Empire Exhibition produced a unique poster (above) and alongside is an advertisement for Wembley to see the 'White Horse' final of 1923, when enormous crowds descended.

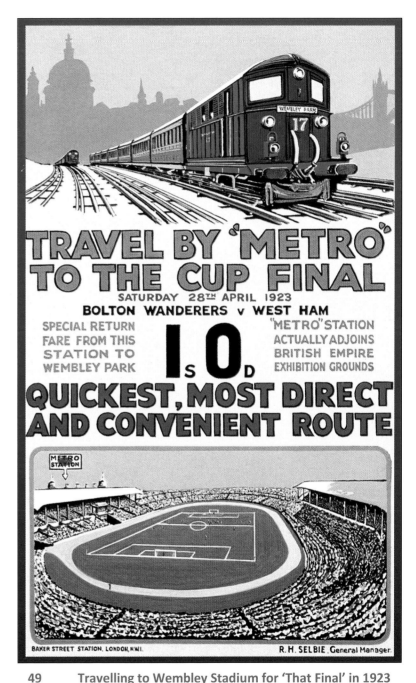

49 Travelling to Wembley Stadium for 'That Final' in 1923

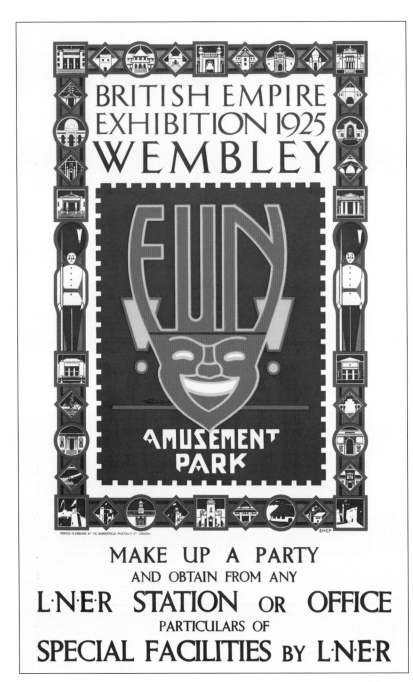

51 One of a large series of posters issued for the 1924 Exhibition, Wembley, North London

This pair of pages shows a small selection of the very many posters produced for the Empire Exhibitions in 1924 and 1925 held at Wembley. These were huge enterprises that attracted millions of visitors, and naturally the railway companies provided enormous assistance in 'people moving'. The idea of an Empire Exhibition had been mooted for years, but it was not until 1922 that funding became available and construction began. The football stadium was completed first and in 1923 became the home of the FA Cup Final. The exhibition halls, 16 of them of various sizes, were ready for the 1924 show. Most of the countries of the Empire took part, some with their own large pavilions, such as Australia, with the smaller nations sharing exhibition pavilions and the largest stands. As well as the spectacular exhibition itself, the event was also historical as the first words ever transmitted over the radio by a British Monarch were spoken at the opening ceremony in April 1924. The poster above was one of a large series issued to show industrial and farming activities within some of the nations.

At that time, the British Empire was made up of 58 nations, and only Gambia and Gibraltar did not take part. In the Palace of Engineering, made from concrete in the 'new style', there were railway locomotives on display. The LNER did much to promote the 1924 and 1925 exhibitions, and in both the famous locomotive 4472 *Flying Scotsman* was displayed. In 1924 it was shown alongside an LNWR *Prince of Wales* class 4-6-0, in tribute to the Royal Patron. They were joined in 1925 by 4079 *Pendennis Castle* from the GWR and Southern Railway engine 866, which was then brand new. Also in both shows an example of the Metropolitan Railway electric cars (shown in poster 49 on page 25) was displayed along with cut-out sections of other cars to show the working of London's new electric railway stock.

Firework displays and colourful lighting shows took place nightly, as depicted in the two posters alongside. In the 1925 exhibition, an RAF squadron gave displays to demonstrate how they would defend London. The LNER excelled in marketing, and it was partly due to the many colourful posters they produced for these shows that they gained a considerable lead in railway advertising at that time. They used both well-known and lesser-known artists and some of these posters have become classics. The near side poster is a real beauty!

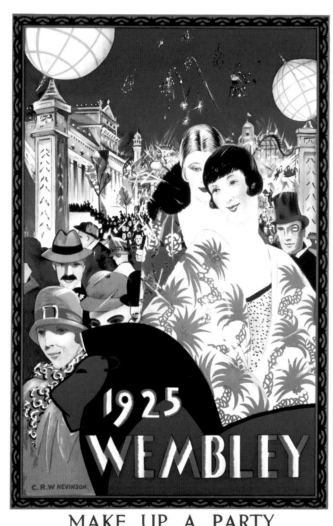

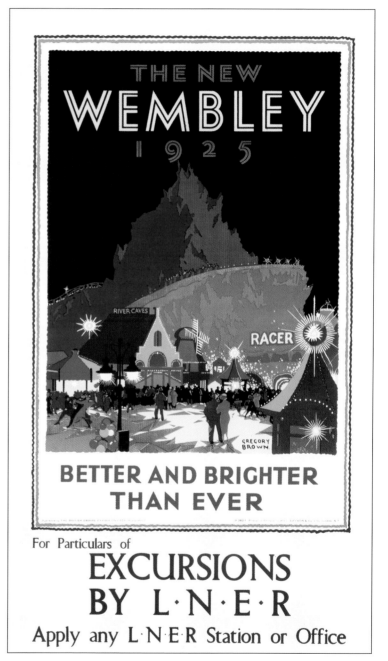

52 & 53 Colourful artwork for Wembley's great 1925 exhibition: C. R. W. Nevison (left) and Gregory Brown (right)

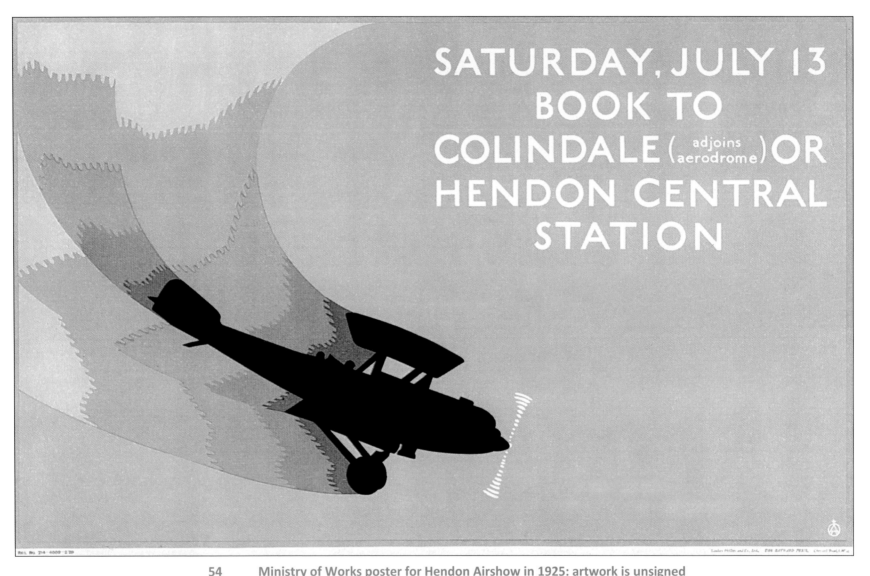

54 Ministry of Works poster for Hendon Airshow in 1925: artwork is unsigned

In the outer northern suburbs

This rarely-seen poster depicts a scene from the 1925 air show, and its appeal is the simplicity of the artwork. From 1908 onwards, Hendon Aerodrome was at the forefront of British aviation. It was a famous RAF base during both world wars and a place where much aviation experimentation occurred, with some notable firsts: these include the first-ever night flights; first airmail letter flights; first parachute drop from a powered aircraft and, of course, the first use of an airport to defend a city in WWI (the Royal Naval Air Service in 1915). The first RAF Pageant was held in 1920, and by 1925 it had become a regular event in London's social calendar. A famous Tiger Moth aircraft silhouette makes for a quite striking poster.

Studying a railway map of greater London shows that the various boroughs are criss-crossed by a multitude of railway lines. All great cities rely heavily on their infrastructure, and the rapid growth of London, as the centre of the Empire, required rail transport to shoulder much of the load. These same maps show lines converging, from all directions. The major stations we will visit in Chapter 3 were constructed in Victorian times, as the railway companies fought for image, prestige and of course, business. The tracks themselves were all laid down in the mid 19th century and it is only recently that new lines in the form of the Docklands Light Railway system in East London and the new route to the Channel Tunnel from St Pancras, have added to the Victorian system. Naturally, as the population increased and the whole of London expanded, the system had to be modernized and capacity added. Commuters came in from ever more distant places, so to show the railways were keeping pace, posters such as the one alongside were produced. Signalling, track, stations and engine developments were all advertised at various times.

Nearly all of the stations in north-central and north-west London received attention in the first decade after WWII. London and its transport system had suffered badly during German air raids so, after initial functional repair and as growing finances permitted, stations were successively upgraded. New stations were also added to serve the increasing population. Carpenders Park and Gospel Oak, shown on the poster here, were two examples, replacing older structures. The former is between Harrow and Bushey, on the main line from Euston, and Gospel Oak is at the southern extremity of Hampstead Heath, where several lines converge. As the poster shows they were built in the modern 'minimalist' style, and these new designs were later used in Hornby Dublo models of station buildings and signal boxes that many boys of the time used to play with. This poster, by artist G.H. Davies, was issued in 1953 to inform local travellers that next year they would have new stations. The aerial views do not really show what was being planned and some later posters came down to ground level to depict more of the building detail.

The final poster in this chapter shows another of Wilkinson's paintings of famous public schools, this time of Mill Hill. It was founded in 1807 in the grounds of Ridgeway House, the former home of eminent British botanist Peter Collinson. He was responsible for introducing many new species to Britain, many of which still grow in the grounds of the school. Wilkinson's expansive painting sets the 1825 building of Sir William Tite (he was only 27 when this building was constructed) against some of the lovely botanical species and makes for a pleasing poster from the series of 15 images the LMS eventually produced of such subjects. In 1939, the Government requisitioned the site for war usage, and the whole school was evacuated to St Bees, Cumberland, for the duration of hostilities. Today Mill Hill is a fully co-educational, though still independent, school.

55 Upgrading London's infrastructure: BR poster first issued in 1953

MILL HILL SCHOOL
by Norman Wilkinson P.R.I.

Mill Hill School was founded in 1807, near the spot where the Revd. Richard Swift organised the first Free Church School in 1660. School House, which forms the subject of this poster, was designed in 1825 by Sir William Tite, P.R.A. to accommodate the entire school, the earliest of the Out-Houses being built just half a century later. The terraced garden, a portion of which is also shown, is of greater antiquity. It was planned by Peter Collinson, the friend of Linnaeus, and still contains some of the trees and shrubs which he introduced to this country from the New World.

56 North London's famous school designed by Sir William Tite at Mill Hill portrayed in the LMS 1938 poster by Norman Wilkinson (1878-1971)

Chapter 2 Roaming the Rails of North London

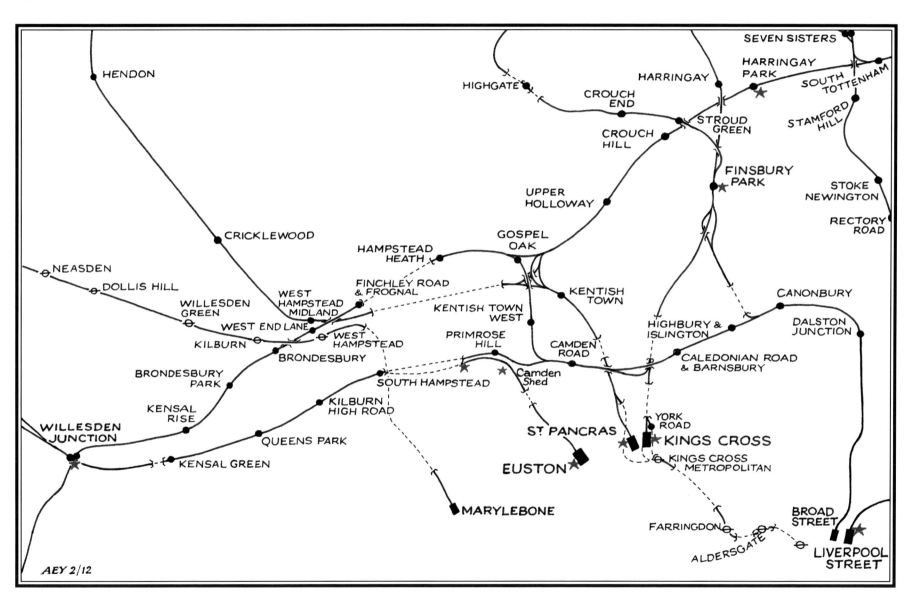

Roaming the Rails of North London

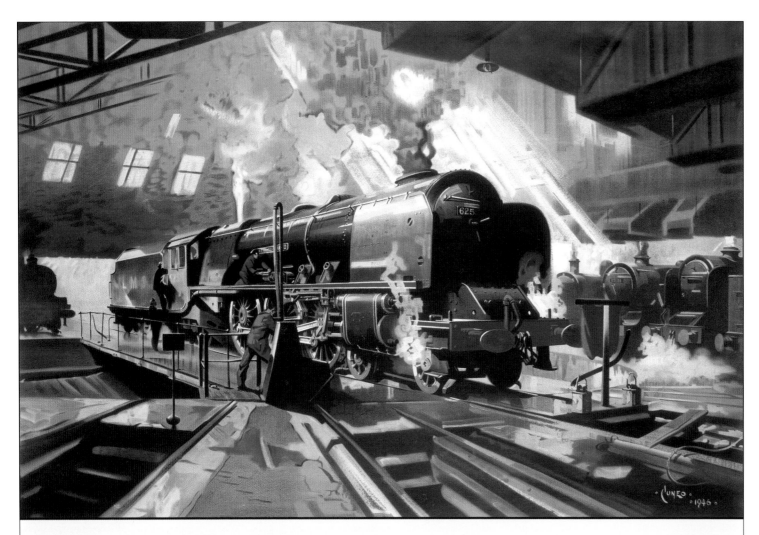

THE DAY BEGINS

57 A collector's railway poster: LMS Camden sheds in north London in 1946: LMS poster by Terence Cuneo (1907-1996)

Trainspotting in LMS territory

All of the main railway companies wanted to run services into London. Being this country's major city, getting into London has always been important, so there are many grand termini in all parts of the city, with some large engine sheds to support the services. This chapter is devoted to the overall subtitle for the series (*Railway Journeys in Art*) as we visit some of the citadels of steam in the north of the capital. In the 1950s many boys used to scurry from depot to depot and platform to platform collecting train numbers, and many reading this chapter will recognise some of the images. Even though the colour chosen for this volume is SR green (because the majority of the overall journey is in Southern Railway territory), we are spending this chapter in areas served by the LMS and LNER companies and the respective Midland and Eastern Regions of BR from 1948 onwards. Some of the largest engine sheds were found in north London, and we begin in firm LMS territory at Camden. In BR times, it was designated with shedcode 1B (nearby Willesden Shed being 1A). Terence Cuneo, in one of his first railway posters, captures Princess Coronation Class engine 6255 *City of Hereford* being made ready for its tour of duty on a northbound express. The first buildings appeared here in 1837, but were replaced with two buildings a decade later on both sides of the existing main line. The depot was enlarged by the LNWR in 1920 and then rebuilt by the LMS in 1932.

There was always an impressive collection of locomotives allocated to this depot, the most famous being the 'Duchesses', so it was little wonder that Camden shed was a magnet for trainspotters. After being readied, the engines reversed down Camden Bank and into Euston station to be coupled up to the coaches full of passengers ready for the journey north. Camden was an impressive sight in the heyday of steam, and even before the arrival of the *Duchess* Class, *Royal Scot* and other named classes of engines were found there.

Our next poster takes us back to 1927, the year the famous *Royal Scot* class of 4-6-0s was introduced. They were designed by Sir Henry Fowler, but later rebuilt by the great locomotive engineer Sir William Stanier FRS, whose masterpiece 4-6-2 in poster 57 was to follow a decade later. In this painting by Norman Wilkinson, a new engine 6100 *Royal Scot*, resplendent in its LMS crimson lake livery with rolling stock to match, leaves Euston on probably the inaugural run, watched by track workers. The North British Locomotive Company in Glasgow built the first 50 and later Derby works constructed a further 20 engines. Most carried the names of famous regiments, and quite a few of the class were also given the respective badges over the nameplate. Today collectors eagerly seek *'badged Scot'* nameplates.

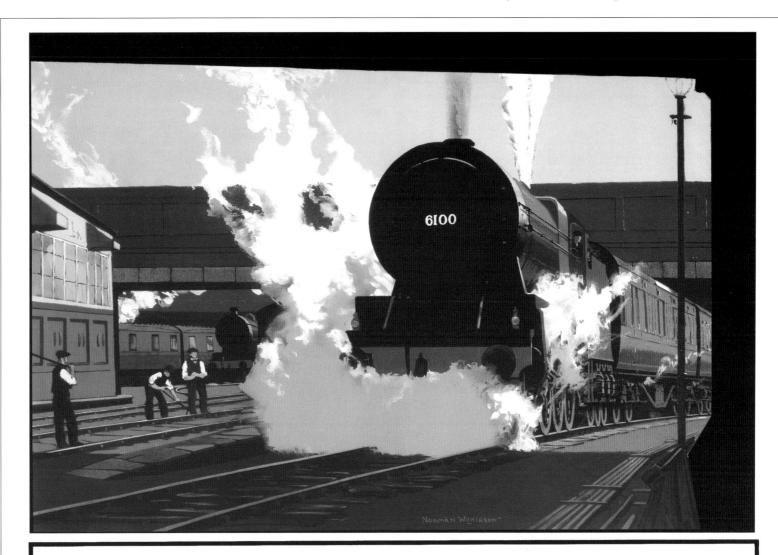

LMS "ROYAL SCOT" LEAVES EUSTON
BY
NORMAN WILKINSON, R.I.

58 An iconic railway poster: engine 6100 *Royal Scot* leaves London's Euston Station: 1927 artwork by Norman Wilkinson (1878-1971)

59 and 60 Euston station old and new: Douglas Brown's LNWR poster (Left) from 1905 and BR photographic from 1965

Euston over the years

The mention of Euston station brings us to the next group of posters. Over the years the station has attracted much attention, including controversy over designs and rebuilding. The next few pages show a contrasting group of posters and railway paintings for the changing face of Euston during the 20th century. The station has the distinction of being the first inter-city railway terminus built in London. The London & Birmingham Railway opened their 200ft long wrought iron roofed trainshed in July 1837, with just two platforms. The architect was Philip Hardwick, who also designed a Doric gateway to the station, which came to be known as the Euston Arch. At 72 ft (22m) high it was by far the grandest structure on the fledgling railway system.

Euston station was built in Camden almost by chance. The line was projected to terminate somewhere near King's Cross station, but a great deal of opposition from local landowners forced the line to terminate at the present site. Lord Southampton initially gave the L&B even more problems, as he stopped steam engines entering the station, so cables pulled the coaches up Camden Bank until 1844.

Much growth in traffic occurred in the 1840s, despite concerted efforts to stop it, and by 1849 a grand new entrance hall had been built, with hotels surrounding the station complex. The NRM's photographic collection at York includes some superb images of the old concourse with the statue of Stephenson in place. This statue is now at the NRM along with the old entrance gates.

In 1960 it was decided to rebuild the station, which had grown in a rather haphazard way, to meet the needs of modern inter-city travel. Plans were afoot to electrify the line, and the need for a modern and more functional building arose. This was not the first time this had been raised, as we will see shortly. Amid a huge public outcry, the old station hall, the Euston Arch and many other surrounding structures were all swept away, and for several years in the 1960s, Euston was a huge building site. The London Midland Region poster, near side left, was one of a series issued from 1964 onwards to show progress with the construction. By 1968 the station, trackwork, signalling and other infrastructure were complete, and the new station opened. The unsigned BR poster on this page shows the architecture, platforms and booking hall complex, all with functional but rather characterless styling.

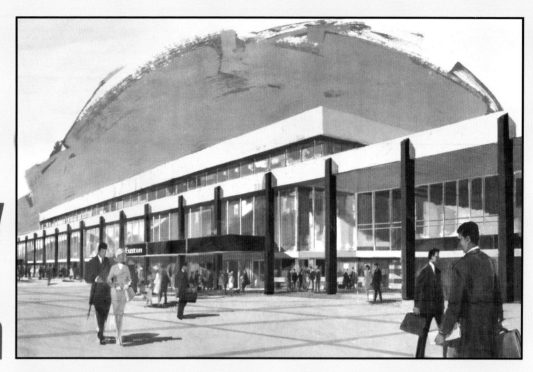

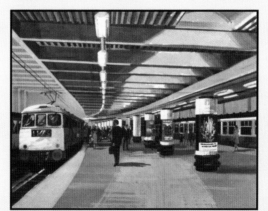

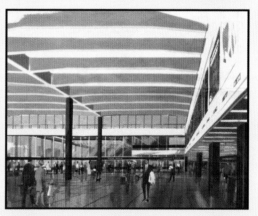

The new Euston Station

is now open and at your service with every modern amenity and a complete travel and information centre.

Frequent, comfortable Inter-City expresses link London with the West Midlands, the North West, Wales and Scotland.

 British Rail

61 The rebuilding of Euston: 1968 BR (LMR) unsigned poster showing the new facilities

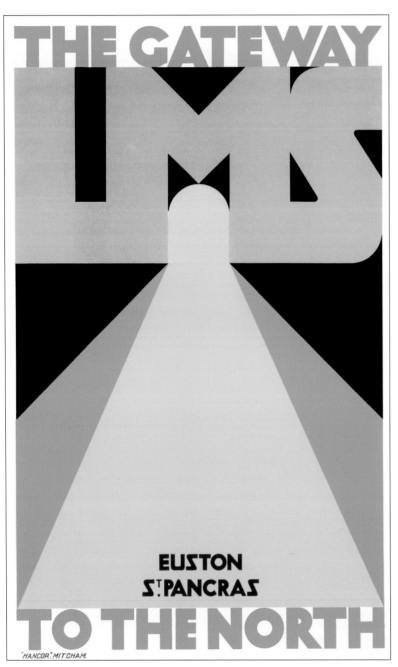

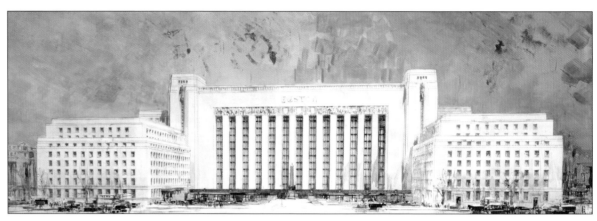

63 Original artwork for proposed 1937 rebuilding of Euston

During research for the book, I came across original artwork dated 1937 for the rebuilding of Euston before WWII. Its inclusion above confirms that the old Euston was threatened in the 1930s, but this design appears to be far grander than the eventual design of the station frontage shown on the previous page. The Art Deco façade is more befitting that of an American railway station, as the heyday of US rail travel also saw some significant structures being built in US cities: Grand Central Terminal in New York is a prime example.

The West Coast main line into Euston was electrified in stages, beginning in 1959. Class 81 electric locomotives were used, and the lower small picture on the previous page shows one arriving at the new platforms. The first electric trains on this line ran out of London in 1965, some three years before the station was finished. These station posters are contrasted with a rather modern looking LMS poster here from the late 1920s, when the Art Deco age was at its height. It still looks fresh today and heralds the speed available from the two LMS stations in London for passengers heading north.

I never saw the old Euston but have arrived many times in the 1968 station from the north. Again in the York artwork archives, I found the next piece of railway art, by eminent artist Michael Turner GRA. This is a view I remember well. Finishing meetings, I often spent extra time at Euston re-living my trainspotting days in the West Midlands during the late 1950s. I was not alone, and several business people I met did the same thing. At that time all of the class 86 and 87 engines carried famous names, a tradition that has largely been abandoned today. I always thought that these engines looked best in BR electric blue with yellow fronts, so seeing them in Virgin red and black, EWS maroon or Railfreight grey, somehow changed their appearance for the worse. Turner's painting shows a class 86 at the head of the *Manchester Pullman* and about to depart. A class 87, built from 1973 onwards, is alongside. These had wonderful historic names: *Royal Scot*, *Patriot*, *Britannia*, *City of London*, *King Arthur* and *Lord of the Isles* to name but a few. On my regular trips down from Crewe, I was often hauled by *Lord Nelson* or *Wolf of Badenoch*, so this picture had to be included.

62 LMS poster from late 1920s: artwork is unsigned

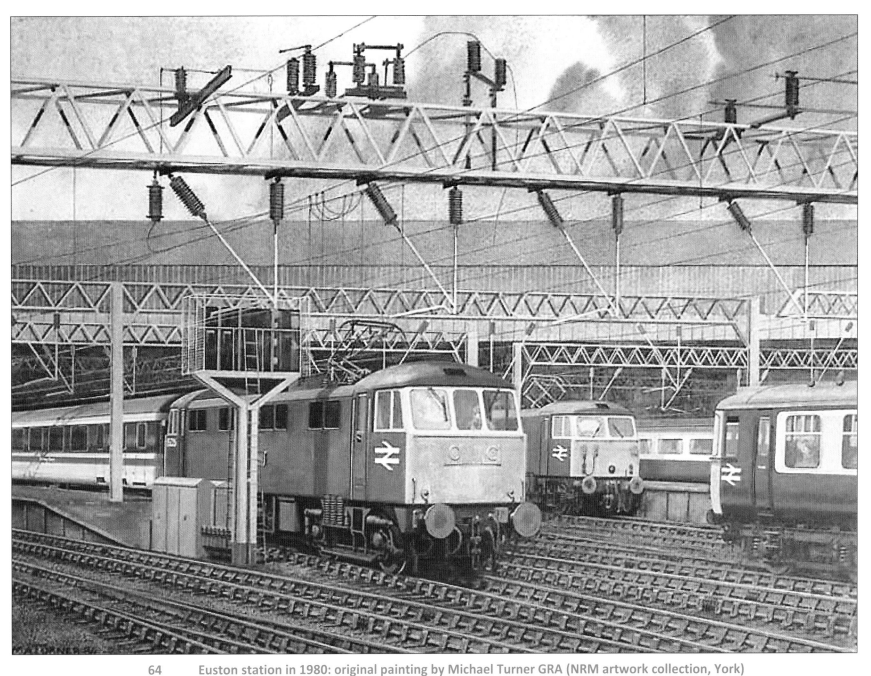

64 Euston station in 1980: original painting by Michael Turner GRA (NRM artwork collection, York)

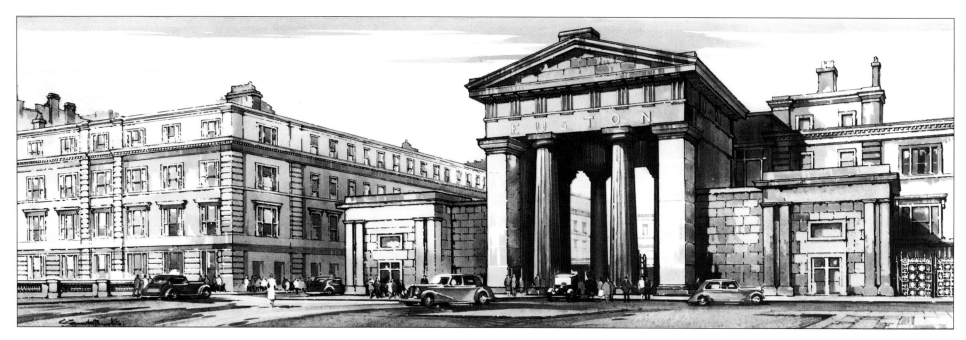

65 and 66 Carriage artwork by Claude Buckle: Doric entrance to Euston (above) and entrance to Primrose Tunnels, Middlesex (below)

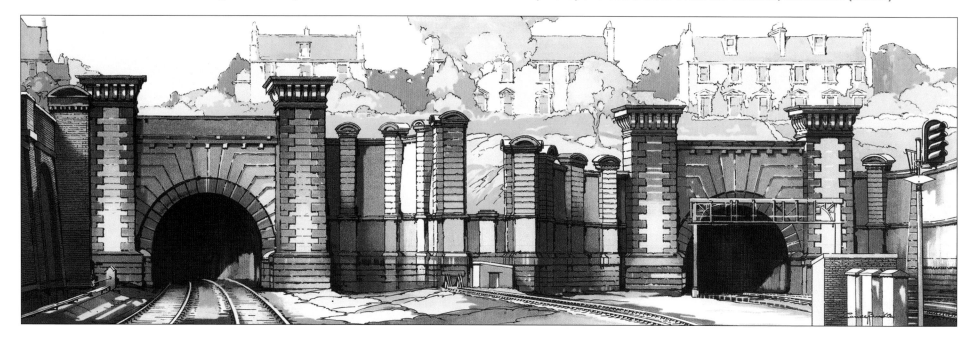

The architecture used by the former West Coast main line companies was quite wonderful. The Euston Doric Arch is shown to good effect in Buckle's carriage artwork, and it blended well with all the surrounding buildings constructed in the same style. What we have today is not as imposing and certainly not visually satisfying. Even tunnel portals and the style of bridges used to be grand, as the painting by Claude Buckle of the Primrose Hill tunnel entrances (built 1837) shows. When these and other paintings of the Victorian railway structure are displayed together, it illustrates just what we have lost.

The two rarely-seen posters alongside provide an opportunity to show the Euston improvement propaganda and also publicise a railway exhibition held in summer 1955 as the Midland Region used a historical approach to show developments and the need for change. It would be interesting to find out more about this exhibition, and I wonder if they used this occasion to gauge opinion on the changes that were being proposed. It is therefore rather appropriate that superb stations such as York, Darlington and Newcastle were retained, even as electrification advanced, but old Euston, Birmingham New Street and Manchester Piccadilly were all swept away on the western side. The 'new' stations at Stafford or Milton Keynes do nothing for me.

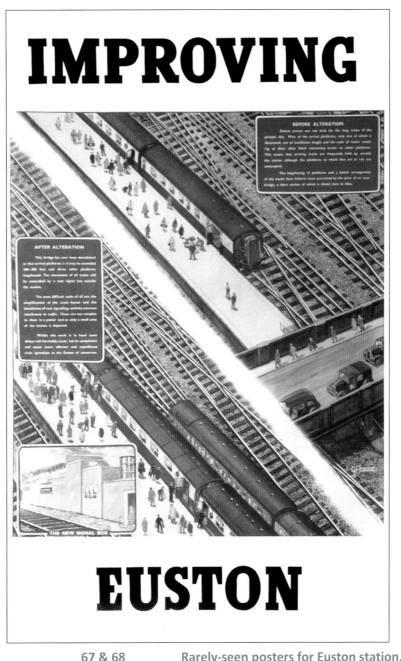

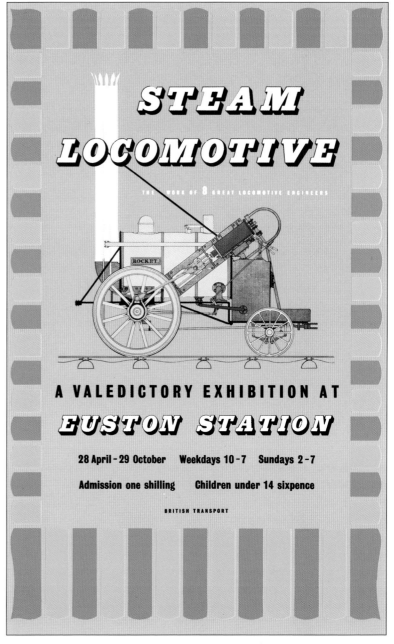

67 & 68 Rarely-seen posters for Euston station, London: G H Davies from 1966 and unsigned from 1955

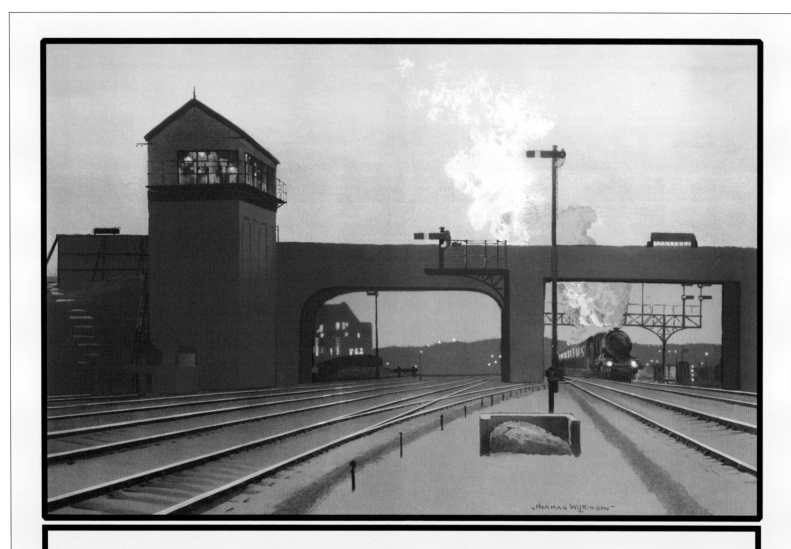

LMS WILLESDEN No. 7 BOX
MAIN LINE—EUSTON TO THE NORTH
By NORMAN WILKINSON, R.I.

From the LMS Carriage Window Series (6)

PRINTED IN GREAT BRITAIN BY McCORQUODALE & CO. LIMITED, GLASGOW AND LONDON.

69 Travelling from Euston on the West Coast Main Line at Willesden, North London: Artist Norman Wilkinson (1878-1971)

More trains and an iconic station

I simply had to include the next railway poster alongside. This is an atmospheric work from the brush of Norman Wilkinson, and it depicts the West Coast main line at Willesden in north London. The composition and colour are exquisite, with your eyes being drawn towards the approaching express. The date is around 1925. The junction here is complex, with both overground and underground lines meeting from several directions. In 2009 over 4.7 million passengers used these combined facilities. To the north the Willesden engine sheds (1A) were located, bordered to the south by the Grand Union Canal and, to the north, by the West Coast main line. On the south side of the canal lay the Old Oak Common sheds of the GWR, so this part of North London was a Mecca for trainspotters hoping to 'cop' that elusive number. *Kings* and *Duchesses* could be seen on the same day, something that Shrewsbury, my local boyhood station, also offered. Wilkinson's picture might feature an LMS 4-4-0 Compound, a real workhorse until the *Royal Scots* and *Duchesses* appeared.

It is now time to travel east and visit what many regard as London's finest piece of railway architecture, which happily has recently been given a new lease of life.

When the LMS was formed in 1923, they inherited a second major London terminus, the Midland Railway's wonderful St Pancras. Many consider its flamboyant architecture some of the best ever built by a railway company, and it seems incredible, looking back, they anybody considered demolishing such a magnificent building; but Victorian buildings were not appreciated in the early 1960s. The building began life in the 1860s after the Midland Railway had used LNWR, and then GNR, lines to make their entry into London. It soon became clear that they needed their own terminus, and they began buying land around the parish of St Pancras.

After their 'knock-backs' by the other companies, the MR was determined to show how a railway station should be constructed. They studied all of the other London termini and took note of their strengths, but it was Brunel's glass and iron roof at Paddington that caught their eye. Their resident engineer, William Barlow, laid out the trainshed on a massive scale. The MR was famed for its engineering skills, not just in locomotives, but in all aspects of the discipline. The St Pancras trainshed is quite magnificent, with sufficient height that the approaching tracks could be on a bridge over the nearby Regent's Canal, affording passengers and local people a fine view of their landmark building. One of Fred Taylor's earliest railway posters shows the interior of the station, with the famous crimson engines and coaches highlighted by the light blue iron ribs and, hopefully, a blue sky above: simple wording speaks volumes.

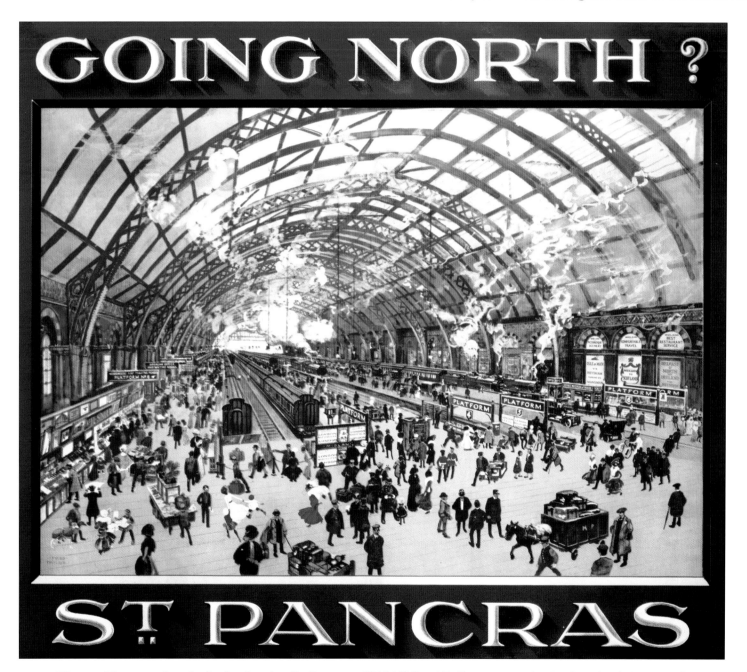

70 The superb trainshed at London St. Pancras: 1910 Midland Railway poster by Fred Taylor (1875-1963)

71 Arguably the best piece of railway architecture in the United Kingdom: St Pancras façade by Claude Buckle (1905-1973)

The single-span elliptical roof was, on completion, the largest structure of this kind in the world. The Butterley Company from Derbyshire produced the wrought-iron ribs, and their crest was cast into each one. A complex lattice network ensured lateral stability, with glass in the two centre sections of the roof and slates further down the curve. The overall dimensions are impressive: 679 ft (207 m) long, 236 ft (72 m) wide, and 98 ft (30 m) high at the apex above the tracks. Its completion in 1868 announced to their rivals that the Midland Railway had arrived! But the MR was not finished yet. A façade was required, and in 1865 they organised a competition to build a station hotel and frontage to complement Barlow's trainshed. The competition was won by Sir George Gilbert Scott (1811-1878), who had already distinguished himself with several innovative works. He was later to design the Albert Memorial in Hyde Park, a direct commission from Queen Victoria herself. The outside of St Pancras is spectacular, as Claude Buckle's wonderful carriage print painting above shows. Scott submitted the most expensive of the eleven entries, a Gothic revival design built in brick. It was the boldness and uniqueness of the design that swayed the MR Directors to invest heavily: remember they wanted to make a real 'statement'. This truly remarkable building does so, and with much room to spare.

Work on the Midland Grand Hotel finally began in 1868, but it took almost five years to build, and the original cost of £315,000 had ballooned to £438,000 by the time the whole building was finished (around £28M in today's terms). (As an aside, the 21st century rebuild costs also rocketed from the initial £320M to almost £800M, so Scott's design really was excellent value for money). In the final years of construction, many of the initial extravagances were dispensed with, and Scott was finally paid off in 1876, but his railway legacy inspires awe and wonder. It is amazing that few other railway paintings were produced of this building. The 20th century was not all kind to St Pancras, and it was indeed lucky even to survive. It was clear that the railway companies had to be rationalised, and in the 1921 Railways Act, the LMS was formed by the forced merger of the two old rivals, the LNWR and the MR, plus some other smaller companies. The LMS chose the LNWR's Euston station as the principal London terminus for their operations, and in 1935, the Midland Hotel at St Pancras was closed.

Once the hotel had closed, LMS staff used the building for offices, but what a waste! It was given the inglorious title of St Pancras Chambers, and it was not long before misuse and decay began. Worse was to follow, as damage was caused during the pounding London took during the war; this included Barlow's superb roof and, after the cessation of hostilities, the platforms were repaired, but the roof was never the same again. Indeed the railways were in a sorry state at the end of 1945, with engines, track and many stations having taken a terrible toll during the previous six years. The formation of British Railways brought more misery, as now there was too much capacity and duplication of lines from London northwards. Both St Pancras and Marylebone served routes north to Sheffield, Euston and St. Pancras both had trains to Manchester, and the old Great Central line from Marylebone linked High Wycombe, Rugby, Leicester, Nottingham and Sheffield. Something had to give, and rationalisation caused the closure of the ex-GCR line and a re-routing of other services. Most of the prestigious trains left Euston and King's Cross, but St Pancras did have the *Thames-Clyde Express* (London to Scotland) and *The Palatine* (to Manchester).

By the 1960s many people saw St Pancras as redundant, and developers took a keen interest in the valuable site. There were strong moves to amalgamate King's Cross and St Pancras, but these did not materialise. As Euston had been demolished and rebuilt in a modern functional style, when it came to St Pancras the people fought harder, and through the efforts of Sir John Betjeman, the Poet Laureate, the building was saved and listed as Grade 1. The station limped along until the creation of Network SouthEast and the opening of the Thameslink line. This brought commuters in from St Albans, Luton and Bedford, plus a few trains each day from Leicester. But then fortune smiled when St Pancras was chosen as the terminus for the new high-speed line to the Channel Tunnel, and the station once again has a key role for London. The restoration has been costly but superb, including new underground facilities, a spacious concourse, an extended trainshed, though not elliptical as with Barlow's design. The need to protect Eurostar passengers from the elements required the building of a flat-roofed section on the northern end of the platforms. However the overall effect is still quite wonderful, and Taylor's poster on page 41 is seen again, this time with sleek modern trainsets that run all over northern Europe.

This short section is closed with a famous poster. Thomas Cook was born in Melbourne, Derbyshire, and his efforts founded the Thomas Cook Travel Group. Being a Derbyshire man, he naturally partnered with the Midland Railway to run trips to London, using their facilities. He had premises in London before St Pancras was built and, by the mid 1860s, was organising trips all over England and as far afield as the United States. He introduced the forerunner of the traveller's cheque in 1874. After his death in 1892 the business continued, and they commissioned shipping and railway posters, of which this is one.

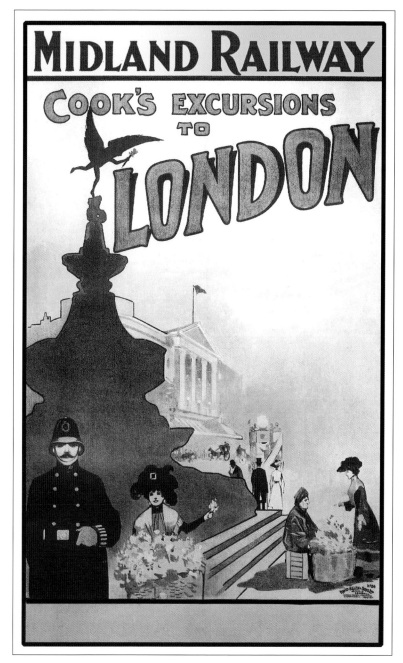

72 1904 MR stock poster for London by Dennis Fitzsimmons

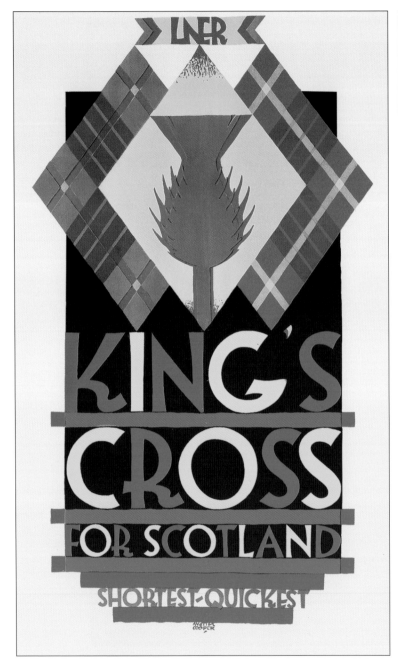

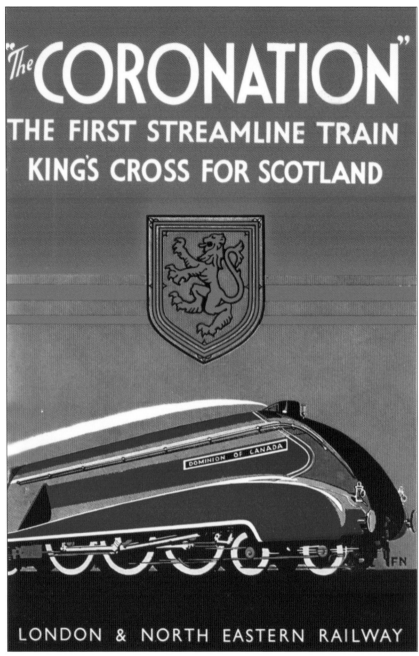

King's Cross station

Alongside St Pancras, to the east, is our next railway citadel, the equally famous King's Cross station. This was originally built as the London terminus for the Great Northern Railway, and today is the southern terminus of the electrified East Coast main line. Some very well known trains have arrived at, and departed from, these famous platforms; and once the LNER had been formed in 1923 (from the GCR, GER, GNR and NER plus the Scottish companies), it set about advertising King's Cross as THE way to go to Scotland. The next few pages present a collection of posters that span the 20th century, and on page 53 is a Victorian lithograph which shows the distinctive exterior. It was the functionality of King's Cross that encouraged the MR to build their own terminus alongside as an elaborate masterpiece.

The station dates from 1852, but the plans were drawn up some four years earlier to a design by architect Lewis Cubitt and constructed under the direction of GNR Resident Engineer George Turnbull. It took two years for the distinctive south façade and trainshed behind to emerge.

73 and 74 Classic 1930s LNER marketing for King's Cross: Austin Cooper (left) and Frank Newbould (right)

The façade is Grade 1 listed, but was sadly somewhat obscured by a rather unattractive extension added by BR in 1972. The trainshed is similar to St Pancras, but nothing like as grand. However in the days when A3s and A4s were waiting to depart from almost all of the platforms, it was a sight to behold. Whilst expresses served Hull, Leeds, York, Newcastle and Edinburgh, frequent commuter trains arrived from Hertfordshire, Bedfordshire and Cambridgeshire, so this was always a busy station. It used to attract trainspotters galore, as the famous 'Top Shed', housing Gresley's magnificent locomotives was not far away. In 1955 David Shepherd painted this superb poster showing the station at night. It is one of the best steam railway posters ever issued, with composition, movement, colour and style that are hard to beat. I always wondered how he obtained permission to use that vantage point to make his sketches.

The original station was opened with eight platforms planned, though in the early days, platform 1 was arrival and Number 8 was departure with sidings in between to house rolling stock. Gradually more were added, and then a second building housing platforms 9 to 11. The trackwork heading north is complicated and has been reconfigured several times to allow train capacity to be increased.

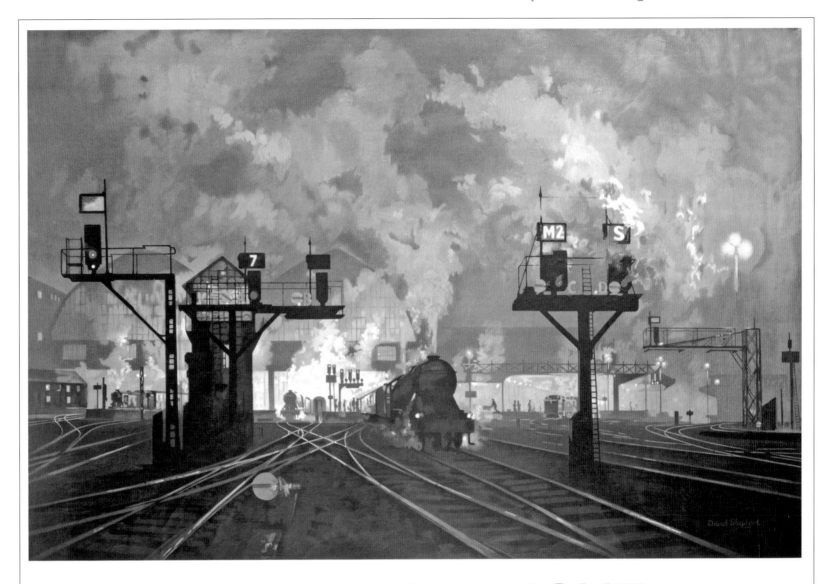

SERVICE BY NIGHT

75 A wonderfully atmospheric poster from 1955: King's Cross at night by David Shepherd (born 1931)

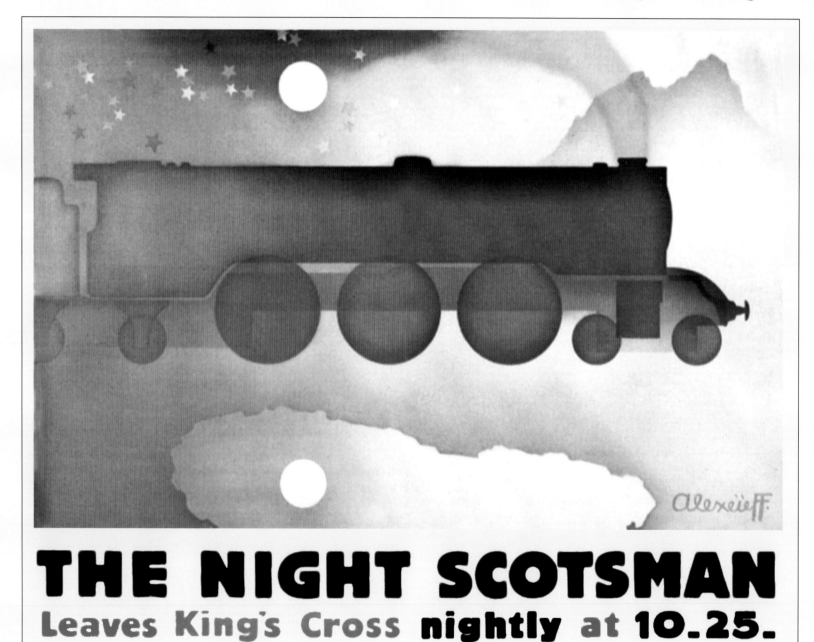

76 Iconic poster of King's Cross services from 1932: artist Alexander Alexeieff (1901-1982)

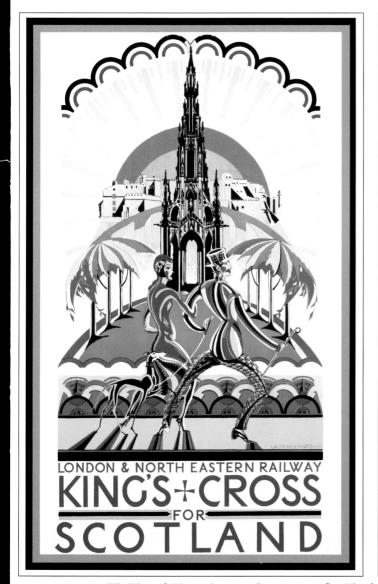

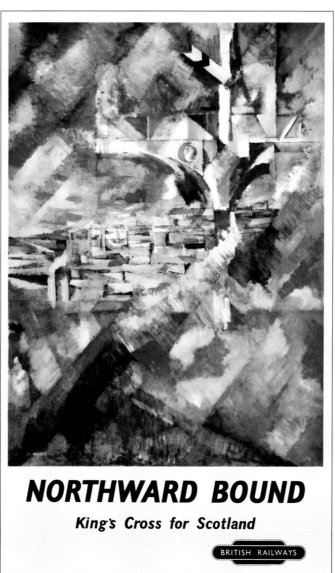

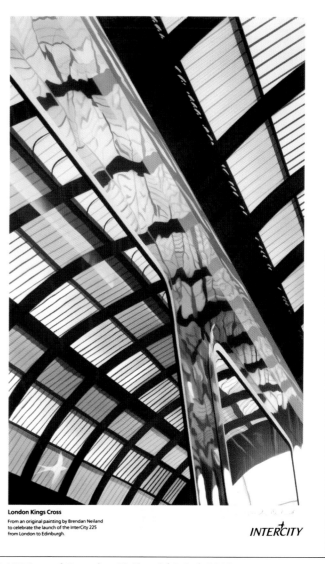

77, 78 and 79 Contrasting posters for King's Cross: Laurence Bradshaw (left) 1920s, Bernard Myers (centre) 1950s and Brendan Neiland (right) 1990s

These two pages depict a quartet of posters produced during the 20th century. Alongside left is a rather ethereal poster advertising the night service to Scotland. Produced by Russian émigré Alexander Alexeieff, it is today once of the most sought-after of all railway posters. Above is a trio of very colourful images, all very distinctive and carrying the tradition that the LNER started in the late 1920s through to modern times. When laying out this chapter, I thought they matched each other well for style and colour, and they illustrate the combined power good posters can have. For each of their respective decades they were departures from normal railway posters.

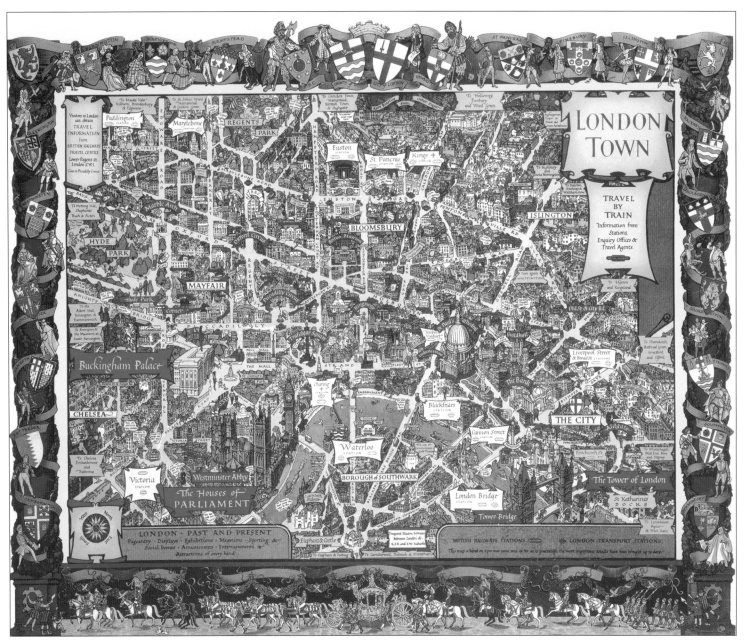

80 **Complex heraldic poster for Old London Town: artwork is unsigned**

Out and About in London Town

The highest concentration of railway stations in the UK is found in the Greater London area, with more than 350 according to present records. In the middle of the 20th century there were even more but service changes and some rationalisation reduced the peak total number slightly. Some are main line termini, whilst others are little more than halts. Whatever the size, the function was to take people in and out of London, either for work or for pleasure. The quad royals on these two pages are rarely seen and sum up visiting London, before we take a more leisurely stroll around the sights in the next chapter.

This unsigned heraldic poster from the earlier years of British Railways shows an aerial view of the old city of London, with the crests of all the London Boroughs, and the main attractions to visit highlighted in red. The main caption 'London Town' is a term of endearment, rather than an official name. The numerous railway lines radiate into all parts of the map. The City of London currently has six main stations: Blackfriars, Cannon Street, City Thameslink, Fenchurch Street, Liverpool Street and Moorgate, whilst Camden and the City of Westminster each have three main stations on the northern side of the Thames.

In addition to the major overground rail network, London has the oldest and second longest underground network, which originated in 1863. (Shanghai in China has surpassed London in terms of route miles). It made getting into and around London probably as easy as for any city in the world of comparable size.

This poster by Anna Zinkeisen, issued in late 1933, shows an area on the south side of Hyde Park with people dressed in all their Victorian finery and 'people-watching' at the same time. The Zinkeisen sisters were used by the LNER to paint scenes from the past, and their prolific use of colours is well suited to such subjects.

Today tourism is vital to the economy of London. As one of the world's premier cities, its numerous attractions draw huge numbers of visitors, and during the 2012 Olympic Games, the population will be greatly swollen. It used to be the greatest city by population in world rankings at the time this poster depicts, but an urban population explosion in Asia, Africa and South America has relegated London to 27th place, and it is also no longer the largest city in Western Europe (Paris is currently larger). But that apart, days out and about in London are still immensely popular, and the railways have had a profound influence on this part of the UK.

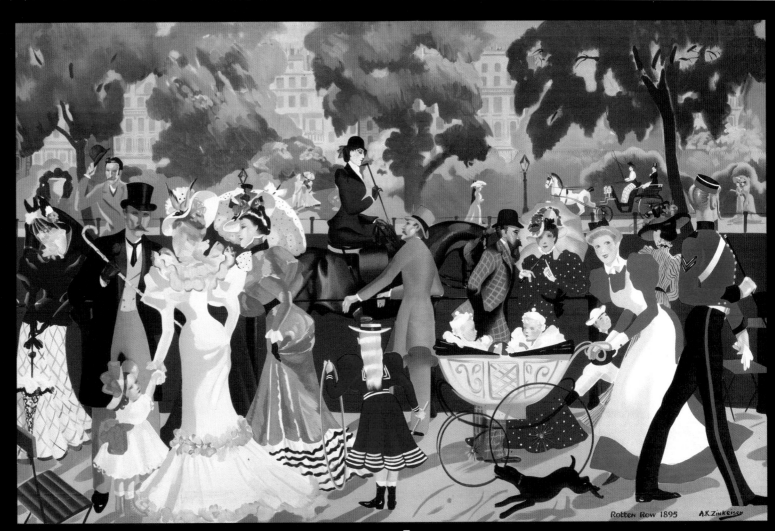

81 Dressed up for the day trip to Old London Town: 1933 LNER poster by Anna Katrina Zinkeisen (1901-1976)

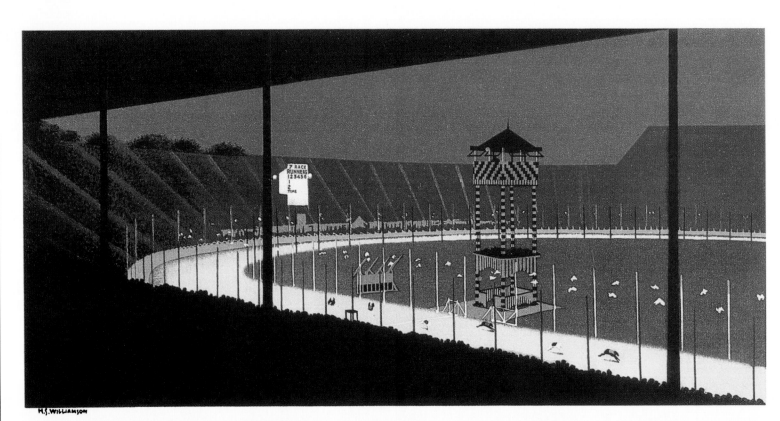

HARRINGAY PARK Tuesdays, Thursdays, Fridays. 8 p.m.
BOOK TO FINSBURY PARK THENCE BY TRAM OR BUS

82 Unusual poster for bus and tram travel in North London: Artist H G Williamson

Main line railways are only part of the transport infrastructure. As well as the underground, London has an intricate bus network, and until the 1950s, possessed an extensive tram system. It is interesting that trams are making a comeback, as in several other British cities. They were removed with indecent haste, and now it is extremely costly to reintroduce them. This striking poster for Harringay Park greyhound racing track advertises linking a surface or underground train journey to Finsbury Park with a short trip on the roads. The stadium opened in 1927, but closed in 1987. A speedway track was laid inside the greyhound racing track, and meetings for this sport began in 1928. Finally, stock car racing was held here from the 1950s until the late 1970s. Greyhound racing declined in the 1960s, and the stadium was soon in financial difficulty, with £20M of debt by 1975. Today it is a large supermarket site.

At Liverpool Street

Travelling further east, we come to our next major station, Liverpool Street. This is the second busiest station north of the Thames (after Victoria), with major tracks to Cambridge and all parts of East Anglia. Main international services from Stansted Airport and the port of Harwich also arrive at this station. It was opened by the Great Eastern Railway in 1874, and a year later was completed, allowing the old Bishopsgate station to close to passengers and be used as a major goods yard. This older station had been the terminus of the Eastern Counties Railway; when the GER was formed they wanted a grander terminus with hotel facilities to match. Between 1884 and 1887, the Great Eastern Hotel was built in red brick, and some of the dining and social rooms were extremely elegant. Gordon Nicoll's 1929 poster shows a stylish, popular rendezvous in the City of London. At this time the hotel was owned by the LNER and grew to become one of the great railway hotels in London. The beautifully ornate ceiling is missing in his poster, but in the York archives I discovered two paintings, one of the main dining rooms, the Soda Fountain and Tea Room, and one showing hustle and bustle at the station. Both look rather fine placed side-by-side.

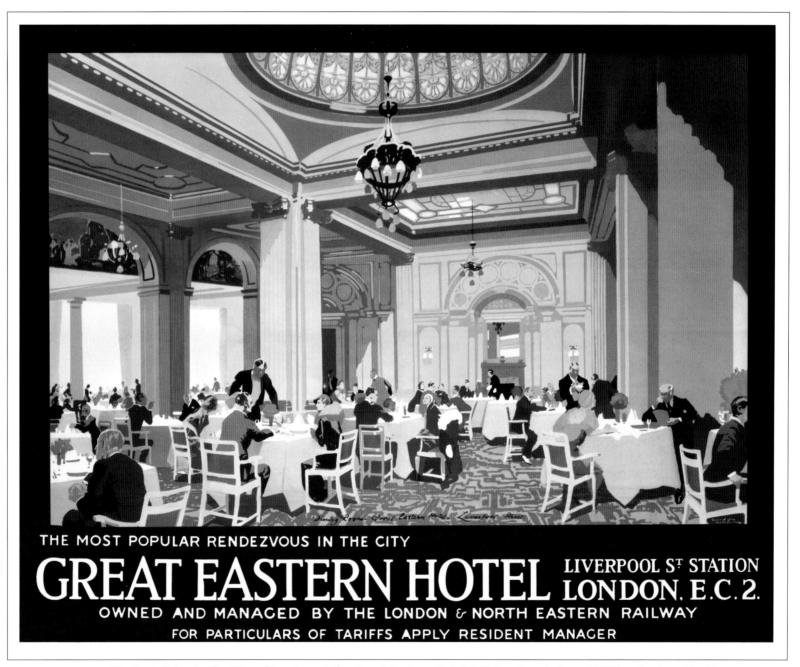

THE MOST POPULAR RENDEZVOUS IN THE CITY

GREAT EASTERN HOTEL LIVERPOOL S^T STATION LONDON, E.C.2.

OWNED AND MANAGED BY THE LONDON & NORTH EASTERN RAILWAY
FOR PARTICULARS OF TARIFFS APPLY RESIDENT MANAGER

83 Socializing in the City of London at the Great Eastern Hotel: LNER artwork from 1929 by Gordon Nicoll

84 & 85 Original artwork for Great Eastern Station Hotel and platform complex: watercolour signed as *BS* (left) and Marjorie Sherlock's 1922 oil painting (right)

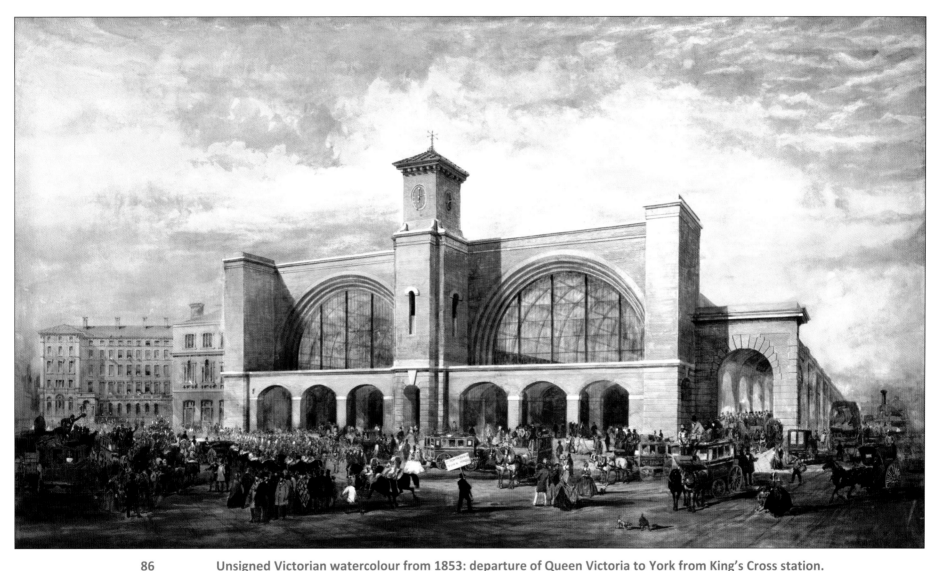

86 Unsigned Victorian watercolour from 1853: departure of Queen Victoria to York from King's Cross station.

Also found in the York art collection is this very fine watercolour study of Lewis Cubitt's great station at King's Cross. This allows the symmetry of the building to be appreciated. In this painting, Queen Victoria is about to depart for the races at York. When the station was built, note how much free and open space there was in front of the building, and happily this open style piazza will be restored when the 1972 frontal extension is removed as part of a soon-to-be completed multi-million pound upgrade. The perfect closing original artwork for this short tour of the north London is Wilkinson's painting of daily activity at the LMS Camden sheds, where *Royal Scots* are being readied for their journeys north.

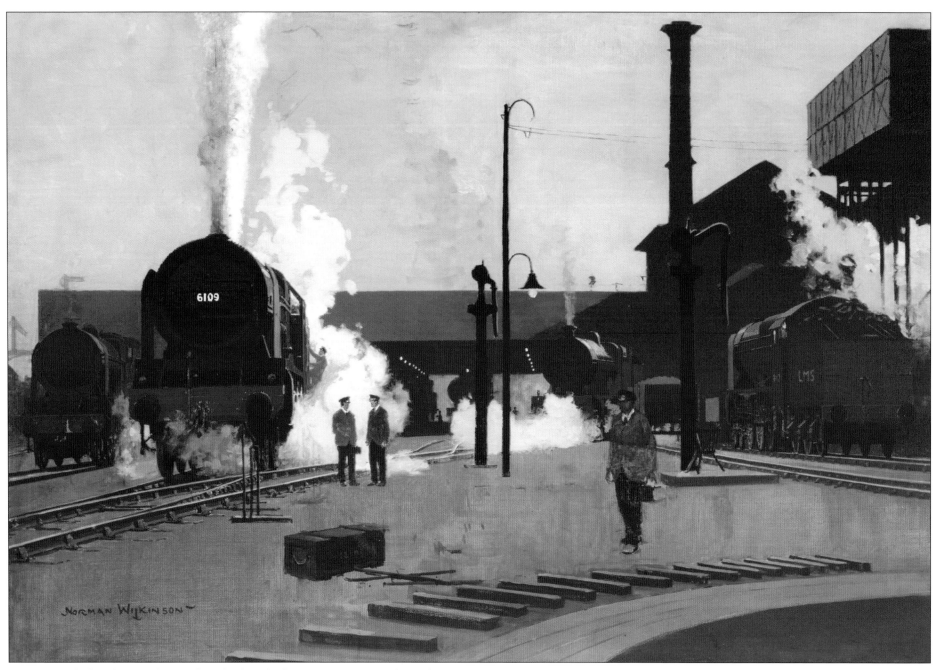

87 Ready for the Road: Camden shed in the late 1920s, as *Royal Scot* locomotives prepare to depart: LMS poster artwork by Norman Wilkinson (1878=1971)

Chapter 3 Touring the Nation's Capital

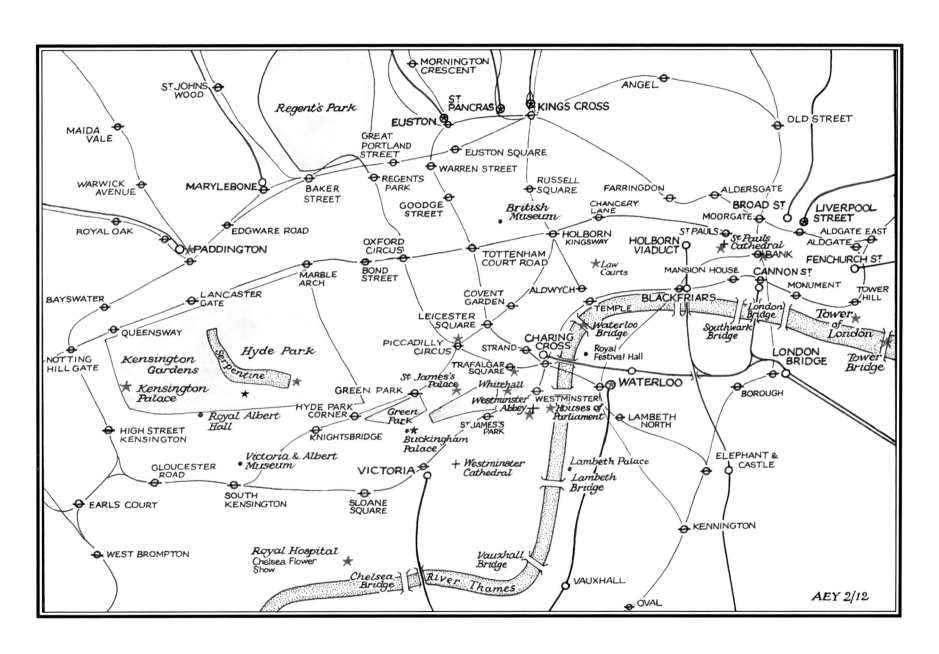

First glimpses of world-famous places

London is a remarkable place, indeed one of the world's greatest cities, full of history, pageantry and iconic buildings. In this chapter we tour the central area, before making our way south of the river and then east towards Greenwich. I suppose the most recognizable symbol is captured in the poster alongside. This fairly uncommon image was painted by Norman Wilkinson in 1925 when he was very active, producing LMS quad royals. It shows the Houses of Parliament and St Stephen's Tower ('Big Ben') in silhouette against the evening sunset as a stream of famous London Transport red buses makes its way across Westminster Bridge. In 1905 the LNWR, one of the constituent companies of the LMS, gave Wilkinson the commission to produce posters for their services, and, throughout his life, his work featured strongly in main railway poster campaigns. In this chapter we will see other examples of his London posters, all distinctive and desirable.

Since Victorian times, railway advertising has strongly featured London, and during the post-WWII years, all of the major advertising departments were centred in London. Looking at a railway map today is not so different from a hundred years ago. All of the major Victorian-era rail routes converge on a ring of stations that serve the enormous weekday influx of passengers. Beneath lie the 400 route miles of the LT Underground, though, interestingly, less than 50% of the track is actually below the surface.

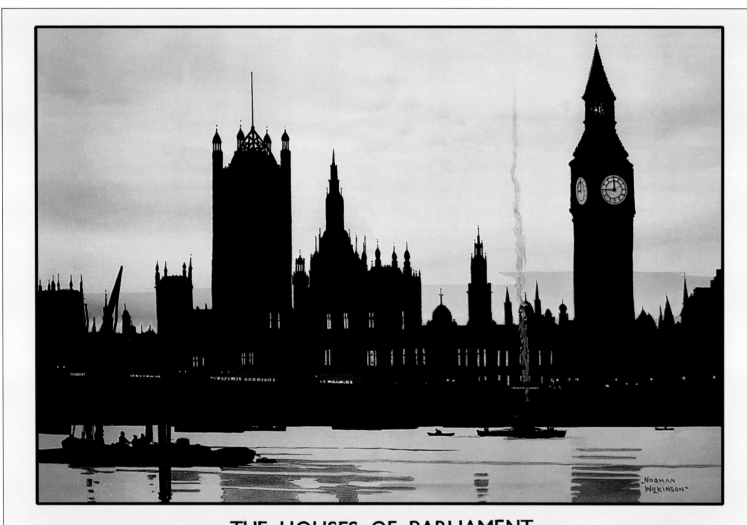
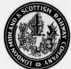

88 London's iconic skyline: LMS quad royal poster from 1925 by Norman Wilkinson (1878-1971)

WWII had taken a terrible toll on the nation and its infrastructure. The railways suffered greatly, and it was no surprise that the collaboration of the war years should be continued. The Government had commandeered them, and with so much rebuilding and investment required, the obvious solution was to nationalise the four main railway companies. The poster alongside, chosen for the front cover, was one of the last group of GWR examples to be produced, although it was probably commissioned several years earlier; advertising costs had to be controlled so that, in the late 1940s, posters appeared which had been painted in earlier times. This quite wonderful poster artwork by Frank Mason shows the Palace of Westminster executed in the same style, and using the same colour palette, as the Clacton-on-Sea poster from the 1930s (see page 166 of volume 4).

Palaces have stood on this site since the eleventh century, but the buildings, which were home to many Kings of England, were destroyed by fire in 1512. They were rebuilt, but in 1834 an even larger fire damaged most of the buildings, so only Westminster Hall, the Jewel Tower and St Stephen's Cloisters remain from former times. Work on the Gothic structures we see today started in 1840 and took nearly 30 years to complete, to the designs of architect Charles Barry.

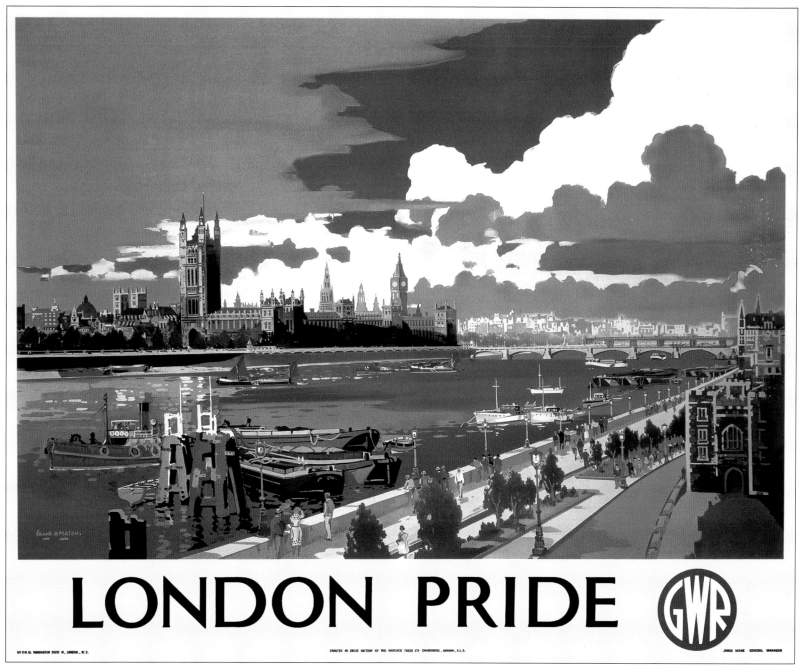

89 A superb piece of railway art: The Palace of Westminster in 1946 by Frank Henry Mason (1876-1965) for the Great Western Railway

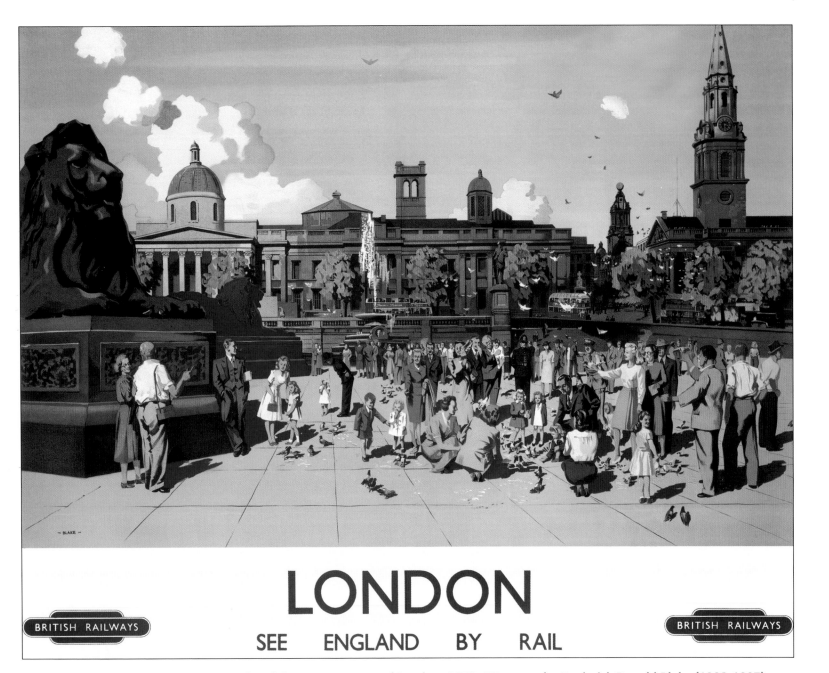

LONDON

SEE ENGLAND BY RAIL

BRITISH RAILWAYS

BRITISH RAILWAYS

90 An unusual perspective of Trafalgar Square, central London: 1950s BR poster by Frederick Donald Blake (1908-1997)

In the heart of London

The importance of the sights of London, in railway advertising terms, cannot be overstated. It was the heart of the British Empire and easily the most important world centre, at a time when railway tracks were criss-crossing the nation. Naturally the publicity offices wanted to celebrate the capital, and this next group of posters illustrates how tourism was encouraged.

For many people, I suppose the area around Trafalgar Square is London. The railways thought so too, and alongside is a BR poster from the 1950s, giving a more unusual view of this famous square. Here the artist is looking north towards the National Gallery, with the famous church of St Martin-in-the-Fields on the right of the image. On the left is one of the four huge lions that guard Nelson's Column. Behind him is Charing Cross. It always was a popular place to pause and admire the surroundings during a day-trip to London. In former times there used to be a one-way traffic system around the square, and Blake's poster shows buses on the north and east sides, but works in 2003 closed the north side, and reduction of the road width also restricted traffic, so that today it is a large and open pedestrianised space in which to stroll, or linger.

Claude Buckle's viewpoint in the double royal poster alongside, which was published in the 1950s is slightly further south and shows the famous Column: to the left is the National Gallery and with the church of St Martin-in-the-Fields to the right. In characteristic Buckle style the poster palette is lifted by the trees and a famous red London bus. The pale orange sky is, however, a departure from his normal style, but is highly effective.

The Square itself began life in the 1810s. Before that, the space was occupied for almost three centuries by the Great Mews Stables for the nearby Whitehall Palace. At that time there was no Column and no National Gallery, but St Martin-in-the Field, completed in 1724, had stood there for almost a century, In 1812 the famous architect John Nash set about redeveloping the area, first by clearing the stabling and then preparing a huge open space extending from Portland Place to Charing Cross. The main aim was to have a cultural meeting place in the heart of London, and these facilities began with the construction of a new National Gallery on the north side in 1832. The whole area was to take more than half a century to evolve, but today is one of the most recognizable locations in the world. It was a natural subject for railway advertising.

Architect William Wilkins (and, later, Sir Charles Barry) further developed the Square, which was officially named Trafalgar Square in 1830 in honour of the great naval victory off Cape St Vincent, a quarter of a century earlier. It was Barry who proposed walkways and terraces to the National Gallery, staircases down to a lower level area that contained two large fountains and, of course, the Nelson memorial to, arguably, our greatest sea-faring man (see volume 4 page 76). The column was designed in 1843 by William Railton and completed by 1845. Barry's fountains were added shortly after, and what we see today was completed when the bronze lions were added in 1867; Sir Edwin Landseer was responsible for designing these. The final touches were the Imperial Measures, added in 1876 on the North Terrace wall, but later moved closer to the main café on the Square. These show the lengths of our former units - inches, feet, yards, links, chains, perches and poles - largely swept away when SI units were adopted as part of International Standardization. (How much more romantic it was when we wrote 5½ yards = 1 pole, 4 poles = 22 yards = 1 chain, 10 chains = 1 furlong, and 8 furlongs = one imperial mile.)

Earlier this century major works brought further change, when a pedestrian area appeared on the north side. The railway poster alongside shows the true beauty of this area, nearly always thronged with crowds from all over the world. It is surprising that this is the only formal poster giving a true impression of the layout: but it is lovely. The poster that follows portrays the Square as a silhouette, and it is a prominent feature in a 1924 poster by Royal Academician Charles Sims.

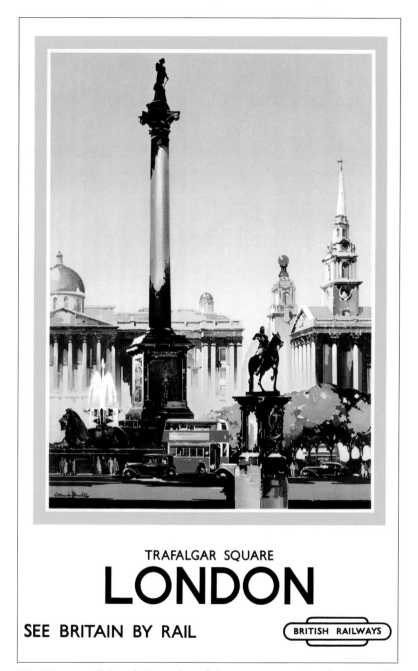

91 More traditional view of Trafalgar Square: artist Claude Buckle

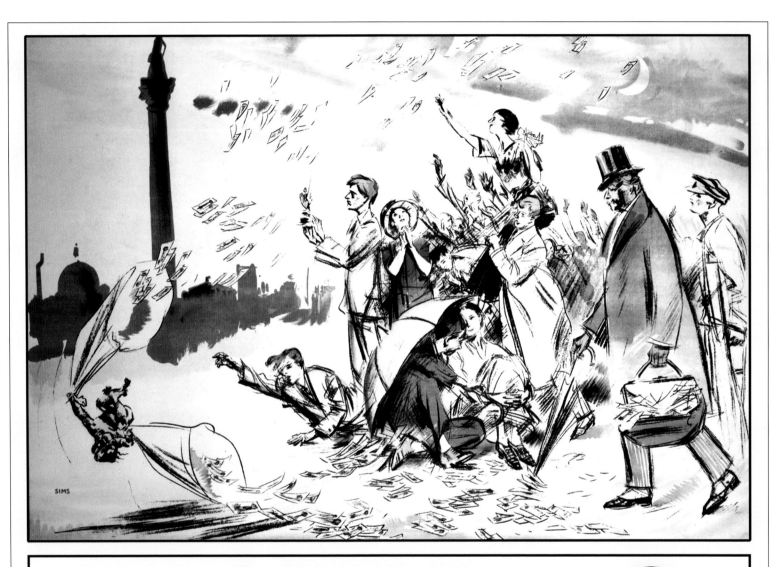

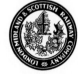

LMS LONDON

BY CHARLES SIMS. R.A.

92 A most unusual LMS poster from 1924 by Charles Henry Sims RA (1873-1928)

This most unusual, indeed unique, London poster, coming from a Royal Academician, may be considered as unexpected when seen in isolation. Sims was a Londoner, born in 1873. He died at the relatively young age of 55 at St Boswells in southern Scotland. Later in later life his growing mental illness caused increasingly irrational behaviour, and though a brilliant painter of landscapes, decorative pictures and portraits, this 1924 poster published four years before his death, gives strong clues as to his mental state past the age of 50 years old. In early life, his academic training was impeccable: Kensington School of Art, Academie Julian in Paris and the Royal Academy.

However, when he was 22, and beginning to show signs of his later illness, he was ignominiously expelled from the RA. His famous painting, *"I am the Abyss and I am the Light"*, completed just before he died shows a tortured state of mind. In this poster the little upside-down imp is floating on the breeze and throwing away money. He is pursued by an eager mob, anxious to collect the banknotes. Quite why this was chosen to show London is hard to imagine, but Sims did have his followers in lofty artistic circles. Certainly somebody in the LMS Publicity Department must have thought such an image would cause people to stop in their tracks. In the legend, voices told Dick Whittington to return to the streets paved with gold; perhaps there are shades of that story included in this picture.

From the cartoon-like poster opposite, we move to a couple of colourful BR-era posters that depict two more of London's famous landmarks. These are the Law Courts, more formally called the Royal Courts of Justice, on the Strand; and, alongside, a view of Hyde Park, the second largest park in central London and a Royal Park. By this time, more colour and detail were features of the advertising style and, indeed, some of our best posters were produced in the 1950s. The ascension of a young Queen to the throne and growing affluence were stimuli to advertising investment. London was given the full treatment, and several BR posters of the city were chosen for promotional use abroad.

Berry's poster shows the 1951 Lord Mayor's procession with the Cross of St George mirroring the coat of arms of the City of London. The Law Courts date from the late 1870s, designed in the Gothic style by George Street, a solicitor turned architect, who sadly died before they were completed; Queen Victoria opened them in 1882. Several extensions were added at various times in the 20th century, the last being in 1990. The interior detail in many courts is quite exceptional, and the Great Hall would not be out of place as a cathedral nave. The use of blue for the roof colour somehow enhances the artwork and sharpens the ornate skyline.

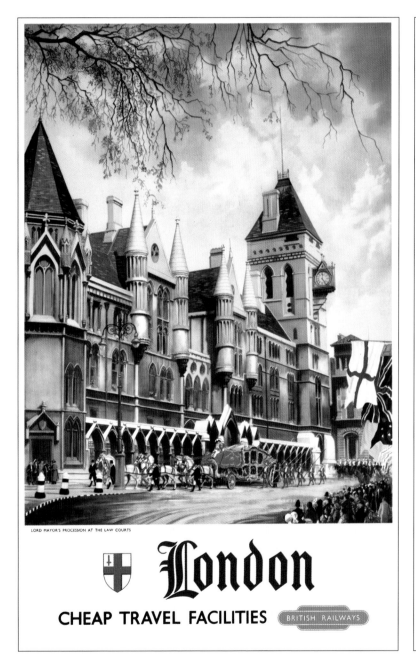

93 & 94 Different faces of London: the Lord Mayor's Procession in 1951 by J. Berry and Hyde Park by Edwin Harris from 1952

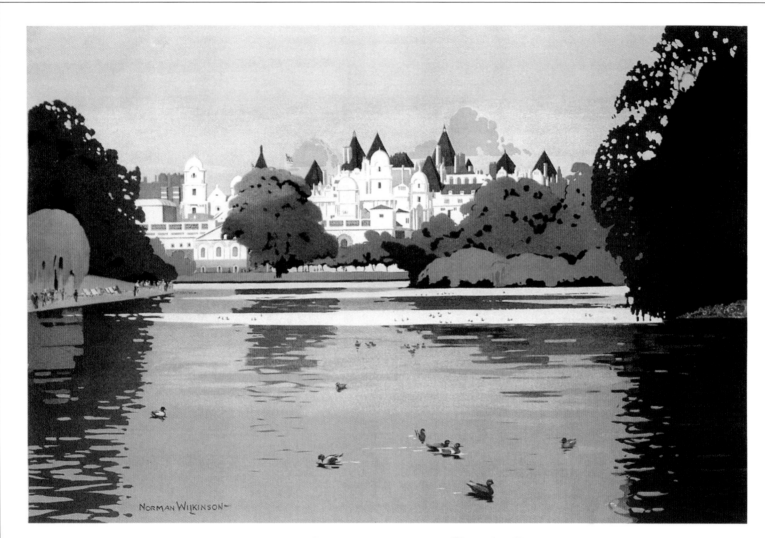

LMS **LONDON**
by Norman Wilkinson R.I.
WHITEHALL FROM St. JAMES'S PARK
THE FINEST VIEW IN LONDON.

95 The seat of power viewed across St James's Park around 1930: artist Norman Wilkinson (1878-1971)

Hyde Park is one of the eight Royal Parks within the present boundaries of Greater London. It occupies 350 acres, and in central London only Regent's Park, at 410 acres, is larger. Adjacent to Hyde Park the visitor will find Kensington Gardens, 275 acres in extent, with the Serpentine separating them. In this poster Harris chose to focus on a small area around the Boy and Dolphin Fountain, close to the Rose Garden. In 1960 this fountain was moved to Regent's Park Broad Walk and returned to Hyde Park in 1995.

The poster alongside is a personal favourite. St James's, the oldest of the Royal Parks, is enclosed by Horse Guards to the east, Buckingham Palace to the west, and St. James's Palace to the north. The whole area has spectacular views, such as that shown here. In the 1530s this was marshland owned by Eton College. Henry VIII purchased the land with a view to creating a regal area near York Place, which he acquired from Wolsey. King James I had the whole area drained and landscaped. Later, following his exile in France, Charles II had the park remodelled by Andre Mollet. A straight canal was installed at this time, later converted by the Prince Regent (George IV) to a more naturally shaped lake. The architect for this work was the eminent John Nash, who also added winding paths and other present-day features, to give us a wonderful space.

Tower Bridge to Waterloo Bridge

Another area of London where buildings are instantly recognizable is around the Pool of London, where we find the Tower of London and Tower Bridge. Travelling upstream between Tower Bridge and Waterloo Bridge, there are six bridges, two of them carrying railway tracks from Cannon Street and Blackfriars stations. The other four are London, Southwark, Millennium and Blackfriars Bridges. However it is the structure depicted here that is almost the face of London.

Built over an eight-year period from 1886, Tower Bridge is part-suspension and part-bascule (lifting) bridge to allow large vessels to pass from the upper Pool of London down to the sea. It is often mistaken as London Bridge, which is immediately upstream. Tall-masted ships used the Upper Pool, so any bridge had to accommodate the mast height. The elegant design came from Sir Horace Jones, who kept the two lifting sections short (100 ft or 30m) via the building of two tall towers each 213ft (65m) high. As the Tower of London is nearby, it has two reasons to be so-named. The total cost then was £1.1M (£100M today) and the main structure consists of 70,000 tonnes of concrete and 11,000 tonnes of steel. The Wilkinson poster was issued in 1948, but was almost certainly painted in the late 1930s.

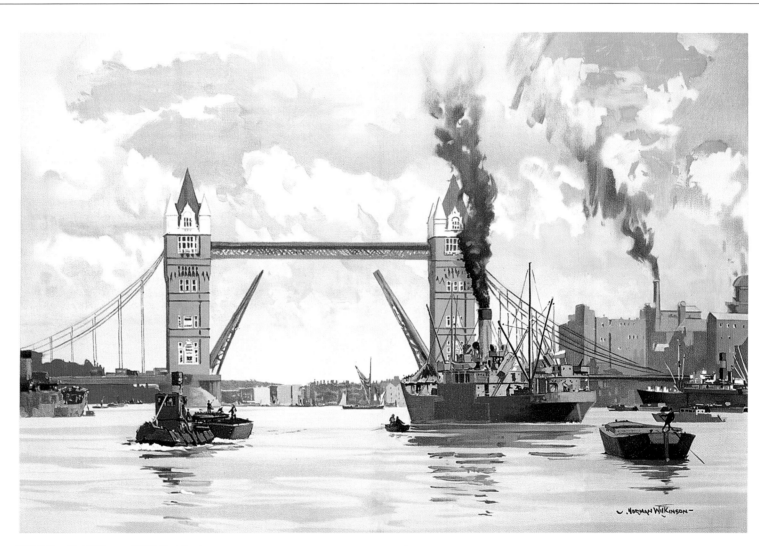

THE THAMES : TOWER BRIDGE

96 Another famous London landmark: Tower Bridge on a 1948 BR poster by Norman Wilkinson (1878-1971)

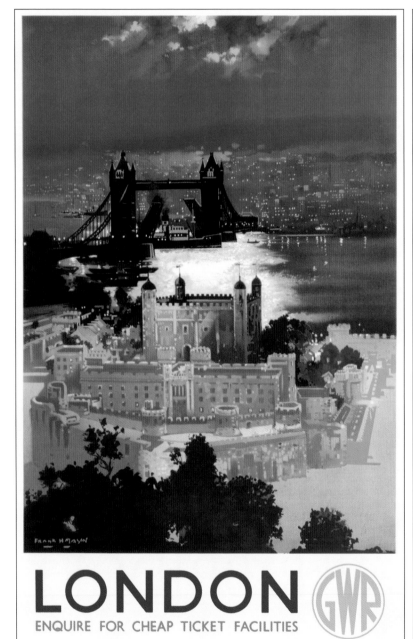

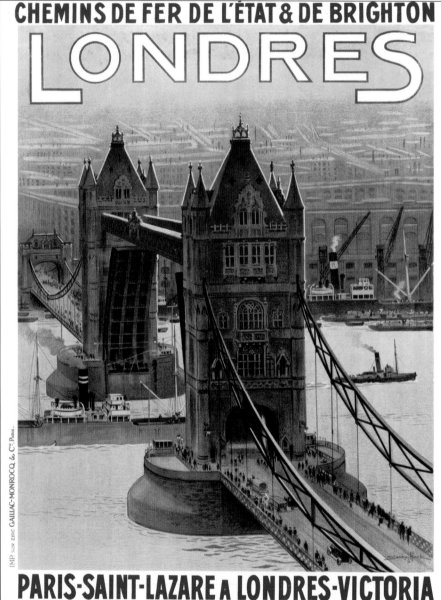

Tower Bridge looks superb from all angles, and I found many posters portraying it during my research. Two of the nicest are shown here, that on the far side being a 1938 GWR poster by the great Frank Mason, and the other a French poster from around 1920. This is a joint Chemins de Fer de l'Etat and LBSCR issue, designed and printed in France. The sepia-like tones allow the detailed design of the bridge to be centre-stage.

Mason, on the other hand, used it as a backdrop, with the historic Tower of London more prominent. Mason's aerial viewpoint is looking east, with buildings on the south bank of the Thames stretching to the horizon. The moonlight on the river accentuates the silhouette of the bridge, as a small freighter comes upstream to discharge its cargo. The stonework that clads the steel skeleton is a mixture of Cornish granite and Portland stone. From 1982 it was opened to the public, the first time since 1910.

97 & 98 Tower Bridge railway advertising: Frank Mason for GWR (left) and an unsigned French poster (right)

Mason's poster showed how close the Tower is to the Thames. It is surprising there were few railway posters issued that featured this most historical of buildings; certainly the best is the rare 1925 LMS poster by Norman Wilkinson shown here. His viewpoint, on the river looking north, allows the size of the Tower to be appreciated. When it was a much-feared prison, victims arriving by boat must have trembled at the building that soared above them.

The Tower of London has a long, rich history. In the past, it seems to have been central to ruling our nation, and it has been besieged several times. The central White Tower was built by William the Conqueror, and successive sections were added by Richard I, Henry III and Edward I, so that by the end of the 13th century, its complex structure was largely complete. The moat and double defensive ring made the Tower very difficult to attack. Although originally intended as a royal palace, it was a prison for a good part of its life, but has also served as an armoury, a treasury, home to the Royal Mint and, of course, today is home to our fabulous Crown Jewels. Wilkinson painted a number of London buildings around this time, as the LMS sought to increase tourism from elsewhere in its territory; this poster therefore would most likely been displayed in the Birmingham, East Midlands, Liverpool and Manchester areas.

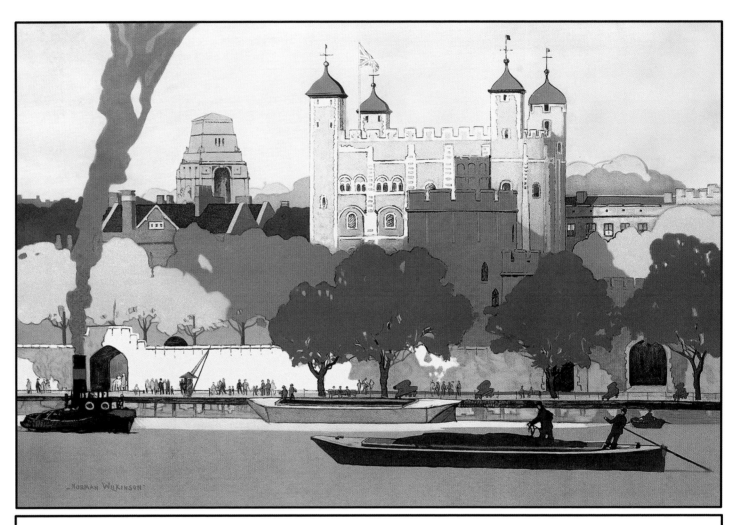

LMS LONDON BY LMS
THE TOWER
BY NORMAN WILKINSON. R.I.

99 Rarely-seen poster for the Tower of London: LMS publication from 1925 by Norman Wilkinson (1878-1971)

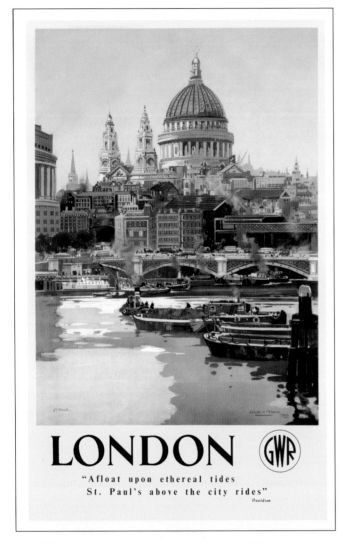
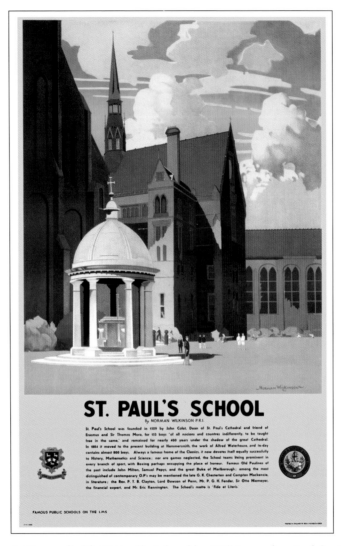
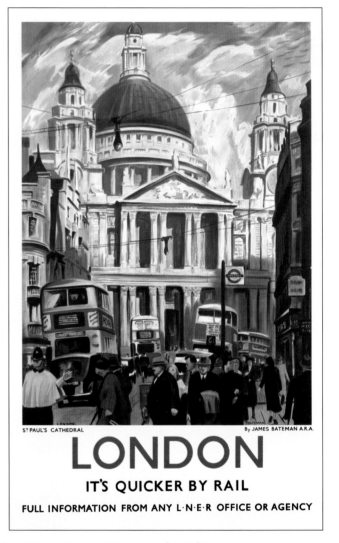

100 to 102 St Paul's, London: GWR poster by Frank Mason (left), St Paul's School by Wilkinson (centre) for the LMS and an LNER poster (right) by James Bateman

Moving north-west from the river, we soon see the great dome of St Paul's Cathedral coming into view. This, plus St. Paul's School, was a target of all the railway companies, and to illustrate this point the trio of posters above comes from three different members of the 'Big Four'. James Bateman's view of the great West Front from Ludgate Hill (on the LNER poster, right) is probably most commonly seen, but this much-loved symbol of Christianity is instantly recognized from any angle. Its dome is a commanding feature of the City of London but in recent times the modern buildings of the financial district to the east are equally distinctive, and taller (such as the Swiss Re building, commonly known as the 'Gherkin'). However, viewed from the river (above left) St Paul's is simply majestic.

The scene on this page is viewed from upstream of Blackfriars Bridge, looking east, so the towers of St Paul's West Front and the magnificent dome are emphasized. This poster also gives an idea of the huge size of Wren's masterpiece, completed in 1677. It was constructed to replace an earlier cathedral destroyed in the Great Fire of London. It is the fifth church on this site, the first being completed in 604AD. Its English Baroque style was later copied and adapted by other cathedrals, such as Birmingham for example, but on a much smaller scale.

The dome is 102 ft (31m) in diameter and 278 ft (85m) high. The additional tower above the dome increases the height to a colossal 365 ft (111m). It is the second largest religious building in Britain, after Liverpool's Anglican Cathedral. The elegance of the columns and symmetry between the west towers and the dome rising above, create the majesty of this wonderful structure. Wilkinson's choice of a cool palette is broken by the afternoon sun highlighting part of the bridge, the central buildings, some of the cloud tops and reflections in the Thames. It is a beautifully composed poster, one of a series of London subjects produced by him at a time when the LMS was going head-to-head with the LNER to promote London. (The Tower of London on page 65 is another in this series).

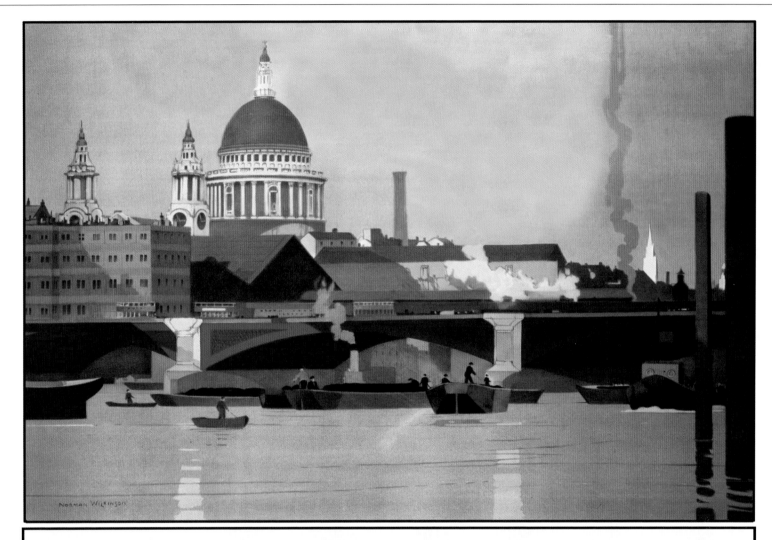

103 Beautiful c1925 LMS poster of St Paul's Cathedral, London by Norman Wilkinson (1878-1971)

105 Waterloo Bridge: carriage artwork by Kenneth Steel (1906-1970)

When the railway traveller walks in the streets of the City of London, he will encounter wonderful buildings at every corner. During the 20th century, many were featured on railway posters, and just two are presented on this page. Alongside is a rare piece of artwork by Claude Buckle. The Bank of England in Threadneedle Street has been much in the news in recent years; this artwork was certainly a waiting room print. (It is likely that it was produced as a poster, though one has yet to surface). Founded in 1694, it is the second oldest central bank in the world - *Sveriges Riksbank* in Stockholm was established 26 years earlier - but the long-term strength of the Bank of England has been a cornerstone to world financial stability for more than three centuries, both in good and troubled times. It has occupied this location since 1734, and the present building, by Sir Herbert Baker, replaced the first building on the site designed by Sir John Soane. The statue in Buckle's artwork is of the Duke of Wellington. It is almost as if he is standing guard to make sure nothing can fail. Nearby, on top of Tivoli Corner and looking down Princes Street, is the golden statue of Ariel, representing the spirit of the Bank and its global dealings.

It is a good walk from the Bank of England down to Mansion House, along Queen Victoria Street and onto The Embankment. Half a mile upstream of Waterloo Bridge we can turn and look back to the City of London, as portrayed in Kenneth Steel's lovely carriage print panorama, with St. Paul's in the distance. The impressive building in the centre is Somerset House. It is now a visual arts centre, but it was home to the General Registrar for Births, Marriages and Deaths from 1837 to 1970, and before that it was a royal palace. Today, it houses part of King's College London, the Royal Society, the Society of Antiquities and the Courtauld Institute of Art. On the left is the Savoy Hotel with the distinctive Cleopatra's Needle in front. Today the London Eye is behind this viewpoint. In the evenings, this area is a blaze of lights, which leads us nicely to the next group of posters.

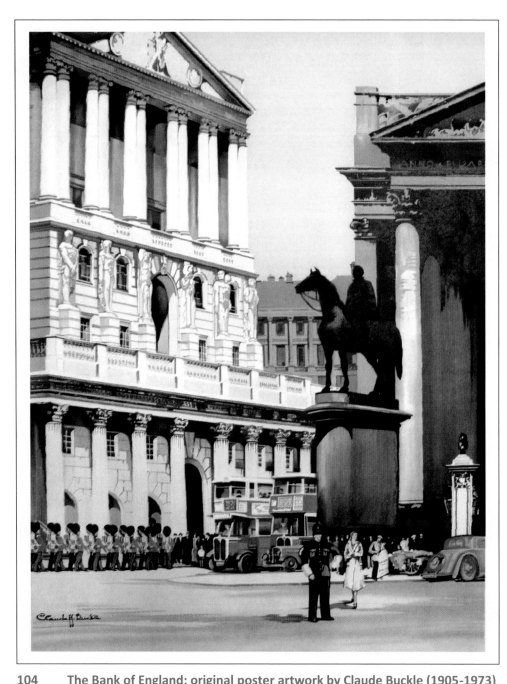

104 The Bank of England: original poster artwork by Claude Buckle (1905-1973)

Evening atmospherics

Like many great cities, London by night is a wonderful place. It takes on a different atmosphere as commuters and sightseers disappear and the theatre-goers, clubbers and revellers throng the streets, as the original 1926 artwork for the poster *London by LMS*, produced by Maurice Greiffenhagen, shows. There are theatres to suit all tastes, and walking along Shaftesbury Avenue, Rupert Street or Haymarket brings images such as those that follow. Not far away are Coventry Street and Leicester Square. This area has always been a popular destination for travellers, and its only relatively quiet period was during WWII; but even then, shows and reviews still went ahead.

The statue of Eros, at the junction of several important thoroughfares, featured on all 'Big Four' railway company posters. I have chosen one from the GWR and another from the LNER to continue the night-time theme. The Circus was created by John Nash in 1819 at the junction with Regent Street.

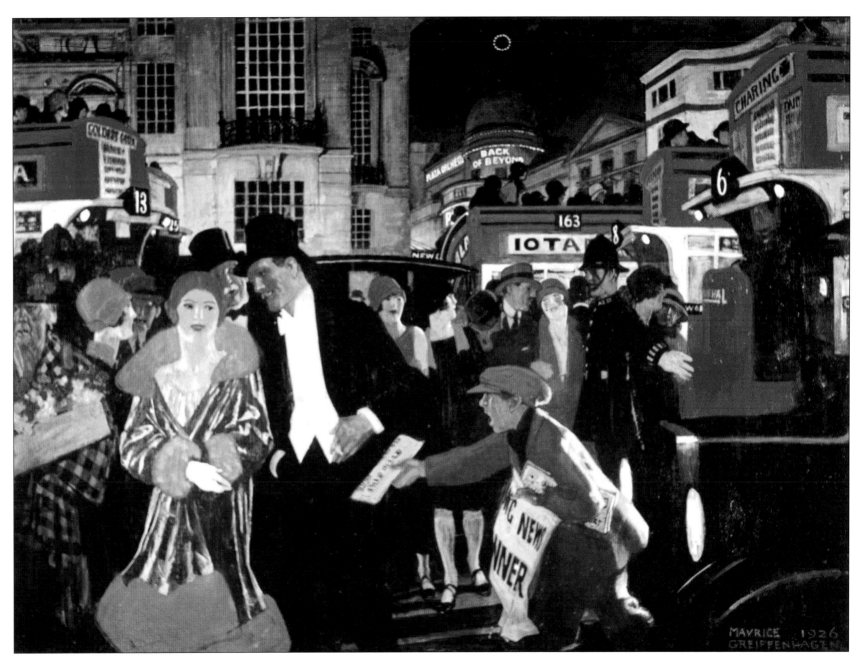

106 On the town near Piccadilly Circus: original LMS poster artwork from 1926 by Maurice Greiffenhagen (1862-1931)

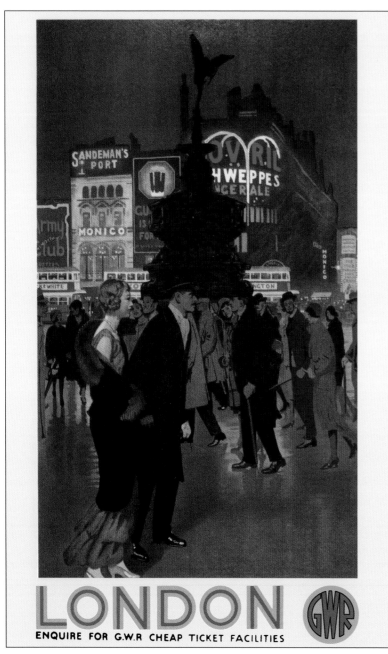

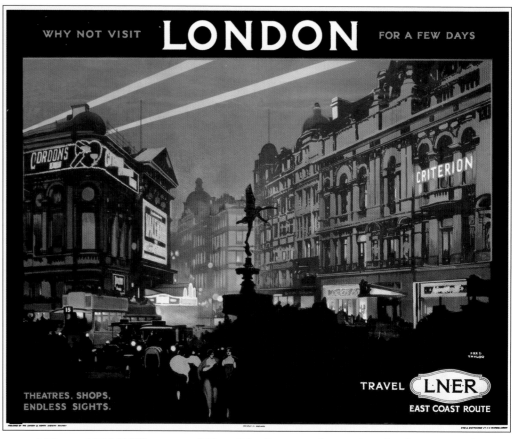

108 1926 LNER poster of Piccadilly Circus: artist Fred Taylor (1875-1963)

When Shaftesbury Avenue was created in 1886, the original shape of Piccadilly Circus was lost. Piccadilly tube station appeared only twenty years later in 1906, at a time when the area was crowded with horse-buses, tramcars, and the novelty of motor cars and charabancs. It was still as busy a further twenty years later, as Fred Taylor's poster (above) from 1926 for the LNER shows. The positions of Eros and the Criterion Theatre to the right confirm that we are looking up Regent Street. This has long been a place for illuminated hoardings, and today large neon signs carry on the tradition of the colourful poster, this time selling products rather than destinations. The 1912 poster alongside shows Eros silhouetted against the lights and the evening sky, as theatregoers make their way to their seats. This ornamental fountain was erected in 1893, the statue section being one of the first to be cast in aluminium. In reality, the statue is not of Eros, who was the pagan God of Love, but is the Angel of Christian Charity, hence the dedication of this famous London landmark to Lord Shaftesbury, who did much to help poor and needy children.

107 1912 GWR poster for Piccadilly Circus: artwork is unsigned

Pomp and ceremony

Britain is world-famous for its pomp and ceremony, and I might suggest nobody does processions and pageantry like the British. The railway companies also thought so, and this next group of posters can only be advertising London. The superb artwork alongside shows a royal procession, one of many that have occurred over the centuries. Go to the Tower of London, the Law Courts, Buckingham Palace, the Houses of Parliament and many other locations to see pageantry at it finest. When there are royal weddings, jubilees and special events, the crowds that line streets and wave flags confirm that our country has a real appetite for ceremonial events.

This poster shows the Royal State Coach, pulled by a team of eight horses and used by royalty since 1762. It is heavy (four tonnes) and gilded, so that its size and weight have restricted use to coronations, jubilees and weddings. Here Christopher Clark, who excelled at such subjects, shows the Red Moroccan harness atop black stallions, with pairs of coachmen in full gold livery. Red-uniformed footmen walk alongside. Ornate figures and cherubs adorn the roof, while satin and velvet line the interior, along with painted panels. The coach was built by Samuel Butler, with Giovanni Cipriani producing the colourful panels. When this poster is viewed full size, it is as stunning as the coach itself.

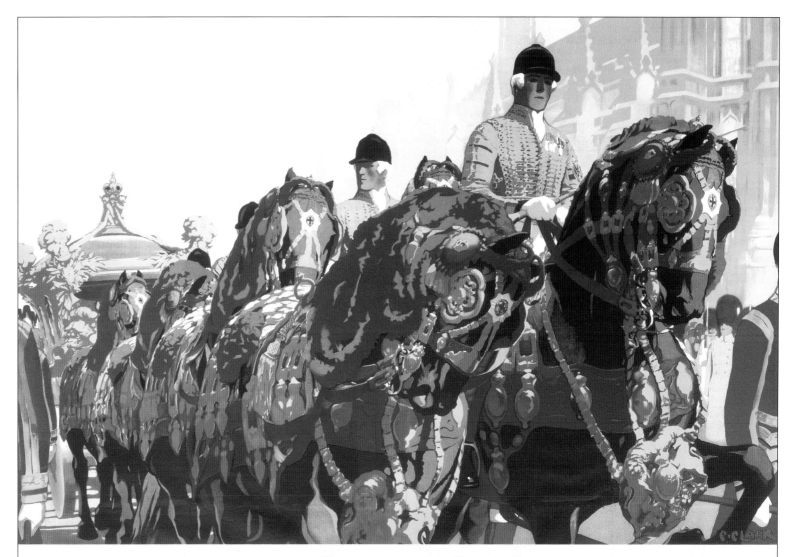

109 Wonderful ceremonial poster from the 1930s: LMS poster by Christopher Clark (1875-1942)

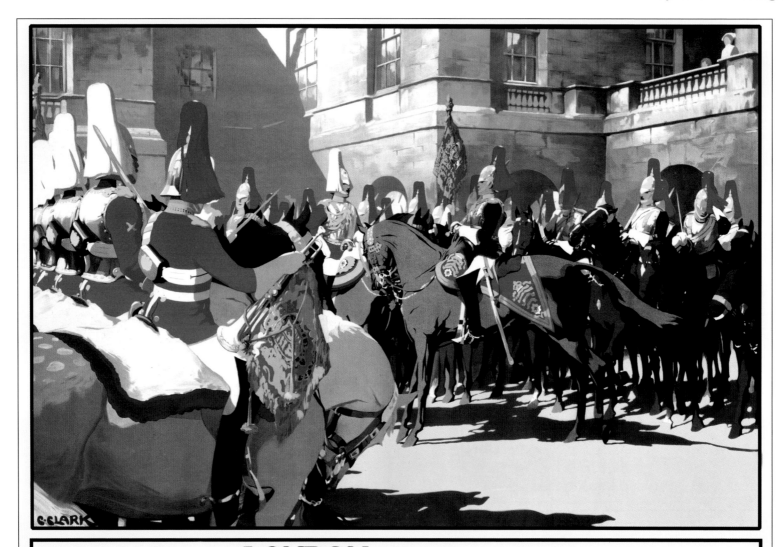

LONDON: The Horse Guards

By Christopher Clark, R.I.

LMS

Every morning at eleven o'clock (ten o'clock on Sundays), to a fanfare on 17th century silver clarions, the King's Life Guard is mounted by one of the Regiments of the Household Cavalry at the Horse Guards. Here Charles II stabled his troop horses, and on the Tilting Yard behind the Tudors held their tournaments.

To-day, the Horse Guards is the headquarters of the General Officer Commanding-in-Chief, Eastern Command, and the General Officer Commanding, London District; and the Tilting Yard has become the Horse Guards Parade, where the ceremony of Trooping the Colour is carried out by the Household Cavalry and Brigade of Guards on His Majesty's Birthday.

110 The wonderful face of military and ceremonial Britain: LMS poster from 1937 by Christopher Clark (1875-1942)

The poster opposite is another stunner by Clark, and this page sees two more of his masterly ceremonial posters, all painted and issued in the 1930s. The Horse Guards is a regiment within the Household Cavalry. This is an elite military group that is directly involved with the Head of State. Two regiments are depicted in the poster. On the right are the soldiers of the Blues and Royals (blue tunics and red plumed helmets), while on the left are the Life Guards (red tunics with white plumes and black collars). The sight of all this finery on parade in the Mall on a bright sunny day is utterly unforgettable.

Below is a ceremonial band on parade at St James's Palace, one of the oldest of the royal residences (dating from the 1530s). It is the official London home of HRH The Princess Royal, and of Princess Alexandra, The Honourable Lady Ogilvy. William III, George I, George II and George III all resided here and, though not used in this role for the past 200 years, St. James's Palace still retains the administrative offices of the Royal Household.

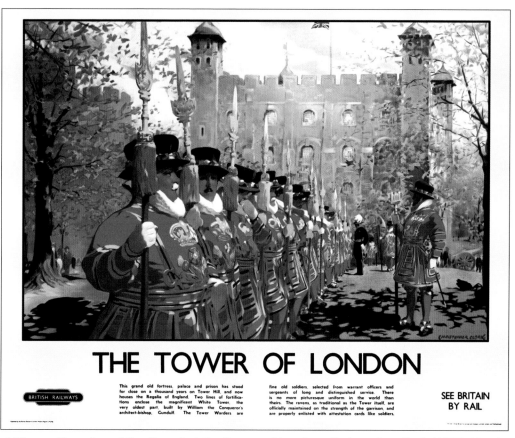

THE TOWER OF LONDON

This grand old fortress, palace and prison has stood for close on a thousand years on Tower Hill, and now houses the Regalia of England. Two lines of fortifications enclose the magnificent White Tower, the very oldest part, built by William the Conqueror's architect-bishop, Gundulf. The Tower Warders are fine old soldiers, selected from warrant officers and sergeants of long and distinguished service. There is no more picturesque uniform in the world than theirs. The ravens, as traditional as the Tower itself, are officially maintained on the strength of the garrison, and are properly enlisted with attestation cards like soldiers.

SEE BRITAIN BY RAIL

112 Changing of the Guard at the Tower of London: Christopher Clark (1875-1942)

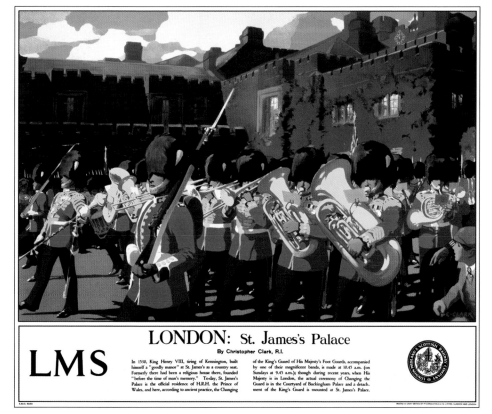

LONDON: St. James's Palace
By Christopher Clark, R.I.

In 1530, King Henry VIII, tiring of Kennington, built himself a "goodly manor" at St. James's as a country seat. Formerly there had been a religious house there, founded "before the time of man's memory." To-day, St. James's Palace is the official residence of H.R.H. the Prince of Wales, and here, according to ancient practice, the Changing of the King's Guard of His Majesty's Foot Guards, accompanied by one of their magnificent bands, is made at 10.45 a.m. (on Sundays at 9.45 a.m.); though during recent years, when His Majesty is in London, the actual ceremony of Changing the Guard is in the Courtyard of Buckingham Palace and a detachment of the King's Guard is mounted at St. James's Palace.

LMS

The band was used in the ceremony of Changing of the Guard at St. James's, and a similar ceremony took place at the Tower of London, where the beefeaters were on parade. Clark's wonderful rendition of this is shown above in the 1950 BR poster. This painting was actually produced in the 1930s, and reissued in the early BR years. At that time attempts were made at boosting tourism, so the colour and tradition of London ceremonies was an obvious target. Clark produced six posters for the LMS showing London, and all were used later by BR. His use of colour in the foreground, with a muted palette behind, gives the pictures almost a 3-D effect when viewed full size. Probably the most famous location where the guards are changed is Buckingham Palace, but similar ceremonies are held in more than 20 countries around the world. I remember some years ago being at Parliament Hill in Ottawa, where Canadian Grenadiers were on parade. Their tunics are virtually identical to those of the British army, and I could almost have been in London!

111 Guards on parade at St James's Palace, London: Christopher Clark (1875-1942)

Arguably our best-known ceremony is Trooping the Colour, and this poster was given pride of place in the 1932 LMS marketing campaign. It is a ceremony that dates back to the time of Charles II, when each morning, the regimental flag was paraded in front of the troops, so that during the heat of battle, when a mustering point was required, the flag (the colours) could be very easily recognized. It became associated with the Monarch's official birthday as early as 1748, but when George III became king he ordered that it should mark his birthday. George IV carried on the tradition, and with only a few exceptions (notably wartime) it has been held each year.

Our Queen's official birthday is in the first week of June, and this is an event I have always eagerly anticipated. The scale is surprising, with well over a thousand troops massed at Horse Guards Parade in full dress uniform, together with both marching and mounted bands and over two hundred horses, as this magnificent poster shows. It is quite without equal as a ceremonial, official and tourist event. Her Majesty has attended 36 times on horseback, wearing the uniform of the regiment whose colours are on parade, and, since 1987, in Queen Victoria's 1842 ivory-mounted phaeton drawn by two white horses, accompanied by the younger members of the Royal Family on horseback.

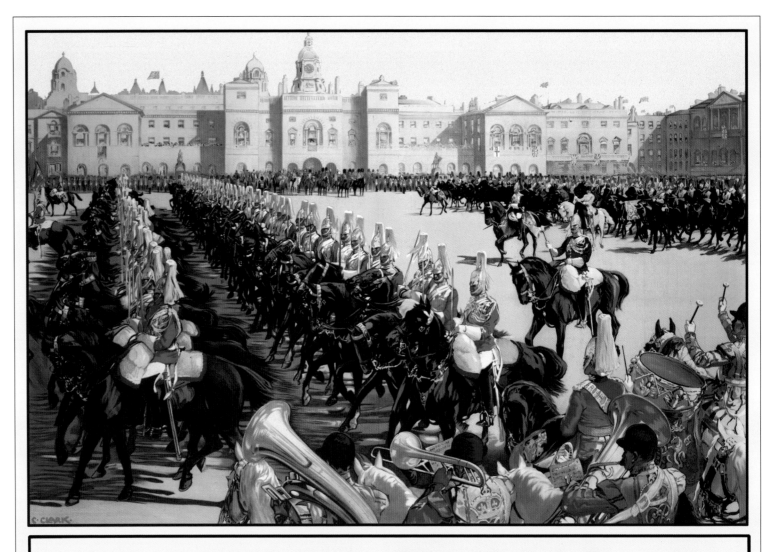

113 Our best-known ceremony: Trooping the Colour on Horse Guards Parade in 1932 by Christopher Clark (1875-1942)

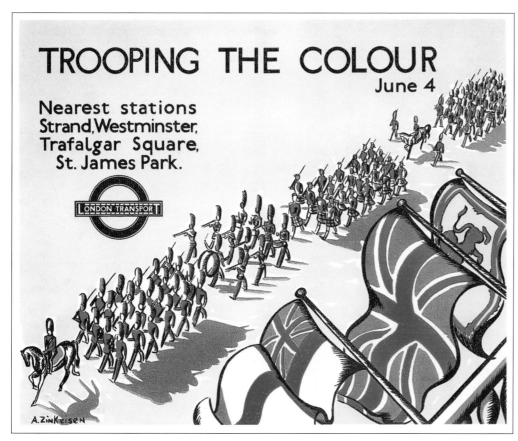

114 Trooping the Colour – poster artist style: Anna Katrina Zinkeisen (1901-1976)

The colours of one of the five regiments of foot guards (Coldstream, Grenadier, Irish, Scots and Welsh) are changed each ceremony, so every five years all the colours are trooped. For 2012, Olympics and Diamond Jubilee year, it is the turn of the 1^{st} Battalion of the Coldstream Guards. In earlier advertising years, London Transport used to produce their own poster, in addition to any of those made by the railway companies. Some of them are also superb, and although trying to minimize the use of LT posters, I had to include this one because it is so vibrant and different from the formal Clark artwork. Anna Zinkeisen captures the parade in a far simpler manner and has also included some of the many flags that fly during the parade. The precision used to manoeuvre so many men, bands and horses is amazing. Horse Guards is a large parade ground, but even here, real skill is required to position the bands and the guards, as well as the movements of the escorts, when the colour is paraded through the ranks.

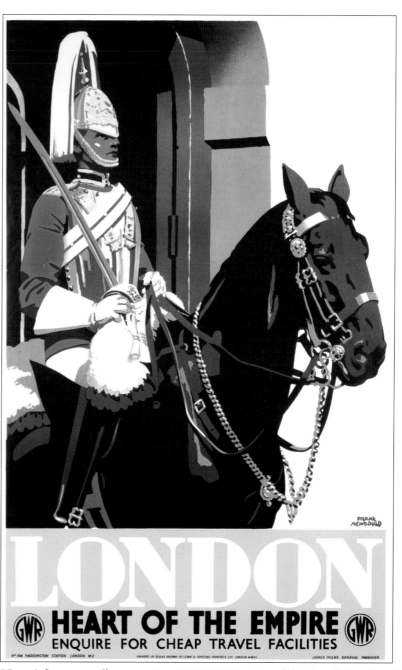

115 A famous railway poster: 1939 GWR artwork by Frank Newbould

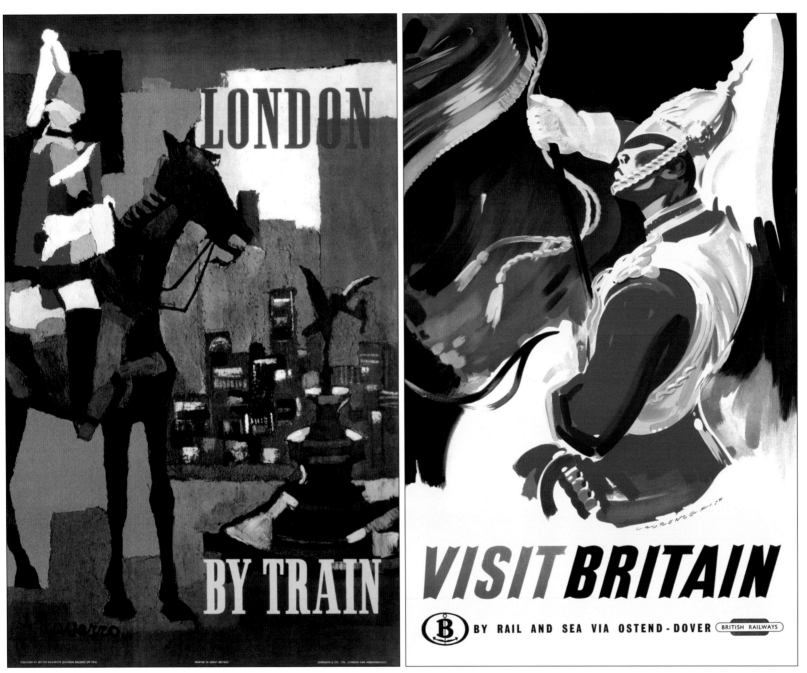

This pair of posters, plus the famous Newbould poster on the previous page, all illustrate how important the Life Guards were in terms of railway advertising. These superbly dressed soldiers really do poster artwork justice, and this trio of artists chose dark backgrounds to emphasise the elegance of the plumes. The colours red, black and white work well together, and it is only the Navarro poster from 1953 that has diluted the boldness of the three colours with the lights of Piccadilly Circus. The Newbould poster is superb, but there is movement and an artistic freshness about the Fish poster alongside. Little wonder, therefore, that is was licensed by British Railways to rail companies on the continent.

The history of the regiment is a proud one. In addition to their public ceremonial face, they have won battle honours at Waterloo, in Egypt and, most notably, in WWI at Mons, Ypres, Passchendaele and Zandvoorte. As the nature of war changed, they mechanized to become first a machine gun, and then an armoured, regiment. They were involved in the major push through Europe in WWII after landing in Normandy a month after D-day. Recent assignments include Cyprus, Kuwait, Bosnia and Kosovo, and currently they are serving in Afghanistan. They are based in Windsor and London, following amalgamation with the Blues and Royals.

116 and 117 Lifeguards in BR posters: J. Navarro (left) from 1953 and Laurence Fish (right) from 1960

This final pair of ceremonial posters comes from the LNER and from one of the French railway companies that enjoyed much collaboration with the Southern Railway. The LMS had taken the lead in such artwork, but this chapter indicates that all the 'Big Four' participated. On the LNER poster again we have the Royal State Coach in front of Westminster Abbey (nearside), while the striking Maurice Toussaint poster (far side) shows guards lining Whitehall as a royal procession passes. The white plumes in the bearskins and evenly spaced buttons on the red tunic indicate that these are the Grenadier Guards on parade.

This poster is one of the few in this book which was printed in France by Dechaux of Paris. It is among the many issued throughout the 20th century in which railway companies of south-east England and in France collaborated to show the finer points of both countries: the French often showed London, while the British showcased Paris. The Fred Taylor example is one of the few railway posters where Westminster Abbey is used, though London Transport produced some lovely posters for this magnificent place of worship.

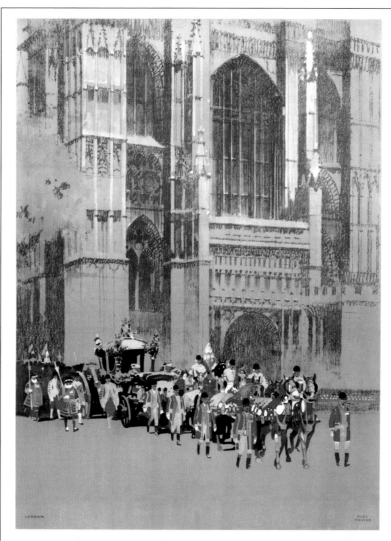

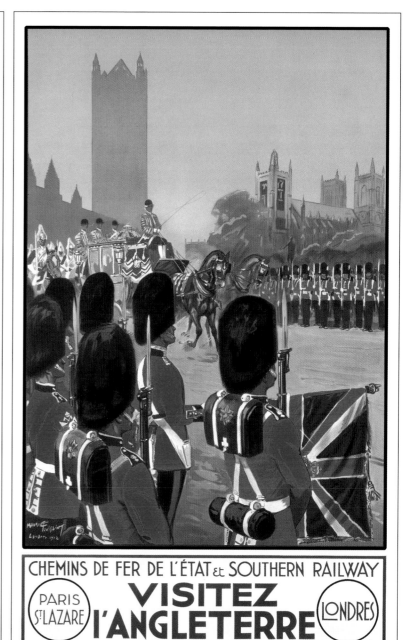

118 & 119 Tourism posters for London: Fred Taylor (Left) for LNER from 1930s and Maurice Toussaint (Right) for SR from 1932

120 1929 City of London GWR poster map: Artist Heather Perry

Before we leave the central part of London, it is worth showing the extent to which some of the railway companies went in promoting this great city. Alongside is a Great Western Railway poster from 1929, with an amazing amount of detail in the artwork by an artist who also produced many LT posters. The small montage of buildings at the top shows a compressed skyline, dominated by St Paul's and Westminster Abbey. The street map itself is precise, with the inclusion of some of the historical characters that frequented them. Measuring the effectiveness of artistic posters is difficult, and during the years mainly covered by this book, the companies themselves did not undertake such an audit; they assumed it was a normal part of promotion, and how much extra revenue was generated is not known. What is clear is that by putting them together and evaluating the result, it can be seen that a longer term strategy is paramount in any advertising campaign. That mounted by the LMS in the 1930s using ceremonials is a case in point, and to this day it has not been bettered when trying to promote London.

West, then south-central areas

From the main centre, we now move to the west and then south before turning east to move beyond the London boundary. Except for notable public events, this was an area travellers came from, rather then went to. South London in particular is crossed by numerous lines, and reference to the *Book of British Railway Totems* (see appendix D) reveals just how many stations commuters travelled from each day. Having made the journey to the office, I suppose they did not want to go back to sightsee at weekends, although the theatre-goers would say otherwise. London Transport issued a large number of superb posters for both underground and bus travel. Appendix C lists some first-class reference books on the London Transport Museum collection by David Bownes, Oliver Green or Jonathan Riddell, showing how avant-garde some of these were. Many in the large LT collection were painted by the same artists depicted in this chapter.

The pair of GWR specimens opposite shows that London posters from the same company, issued around the same time, could differ greatly. The Ernest Coffin aerial view is very detailed and shows the central parks effectively. The viewpoint is high above the Thames looking west-north-west. On the horizon is Paddington, the GWR's London terminus. This famous and busy station disgorges thousands of commuters on weekdays, and also has four underground lines around and beneath it. The station serves main destinations in the west of England, South Wales and in a large part of the Midlands. The overall station design was produced by Brunel, but much of the fine structural detailing is the work of Associate Matthew Digby Wyatt. The station became operational in 1854, replacing the 1838 structure to the west, for the first GWR trains from Taplow.

Like King's Cross, St Pancras and Euston, Paddington is a historic site. Much of the present station is mid-Victorian, but in 1863 it also acted as the western terminus of the Metropolitan Railway, the world's first underground line. The train shed was built with three great spans, and a fourth was added in the Edwardian years. Visiting here was always a pleasure, and on busy Saturdays in summer in the 1950s, *King* and *Castle* class engines were found at the western end of the platforms at the head of long, heavy trains bound for the seaside. All the platforms were bustling with excited families eager to get away. This was a sight I shall never forget.

The photo-poster (far side) is one of a series featuring GWR hotels around their network (see volume 3 page 127 for a similar poster of Fishguard Bay Hotel). This one was built on Praed Street, at the front of the station, and was always a luxurious place to stay. The façade is particularly interesting, and over the years the interior has been refurbished several times. This poster advertises the 1930s styling undertaken during the art-deco era. The Royal Hotel was purchased by the Hilton Group in 2001, who updated it once again.

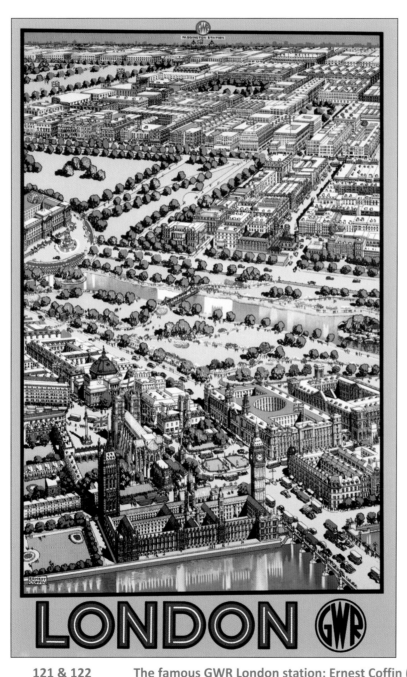

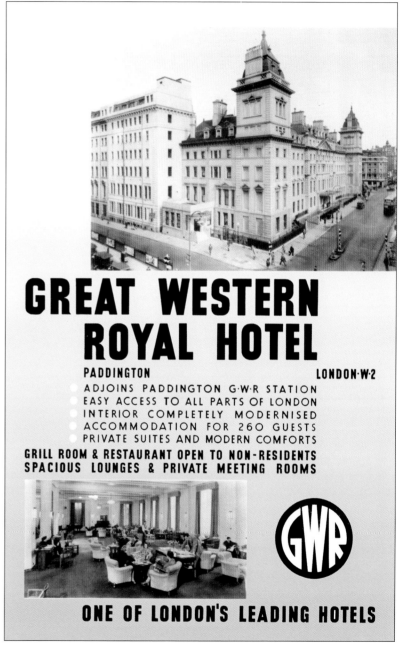

121 & 122 The famous GWR London station: Ernest Coffin (left) from 1936 and a photographic poster from the mid 1930s

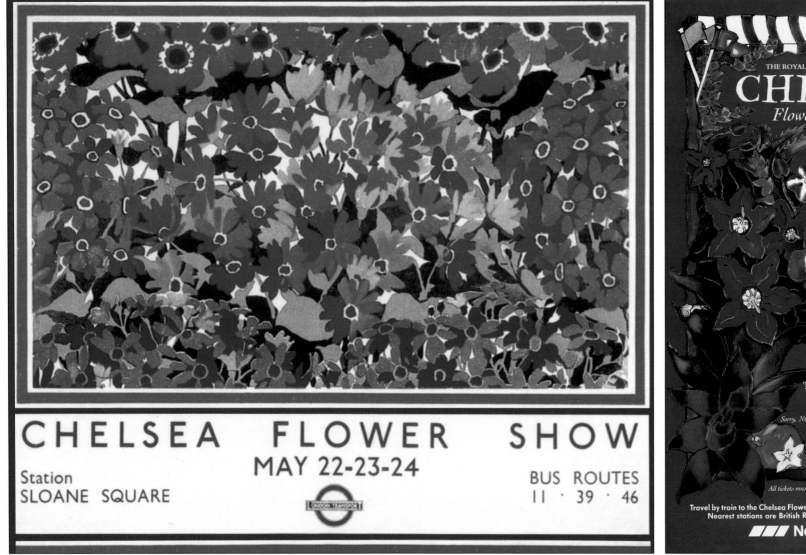
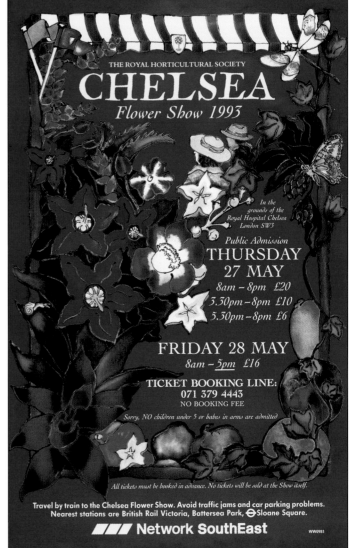

123 & 124 The world's greatest flower show in West London: simple, but stunning, LT poster (left) and a modern NSE Poster for the 1993 show (right)

South-west London is home to the greatest flower show in the world. The Royal Horticultural Society takes over the grounds of the Royal Hospital to exhibit a profusion of colour and the best of floral delights. One of the finest posters for this event is above left: but contrast this with a modern photo-based design from 1993 from Network SouthEast. This tends to show that original artwork is better, and many such examples throughout this series of books support this hypothesis; nevertheless the NSE poster is still a rich and colourful poster. Chelsea has been the home of this prestigious show since 1912, but its forerunners took place in Kensington and Temple Gardens.

We now move south of the Thames to a location very familiar to rail travellers. This poster by Cuneo shows Clapham Junction, where tracks from two of London's busiest stations, Victoria and Waterloo, meet and pass through the huge complex. Even outside the peak commuter times, a train moves through the area every 40 seconds, making it by far the busiest junction in Europe. On an average day some 2,000 trains pass through or stop in each 24-hour period. Cuneo was perched on one of the large signal gantries to make his sketches for this busy poster, at a time when *Battle of Britain* and *Merchant Navy* class express locomotives rubbed shoulders with electric commuter trains. The use of so many engines and EMUs in the picture is no exaggeration.

Clapham Junction station opened in 1863 and was jointly funded by the LBSCR and the LSWR, two of the largest constituents of the later Southern Railway. The station is actually in Battersea, a very poor district at the time of construction. In order to give the impression of a more affluent area, the name of Clapham was used, being a mile or so to the east. I have positioned this poster deliberately out of sequence, so that the two famous Helen McKie Waterloo posters can be shown together on the next pages.

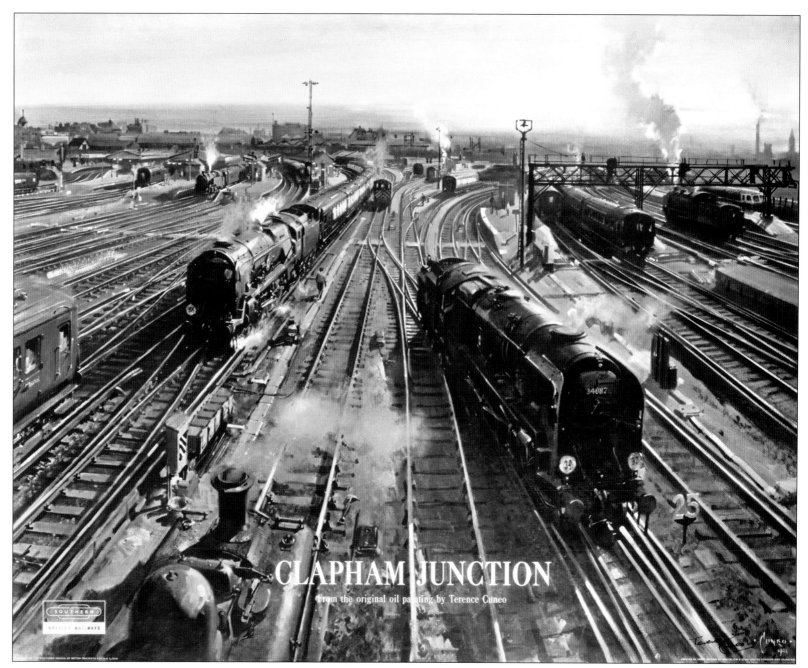

125 World's busiest railway complex in south London: Clapham Junction for BR (SR) by Terence Cuneo (1907-1996)

Going back into London, we visit Waterloo, the busiest station in terms of passenger numbers. Current figures show in excess of 88 million people use the main station alone, but add in the underground system and the figure is far higher. The first station on this site appeared in 1848. At that time the area was marshland, and the station was built on arches, with the intention of taking the line further towards the City of London. The station grew in a rather haphazard way, with platforms being added at different times, and each group of platforms had its own booking facilities. By 1899 the LSWR decided the whole complex should be rationalized and over the next 20 years the new station gradually emerged, with construction being interrupted for several years by WWI. The poster alongside shows the front 1921 entrance arch, known as Victory Arch, which is also a memorial to staff killed during that war.

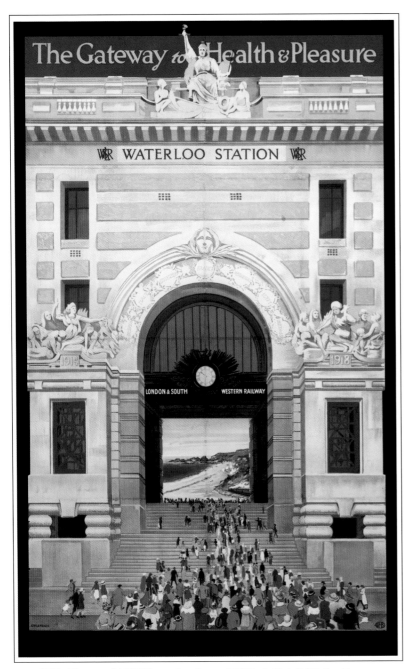

126 Unusual LSWR poster from 1920: Artist S.W. Le Feaux

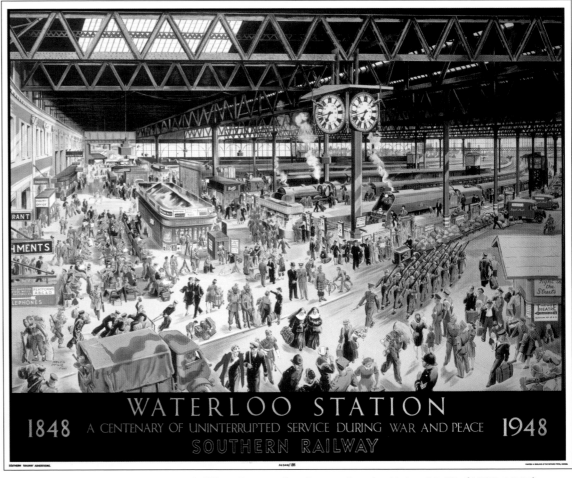

127 Centenary poster 1: Waterloo station in wartime by Helen McKie (1889-1957)

In 1947 the Southern Railway commissioned Helen McKie, a famous artist at the time who was also a regular contributor to several prominent London magazines, to paint two images of the station in peacetime and wartime, marking the centenary of the first station. Of course, by the time the centenary came around Waterloo was managed by British Railways, so this unusual pair of posters shows an SR notation on a poster referring to BR years. The artwork on both is exquisite, and much can be gleaned about the social aspects of travel in the 1940s: the everyday hustle and bustle of Waterloo is clearly evident.

This station was revisited in 1967 when Terence Cuneo painted his version of the concourse from a very similar position, but with more of the station platform stretching away into the distance. This artwork is found at the end of the chapter on page 86. The huge picture, 10 ft high by 20 ft wide, was commissioned by the Science Museum for their new transport gallery, which opened shortly after Cuneo completed the painting. He actually undertook the work within the part-finished gallery, surrounded by all of the covered exhibits. The frantic travel activity within Waterloo station in 1967 seems undiminished from Helen Mckie's time.

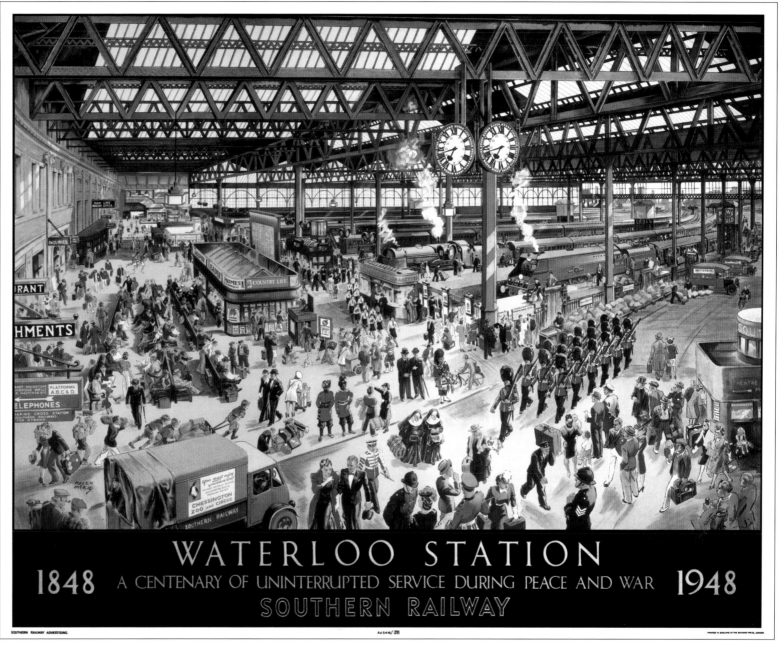

128 Centenary poster 2: Waterloo Station in peacetime by Helen McKie (1889-1957)

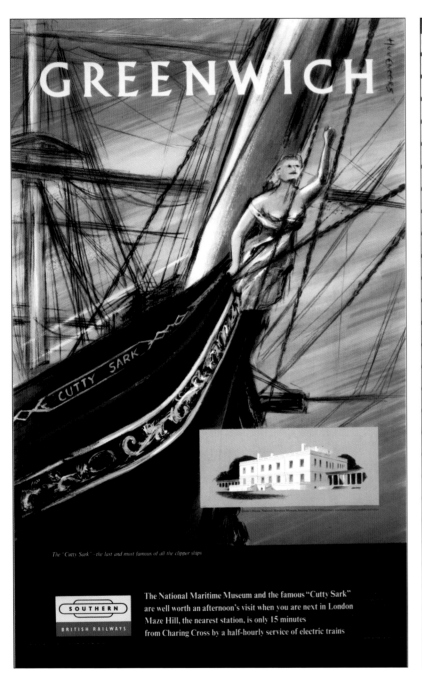

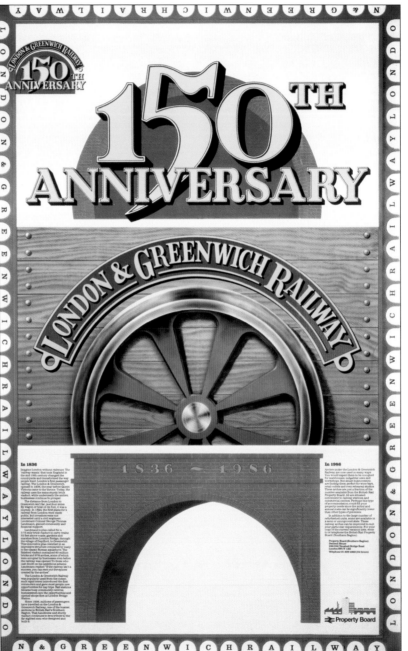

129 and 130 Marketing Greenwich: BR Poster from 1970 by Huveneers (left) and an unsigned 150th anniversary poster (right)

Time for a 'Mean Time'

The last group of posters in this section is for Greenwich, possibly the most popular tourist destination outside the central area. It has a long and proud maritime history and, of course, gives its name to the Greenwich Meridian and to Greenwich Mean Time, the world chronological standard. But as well as these connections, there are centuries of royal patronage, beginning with the Palace of Placentia. This was constructed in 1447 by the Duke of Gloucester, and it remained a royal residence for more than two centuries. Both Henry VIII and Elizabeth I were born here, in 1491 and 1533 respectively. The connection with Henry VIII was particularly strong, and he married Anne of Cleves in the palace in 1540. Neglect and subsequent demolition saw the site redeveloped by Sir Christopher Wren as the Royal Naval Hospital for Sailors. In 1873 the Royal Naval College was opened when the site was redeveloped once again. The *Cutty Sark*, the last of the great tea clippers, is today marooned in a purpose-built dry dock following a disastrous fire in 2007. It has been a central feature of railway advertising, and the poster (far side) shows the bow of this ship, with the white buildings of the Maritime Museum as an inset.

The nearside poster on this page shows the ship and the façade of Wren's building, where the similarity to St Paul's Cathedral is easily seen.

The London and Greenwich 150th Anniversary poster is disappointing for a railway with such proud beginnings. It was the first to have a terminus in the City of London and one of the first railways to be built in the south of England. This poster, issued in 1988, gives a potted history of construction and development of the line that opened in sections. Although the London Bridge terminus opened in 1836, it would be four years before the Greenwich terminus was completed.

It is, however, the naval connection that gives Greenwich its reputation. The National Maritime Museum is one the largest of its type in the world, and it is now part of a World Heritage Site that incorporates the Royal Observatory and the 17th century Queen's House. There is a wonderful collection of maritime paintings executed by the great poster artist Norman Wilkinson, as well as the world's largest collection of maritime books dating back to the 15th century. An illuminated pageant was held in 1933 to re-enact great moments from the past, and the rare poster (far side) advertised this unique event.

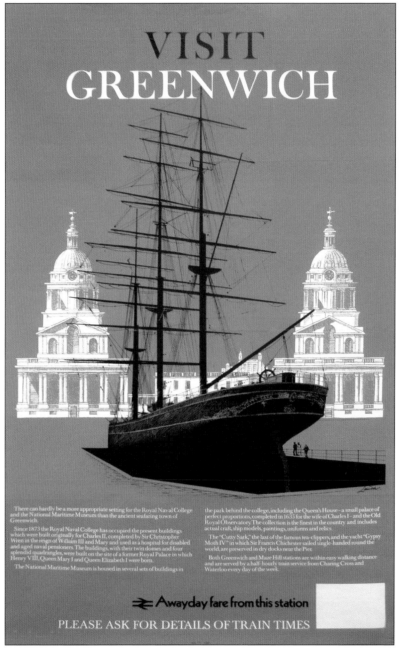
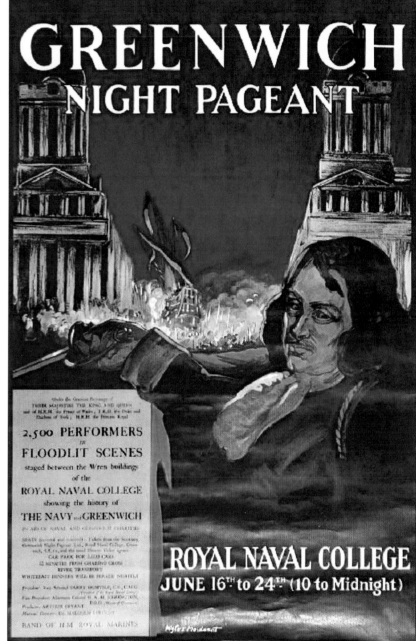

131 & 132 Contrasting poster images for Greenwich: Reginald Lander from 1977 (left) and Myles Mordaunt from 1933 (right)

133 & 134 London Embankment by Kenneth Steel (above) and Waterloo concourse in 1967 by Terence Cuneo (below)

Chapter 4 Into Kent: The Garden of England

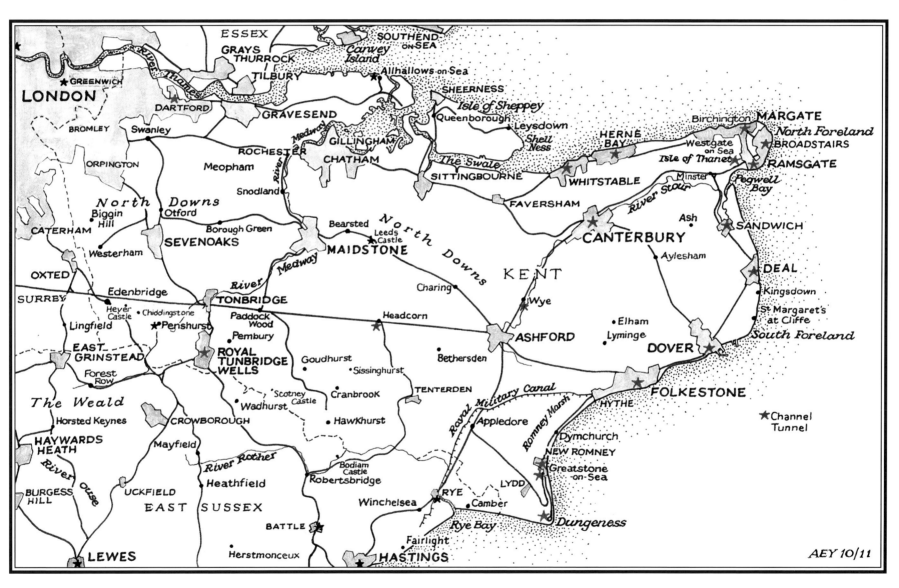

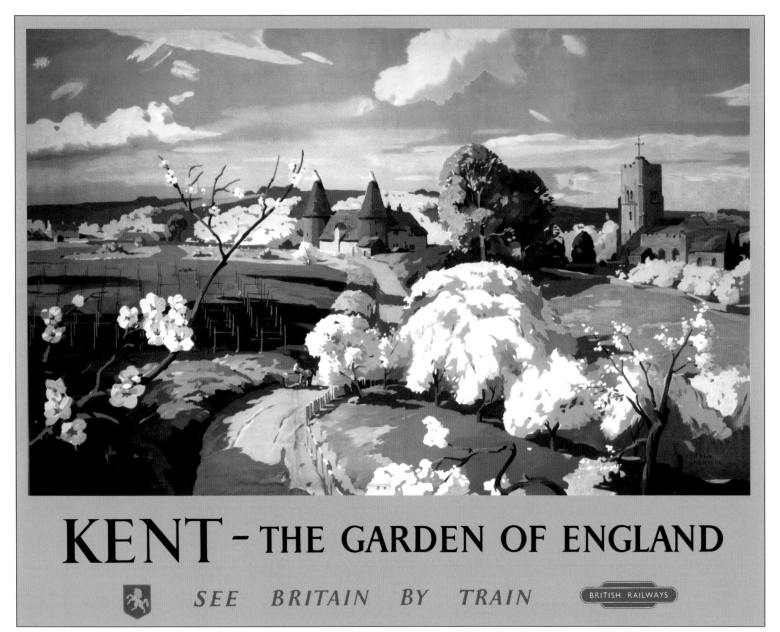

135 Kent in springtime: BR (SR) quad royal from 1955 by Frank Sherwin (1896-1986)

The gateway to England

The poster alongside marketed Kent in the mid 1950s as the *'Garden of England'* but it is also the gateway to England because of the strong cross-Channel connections to the Continent. Kent is one of three English counties with both north and south coastlines (Cornwall and Devon are the others) but it is the only English county with a nominal border with France (at mid-Channel within the Channel Tunnel). The other borders are with Sussex, Surrey, London, and via the Thames, with Essex.

It is a most historic and beautiful county, with rich soils formed during the times when, for countless millennia, it was below the sea. The spectacular white cliffs were formed by billions of microscopic shellfish that lived there for millions of years. Erosion by the sea has produced the White Cliffs, a symbol of steadfastness and defiance. The Sherwin poster shows the profusion of springtime blossom when swarms of insects pollinate the huge population of fruit trees. Other counties may claim the title *Garden of England,* but even modern car registrations in the UK use the letter 'G' to signify vehicles documented in Kent, the letter 'G' standing for garden, so the title is rightfully theirs. The Weald, which occupies most of the county, was once a vast forest, of which fragments remain.

These two colourful posters show some of the attributes of Kent in a nutshell. The North Downs fringe the northern boundary, while the fertile centre is underlain by greensand and sandstone. Characteristic oast houses are found dotted throughout the county (as in the nearside poster) whilst the proud historical heritage, including both failed and successful attempts to conquer our nation, loomed large in railway advertising campaigns (far side).

The county has often been the front line in conflicts, and the string of ports that fringe the coastline featured in a series of carriage prints in the middle of the 20th century. These are the Cinque Ports of the 12th-14th centuries, originally formed for trading, but now ceremonial places with a proud diplomatic past. In addition to these ports, there are the historic docks at Chatham plus, of course, Dover and Folkestone with their strong links with the Continent. All of these have featured in railway advertising, so that the maritime content of this chapter is strong. But in addition to shipping, the coast was always a popular destination for rest and relaxation, so throughout this chapter there are many colourful posters of seaside locations and of architectural treasures.

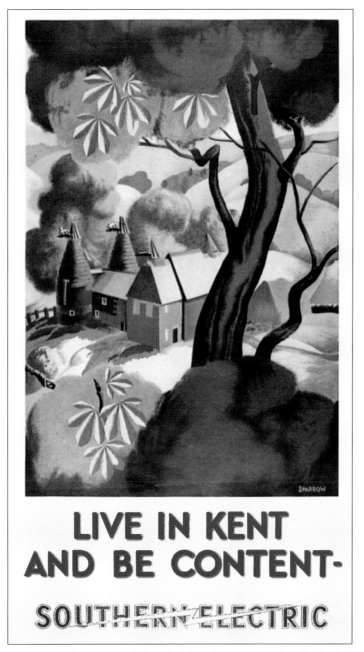

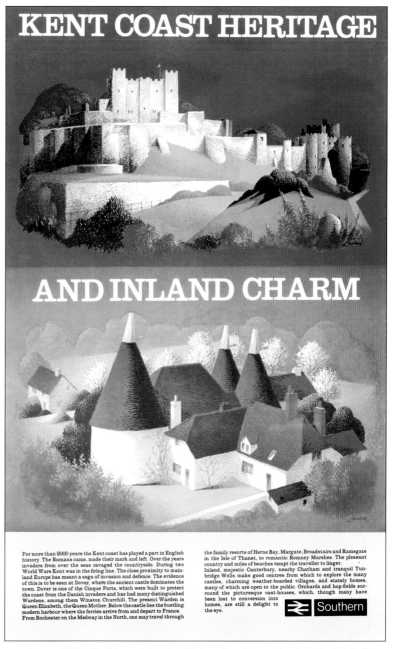

136 and 137 Colourful Southern artwork: Clodagh Sparrow from 1937 (left) and Reginald Lander from the 1970s (right)

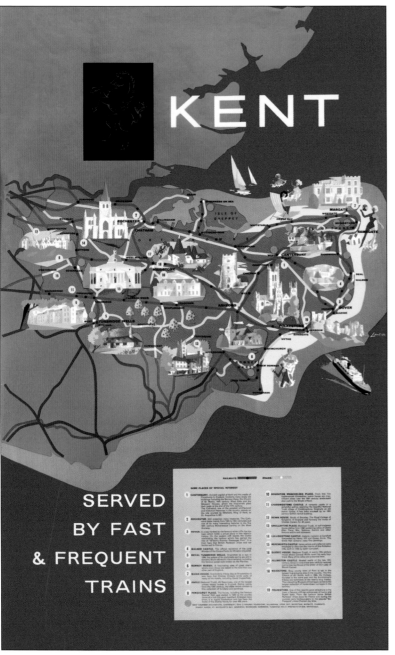

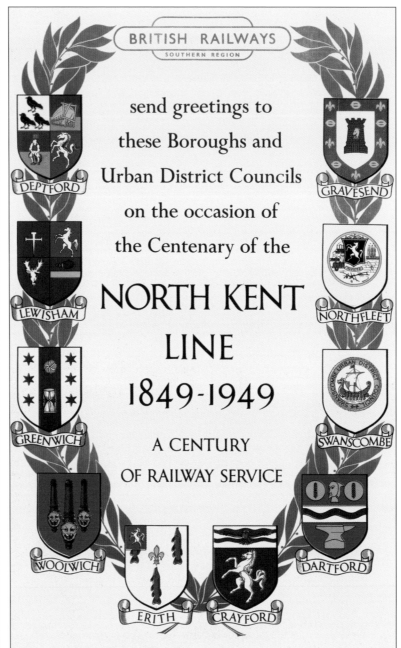

Poster 1 on page 1 showed the railway lines of the south-east, and this is repeated in the poster (far side) together with some historical features of this part of England. With the birth of the railways in northern England, tracks were constructed rapidly there in the 1830s. By comparison, progress in this area was more sedate, and the nearside poster celebrates the centenary of the opening of the North Kent line, and includes the coats of arms of the towns it served. Both of these posters are rarely seen. The heraldic poster here was one of series BR produced in the first five years of its existence, when famous places and significant railway lines were so honoured. The North Kent line was electrified to Dartford by June 1926, using a third rail 750V DC system, and this was extended as far as Gillingham by 1939. There are many tunnels, especially in the Greater London suburbs, so construction was not easy.

As well as a seaside county for the people of London, Kent is a residential area where tens of thousands of commuters live, and there are hundreds of stations both large and small from which electric trains travel to converge daily on London. But it is now time to start our tour of the county, and we begin close to one of England's earliest railways.

138 and 139 Two bold posters for the County of Kent: Reginald Lander from 1962 (left) and an unsigned poster from 1949 (right)

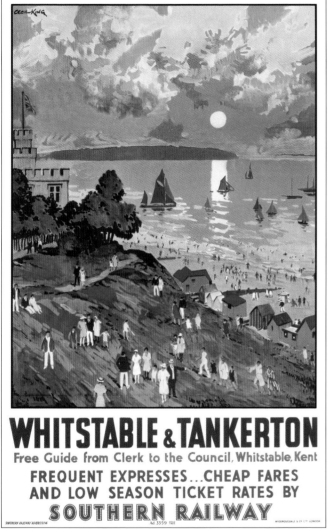
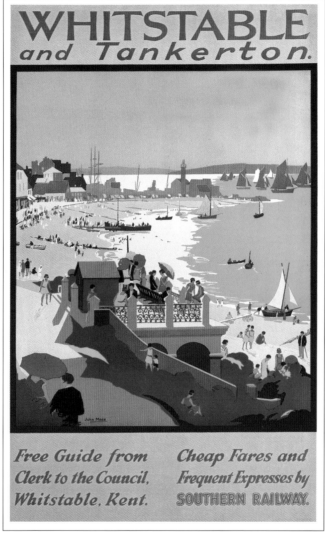
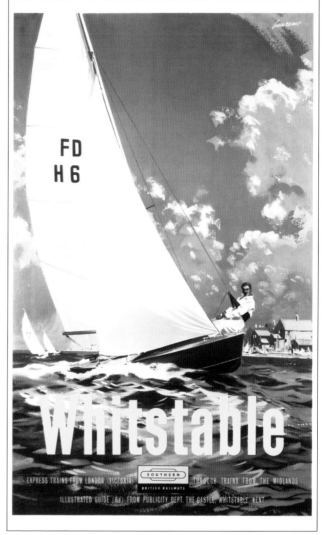

140, 141 and 142 Trio of seaside posters for Whitstable: Cecil King from 1936 (left), John Mace from 1929 (centre) and Laurence Fish from 1959 (right)

Whitstable to Herne Bay; Our first seaside stops

Whitstable (with adjacent Tankerton) was the site of the terminus of what some claim to be the earliest railway in Britain. The five miles from Canterbury to Whitstable opened in 1830 so that people from the city could reach the coast more easily. The first trains were cable-hauled over a good deal of its length using stationary steam engines, plus some steam locomotives on the level stretch. There were several steep gradients, with Canterbury itself some 200ft (70m) above Whitstable. It opened about four months before the Liverpool & Manchester Railway.

143 Claude Buckle's characteristic treatment of Whitstable harbour in 1960

The idea for the line came from William James, who was a real visionary in the early days of the railways. He was a surveyor, lawyer and land agent. It was he who undertook much of the background work on the Liverpool & Manchester. Many rightly regard him as the 'father of the railways', a title often accorded to George Stephenson from the north-east; but records show that James began his promotional work first. Quite why this area was a forerunner is unclear, as the terrain was not the easiest, and certainly hillier than between Liverpool and Manchester. Once he had seen some of Richard Trevithick's early engines though, he was enthralled and began his lobbying around 1808. The line did use the *Invicta,* a locomotive designed by Robert Stephenson, and this ran for a decade before being retired. It has been restored and is today on display at Canterbury. The railway had the initials C&WR, but it soon gained the delightful nickname *Crab and Winkle Railway,* in due homage to the town's thriving shellfish industry! This railway does have the honour of issuing the world's first season ticket for travel, in 1834. The Crab and Winkle line closed completely in 1953, but sections of it are now cycleways and walkways run by a local trust.

Whitstable itself is famous for shellfish, especially oysters, with records indicating that they were caught in Roman times. The town has a long, proud maritime history, celebrated annually with a local oyster festival. It has long been a popular tourist destination, and the first three posters show that the railways regularly advertised its delights throughout the first half of the 20th century. It used to have its own railway station at the harbour, but this was closed in 1931. There was also a station at Whitstable Town (closed 1915) and the present station is on the main line from Ramsgate to Chatham. There are regular services into London Victoria, so travelling to Whitstable today from 'the smoke' is easy.

The King and Mace posters on the previous page show the delights of the beach area. Another local attraction is the climate, with this area being slightly warmer than the rest of the county, because the North Downs behind act as a barrier. Whitstable is listed in Domesday Book as *Witenestaple* (the meeting place of the white post), a name derived from a local landmark of the time. Until 1610 it was known as *Whitstaple,* and the present spelling was adopted shortly after. It had a small iron works (producing copperas – ferrous sulphate – which is a reducing agent used in many processes) which had closed by the time James's railway opened. The beautifully composed poster, alongside, by Claude Buckle shows local fishing boats at rest in the picturesque harbour. In the background Whitstable Castle is a grand house begun in 1789 by Charles Pearson, owner of the copperas company. A subsequent owner, Wynn Ellis, added to the original octagonal tower, creating almost a manor house (known as Tankerton Castle) by the end of the Victorian period. It became better known by local people as Whitstable Castle and today is managed by a Trust, which has opened the gardens as a public park and the buildings as a community centre.

Just to the east of Whitstable lies Herne Bay. In many ways this is more of a seaside town than Whitstable, as it possesses two miles of sea front lined with some fine Victorian buildings, as Frank Sherwin's classic seaside poster (nearside) shows. To the east, are coastal cliffs and, in the distance, the twin towers at Reculver; but more of this historic village shortly. The Sherwin poster also depicts the tall clock tower, at the end of the promenade. When built in 1837, this was the world's first purpose-built free-standing clock tower, and in many old Victorian photographs it features prominently. Herne Bay also possesses a rather long pier.

On the far side, a really colourful, typical 1950s poster by Kenneth Bromfield is included. He was often used by the Southern Region to illustrate seaside towns for the whole of the south-east. When shown together, these posters illustrate the range of styles and colours used in the first years of BR, even for the same place. We also have an artistic poster (Sherwin) and work of a commercial artist (Bromfield). Herne Bay developed slowly, first as a coaching stop between London and Dover, and then as a seaside resort when the pier and seafront were built in the early 1830s. Once the railway arrived, visitor numbers rose.

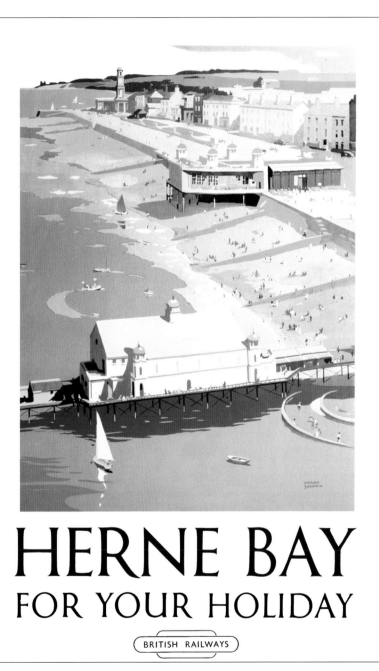

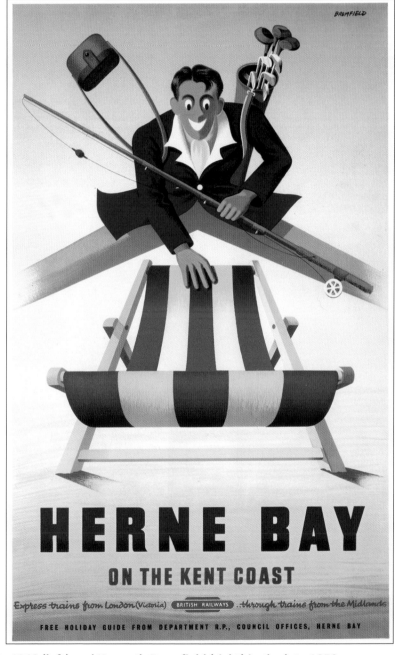

144 and 145 Advertising for Herne Bay by Frank Sherwin in 1948 (left) and Kenneth Bromfield (right) in the late 1950s

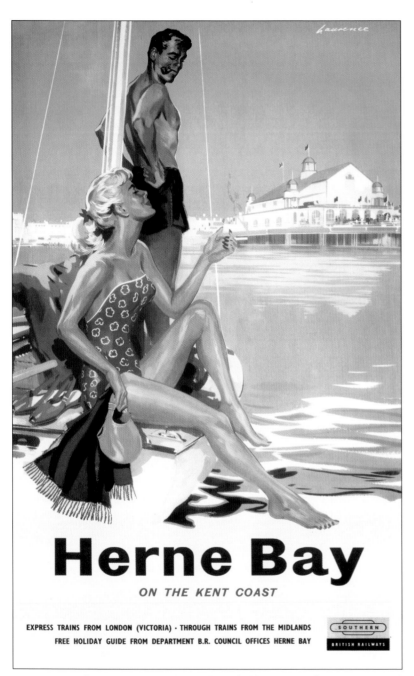

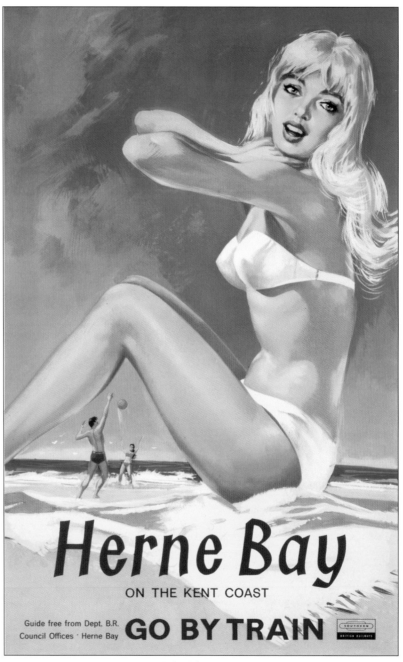

During the 1840s, steamboats used to bring day-trippers from London: Victorian pictures of the town show the seafront thronged with people. The late Victorian years saw the heyday of this resort, though even today visitor numbers are respectable. Around 1960, British Railways commissioned a series of bathing belle posters, and two are shown here. Such artwork today is very collectable, with the Laurence Fish poster (far side) being a first class example of a 1960 seaside image. It is thought the nearside poster could be the work of Mario Tempesti, as he was active painting similar subjects for other resorts around this time.

I mentioned Reculver a little earlier, a small village that once occupied a strategic location at the northern end of the Wantsum Channel. This used to exist between the Isle of Thanet and mainland Kent. The Romans built a fort here, and in Saxon times it was a thriving community. When the church of St Mary was built, the two tall towers, which are the only remains, became known as the 'twin sisters' by sailors. During WWII, the military connections of the past returned when Barnes Wallis used Reculver to test his bouncing bomb before use by 617 Squadron (the *Dambusters*) in the famous strategic raid on the dams of the Ruhr.

146 and 147 Seaside bathing belle posters for Herne Bay from around 1960: Laurence Fish (left) and unsigned artwork (right)

Onto the 'Isle of Thanet'

Travelling further east, we come to the former Isle of Thanet. This used to be a separate tract of land with the River Wantsum to the west, but coastal erosion and subsequent silting caused the river to disappear and Thanet is now contiguous with Kent. In ancient times the channel had been protected by Richborough Castle and Reculver Fort. The first bridge across to the island was built in 1485, and even as late as the mid 1700s there was a ferry from Sandwich.

In this part of Kent are the important towns of Margate, Broadstairs and Ramsgate. All of these featured strongly in railway advertising campaigns. This poster is unusual because it carries the designation Isle of Thanet, even though it shows Broadstairs. Being surrounded by sea on three sides, this area has long been popular for holidays and all-year-round trips because of the relatively mild winters and warm, dry summers. There are many sandy beaches on 'the island' as the poster alongside shows. Both Margate and Ramsgate have strong maritime traditions, and sailing links with the continent.

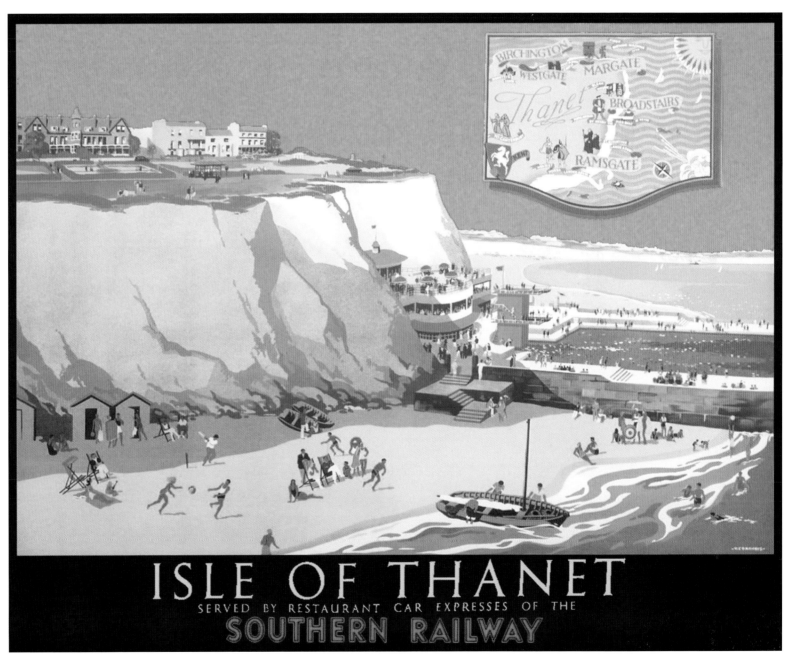

148 Verney Danvers' c1930 quad royal of the Isle of Thanet for the Southern Railway

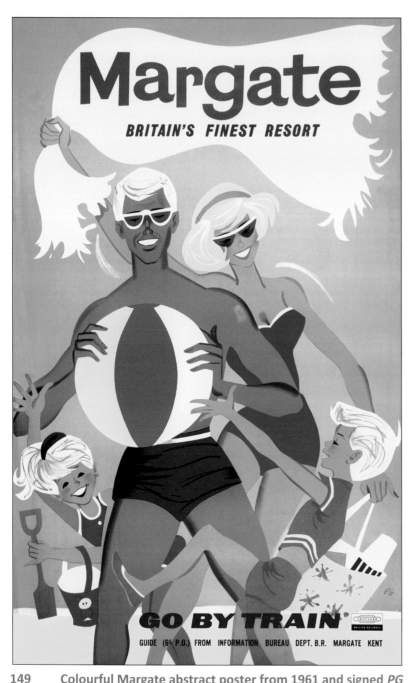

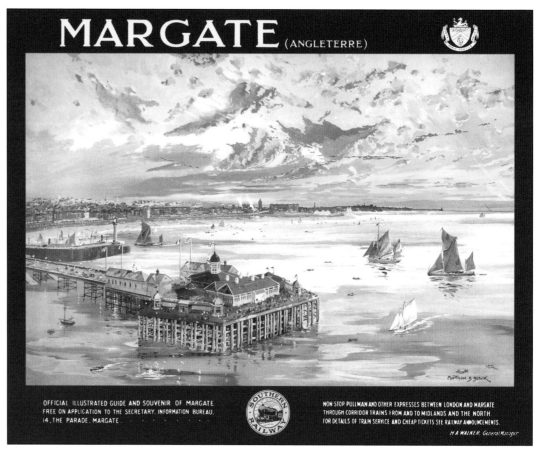

150 Rare poster for Margate and used in France: Artist Montague Birrell Black (1884-1961)

Margate is situated at the east end of the Isle of Thanet, where the coast turns southwards. Records for 1264 show the town listed as *'Meregate'* but within 50 years this had changed to the present name. It has always had a strong sea-going tradition, and has been a seaside resort for 250 years. An 1805 guide to the town describes 'bathing machines'. Railways arrived here in the 1840s and, as a result, tourists flooded in. Stations were built to the east and west sides of the town but rationalisation occurred when the Southern Railway took over in 1923. The building of a new line and station meant that passengers now alighted at a 1926 Grade II listed building, designed by Edwin Maxwell Fry. The Black poster, above, depicts a sandy foreshore, and in the foreground is the Victorian pier, destroyed by a major storm in 1978. Rainfall in east Kent is well below the national average, which contributes to Margate's popularity. Visitor numbers fell steadily during the 20th century; unemployment is higher than in many places in south-east England, but there are plans to rejuvenate the town, including restoration of both an old scenic railway and a wooden rollercoaster.

149 Colourful Margate abstract poster from 1961 and signed *PG*

Margate's near neighbour is the town of Broadstairs, facing due east and midway between Margate and Ramsgate. It was also a popular Victorian seaside resort, but when the railways arrived in 1863, giving a direct service from the town to London, visitor numbers quickly rose. The coast here has a number of small bays, each with safe sandy beaches, as these two posters illustrate. Chalk cliffs enclose each of the bays, giving sheltered bathing, ideal for families.

The name of the town derives from a series of steps that led up to the Shrine of St Mary's on top of the cliffs. The town name used to be *Bradstowe,* but over time, this has mutated to Broadstairs. It is only 80 miles (130 km) from London, facilitating day-trips. The railway companies seem to have had two campaigns to promote the town, one in 1929-30 and the second in 1957-58, both of which are represented by these posters. In these images (and Danvers' poster on page 95), the beaches are strongly featured. Records have the origins of the town in the 11th century, but it was from the 14th century that it developed as a fishing community. In the 18th century it was a haven for smugglers, and numerous caves and tunnels are found in the chalk cliffs where their contraband was stored. The 19th century saw a jetty built; boats started to call and the tourist trade began.

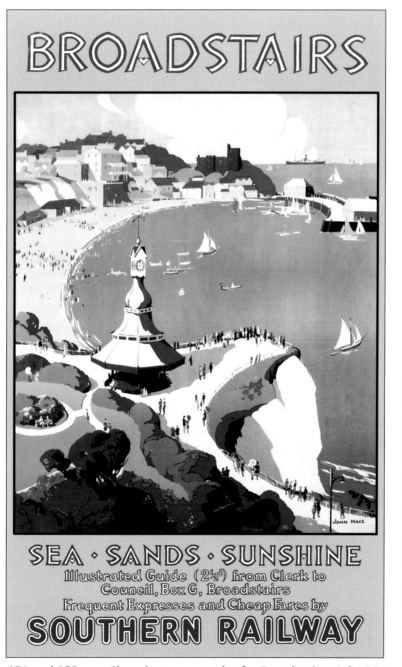

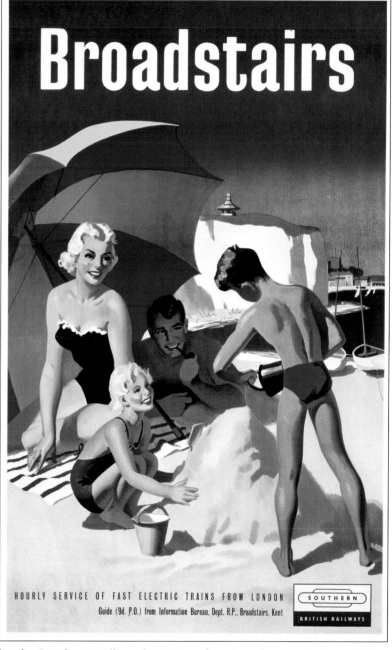

151 and 152 Changing poster styles for Broadstairs: John Mace for the Southern Railway in 1929 and unsigned artwork from 1957

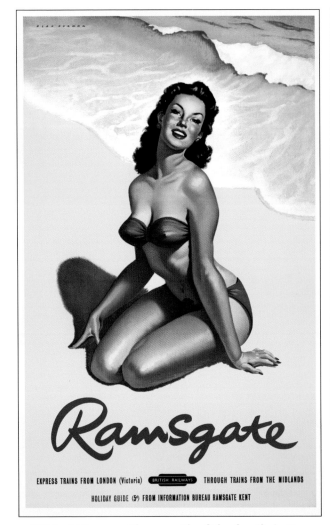
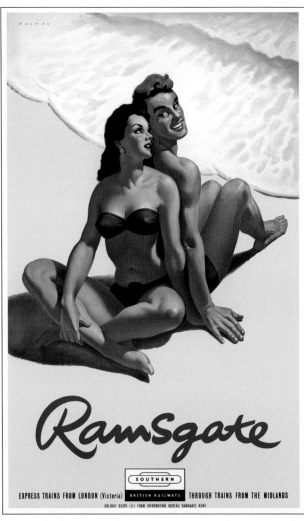
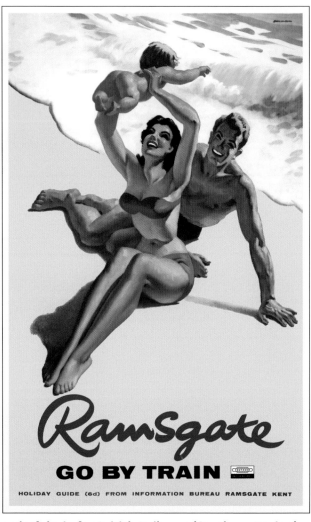

153 to 155 **The growth of the family in Ramsgate! BR (SR) posters from 1957-1960: Alan Durman's wonderful trio for British Railways (Southern Region)**

Travelling a few miles south, we soon arrive in Ramsgate, one of the greatest seaside towns of the 19th century. This has always had a strong maritime tradition, and indeed holds the distinction of being the home of the only Royal Harbour in the United Kingdom. Its history goes back two thousand years, and it has been the site of several important landings, notably the mercenaries Hengist and Horsa who established the first Anglo-Saxon colonies in Britain. The famous harbour - which featured so strongly in both the Napoleonic Wars and the Dunkirk evacuation, and is shown in the poster opposite - was begun in 1749 and completed a century later. For many years it was the base for cross-Channel ferries to Dunkirk and currently provides services to Ostend in Belgium. Hovercraft used to ply across the Channel from here, with France a mere 35 miles (56 km) away. The unusual joint-artist signatures on the poster opposite show the town rising above the busy harbour, which is flanked by sandy beaches. These were the subject of a prolonged advertising campaign that began in 1957 and lasted for five seasons, to lure families to the sands: judging by the three posters above, somebody in the Publicity Department also had vision and a sense of humour!

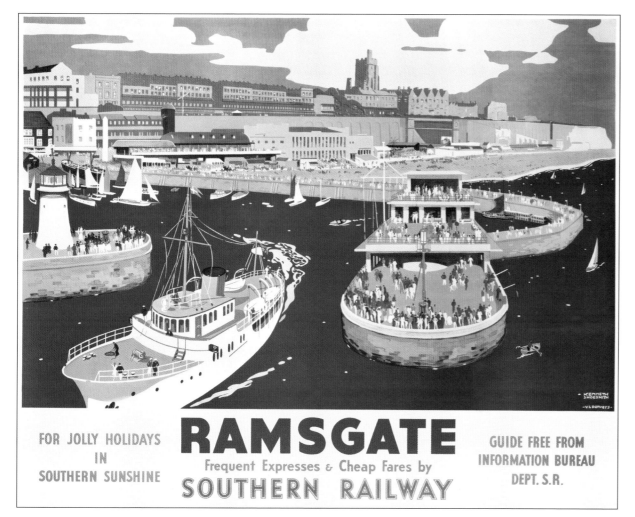

156 Ramsgate maritime poster from 1939 jointly signed by Kenneth Shoesmith and Verney Danvers

The Royal Marina, situated below Royal Parade, today has several hundred moorings, and the poster above shows some of these yachts within the harbour basin. Here, in 1939, people flocked to the breakwaters, and the beaches were crowded even though hostilities were only a few months away. The notorious Goodwin Sands, claimant of so many ships over the years, are just offshore. It may surprise readers to know there are more than 900 listed buildings in the town, with almost 200 of these around the marina. A good deal of the architecture in the central areas is Regency and Victorian, which speaks eloquently of a long history of tourism and wealth in the town. The famous 1904 library was endowed by the great Scottish steel entrepreneur Andrew Carnegie, but was sadly destroyed by fire just before the centenary of its opening.

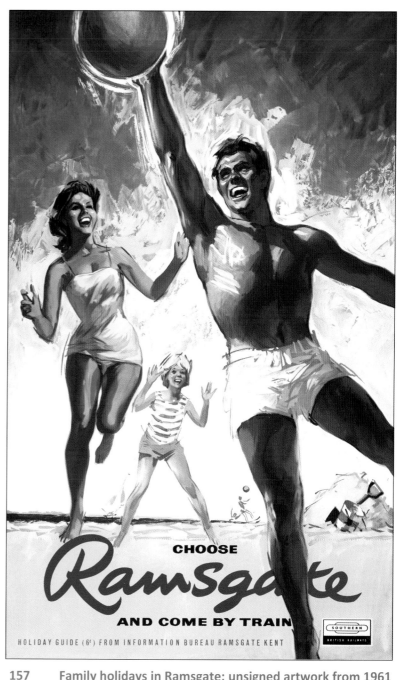

157 Family holidays in Ramsgate: unsigned artwork from 1961

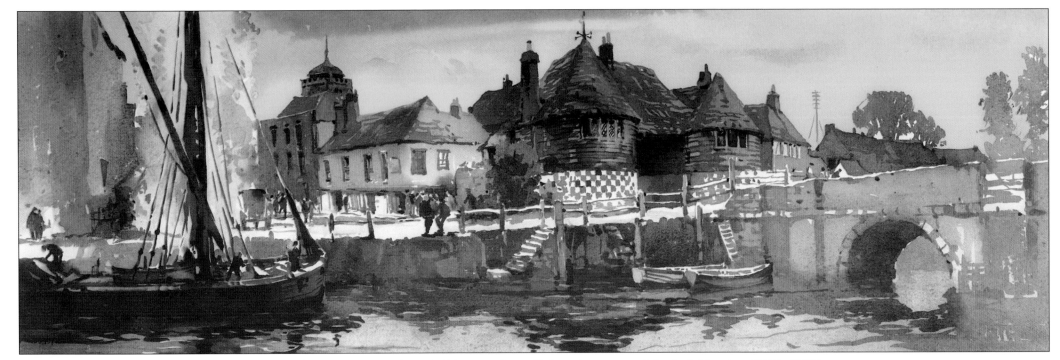

158 The Cinque Port of Sandwich, Kent: beautiful carriage artwork by Jack Merriott (1901-1968)

We travel a short distance south from Ramsgate to the ancient port of Sandwich. Its role as a port ceased when erosion and deposition along the shoreline left the lovely preserved town two miles from the coast. The artwork shown above is one of a series, painted by the great Jack Merriott in 1952 for British Railways, showing all five of the Cinque Ports. Sandwich itself is located on the River Stour, which used to be wide and deep enough for fair-sized vessels to dock and make cargo transfers. It was first mentioned in seventh century records, and Richborough, to the north, where the Romans first landed in AD 43, used to be at the southern end of the Wantsum channel. The town therefore used to have navigable links with the sea. Today all the land between the town and the sea has been turned into two superb golf courses: Royal St. George's -which hosted the 2011 Open Championship. – and Prince's Club. The Merriott artwork, above, shows some wonderful architecture, and many of the buildings are listed. Impressive gates used to guard the town, but only Fisher Gate, dating from 1384, survives, and is a Grade I listed building. Equally impressive are the Guildhall, built 1579, and subsequently modified and enlarged; the Admiral Owen public house, a two-storey timber-framed building; and the Barbican, dating from the late 14th century, which used to guard the toll bridge.

Sandwich became a Cinque Port when the Confederation was set up by Royal Charter in 1155, to maintain ships ready for any eventuality, should the Crown require them. Five towns in Kent and Sussex were chosen: Dover, Hastings, Hythe, New Romney and Sandwich. Edward the Confessor believed control of the English Channel was the key to security; history showed the threats from abroad all seemed to occur along the Kent coast. Dover, New Romney and Sandwich were the founding three members with Hythe and Hastings being added later. In addition, there were 'limbs of the Cinque Ports' - towns who had a strong association with the five named ports - plus two *'Antient Towns'* which helped in defence of the realm: these were Rye and Winchelsea. Faversham, Folkestone and Margate were limbs of Dover; Deal and Ramsgate were limbs of Sandwich; Lydd was a limb of New Romney; and Tenderden was a limb of Rye. From this, the historical strategic significance of Kent can be appreciated In addition to their military role, the five ports were also to foster trade with France, but today the title of Cinque Port is entirely ceremonial. New Romney was considered the Confederation's centre, but as a result of storms and silting it is now stranded 1½ miles from the sea.

A visit to a great cathedral

Travelling due west, following the course of the River Stour, we come to the historic city of Canterbury with its magnificent cathedral. The city has a remarkable history, being first a Brythonic (British) tribal settlement, and then a Roman encampment for 300 years. After they left, the whole settlement declined, before it was chosen as the seat of the first Christian archbishop in 603AD. It has therefore been the Seat of the Primate of All England for more than 1400 years. By the 9th century it was a busy town, and large by the standards of that time. However the Danes soon began their raids, and in 1011 they burned both the cathedral and the town. The rebuilt church suffered again in 1067, then for a third time in 1174, after the Normans had rebuilt it. Undeterred, it was rebuilt yet again, and this structure has survived and is quite magnificent, as shown by both the Shepard and Griffin posters. The Frank Coventry image on page 6 shows how beautiful the interior is. A highly significant event occurred in 1170 when Archbishop Thomas A Becket was murdered in the cathedral by soldiers loyal to the King, who mistakenly believed he wanted Thomas dead. The cathedral became a shrine to the murdered Archbishop, and visitor numbers have never really diminished over the centuries.

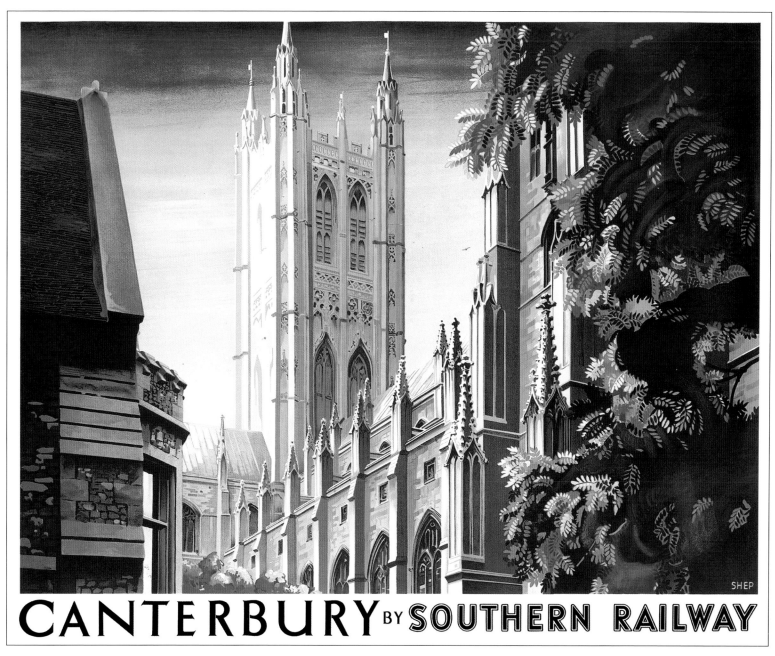

159 Beautifully composed 1938 SR poster for Canterbury Cathedral: artist Charles Shepard (1892-19xx)

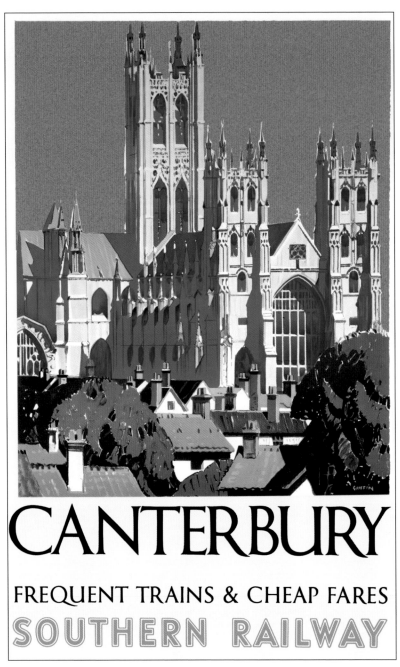

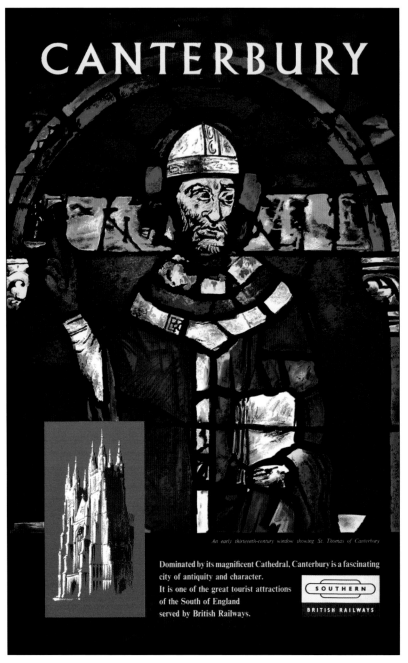

As well as being a large and very imposing building, Canterbury Cathedral has a magnificent set of stained glass windows. Many of them date from the late 12th and 13th centuries, one of which is depicted in Reginald Lander's 1960s poster alongside: this is the window commemorating St Thomas of Canterbury. The oldest window, showing Adam, dates from 1180 and many others illustrate important figures from the past. The windows are the subject of never-ending conservation work. Some of them date from the 19th century and others are more recent, but all are truly superb.

The cathedral suffered heavy damage during the English Civil War, and parts were also damaged in WWII, including the Library and the Precincts. Thankfully the main nave and transepts were untouched owing to heroic efforts during the incendiary attacks. Prior to this, the north-west tower was taken down, owing to structural concerns, and rebuilt in the Perpendicular style to give symmetry to the west front. As Griffin's poster (far side) shows, it is a truly beautiful building when seen from any angle.

160 and 161 The magnificence of Canterbury: posters by Frederick Griffin (left) from 1927 and Reginald Lander (right) from the 1960s

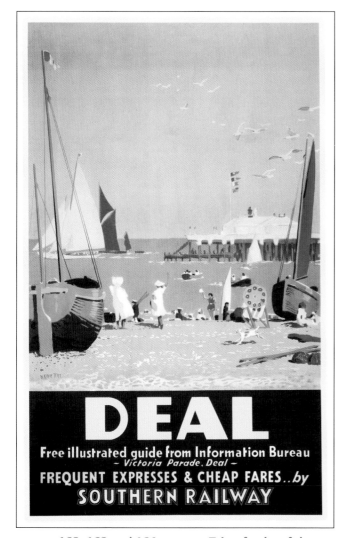 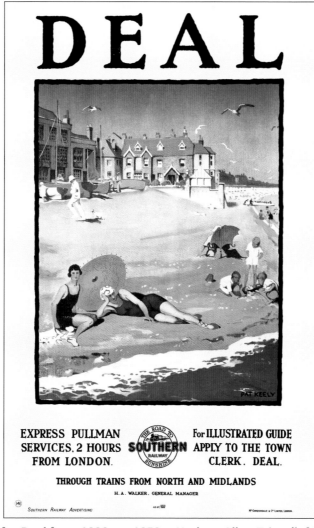 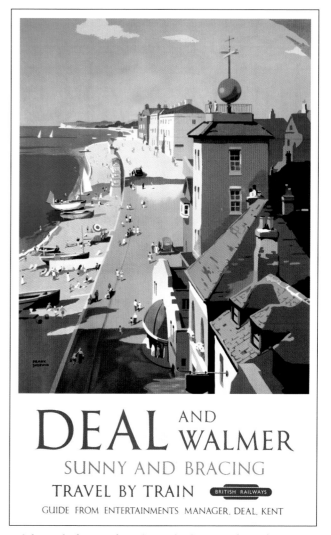

162, 163 and 164 Trio of colourful posters for Deal from 1930s to 1950s: Herbert Alker Tripp (left), Patrick Keely (centre) and Frank Sherwin (right)

Canterbury has many other historical buildings, such as the city walls, the ruins of St Augustine's Abbey, its Norman castle, St George's Tower, the Huguenot Houses and many more. Great damage was suffered in multiple air-raids, the most devastating of which occurred in June 1942. Today it has been well restored and the pedestrian centre is a real pleasure to walk around. But now it is back to the coast and nearby Deal, where my mother was stationed during WWII RAF duty. For a time this was one of the busiest ports in England, but it has also attracted tourists, as this trio of posters shows. Deal Castle, commissioned by Henry VIII, is superb and is shaped like a Tudor rose, with multiple curved walls and a central low keep. Numerous gun emplacements and a wide moat complete the defences. But these posters highlight the sunny, bracing and rather attractive features of the seafront. Deal is also home to the Royal Marines School of Music, and at various locations there are buildings that reveal the long maritime and military history.

The White Cliffs beckon

From Deal, it is only 8 miles (13 km) to Dover, arguably Kent's best-known town, and repeatedly a focus of railway advertising. These next few pages show why Dover was important both to the railways and the nation.

It has always been a strategic town, facing France across the narrowest part of the English Channel. This naturally allowed it to develop as a major port, but it was always a prime target for any invasion forces over the centuries. As a result of this, Dover Castle, built in medieval times and shown in these two posters, guards both the town and the cliffs. Indeed Dover Castle has been described as 'The Key to Britain' because of the importance of the right of ownership. Dover's community was established long before the Romans arrived. It was situated at the mouth of the River Dour. As at Sandwich, its river suffered from silting, so the harbour was enlarged and breakwaters built to stem these problems. Over the years the harbour has been progressively extended, with new sturdy defences being constructed, so that the present docks now largely sit on reclaimed land. Today, Dover is one of Europe's busiest ports, with 14 million passengers, 2.8 million cars and 2.1 million lorries passing through.

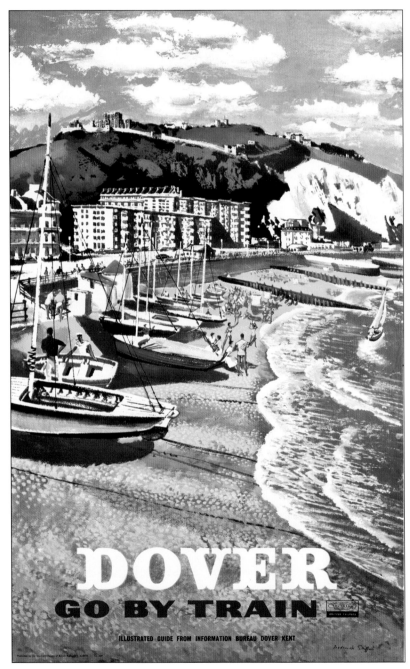

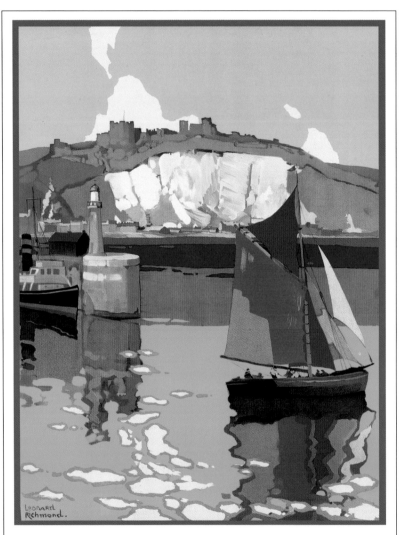

165 and 166 Uncommon posters from Dover: Frederick Griffin (left) from 1959 and Leonard Richmond (right) from 1930s

Many of the ferries conveyed railway carriages by day and by night. The famous *Golden Arrow* and the *Paris Night Ferry* coaches were shunted onto large steamers that continually plied the route. Several colourful timetable posters were issued showing services between London Victoria and Paris Nord, and it was not until HS1, the Channel Tunnel and the TGV lines were constructed in the late 20th century that travel times shown here were bettered. Shoesmith illustrates the railway and the car ferry leaving simultaneously during the summer of 1934, again with Dover Castle guarding both the cliffs and the harbour.

The *SS Canterbury* was completed by Denny of Dumbarton in 1929, being designed and built especially for use in connection with the all-first-class *Golden Arrow* which operated from Victoria to Paris Nord (via Dover-Calais ferry) from May 1929 onwards. During the war it acted as a troop carrier and, after hostilities ceased, it was moved to the rival Folkestone-Boulogne route when the new *TS Invicta* became available in 1946: more of these ships shortly. The Port of Dover was formed by a Royal Charter conferred by James I in 1606. There used to be both a purpose-built railway station (Dover Marine) used by the *Golden Arrow* and a hoverport, but both areas are now defunct and have been redeveloped.

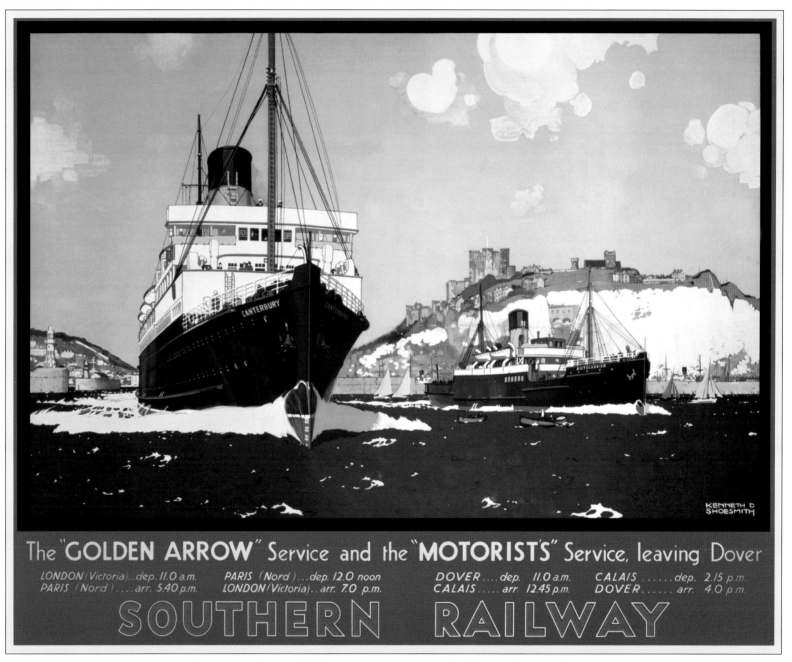

167 Kenneth Denton Shoesmith's famous Dover poster for the Southern Railway, issued in 1934

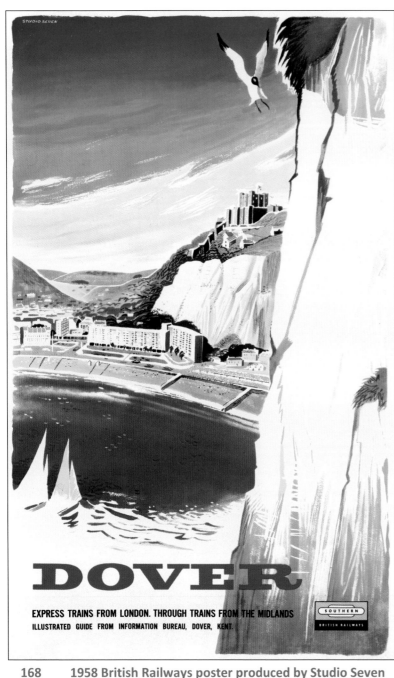

But before we consider the large number of railway shipping posters produced, it is worth spending time looking at Dover itself. The poster alongside exhibits considerable artistic licence, and positions the viewer as 'one of the birds'. We are high up on the east cliff at the same height as the castle and looking down over the beaches; the port is off to the left. Below is Jack Merriott's brooding study depicting the actual cliffs and beach area, showing it would have been difficult to see the artist's view alongside. Dover was a key link in the Roman logistics network; named *Portus Dubris* it was where Watling Street began, which continued to Canterbury, London, and on up to Wroxeter (*Viroconium*), the fourth largest garrison and administrative centre in Roman Britain, near Shrewsbury.

The railways came to the town from two directions, with lines built by rival companies. The SER arrived first (in 1844) from the Folkestone direction followed by the London, Chatham & Dover Railway (LC&DR) in 1861, who built the direct line to Canterbury. The town also possessed a tram system from 1897 to 1936. This was the second tram system to be built in the United Kingdom, with three miles (5km) of 3ft 6in-gauge track.

Dover Castle is on the site of an Iron Age fort, and there is a preserved Roman lighthouse within the castle. In its heart, and constructed from 1160 by command of Henry II, is the Great Tower (the central keep) whose dimensions are difficult to match. It is around 100ft square (sides 30m) and stands 83ft (25m) high; the walls at the base are nearly 21ft (6.5m) thick. It took five years of hard slog to build. The rest of the castle is no less impressive, and it has stood as a symbol of defiance for nine centuries. Henry VII, Elizabeth I and Henrietta Maria, wife of Charles II, all visited and stayed here, and every conflict up to 1945 in which Britain was involved has seen it strengthened further, the last time being just before WWII. Dover is mentioned in Domesday Book, and it was a key bastion against France during the Napoleonic Wars. During the Battle of Britain it served as a main observation station.

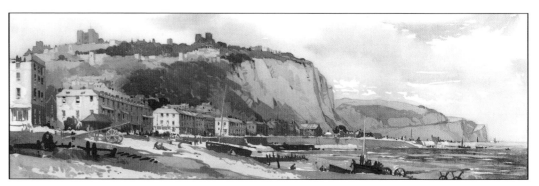

| 168 | 1958 British Railways poster produced by Studio Seven |
| 169 | The Cinque Port of Dover: carriage artwork by Jack Merriott (1901-1968) |

The next group of posters shows the port of Dover and its close link with railway companies. The Southern Railway may not have had the streamlined expresses of the LMS and LNER or the famous *Kings* and *Castles* of the GWR, but it probably had more of an integrated vision of transport, and, under the guidance of the legendary Herbert Walker, developed a fleet of ships for short sea crossings that was well ahead of its rivals. It also had a more relaxed attitude to poster advertising and collaborated with the other three companies of the 'Big Four' with consummate ease. Their vessels were also innovative and sleek, with comfort and performance to match.

They had the vision to include shipping in their portfolio and developed close ties with Scottish shipyards to produce their vessels to exact specifications. The poster alongside shows the *TS Invicta,* ordered before WWII and then requisitioned in 1940 to become *HMS Invicta*, until being released back to the Southern Railway in late 1945. This is also one of the very few Norman Wilkinson posters for the SR. At 4,180 tonnes gross and an overall length of 336ft (105m) she was tailor-made for the Dover-Calais route and worked until 1972 before being scrapped in Belgium.

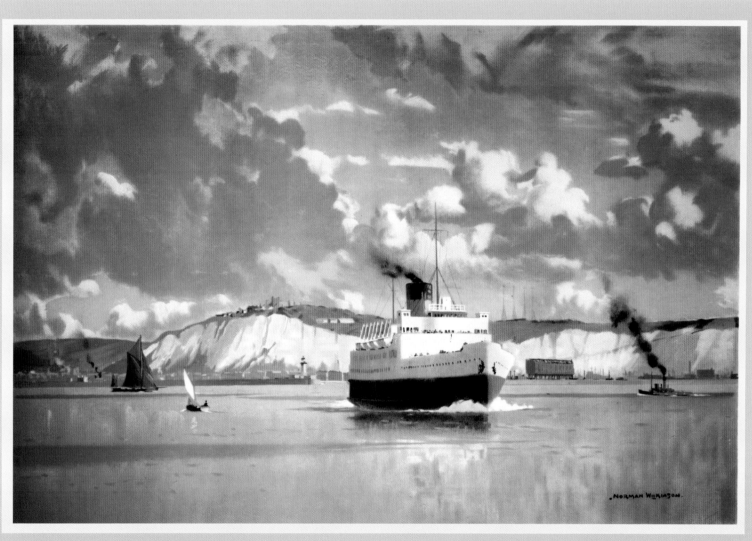

T.S. "INVICTA" LEAVING DOVER IN THE "GOLDEN ARROW" SHORT SEA ROUTE

SOUTHERN RAILWAY

170 A "Golden Arrow" ferry sails from Dover during 1946: artist Norman Wilkinson CBE (1878-1971)

Here we have two interesting posters showing a car ferry in BR times and a train ferry in SR days. The car looks to be an Austin Cambridge A55, while the Southern Railway poster shows loading of Wagons-lits cars for the journey to Paris. Leslie Carr was commissioned to paint several of the shipping posters for the SR, both for Dover and also other ports along the south coast. The bustle of the western docks, where the train services were located, is shown in this 1937 picture. The vessel in the centre could be the *SS Canterbury*, a stalwart of that time. Although the South Eastern Railway (SER) arrived here first, it was the LC&DR that developed the railway facilities and the strong ties with the port. The SER eventually left to concentrate on services from Folkestone. The two companies later merged in 1899, so both rail links were rationalised to optimise traffic loading according to the destinations. The railway traffic at Dover was so successful that the whole ship was filled by a continental express, with a few cars on deck.

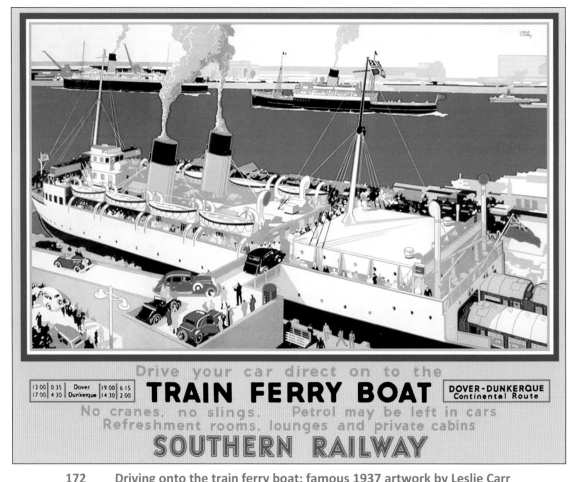

171 Laurence Fish's poster from 1960 as we head across the Channel

172 Driving onto the train ferry boat: famous 1937 artwork by Leslie Carr

This 1936 poster shows one of the three ferries commissioned for cross-Channel operation. The artist chose to show the *TSS Twickenham Ferry*, the other two sister ships being the *Hampton Ferry* and the *Shepperton Ferry.* Swan Hunter built them for the Dover-Dunkerque route, but initially they operated out of Southampton, until the new facilities at Dover were completed; this is why the poster advertises the new services in 1936, by which time the ships were nearly two years old. This poster is very well composed with exquisite colouring, the only curiosity being the 'Artex' appearance of the sea, which is supposed to represent the swirl of the water as the vessel turns. At nearly 3,000 tonnes, these three sister ferries could accommodate 12 sleeping cars, or 40 freight wagons, plus a number of cars down each side. During WWII they were given different duties, serving as minesweepers. From 1945 until 1974 they regularly plied the Channel.

The final poster on page 110 has us on the bridge of one of these ferries, an unusual subject for a railway poster. As also seen in the wonderful 'Racing off Ryde' on page 200, the Southern Region - and the Southern Railway before it - was prepared to publish images not obviously associated with train travel; however their vision for integrated transport could be inferred from their choice of poster subjects.

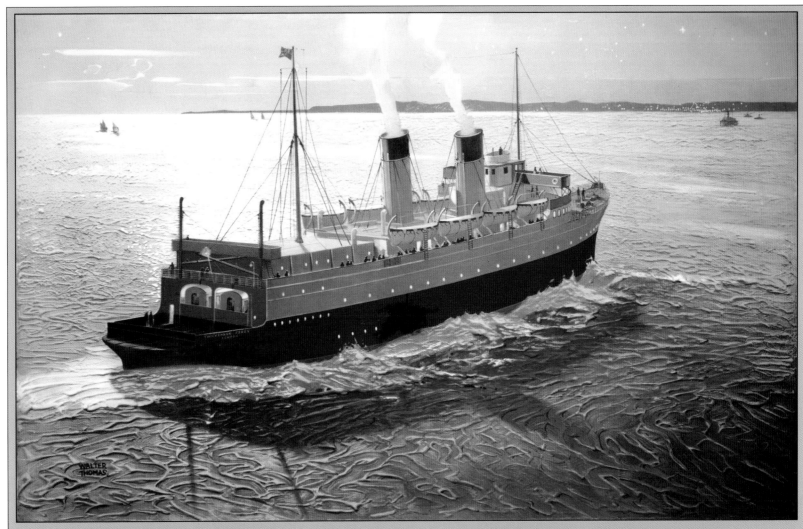

173 Departure from Dover: superb Southern Railway shipping poster issued in 1936: artist Walter Thomas

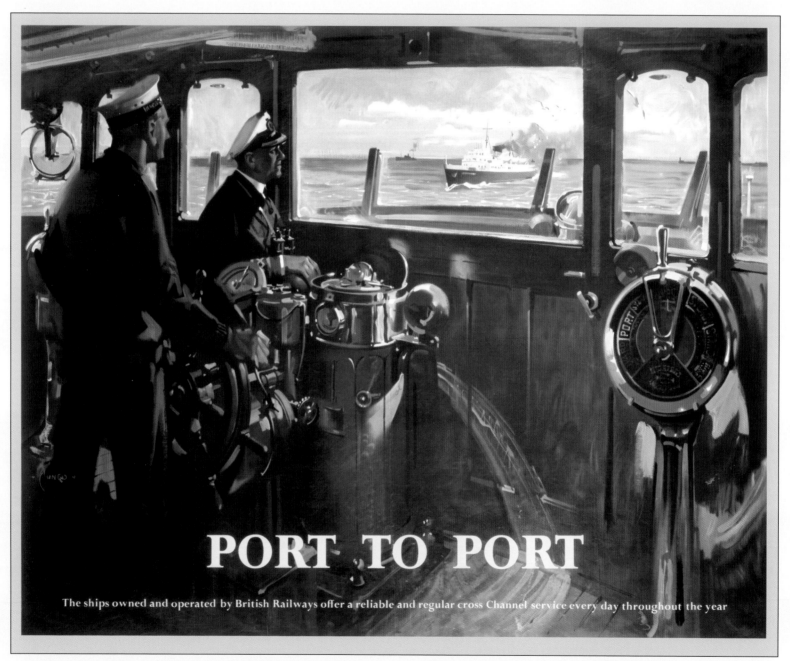

174 A view from the bridge: Terence Cuneo's atmospheric poster from 1960s for British Railways

More coastal travels

From Dover we travel south-west a few miles to its great rival port, Folkestone. Although possessing extensive maritime facilities, the railway chose to portray the social and holiday side of the town and, in doing so, produced some great posters. Two of the Southern Railway's most vibrant images are shown here, and both still appear fresh today. The poster (far side) of Leas Cliff Hall is a particular favourite because of the style and colours used by Verney Danvers. The complex is a major entertainment centre for Kent and has a proud history. It was completed in 1927, following a decision by the town council to build a facility to support the growing tourist trade. The architect was Norwegian, J S Dahl; what a wonderful vision he had to build this into the cliff area of the town. The nearside poster shows the seafront looking east, with the bandstand in the foreground and Leas Cliff Hall in the centre. The poster also shows Victoria Pier, which was a popular destination at that time. It was built between 1887 and 1888, but it was not until the Edwardian years that its popularity was established. This continued through WWI and until WWII, though with a steady decline. The centre section was removed in 1940 and the pier never recovered. It was blown up in 1949.

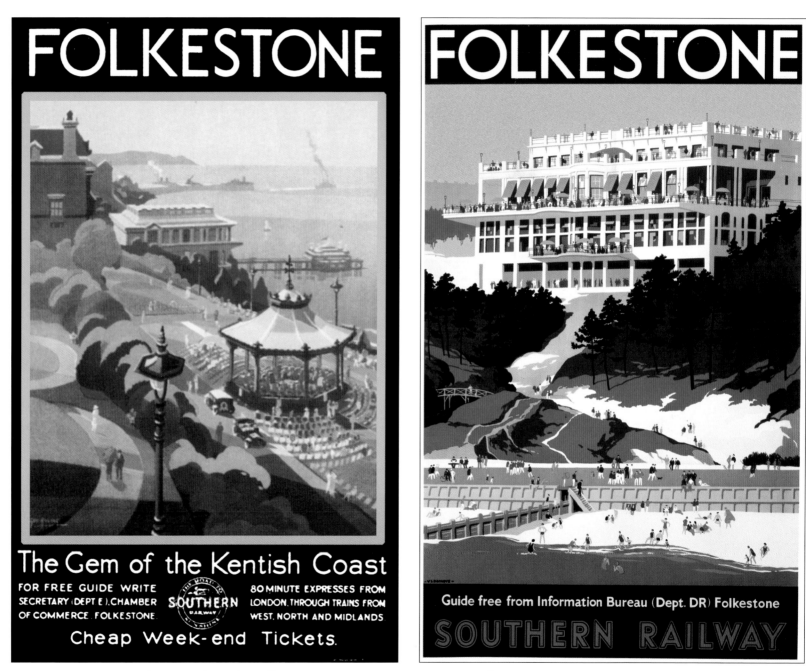

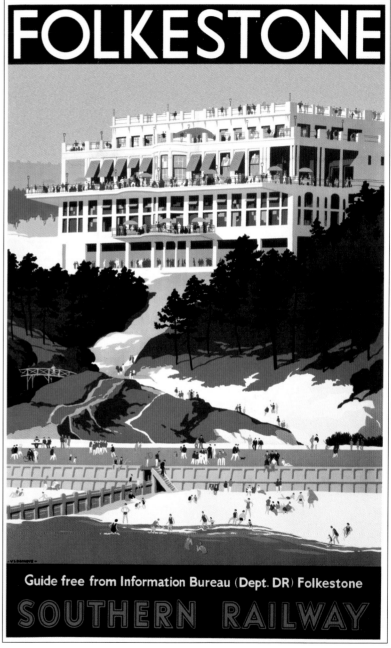

175 & 176 Glorious colours for Folkestone: SR posters by George Ayling (left: 1928) and Verney Danvers (right: 1947)

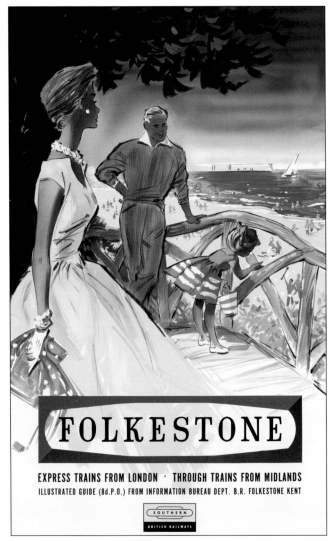
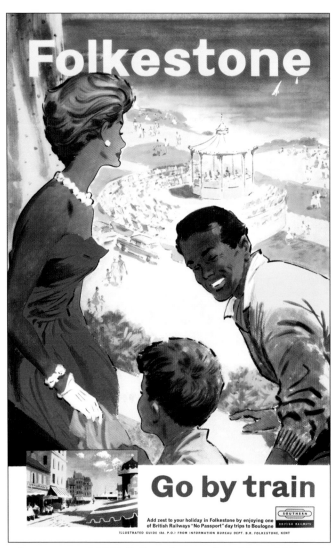
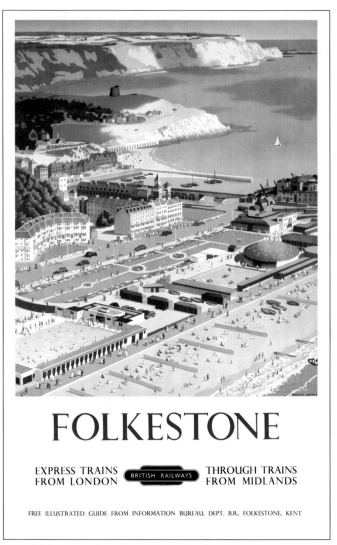

177, 178 and 179 Two unsigned BR posters from around 1960 (left and centre) and Ronald Lampitt from 1956 (right) for the town of Folkestone, Kent

In the three posters above, issued during the British Railways years, the pier is not present, though it used to be located near the bottom left-hand corner of Ronald Lampitt's aerial view (right). In the distance in George Ayling's poster (number 175) the docks area can be seen. Thomas Telford had constructed the harbour in 1809, but the structure was prone to silting. In 1843 the SER bought it for development. They dredged the harbour, built a terminus and rail connection, and the service of cross-Channel vessels to Boulogne became established as one of the major routes to France. The area is now the subject of several development proposals. But the seaside elements of Folkestone are particularly important, and these posters show attempts by BR to boost tourism from the mid 1950s to the mid 1960s. Eckett was the Head of Publicity at this time, and his radical approach resulted in bold, colourful posters appearing for most of the southern resorts. Again families are targeted, and the posters left and centre show families in the Leas area enjoying the delights of the seafront.

From Folkestone, we soon arrive at one of the world's most famous small-scale public railways, the Romney Hythe & Dymchurch Railway (RH&DR), with 13½ miles of 15 inch-gauge track. Linking Hythe and Dungeness, it opened in 1927 as a single-track line. It was doubled the following year and has remained very popular over the years. The superb fleet of locomotives includes eight Pacifics (4-6-2) and two Mountain engines (4-8-2). Many were built by Davey, Paxman & Company of Colchester, but number 11 (*Black Prince*), weighing over 9½ tonnes, came from Krupp of Essen in 1937. The railway was the brainchild of racing drivers Count Louis Zborowski and Captain J E Howey; both were millionaires who were fascinated by miniature railways.

They initially wanted to purchase the Ravenglass & Eskdale Railway in Cumberland, but when they failed to do so, they ordered two locomotives anyway, designed by Henry Greenly. The Count was killed before his vision could be realised, but Howey and Greenly pressed on, building their own railway on the edge of Romney Marsh. The inaugural train ran the year these two posters appeared. Notice the unusual colour palette used by the artist N. Cramer Roberts, and his artistic licence in giving Dungeness a rocky shoreline!

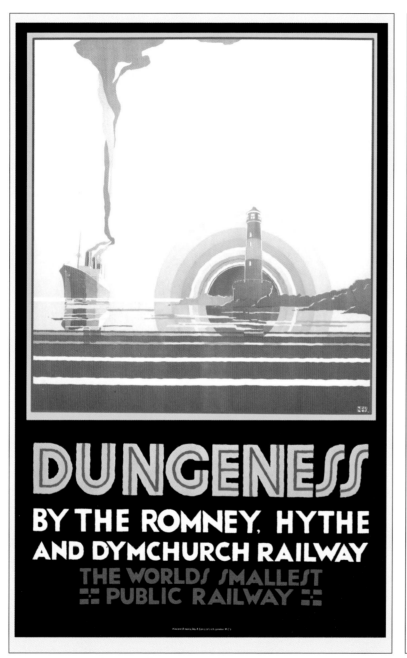
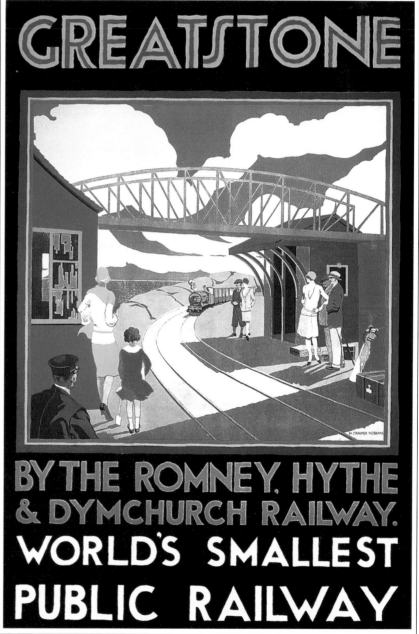

180 and 181: A famous small-scale railway, the Romney, Hythe & Dymchurch: both posters by N. Cramer Roberts from 1927

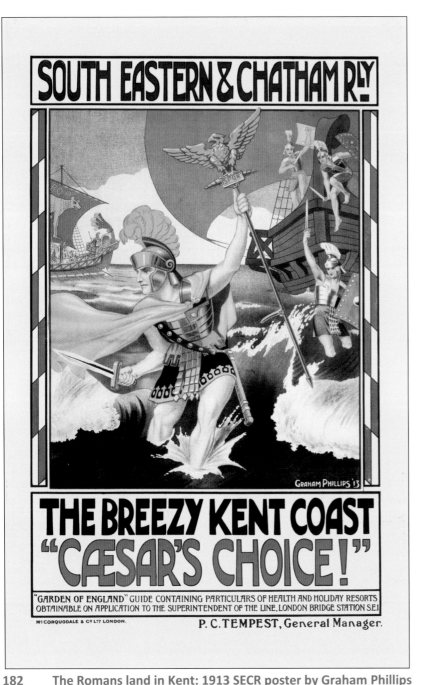

The route of the RH&DR crosses an open and exposed wilderness of shingle, not the obvious choice for a railway; but the flatlands on one side and the sea on the other make for a fascinating train ride. Heading south from Hythe, we pass through Dymchurch and soon reach New Romney. Dymchurch developed as Romney Marsh built up. This was an ideal place for smuggling, and during the 17th and 18th centuries, copious amounts of contraband came ashore. Martello towers and a large Redoubt were built here during the Napoleonic Wars: it is now largely a holiday resort. New Romney, however, was once an important port, and one of the five Cinque Ports. The beautiful artwork below gives a real flavour of the centre. Once at the mouth of the Rother, the importance of the town diminished from the late 13th century. The course of the Rother changed, and it now flows into the sea at Rye, East Sussex. The artwork below shows an impressive Norman church, which used to be on the harbour-side, and as Merriott illustrates, there are many historic and character-laden buildings in the centre of this small town.

Nearby Romney Marsh is an important wetland of almost 100 sq. miles (260 km^2) whose character and shape have changed over the centuries. Storms caused sea water to flood the land, and, when defences were built, it was drained by a series of waterways known locally as the 'The Sewers'. Europe's largest expanse of shingle, which stretches out to sea at Dungeness, supports a unique range of plants which tolerate the almost arid conditions and salt-laden winds, whilst migratory birds make landfall here. In 1965 the first of two nuclear power stations was opened here. The site's isolation, in case of mishaps, was important, but it also drew cooling water from the sea, which is remarkably deep close to the shore. Inland, the famous Romney Marsh sheep once roamed the area in their thousands, especially during the 19th century. As the land was steadily reclaimed and flocks increased, this famous breed was exported to Australia from 1872. The marsh is also home to unique flora and fauna, and several research centres have been established. In 2009, the RH&DR built Warren Halt for easy access to Romney Marsh Visitor Centre. A station existed here for a short time in 1927. Today trains call so pre-booked parties can visit the Centre.

182 The Romans land in Kent: 1913 SECR poster by Graham Phillips

183 The famous Cinque Port of New Romney by Jack Merriott (1901-1968)

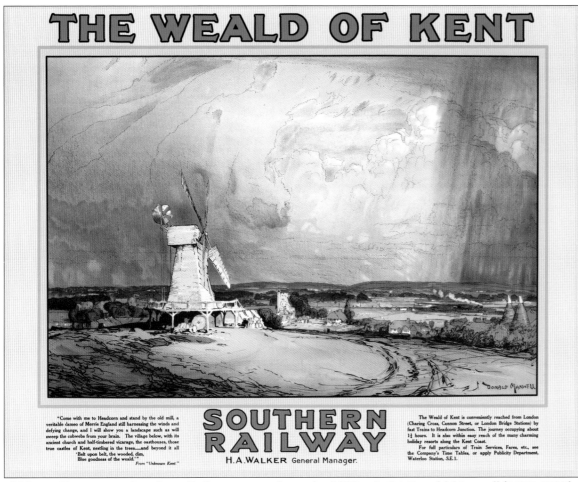

184 Uncommon Southern Railway poster from the 1930s: Artist Donald Maxwell (1877-1936)

Between London and the south coast lies an Area of Outstanding Natural Beauty called The Weald. It stretches from Kent through Surrey and Sussex to the Hampshire borders. It was originally a vast forest, and the name in Old English means 'woodland'. Ashdown Forest and numerous small woods and copses remain, but most of the trees were cleared to leave a fertile area suitable for crops and fruit – hence the title *Garden of England*. Donald Maxwell's expansive landscape from the 1930s shows pretty communities and oast houses below the surrounding hills, on which windmills were built to harness the power of nature. The village shown is Headcorn, between Maidstone and Cranbrook. To the east is Ashford, and to the west Royal Tunbridge Wells. The colourful painting by Claude Buckle shows a group of traditional oast houses, used to dry hops, an essential ingredient in the brewing process. Kent is famous for its extensive 'hop gardens'.

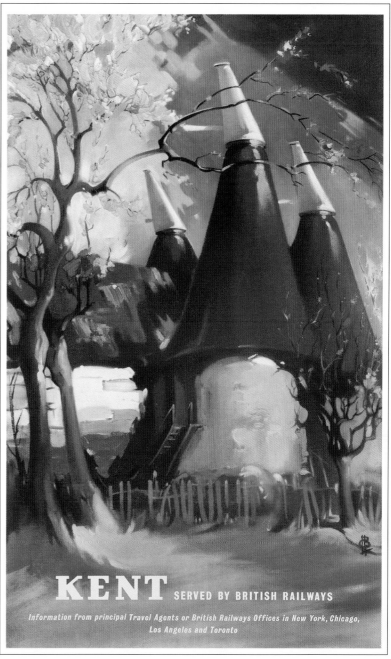

185 Oast houses, a symbol of Kent: Claude Buckle from 1960

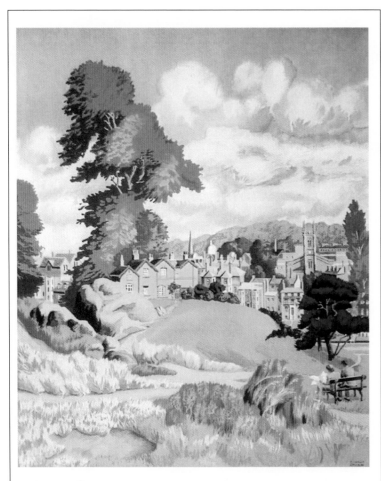

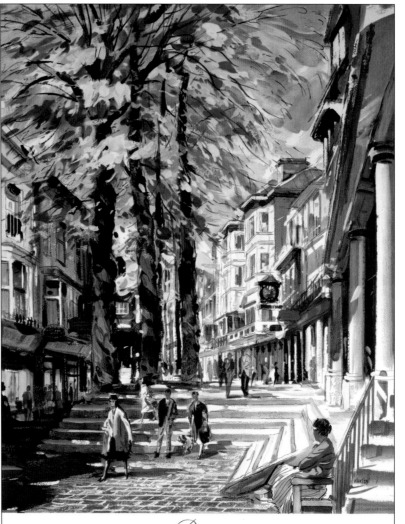

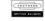

186 and 187 Historic Tunbridge Wells: Clodagh Sparrow (left) from 1947 and Johnson from the 1960s (right)

Royal Tunbridge Wells

The final town on our artistic tour of Kent is the spa of Royal Tunbridge Wells, close to the East Sussex border. The town was used as a target by the railways to promote days out, but being only 35 miles (55km) by rail from London, it acts as a wonderful 'dormitory town'. Located in the High Weald, it became a spa in Georgian times, when Beau Nash popularized the town. Its water rich in manganese and iron was believed to have health-giving properties: 'taking the waters' was said to cure colic and stomach worms. Princess, later Queen, Victoria was fond of both Tunbridge and its healing-waters in her early years.

The mineral springs were discovered in the first decade of the 17th century. The word spread quickly, so by the 1640s there were promenades linking the wells. The Civil War, and then a disastrous fire, caused much damage, but rebuilding followed in the 1680s. During this time the buildings shown on the nearside poster were constructed. The other poster, by Clodagh Sparrow, shows the town nestling below the hills, but it is the town centre that is so delightful, and Johnson's 1960s poster shows the Pantiles, the main street with its fine late 17th century architecture. The street was paved with clay tiles, hence its name.

Towards the end of the 18th century the tiles were taken up and replaced with stone flags. The road name changed to The Parade, but a century later its former name was restored. The area is south-west of the railway station and away from the Mount Pleasant Road area where the Town Hall and the Great Hall are found. The Sherwin poster, near side, is looking in the opposite direction to that depicted by Johnson. The claim on both of these posters is *'Britain's Sunniest Inland Resort'* so the climate promises a pleasant day out wandering the tree-lined streets. The Alan Durman poster from 1957 is a very colourful version aimed at day-trippers. In 1846 the SE&CR opened the present station; the LB&SCR opened theirs in 1866. Both were called 'Tunbridge Wells'. Under the SR the older station became Tunbridge Wells Central whilst the newer one (closed in 1985) became Tunbridge Wells West. Sadly the 'Royal' status conferred on the town in 1909 has not been acknowledged in the station names.

The final two posters show contrasting faces of Kent. Canterbury's history and pageantry (1573) contrast with the greatest engineering project of the 20th century, the Channel Tunnel, connecting England and France; its English portal is near Folkestone. The 31½- mile (50½ km) tunnel, 23 miles (38 km) of which is beneath the sea, was under construction for six years and completed in 1994.

Royal
TUNBRIDGE WELLS
Britain's Sunniest Inland Resort

ONE HOUR BY TRAIN FROM LONDON AND THE SOUTH COAST BRITISH RAILWAYS
LITERATURE FROM INFORMATION BUREAU TUNBRIDGE WELLS KENT

188 and 189 Contrasting posters from 1957 for Tunbridge Wells: Frank Sherwin (left) and Alan Durman (right)

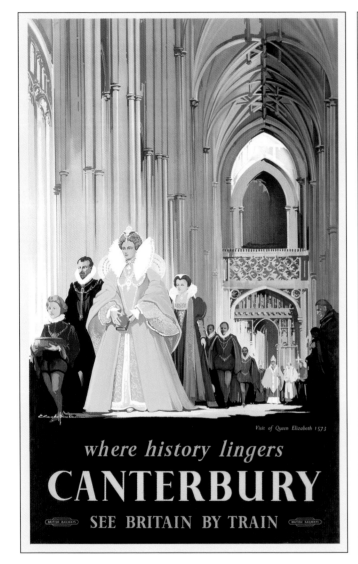 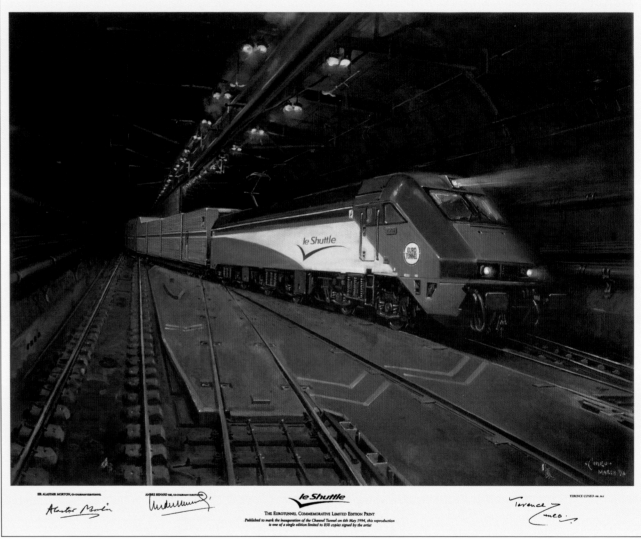

190 & 191 Two railway poster faces of Kent: Claude Buckle (1905-1973) from the 1950s (left) and Terence Cuneo (1907-1996) from 1994 (right)

The sheer size of the construction can be best appreciated by a visit to the NRM at York, where there is an exhibit of a full-sized tunnel section, the overhead power cables and a Eurostar express passenger train. Cuneo chose to paint *Le Shuttle*, electric locomotives used at both ends of the train for freight duties. His picture is located close to one of the tunnel portals, as multiple tracks and a larger tunnel diameter allow the freight train to be switched to the appropriate siding at the terminal. More than 17 million passengers and over 15 million tonnes of freight are carried through the tunnel each year, and it is now a vital link in cross-Channel trade. After some teething problems, including near-bankruptcy, it is now a financial success.

Chapter 5　　Sunny Sussex by the Sea

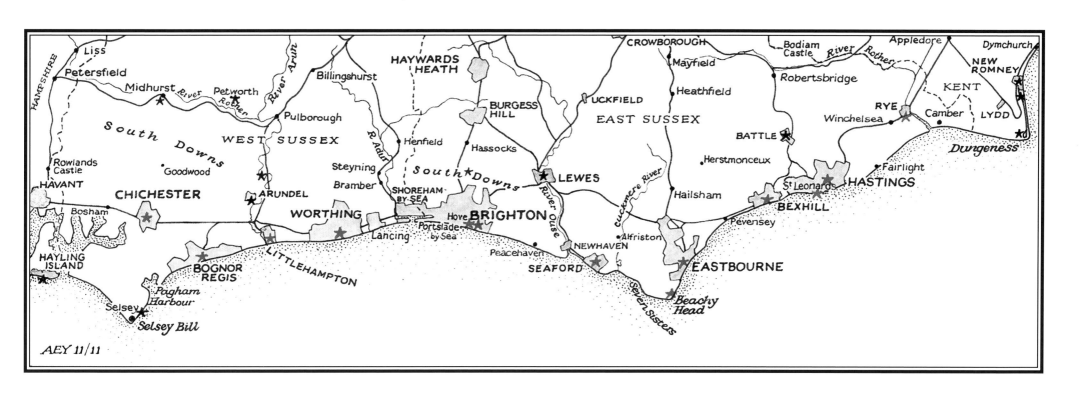

Sunny Sussex by the Sea

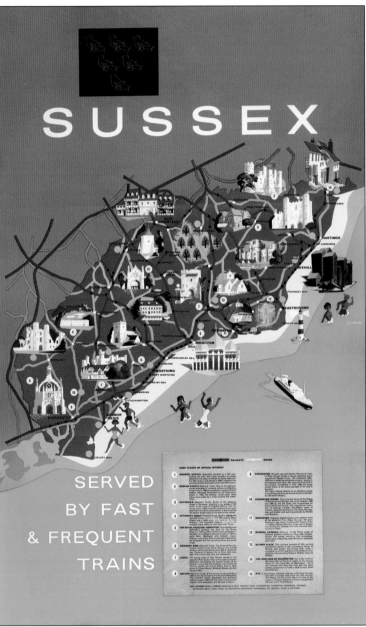

192 The BR map of Sussex in 1962: artist Reginald Lander

Overview of a traditional English kingdom

When one thinks of Sussex, the sea and sunshine immediately spring to mind, and these elements formed the thrust of this county's railway advertising throughout the 20th century. If you travel due south from London, the Sussex coast is the nearest, so for many decades people have been rushing south to obtain doses of vitamin D and ultraviolet in equal measures. I am sure readers also will recall the 1953 BBC interlude film *London to Brighton in 4 minutes,* when 51 miles are covered at an average speed of 765 miles per hour; but do you remember a repeat journey in 1983, this time in colour, where some track and suburb changes are clearly evident? People have been hurrying down to Brighton since Regency times, and the visits of the Prince Regent (George IV) since the 1780s set the trend for the 'getaway weekend'. But Sussex is an ancient kingdom, the Kingdom of the South Saxons, from which the name is derived.

Sussex has seen its share of significant English history, but the year 1066 in particular is etched in everybody's mind. It is also a county of great beauty, with the Weald to the north and the South Downs acting as highlights. The South Downs are a chalk escarpment which runs west-to-east, before tumbling into the sea near Eastbourne. The highest point is Ditchling Beacon at 814 ft (248m). In between is the Vale of Sussex, an undulating landscape composed of softer clays, with many pretty villages and some fine country houses. Many of the rivers in Sussex (Arun, Adur, Cuckmere, Ouse and Rother) cross this valley, before cutting through the Downs on their way to the sea. The Weald contains much of England's ancient woodland, notably St. Leonard's Forest near Crawley and Ashdown Forest between Crowborough and Forest Row.

The South Downs enter Sussex from Hampshire about 10 miles from the coast. Between this upland and the seashore, there is a fertile plain that once grew wonderful produce. Today this area has been largely urbanized, as the sunny delights of the area and rapid train links to London allow easy commuting. In the far west (south of Chichester) and the far east of the county (beyond Rye and into Kent) there are marshy areas, so there are landscapes and facilities to suit all tastes. The poster alongside shows many of the towns we shall visit in this chapter, including the old city of Chichester in the west and the new city of Brighton in the east. Inland are wonderful downland walks, depicted in more artistic detail in Chapter 6. We are going to be looking at the coast in this part of journey.

The poster, alongside, dates from 1980 and is one of a set featuring all of the southern counties; it was the last series of posters to use original artwork. Even at this time, such a poster in the midst of the mass of mediocre photo-posters stood out: this series, as well as being colourful, is also most informative.

East Sussex travels

We begin in the far east of the county and the ancient town of Rye. Despite being steeped in history, the only artwork found for the town is a rather lovely drawing by David William Burley (1879-1957). Around 800 years ago, Rye was almost completely surrounded by water, being in a large coastal bay and at the confluence of three rivers. The waters of Rye Bay extended inland almost as far as Tenterden. At that time, nearby Lydd was on an island that guarded the entrance to Rye Bay, and the headland at Dungeness had not even formed. Rye had royal connections, through Edward III and then Elizabeth I, who conferred the title 'Rye Royal' in 1573 as she toured this part of Kent and Sussex (see poster 190 on page 118). George I visited unexpectedly in 1726, when his ship was grounded on nearby Camber Sands. The absence of a full sized poster for the town is curious, as there are some fine buildings, with the view from Ypres Tower out over the rivers being quite lovely. It was built in 1249 as a look-out point to warn of attacks by the French. There was constant silting of the bay, requiring much work to keep the port open. Eventually the silt triumphed, and Rye Bay was completely filled over the years, to leave the town centre two miles from the coast. Rye is remarkably hilly, being built on a sandstone ridge that fell into the sea at this location.

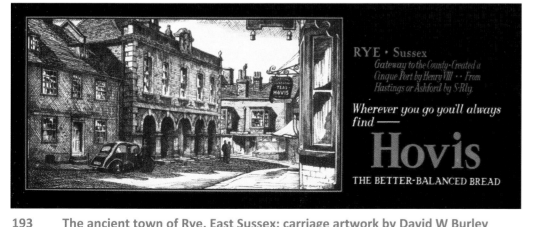

193 The ancient town of Rye, East Sussex: carriage artwork by David W Burley

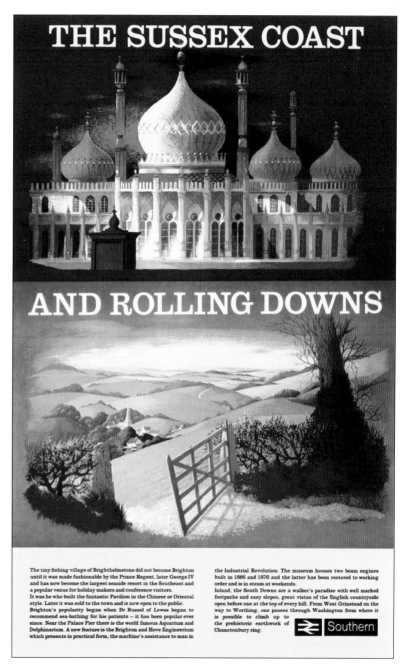

194 Two faces of Sussex: Coast and Downs by Reginald Lander

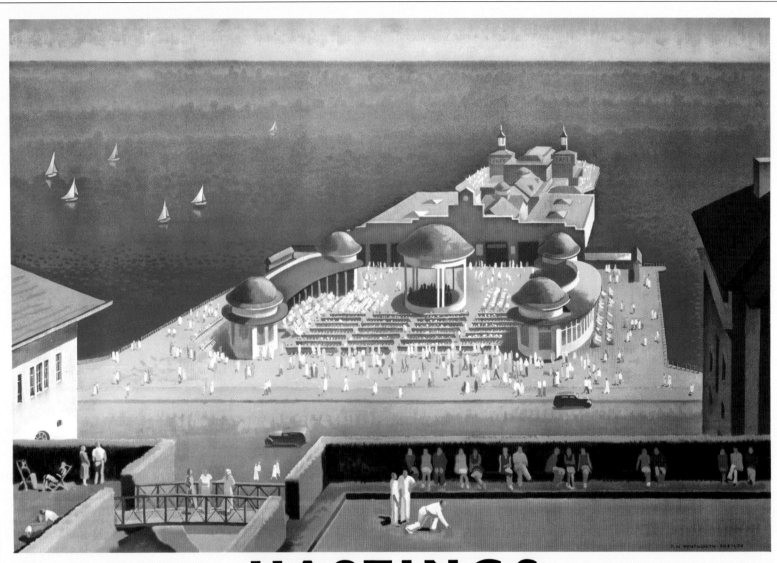

All enquiries to PR 300
Information Bureau, Hastings

HASTINGS
AND ST. LEONARDS

Fast and Frequent Service
of Trains from London

BRITISH RAILWAYS

195 A relatively uncommon BR poster for Hastings, East Sussex from 1959: artist F. W. Wentworth-Shields (dates unknown)

Hastings is a few miles to the west, and our train makes short work of the trip. It is associated with the Norman Conquest, even though the Battle of Hastings took place some eight miles to the north; but more of this later. Hastings was one of the original Cinque Ports and an important trading place, even before William landed in 1066. As well as having a fishing port (at the eastern end of the modern town) its role within the Cinque Port Confederation showed the importance the Crown placed on Hastings. Even today, fishing boats are hauled onto the shingle to recreate scenes from the past. By 1750 it had also developed into a 'watering place' for peace and relaxation, but with the coming of the railways it was transformed into more of a seaside resort, with fishing a secondary industry. The railways arrived in the western part of the town (Hastings & St Leonards) in 1846 as the LB&SCR built their station, later renamed St Leonards. The SE&CR arrived later, from the east, and built their station as Hastings. The direct link with London afforded an easy route from city to coast: visitors could travel via Tunbridge Wells and Battle from Charing Cross, or via Lewes and Eastbourne from Victoria. Our first poster shows the joys of the pier and its environs in 1959, with the bandstand attracting an audience for an afternoon concert.

The railway companies produced a diversity of images to portray the town, but the poster, nearside, must rank as one of the most unusual. The artwork is unsigned, and the cheerful, cheeky boy staring out of the brochure is an appealing image to lure families to the resort. Contrast this with Alan Durman's poster: in the shade, a fisherman mends his nets in the eastern part of the town, while the area to the west towards St Leonards, favoured by holidaymakers, is given highly colourful treatment. The Art Deco building in the centre is Marine Court, a 1937 structure which can be seen from miles away. It is nicknamed 'the ship' as from certain angles it resembled the great vessel of the day, the *RMS Queen Mary*.

The east of the town is picturesque, with narrow streets running north off Marine Parade. But for those who are fascinated by the town's maritime past, there is the Fishermen's Museum to the south-east of Marine Parade. The central part of Hastings has many parks and open spaces, so those who tire of the beach can relax in White Rock Gardens or West Marina Gardens - and there are other gardens too. For those with an interest in fossils, this area is rich in prehistoric bones, with the cliffs to the east giving up their treasures during winter storms. All of these attractions were advertised during the 20th century.

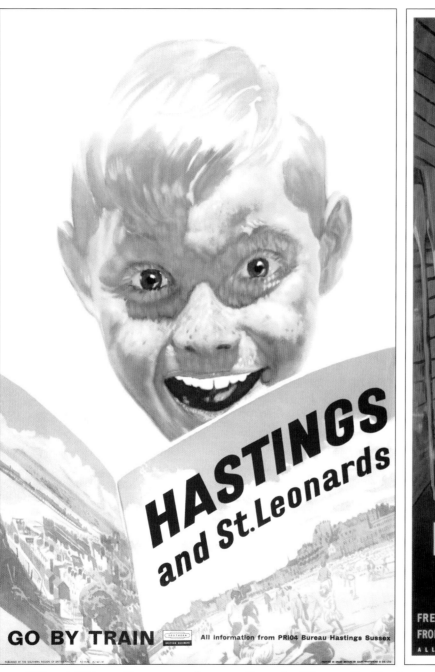

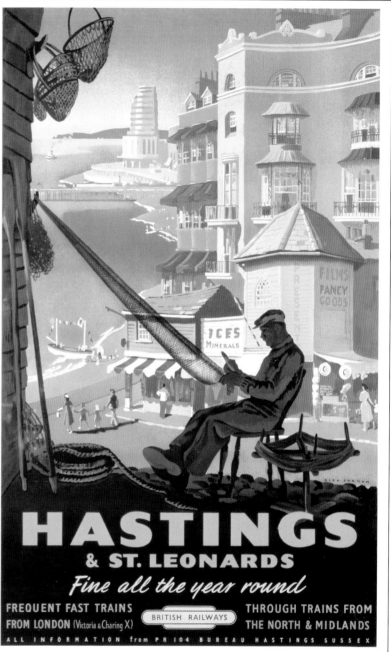

196 and 197 Two unusual posters from the BR years for Hastings: unsigned (left: 1961) and Alan Durman (right: 1952)

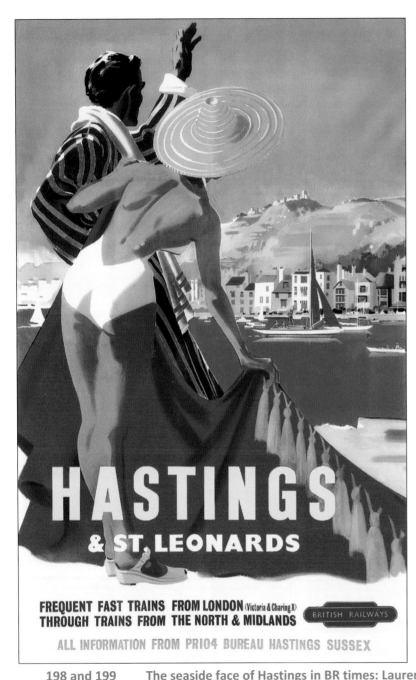

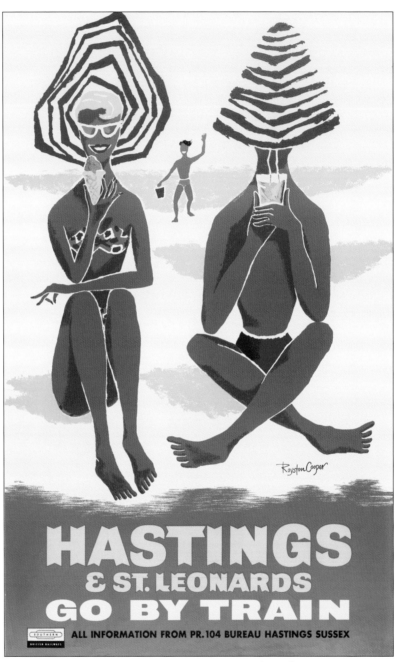

But it is the western side where the holidaymakers congregated during the 1950s and '60s as a result of heavy railway advertising. At that time the poster artwork consisted of bold images and strong colours, with two good examples shown here. The Laurence Fish poster (far side) has a bright red towel set against a blue sea, while the Cooper (nearside) uses stylised hats to attract attention. The Fish poster has the couple at the eastern end of the town looking towards the castle and the sandstone cliffs.

The beaches in this area are certainly the major attraction. There are miles of sand and shingle, and the urban development along the foreshore means that facilities are always nearby. Most of the beaches in this area are shingle, but at low tide, wide expanses of sand are exposed: Pelham Beach is particularly fine. The various councils have worked hard to ensure that families are well catered for: could it be that images such as these might be used again?

Hastings, along with many Sussex coastal towns, enjoys the highest average sunshine hours in Britain. In summer 1911, it tied with Eastbourne for the highest sunshine figures recorded in a single month: a massive 384 hours, or 12.4 hours per day.

198 and 199 The seaside face of Hastings in BR times: Laurence Fish (left) from 1956 and Royston Cooper (right) from c1960

This poster sees summer visitors walking along the pier, with the town and eastern cliffs behind. As in many British seaside towns, the pier at Hastings has had its ups and downs: at the moment it is down. It opened in 1872, designed by Eugenius Birch, who was also responsible for the piers at Brighton and Eastbourne. From the beginning it was popular, with visitor numbers reaching a peak in the 1930s, around the time this poster appeared. The original pier pavilion was destroyed by fire in 1917, but rebuilt. This is the structure shown on the Wentworth-Shields poster on page 122; during the 1960s and 1970s, some of the *Rock Scene's* biggest artists played here.

Elements of the pier were listed in the 1970s, but then in 1990, events took a huge turn for the worse. Massive storm damage forced a million-pound facelift. It was then put up for sale in 1996, but significant investment was needed to safeguard the pier supports. No buyer emerged, and in 1999 it closed. New buyers opened it again in 2002, but in 2006 serious structural defects again caused closure. After legal wrangling and some investment, it seemed the pier would survive, but a major fire in October 2010 put paid to those plans. Currently the Heritage Lottery fund is supporting the work needed to restore it to its former glory: here's hoping?

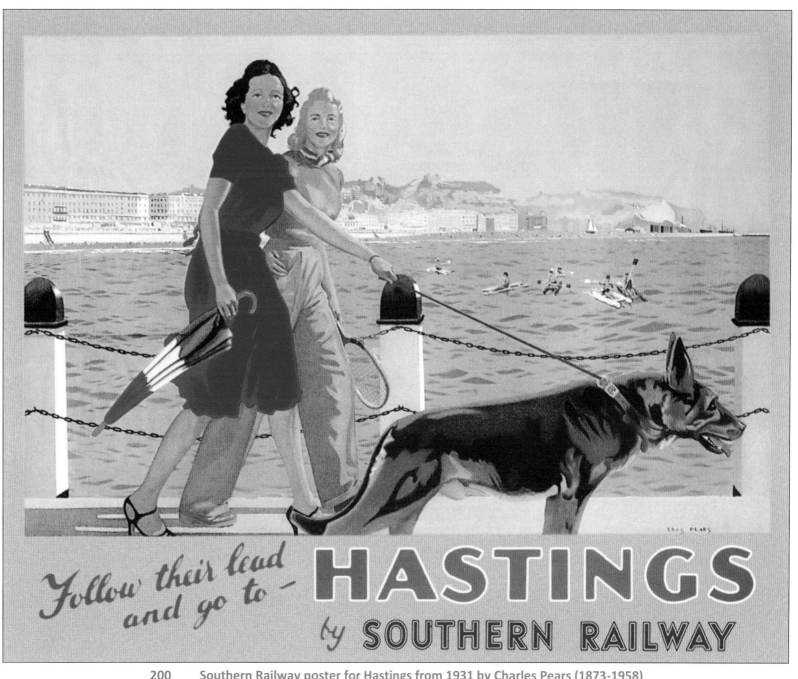

200 Southern Railway poster for Hastings from 1931 by Charles Pears (1873-1958)

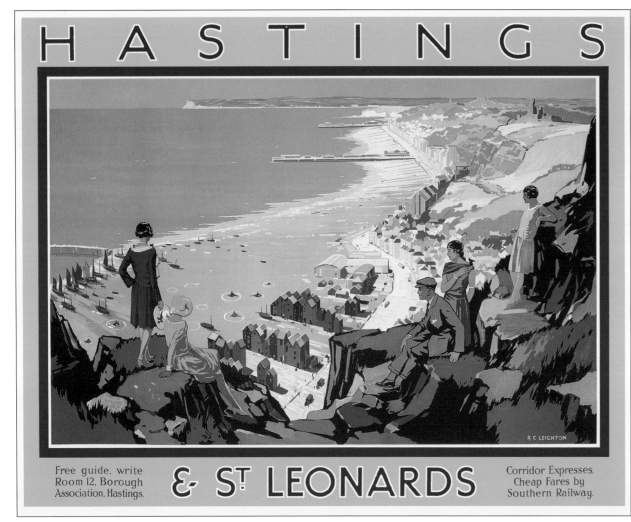

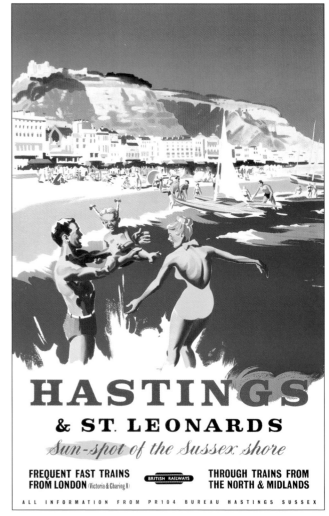

201 and 202 Panoramas of Hastings: Alfred Leighton (left) from 1930 and an unsigned BR Southern Region poster (right) from the 1960s.

The final trio of posters for Hastings & St Leonards shows diverse ways to promote the resort. Above left, we are now on the east cliff, looking west over the fishing activity area, with the beaches and pier beyond, then the west pier and St Leonards in the distance. On the horizon the dramatic white cliffs at Beachy Head come into view. Hastings Castle, the first one built by William in England after his invasion. lies behind the group of sightseers. Over the centuries, cliff erosion meant parts of it were lost to the sea, but today it is a distinctive east cliff landmark, as the holiday poster (above right) shows. This was the popular face of Hastings in the early 1960s, and such a poster would have been displayed at all of the main London stations. The poster opposite shows a famous Hastings feature, now sadly gone. It is also a rare opportunity to include an LMS poster amidst what is otherwise a sea of Southern images, and it shows the open-air Olympic-sized pool, built in 1933. From the air it resembled an amphitheatre, with curved, stepped terracing for spectators on one side and a curved deck for sunbathing on the other. More energetic visitors could sample the many diving boards. Overall it was not as successful as the poster indicates, and during the 1980s it was demolished.

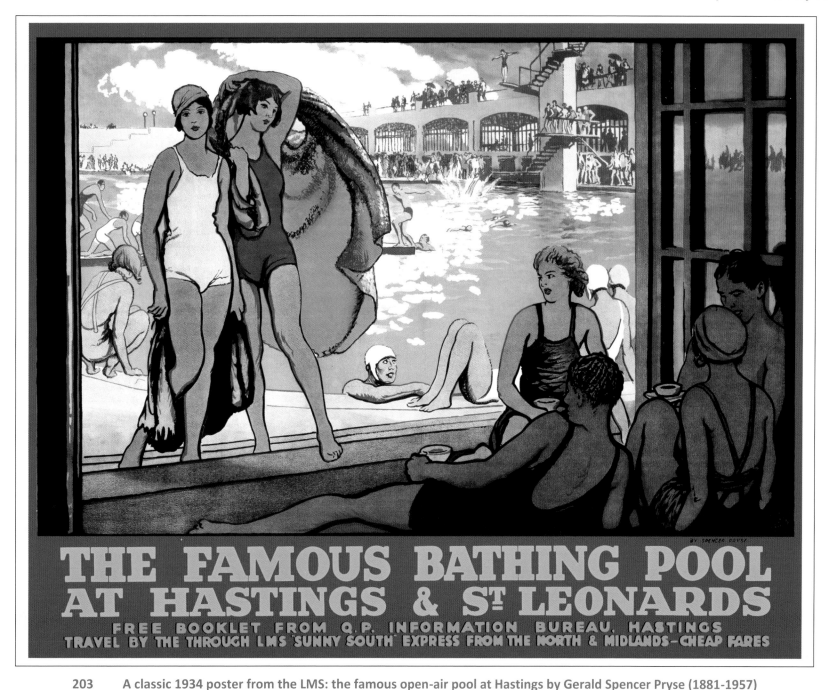

203 A classic 1934 poster from the LMS: the famous open-air pool at Hastings by Gerald Spencer Pryse (1881-1957)

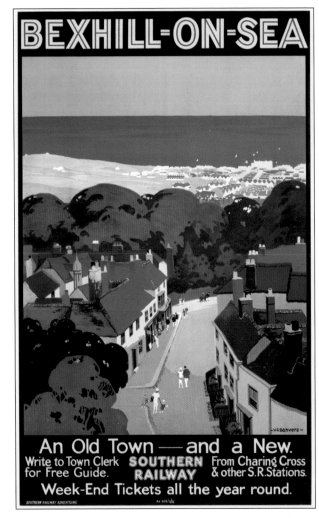
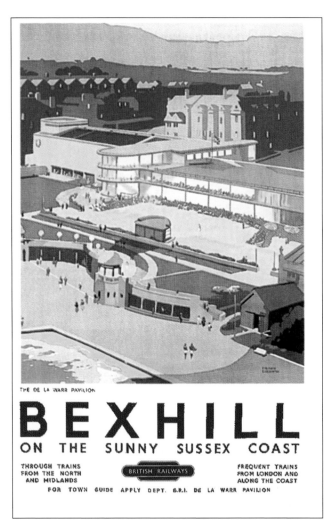
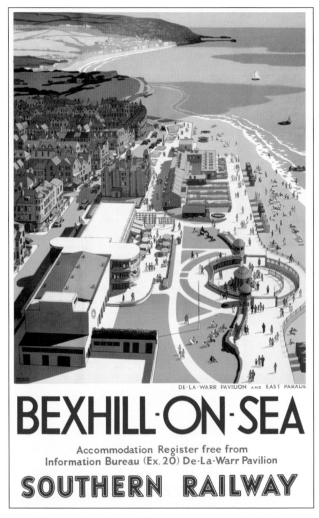

204, 205 and 206 Trio of posters for Bexhill-on-Sea: Verney Danvers, 1928 (left), Frank Sherwin, 1950s (centre) and Ronald Lampitt, 1947 (right)

Neighbouring Bexhill-on-Sea is less well known as a resort, and indeed was not developed as such until Lord de la Warr built Victorian terraced houses on land he owned between Old Bexhill and the sea. 'Old' Bexhill was a Saxon settlement, captured during the 1066 invasion. People closely involved with the town's history are remembered in street names, such as Sackville Road and King Offa Way. Surprisingly it is the birthplace of British motorsport, when in 1902, Earl de la Warr worked with the Automobile Club to stage the first-ever race in Britain. The three posters show the town and its environs. The right hand image shows the view east along The Promenade, with the de la Warr Pavilion in the foreground and St Leonards beyond. The centre poster shows a frontal view of the Pavilion. Built in 1935, it is one of the finest examples of Art Deco architecture in Britain. The pavilion benefited greatly from restoration and upgrade between 2003 and 2005. The left hand poster from 1928 is a view from the north: old Bexhill is in the foreground with Bexhill-on-Sea in the distance.

Travelling west to Eastbourne

Poster 201 on page 126 gave us the first tantalizing glimpse of the spectacular Beachy Head, on the western side of Eastbourne. It is now time to visit one of the most popular resorts of the south coast. When the railway arrived here in 1849, visitor numbers increased rapidly. Today the town possesses many high-quality hotels, which seem to strike an excellent compromise between slight brashness and gentility. The long Promenade is ideal for strolling, while the Downs on the edge of town are tailor-made for more strenuous walks, hiking and rambling, as shown below. Posters for the resort come in all shapes, sizes and subjects; taken collectively, show the compromise to which I referred.

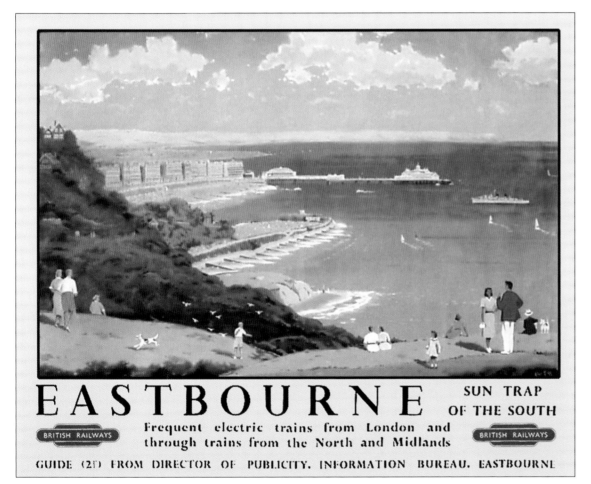

207 BR Poster from 1950s, looking east over Eastbourne: Herbert Alker Tripp (1883-1954)

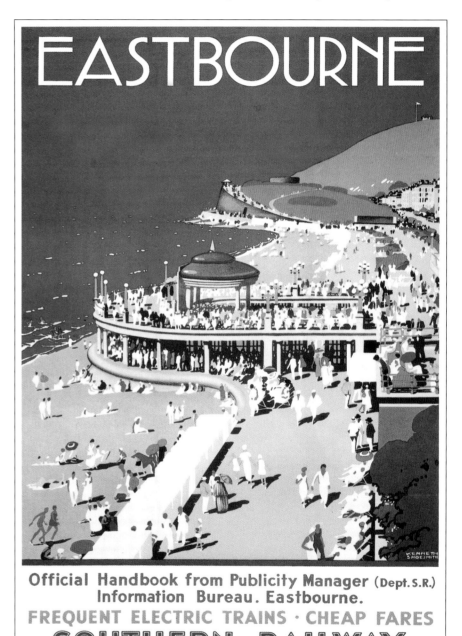

208 The Promenade, Eastbourne in 1925: Kenneth Denton Shoesmith

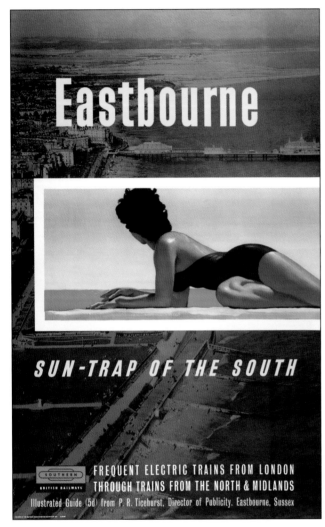 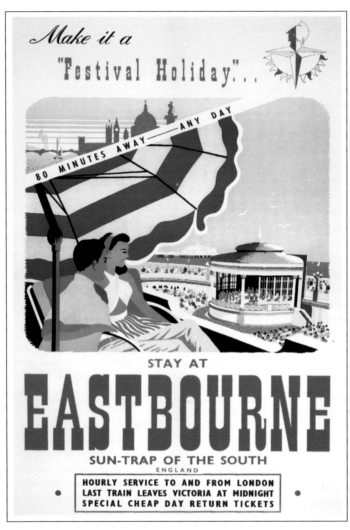 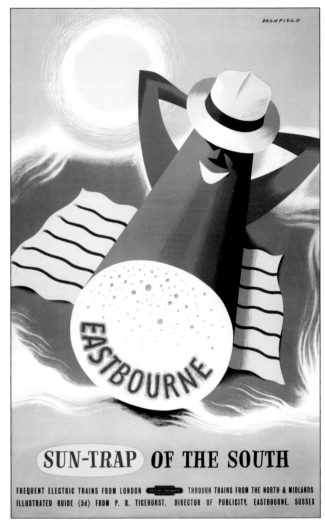

209, 210 and 211 The commercial side of Eastbourne: two unsigned BR posters (left and centre) from the 1950s and Kenneth Bromfield (right) from 1961

The slight brashness is shown to good effect in the three posters above, issued during an era when British Railways mounted a prolonged campaign. This began in 1951 and lasted for a decade. Each one is eye-catching; the left hand image above appeared when Elizabeth Taylor was at the height of her career: a coincidence or not? The cleverly conceived and eye-catching image on the right hand poster is undoubtedly aimed at children rather than parents, as the Southern Region Publicity Department intensified and targeted their advertising under Eckett's leadership. Eastbourne was the site of a Roman settlement, but even before that, there were Bronze Age dwellings on the eastern side of the Bourne, an ancient stream in the valley. The town was filled with Victorian houses from around 1850, as the 7th Duke of Devonshire developed some of his landholdings. The beach is mainly shingle, with sand exposed at low tide. Wooden groynes were built to stabilise the beach and to counter the cross-flow that occurs as the tides ebb and flow. The South Downs afford a good deal of protection from westerly winds, so the micro-climate is most agreeable, resulting in Eastbourne regularly topping the 'sunshine league'.

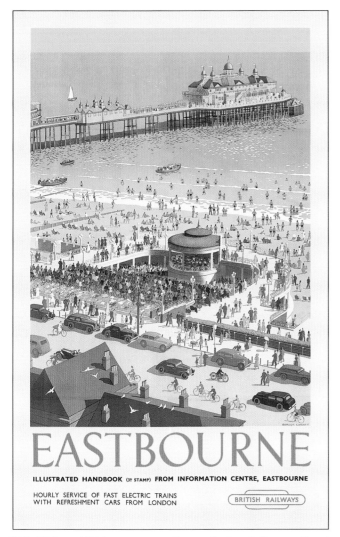
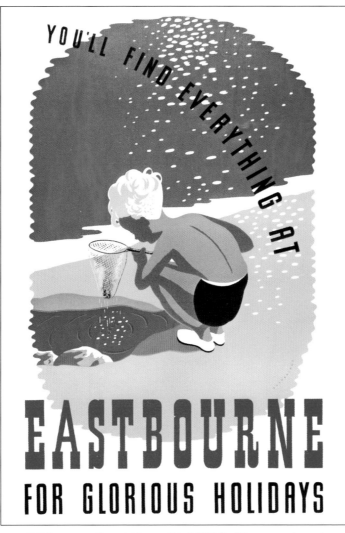
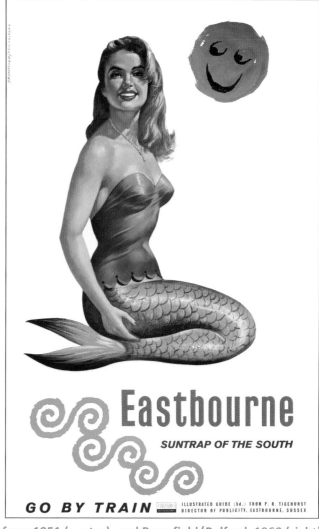

212, 213 and 214 Second trio of diverse Eastbourne BR images: Ronald Lampitt, 1950 (left), an unsigned work from 1951 (centre), and Bromfield/Pulford, 1960 (right)

This second trio from the 1950s and '60s continues the theme of diverse advertising. The bold use of colour and striking subject was the brief Gordon Eckett gave to all his commissioned artists, irrespective of the resort they had been asked to illustrate. The poster on the left was used a year before that in the centre, so the change of influence within BR publicity is very strong. On the right is a really modern-looking image: one of the more radical posters which were a response to the erosion of railway holiday traffic by road transport. Children are again the target in the centre poster, but the mermaid is something quite different. There are four Grade II listed theatres in the town; the Devonshire Park boasts an ornate Victorian interior whilst the three-level Royal Hippodrome also has a proud history as the former opera house. When viewed from the Downs, the immediate impression of Eastbourne is one of spaciousness and greenery, with many trees adorning its parks. Its floral gardens and bold summer planting are famous, but these attributes were not used in poster promotions.

The Victorian Promenade is shown to good effect in this 1938 poster produced for the Southern Railway by a favoured artist of theirs, Kenneth Shoesmith. The proximity of Beachy Head is now evident in this view, but for me, the use of the flags takes the eyes away from the real focus: the town itself. We walk up the hill westwards towards Beachy Head, and from the crest a quite magnificent view unfurls before us, captured on this beautiful BR poster from the early 1950s by Paul Allinson. The superb coastline is protected, and a 10-mile walk to Seaford following the South Downs Way over the Seven Sisters, through Birling Gap and Cuckmere Haven is a pure delight: arguably the finest coastal walk in Britain; I am sure readers have other favourites. The poster shows the first part of the walk, very little of which is flat, but the vistas *en route* are well worth the effort.

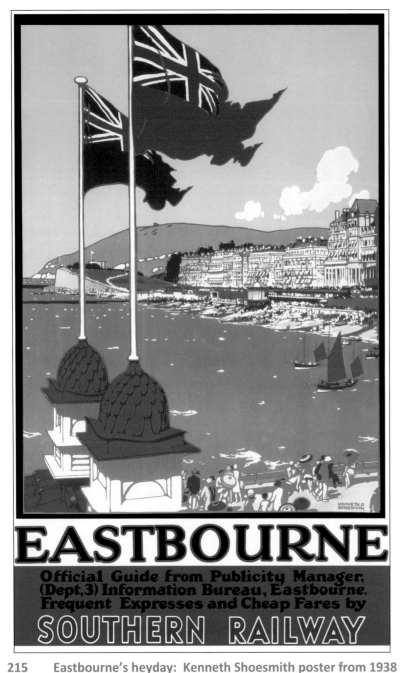

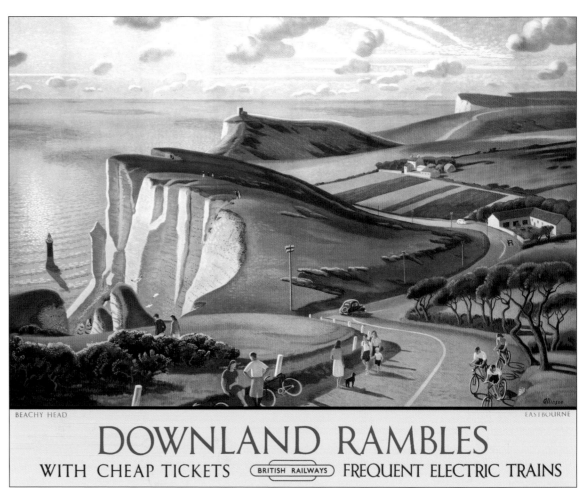

215 Eastbourne's heyday: Kenneth Shoesmith poster from 1938

216 The beautiful South Downs, Beachy Head towards Seaford: Paul Allinson from the 1950s

We have reached the end of the walk, and now the seaside town of Seaford stretches before us. On the way we have been captivated by spectacular views from the cliff tops, particularly that from Beachy Head's 530 ft (162m) cliff down to the diminutive lighthouse, which is actually over 140 ft (43m) tall. The Seven Sisters are the hills in the centre of the walk, named after the common name for the Pleiades, a seven-star cluster in the constellation of Taurus. They are often mistaken for the White Cliffs of Dover, well to the east, because in some films they have been used in this role. The poster (far side) shows the magnificence of these seven white hills that stretch between Cuckmere Haven and Birling Gap. They are receding at the rate of around 40cm per year, and occasionally there are rock falls, especially during rough winter storms. Each time there is a fall, erosion rates drop, as the waves are impeded for a period of time by the rock debris.

This section of the South Downs Way has long been popular with walkers, particularly Londoners, so most of the posters were produced in the 1930s, with few before or since. Surprisingly, no quad royals were produced to show a panorama of this beautiful part of the coast. As we approach the little Sussex town of Seaford the vista along to Brighton stretches before us (nearside poster from 1930).

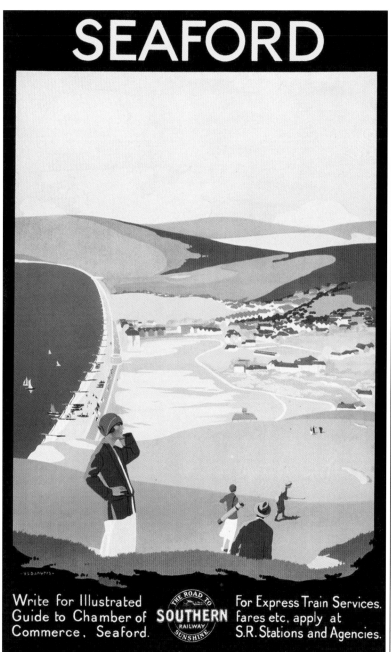
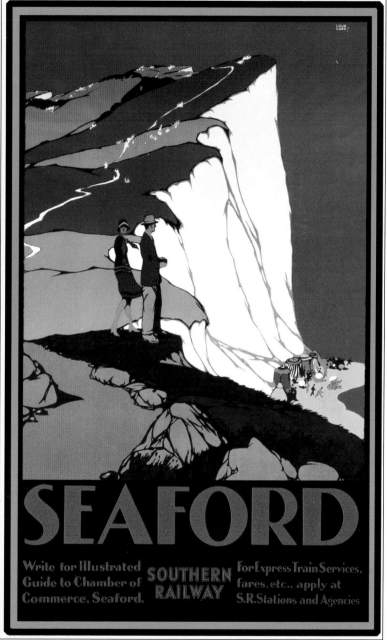

217 & 218 Along the cliffs at Seaford around 1930: Southern Railway posters by Verney Danvers (left) and Leslie Carr (right)

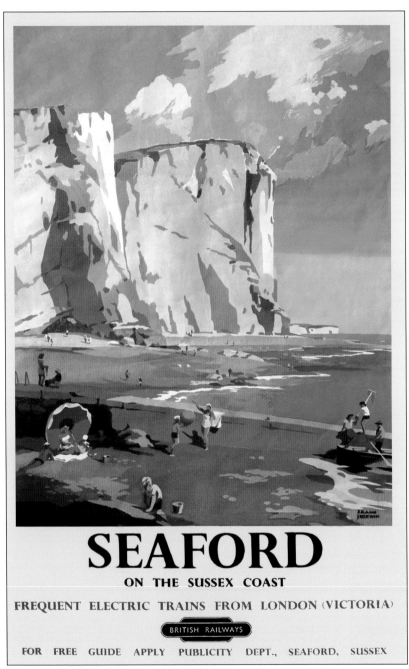

SEAFORD

ON THE SUSSEX COAST

FREQUENT ELECTRIC TRAINS FROM LONDON (VICTORIA)

BRITISH RAILWAYS

FOR FREE GUIDE APPLY PUBLICITY DEPT., SEAFORD, SUSSEX

219 The cliffs at Seaford Head: 1950s BR poster by Frank Sherwin

Seaford is a place I know well, having lived at nearby Peacehaven some years ago. The poster here, by Frank Sherwin, shows the might of the chalk cliffs of Seaford Head looking up from the beach. Seaford used to be an important port in the Middle Ages, but raids by the French, who burned the town several times over a 200-year period, plus those dreaded silting problems, caused its fortunes to decline. However, in common with many seaside communities, the railway's arrival in 1864 revived its fortunes. The station is the terminus of the branch line from Lewes, so commuting by rail to Brighton or even London is easy today. The railway line passes through nearby Newhaven, which developed as a cross-Channel port. This came about as a result of storms that changed the course of the River Ouse, which formerly entered the sea at Seaford, but a new break in the shingle spit allowed Newhaven direct sea access. There is still a brackish pool remaining as evidence of the old channel. The 1950s poster shows a wide, sandy beach at the base of the cliffs, but the building of new breakwaters at Newhaven changed the silting patterns, and the sand gradually disappeared. Consequently, regular replenishment is now carried out so that the view depicted is largely unaltered today, and the popular beach, sheltered by these cliffs, can still be enjoyed.

Travelling west along the coast, we cross the mouth of the Ouse at Newhaven and then the Greenwich Meridian, which leaves Britain at Peacehaven, before coming to the dormitory suburb of Saltdean and the site of a superb Art Deco lido. Similar pools had appeared in Hastings (1933: see page 127) and Brighton (1935), and the popularity of such facilities led to several being opened elsewhere in Britain between the early 1920s and the late '30s. Some appeared on railway posters, but sadly not Saltdean, and in many respects this is the nicest of them all; it is Grade II listed, reflecting its architectural importance. From here it is a very short journey into the relatively new City of Brighton & Hove.

So on to Regency Brighton

This was a major focus of railway advertising throughout the 20th century, and the problem in this part of the book was what to include and what to omit. Brighton has long been a popular resort, and boasts some quite fantastic architecture; but more of that shortly. The ancient settlement of *Brighthelmstone* was recorded in Domesday Book, but real development did not occur until the eighteenth century, and it accelerated in the century that followed. Brighton remains one of the south coast's most popular destinations. For the past two centuries the core of the town's local economy has been tourism; it is fair to say that seaside holidays were invented at Brighton once the benefits of bathing in saltwater – and, at first, drinking it! - had been discovered were then widely promoted. Royal support only strengthened these beliefs, and, as a result, money poured into the town during the Victorian years.

We begin the artistic tour at the pier. This seldom-seen poster shows the central waterfront of Brighton in the early 1950s, viewed from a high point on the old theatre at the end of the pier. Marine Parade is to the right and following the line of the pier inland on the A23 for a short distance would bring us to the Royal Pavilion. In former times this pier was therefore called the Palace Pier, to distinguish it from the West Pier on the Hove side. A third one - the Chain Pier - was built in 1823 but removed in 1896.

Britain's piers have all seen damage or fire at some time in their lives, but Brighton Pier was hit by a storm even as it was being built. In December 1896, the dilapidated Chain Pier was destroyed and debris from its collapse struck and damaged the new pier. This was rectified and in 1899, the third of the Brighton piers was opened to the public by the Brighton Marine Palace & Pier Company. The concert hall was opened in 1901; by 1911 it was a theatre, and it is the vantage point in this classic seaside poster. In 1986, it was removed and so far has not been replaced, but there are a number of attractions and rides at the seaward end today.

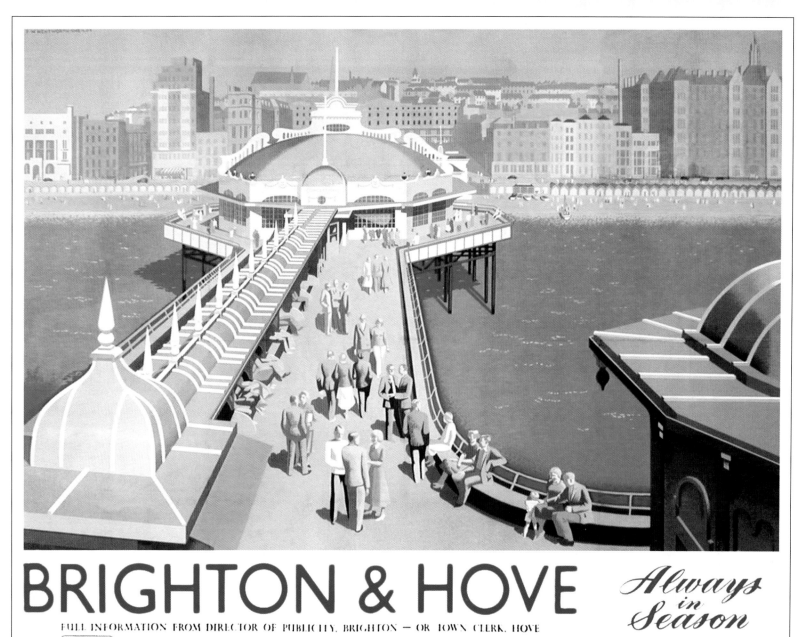

220 A classical seaside poster, Brighton Pier in the 1950s: artist F.W. Wentworth-Shields (dates unknown)

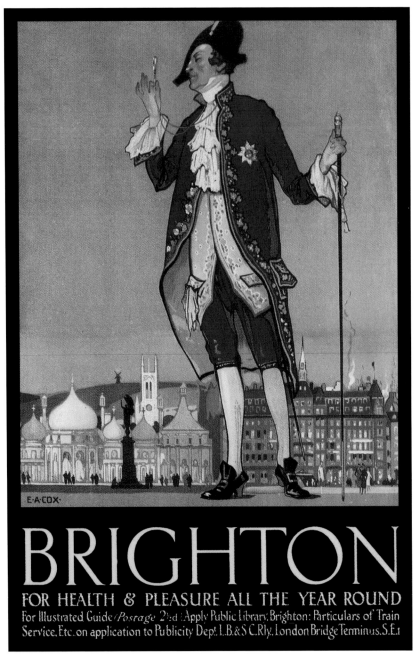

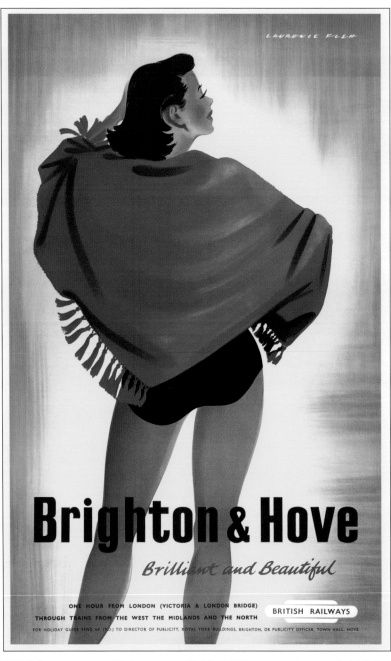

Brighton was the place to see and be seen, so the quartet of posters on these two pages show style and fashion through the ages; they also illustrate the diversity of poster images used for Brighton over a 40 year period. We begin our survey with a Regency gentleman on the seafront, with a collage of buildings as the backdrop below a peach coloured sky. In the 1920s Elijah Cox was commissioned to paint four images of people from the past; an idea later copied by the LNER in Austin Cooper's set in a similar vein. In complete contrast, the 1960s Laurence Fish poster shows a far more appealing visitor around 1960, with even bolder use of colour in an uncluttered, imaginative poster. The large blocks of colour were a feature of many Southern Region seaside promotional campaigns at that time.

The Georgian influence started in 1780, with the building of elegant terraces, and soon patrons from London were visiting regularly, in eagerness to use seawater to treat their gout and other ailments. In 1783 the Prince Regent arrived, and he liked the place so much that he made frequent visits, usually with long-time friend Mrs Fitzherbert. In 1787 he started work on his own development, the amazing Royal Pavilion which, over thirty years, grew into a truly fascinating palace.

221 & 222 **Brighton posters through the ages - 1: E A Cox from 1920 (left) contrasts with Laurence Fish's 1960s evocative model (right)**

It is a cross between an Indian palace and St Basil's Cathedral in Moscow. Nothing like it was built in the country before and nothing has appeared since: a total one-off. Built by Henry Holland, it was then enlarged and extended by John Nash, with both additional rooms and extensive stables. After George IV's death in 1830, the Royal Pavilion was used less often by William IV. Queen Victoria disliked the town, preferring genteel Osborne House on the Isle of Wight for her seaside visits, and she sold the Royal Pavilion to Brighton Council. Other developments at that time included the Grand Hotel (1864) and the West Pier (1866). Madeira Drive was built on reclaimed land, and over the years this became a fashionable place to stroll, as seen in the 1920s poster (far side). The original intention was to stabilize cliff erosion along Marine Parade; groynes, built at the same time, allowed the shingle bank to rise, affording even better protection. It was the place often seen in newsreels where the annual London-Brighton vintage car run finished, and is home to the Brighton Aquarium. In complete contrast, the photographic poster (near side) does not do Brighton justice at all, and in many respects was a forerunner of today's rather poor crop of railway advertising.

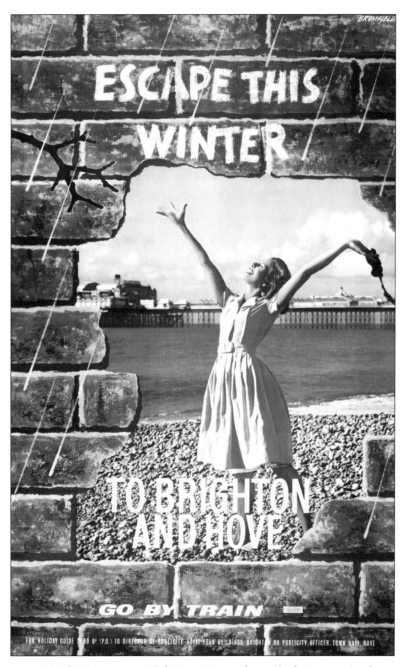 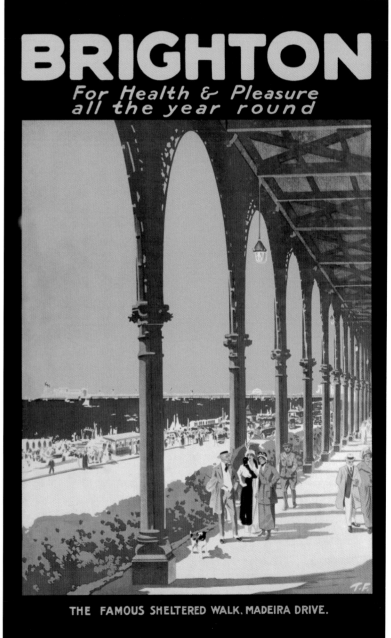

223 & 224 Brighton posters through the ages - 2: photo poster from the 1960s (left) and a 1920s poster signed *TF* (right)

There is no doubt that when British Railways was formed, the lessons that had been learned when railway companies collaborated were taken on board for key resorts such as Brighton, Blackpool and Skegness. Around 1950 British Railways began major advertising campaigns, with Brighton at the forefront. Below is the third in this chapter by Frank Wentworth-Shields, who seemed to be able to do no wrong for the Southern Region. Now we are on the Downs above Hove, and looking south-eastwards towards Brighton. Already an Area of Outstanding Natural Beauty attracting many visitors, the South Downs were designated a National Park in 2010. This view, which I believe shows Waterhall Mill at Patcham in the foreground, is one of many areas available to downland walkers. At the time this was produced it had ceased to be a functioning mill, but it had not yet been converted to a home - this took place in 1963 - so the poster shows some disrepair of the sails and the tail. Built in 1885 by James Holloway of Shoreham, it is now fully restored.

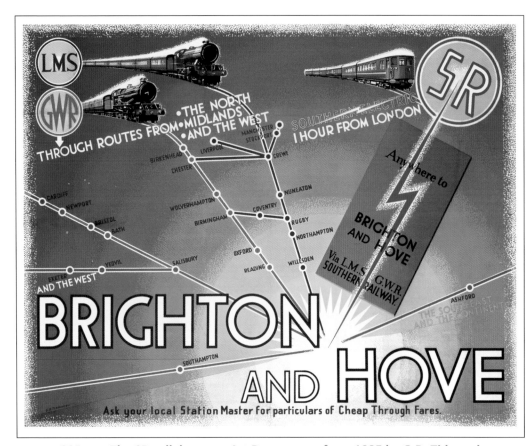

225 The SR collaborates: Art Deco poster from 1935 by G.D. Tidmarsh

The importance and appeal of Brighton as a holiday resort in the 1920s and 1930s did not go unnoticed by the other three railway companies. When they were formed in 1923, there was initial rivalry, and, in the case of the LMS and LNER, open hostility. The Southern Railway was, in many respects, more relaxed and soon began associations, then closer collaboration, with the others. Joint posters with the GWR came first and then with the LMS, but there were not many with the LNER. On rare occasions, as above, three of them worked to link the South Coast with the Midlands, the North and the West. On this poster, Exeter, Cardiff, Birmingham, Liverpool and Manchester are all shown as having direct links with Brighton and Hove. The SR took the opportunity to highlight their growing electrified network. There is no doubt that this poster would have been driven by the SR who also succeeded in showing people in the other regions the benefits of their trains.

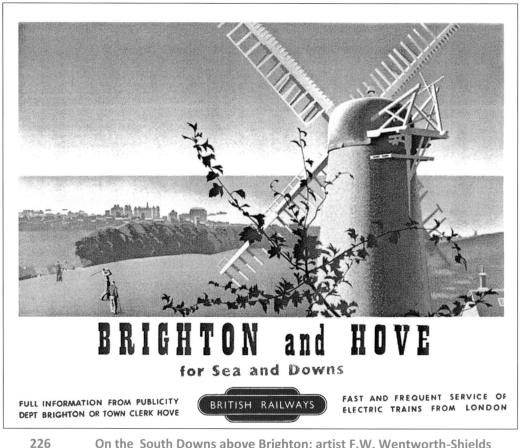

226 On the South Downs above Brighton: artist F.W. Wentworth-Shields

The one area where the Southern Railway did have an edge was in electric traction and, in particular, Pullman trains. Their Bournemouth and Brighton Belles are legendary, and the posters shown here recommend the very best way to leave London for the coast. The *Brighton Belle* ran between 1934 and 1972, and both the Southern Railway and British Railways heavily advertised the service. The one-hour journey was somewhat slower than in the BBC film mentioned on page 120. The train consisted of five-car all-Pullman electric multiple units, built for the service by Metro-Cammell and used throughout the train's life, usually with two sets coupled in. Some restoration work was undertaken in the 1950s, but by 1972 the cars did not meet modern standards and were withdrawn; happily, however, several have been preserved.

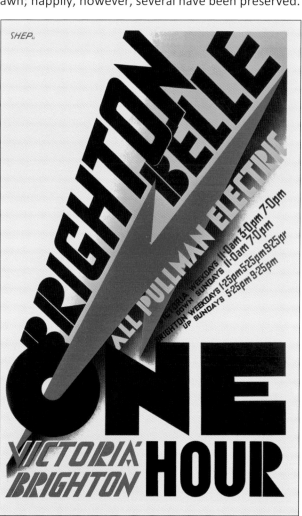

227 & 228 Advertising the Belle: Wolstenholme from 1953 (left) and Charles Shepard 1934 (right)

THE BRIGHTON BELLE
ALL-PULLMAN TRAIN

DAILY THROUGHOUT THE YEAR

WEEKDAYS

LONDON (VICTORIA)	dep	11 0 am	3 0 pm	7 0 pm	
BRIGHTON . .	arr	12 noon	4 0 pm	8 0 pm	
BRIGHTON . .	dep	1 25 pm	5 25 pm	8 25 pm	
LONDON (VICTORIA)	arr	2 25 pm	6 25 pm	9 25 pm	

SUNDAYS

LONDON (VICTORIA)	dep	11 0 am	7 0 pm	
BRIGHTON . .	arr	12 noon	8 0 pm	
BRIGHTON . .	dep	5 25 pm	8 25 pm	
LONDON (VICTORIA)	arr	6 25 pm	9 25 pm	

FOR FURTHER INFORMATION PLEASE ENQUIRE AT STATIONS AND TRAVEL AGENTS

SOUTHERN

229 Brighton Belle 1958 colour timetable by Adelman

Brighton's visitor numbers grew from under 7,000 in 1801 to over 120.000 a century later, thanks to the arrival of the railway. The three-storey station frontage was built on an awkward sloping and confined site in the Italianate style, with the headquarters of the London & Brighton Railway Company housed within. The station has a lovely curved roof which underwent restoration work at the end of the 20th century. It had been built as four pitched roofs, each 250 ft (76m) long, but when some rebuilding work and platform lengthening occurred around 1883, the roof was replaced with two well-proportioned curves.

The final poster in this short selection has us looking towards the end of Brighton (Palace) Pier. The artist Charles Pears chose a somewhat disappointing viewpoint, low down and close to the sea, as if he were another of the canoeists. This could have been improved by taking a bird's-eye view and giving details of the unique pier. Considering Pears' artistic talents, this is one of his least appealing quad royals. Brighton's population reached a peak in 1961, and the conurbation, which has expanded along the coast to include Hove, Worthing and Littlehampton, is now approaching half a million.

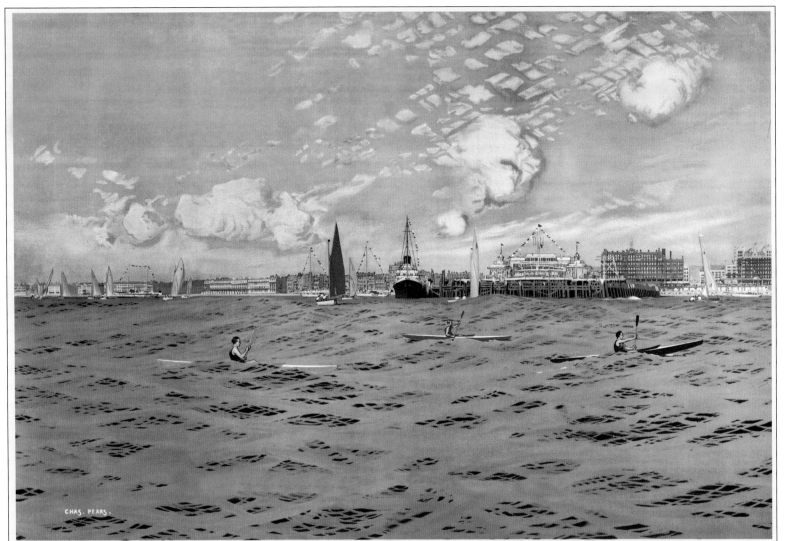

230 A 1935 view of Brighton and the Palace Pier from the sea: artist Charles Pears (1873-1958)

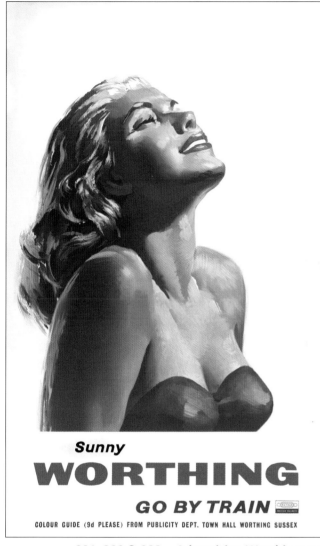
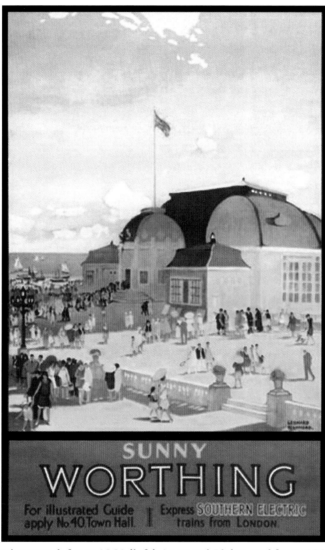
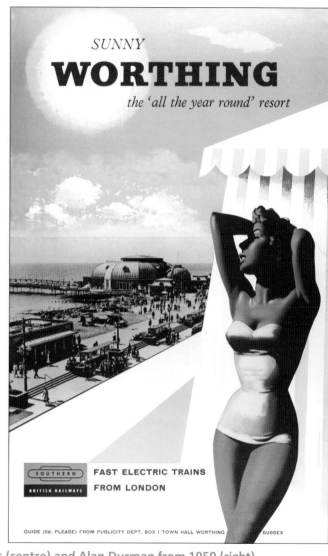

231, 232 & 233 Advertising Worthing: unsigned artwork from 1961 (left), Leonard Richmond from 1920s (centre) and Alan Durman from 1959 (right)

Travels along the West Sussex Coast

Travelling west from Brighton today, all the formerly separate towns have grown into one long sprawl; they include Portslade, Southwick, Shoreham, Worthing, Ferring and Littlehampton. The next town with posters was Worthing, and a trio of images is presented above. The left hand poster is another which illustrates the bold approach that BR adopted. Like Brighton, Worthing is a long-established resort, and, with over 200 listed buildings, it is also rather fashionable. A walk on Marine Parade, shown in the centre and right hand posters, is most agreeable. As well as tourism, Worthing has a strong financial services base, and its ease of access to London (49 miles) allows commuters to live at the coast.

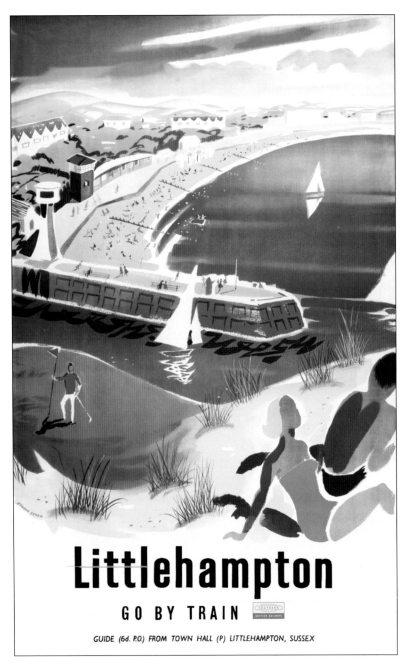

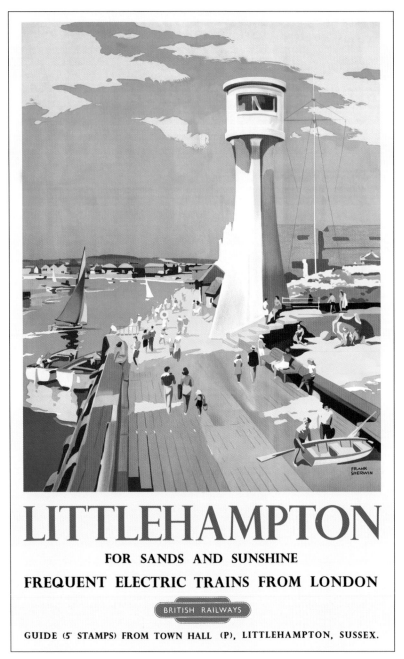

Our next poster destination is Littlehampton, shown in this very colourful pair of images. Strangely, this was another destination advertised strongly only in the BR years. It developed on the east bank of the River Arun, and both posters show the point where the river meets the sea. It is 52 miles (83 km) from London and here we are just over 17 miles (28 km) from Brighton. Seafront development has been considerable over the past 100 years. As the nearest coastal village to the home of the Earls of Arun at the nearby Arundel Castle, it became their port, with fishing as the main industry. Gradually it developed into a resort, and with it being more remote, it attracted distinguished visitors from the arts: Byron, Shelley, Coleridge Taylor and Constable. The sandy beaches shown in the Studio Seven poster proved irresistible. The railway arrived and stayed, and a cross-Channel ferry service to Honfleur was also introduced. The busy harbour is lined with red-brick, Victorian and Edwardian houses and several good hotels: Littlehampton does manage to squeeze a lot into a small space. The west bank hosts the boatyards, marina and yachting fraternity, so there is something here for everybody. This is why BR spent money promoting the resort.

234 and 235 Colourful portrayals of Littlehampton: Studio Seven from 1957 (left) and Frank Sherwin from the early 50s (right)

A few more miles west and our next holiday resort comes into view, the wonderfully named Bognor Regis. The small selection of posters leaves readers in no doubt as to the attributes of this West Sussex town.

In former times, Bognor was a sleepy fishing village, with a remoteness that favoured petty smugglers. It was not until Sir Richard Hotham came in the 18th century that the potential to turn it into a resort was seen. He was a property developer who came from humble origins in the hat trade, but rose to become a politician of some considerable influence. Finding the climate in Bognor most agreeable, he soon built a house there. It was not long before he acquired more land and started work on a residential development. As it proceeded, he had the idea of tempting the King away from Weymouth, and the Prince Regent from Brighton. The King did visit, with favourable results, and he was eventually persuaded to bestow the suffix 'Regis' on the town. Hotham's idea, however, to attract more permanent royal patronage failed, though minor members did visit and stay in the Dome House. Sir Richard's home remains a symbol of one man's drive to change a whole town.

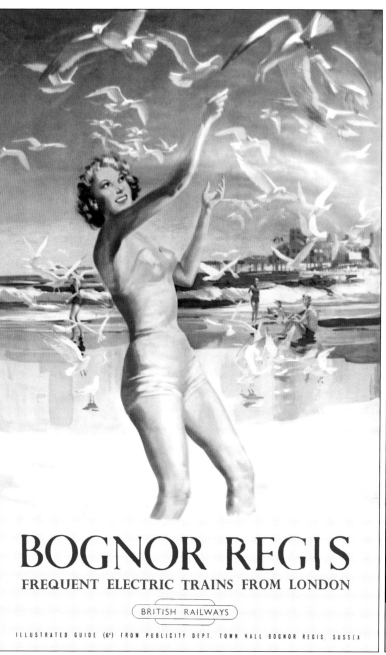

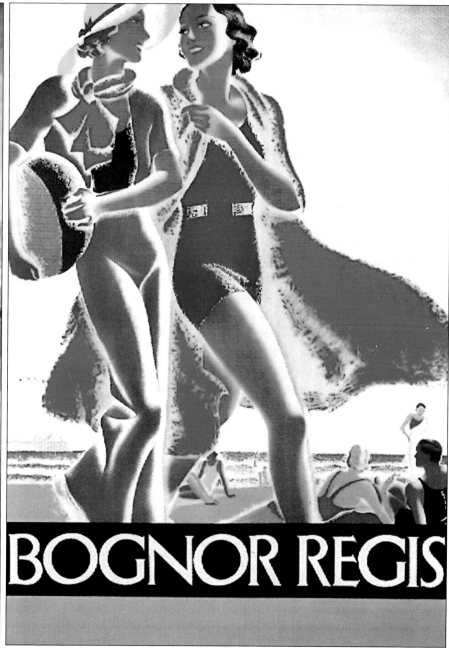

236 and 237 Seaside face of 'Royal Bognor': Johnson from 1952 (left) and an SR stock poster by Bruce Angrave from 1925

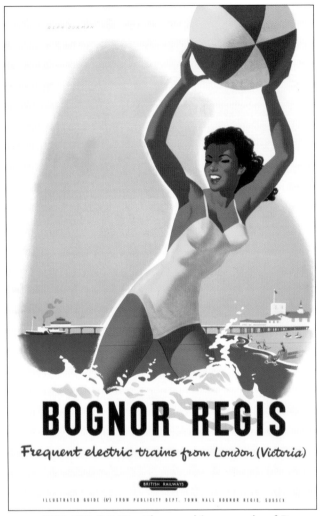
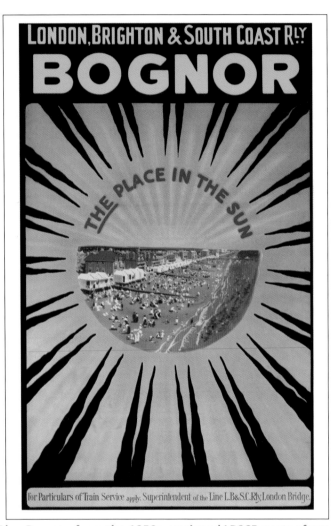
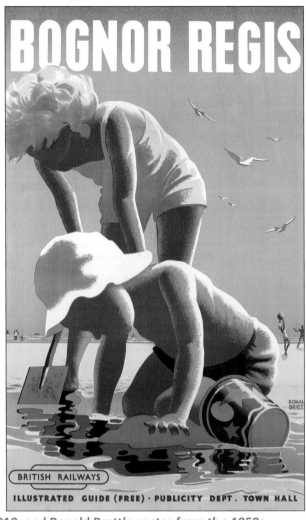

238, 239 & 240 The sunshine parade of Bognor: Alan Durman from the 1950s; unsigned LBSCR poster from 1910; and Ronald Brett's poster from the 1950s

There are miles of shingle beach spread along this coastline, but considerable artistic licence is shown in the two posters on the previous page. Angrave's stock poster (right) would have been overprinted with local station details of trains that took day-trippers to the resort. The trio of posters above shows the sunshine delights of Bognor, with children and families the focus. The central image, above, is an early LBSCR poster extolling the sunshine hours found here in summer: a reason that Butlin's Holiday Camp opened in Bognor in 1960. Butlin had enjoyed success - which continues today – in other places too; major investments this century in their Bognor premises have maintained the attraction of this resort. The short pier at Bognor is home to 'The Birdman of Bognor' contest, where people launch themselves from the end of the pier to see who can fly or glide the furthest. This began in Selsey in 1971, but transferred here anglo in 1978. Bognor is 56 miles (90km) from London and 6 miles (10km) from Chichester, and we now travel west to visit this small Sussex city. It has a Roman and Anglo-Saxon heritage, whose 12th century cathedral is one of the jewels in the city's crown. Nearby Fishbourne Palace, a Roman structure, did not feature on posters, but is superb.

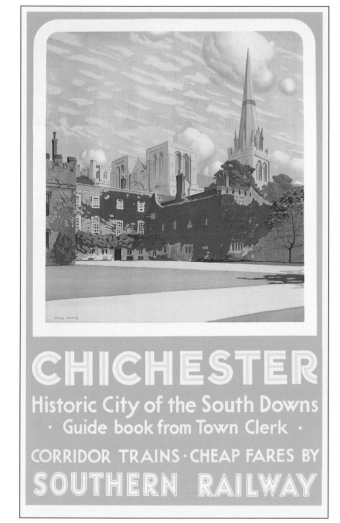

241, 242 and 243 The historic city of Chichester in posters: Charles Pears (left) from 1930s, Edward Pond (centre) from 1989, and Claude Buckle (right) from 1955

The diverse group of posters above shows advertising spanning more than half a century, and illustrates traditional, contemporary and classic poster art. The colouring and style of the Buckle poster is exquisite, while the more modern Network SouthEast offering is, quite frankly, rather boring. Both of these show the Market Cross, built of Caen Stone, where the four major roads in the city meet. It was constructed around 1501 as a place for poor people to sell their wares. There are eight sides, and on four of them clocks were installed, each facing one of the four approaching streets. The spire of the cathedral was completed around 1402, and it soars above the town; the cathedral itself was dedicated in 1299, a century earlier. It may be a small cathedral, but the interior is rather lovely and testifies to a turbulent past, notably some collapses, and rebuilding in different styles. Many other buildings in Chichester are ancient, and the bulk of the centre is built on the foundations of the Roman city *Noviomagus Reginorum*. Major roads once led to *Londinium* and *Calleva* (Silchester).

-very fit - and you ? -wonderful !!!

BRIGHTON and HOVE

Free Guide from Municipal Enquiry Bureau, Brighton Frequent S·R Expresses 1 hour from London

244 A wonderful 1931 social poster for Brighton and Hove from the Southern Railway: artist Andrew Johnson

Chapter 6 Inland Sussex and Surrey

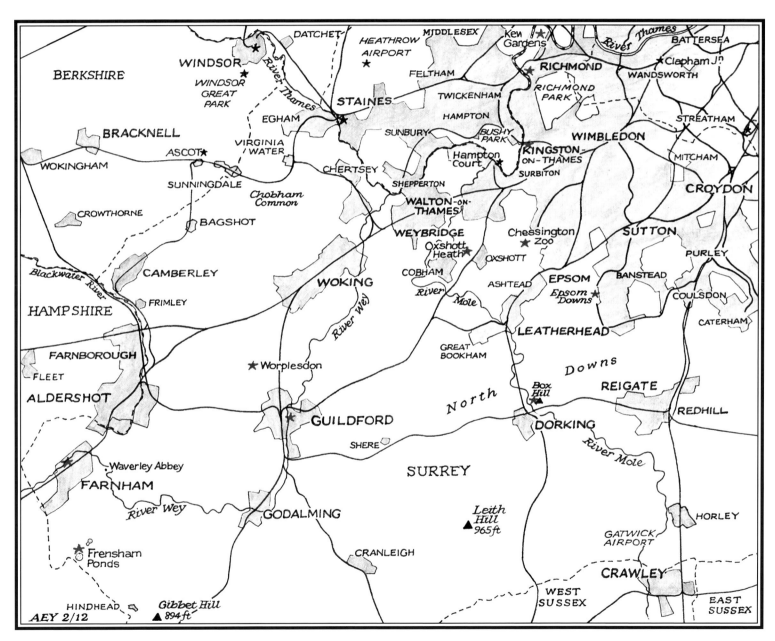

Chapter 6 | Inland Sussex and Surrey

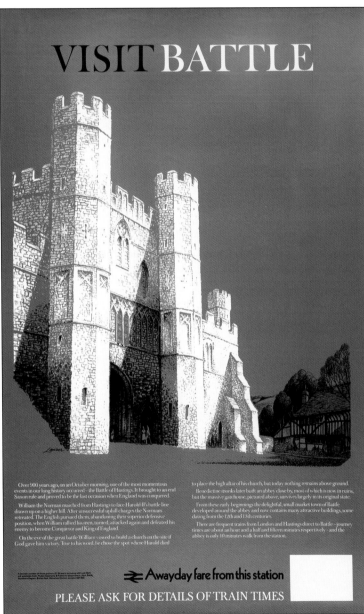

245 1978 Inter-City poster for Battle by Reginald Lander

A most famous battle

In this chapter we move away from the coast and travel through the neighbouring counties of Sussex and Surrey. We start in East Sussex, just north of Hastings at arguably the best-known battle site in England's long history. We are at Senlac Hill, where William of Normandy faced King Harold. It was the first time that an English army had had to cope with archers, cavalry and infantry working in close harmony. Harold's army was mainly infantry, who fought bravely in a battle that saw both sides gain the upper hand at times. Eventually, once the Norman knights attacked and killed Harold, the English resistance was broken. Having fought at Stamford Bridge in Yorkshire against the Vikings three weeks earlier, the English fought bravely, but Norman numbers and tactics prevailed.

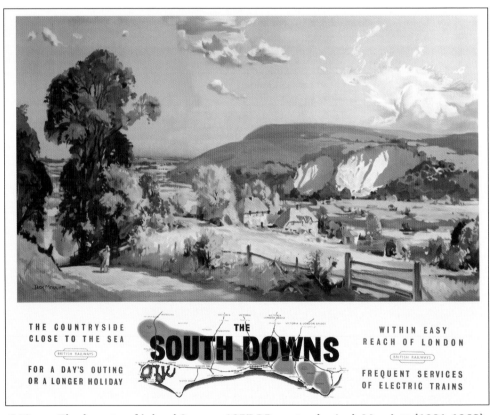

246 The beauty of inland Sussex: 1957 BR poster by Jack Merriott (1901-1968)

Given the significance of the Battle of Hastings in British history, the amount of attention given to the town by all the railway companies was derisory. The Inter-City poster, on the previous page, of the front of Battle Abbey is somewhat disappointing. The Abbey front is at the southern end of Battle's main street, and such a view would have made a far better poster. Battle is also set in utterly charming countryside and Jack Merriott's 1957 poster shows the rolling beauty of the South Downs. Twenty years earlier, the Southern Railway issued this poster by Herbert Alker Tripp, a fine study in clouds, where the healthier aspects of walks along the Downs were the focus. The artist was a Metropolitan Police Transport Commissioner, whose hobby was art. He captures the crest of the South Downs, as a storm approaches, with deftness and style.

This poster also advertises one of the SR's famous books by S.P.B. Mais, a prolific author and a real champion of the countryside. After WWII he turned his pen towards foreign destinations and, over a forty-year period, completed nearly 200 books. The GWR, LMS and SR all used him to write their guides, and several great posters were produced by all three companies to advertise them.

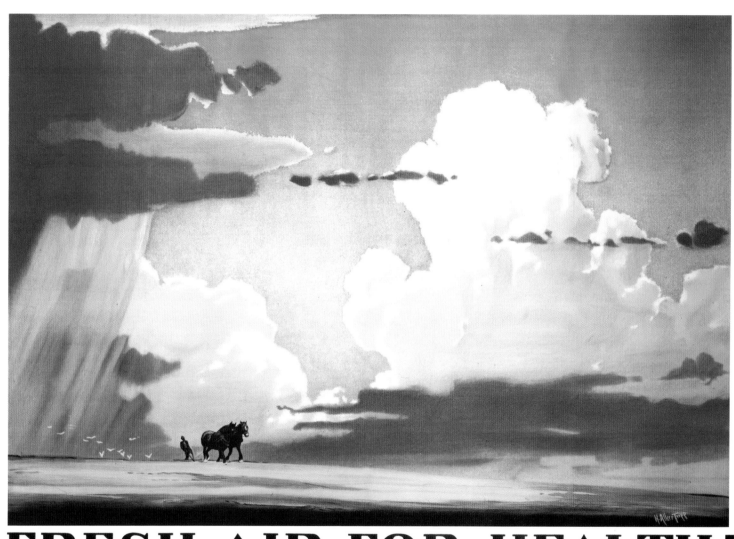

247 Fine 1937 study of the South Downs, when the railways promoted health: artist Herbert Alker Tripp (1883-1954)

Lewes and the South Downs

During the 1930s and 1940s, the Southern Railway published a number of superb posters extolling the virtues of the South Downs. One of the artists favoured to portray this area was Walter Spradbery, and two of his posters follow. Alongside, he first shows the Downs cloaked in the bright greens and vibrant yellows of summer. Here we are in the Vale of Sussex behind the chalk escarpment, with the sea beyond the hills. The South Downs have a steep northern face (shown here) and a gently dipping southern face, but a view from the top in either direction shows southern England at its very best. In this poster we are standing on the clay deposits of the Weald. This vale runs parallel to the chalk hills and is ideal for farming, unlike the outcrops of greensand which form the uplands closer to the centre of the Weald. In some parts it is wooded, with extensive areas of hazel, oak and birch, remnants of the former extensive forest. Conifers have recently been planted, but they look somewhat incongruous in this landscape. There are also patches of heathland that support unique wildlife, and on top of the chalk hills there are flowers not found elsewhere in Britain. Whilst man has contributed small farmsteads and villages, large rural estates and grand homes with expansive gardens to the landscape, the rivers have created the scything cuts through the chalk hills.

248 The rich landscape of the Sussex South Downs: 1946 poster by Walter Spradbery (1889-1969)

The colours change with the seasons, and Spradbery's next poster has us in the autumn, with brown tints creeping into the picture. The fields have been ploughed, and a winter crop is just appearing through the surface.

The South Downs were formed during the Cretaceous Period, some 60 million years ago, when extensive shallow and warm seas covered much of Europe. The plankton-rich waters built up layer upon layer of skeletal white rock, which was forced upwards during later tectonic plate movements. The rock has many fossils and flints embedded, and these flints characterize many of the houses in East Sussex. The Merriott poster on page 148, shows small quarries on the north scarp, where stone has been extracted, and the whiteness of the rock beneath is clearly evident. The North Downs on the opposite side of the Weald are also the remnants of the enormous dome of chalk that once covered the Weald. Over the millennia this has been eroded, so exposing the Greensand and softer clays of the Weald, which were eroded even faster. In the centre is sandstone, where erosion has been slower, so that forests around Crowborough and Forest Row are at the highest points in the region.

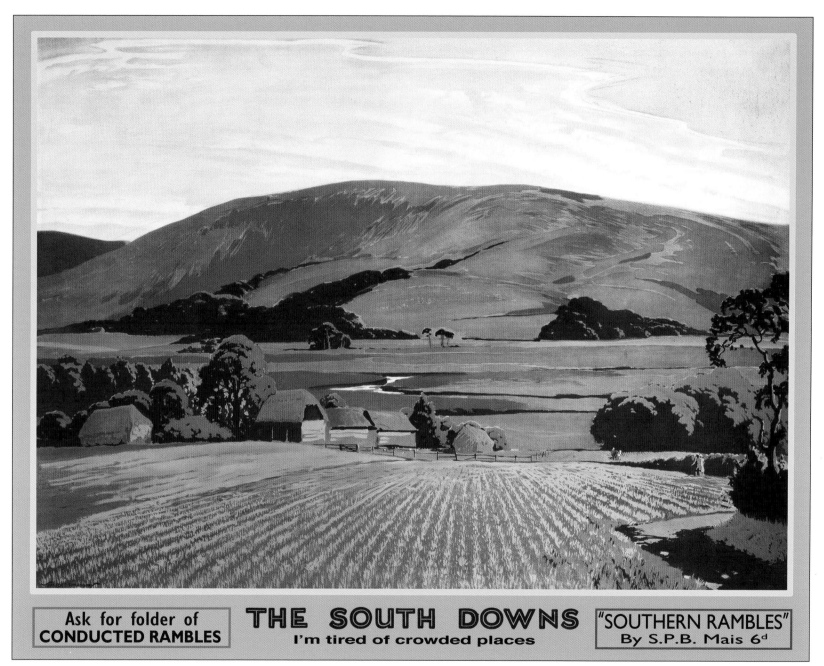

249 The expanse of the South Downs in late summer depicted by Walter Spradbery (1889-1969) in 1934

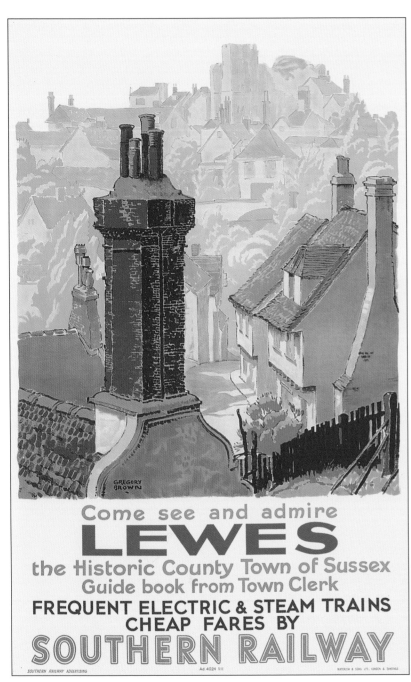

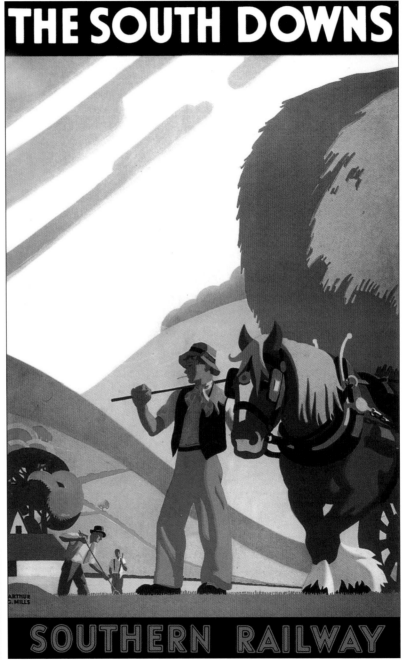

250 and 251 Southern Railway posters from the 1930s: artists F. Gregory Brown (Left) and Arthur G. Mills (Right)

In ancient times, the dense oak forest of the Weald left only the coastal strip and any open hill tops free for habitation. As a result Sussex is sparsely populated, save for the seashore and the sandstone ridges of Ashdown Forest: these reach an altitude of 790ft (240m) near to Crowborough. Surprisingly, no posters were made for this archeologically rich area, where open heathland and dense woodland are interspersed with ancient iron workings. The poster of Oxshott Heath, Surrey, on page 155 does allow a glimpse of what this area of north Sussex offers.

Arthur Mills' beautifully composed double royal poster (nearside) shows harvest-time in the South Downs. This used to be a common sight throughout the Vale of Sussex in late summer. The colours used blend well with the two Lewes posters on either side. Lewes is the County Town of East Sussex and, historically, for the whole of Sussex. The poster by Gregory Brown shows a view looking towards Lewes Castle, built in 1069 by William the Conqueror's brother-in-law, William de Warenne, who became 1st Earl of Surrey. A view from here across the town to the South Downs beyond is particularly splendid and would have made an excellent poster. Lewes Castle has a fine barbican and, unusually, two mottes within its motte-and-bailey design.

This poster, also by Gregory Brown, shows the beauty of old Lewes. Roman artefacts have been found here, and it is known that the Saxons built their settlement and castle to defend the River Ouse crossing. After 1066 it became an important Norman town, and the coin mint of Saxon times was re-established by the Normans. The town's charter was granted by King Stephen. In 1264 it was the site of the battle between Simon de Montford and Henry III, when the King was defeated during the 2nd Barons' War. In the 17th and early 18th centuries it developed first as a port, as the Ouse was navigable down to the sea, but then as an administrative centre. Its streets are unchanged from those shown here.

The LBSCR arrived at Lewes in 1846, with two stations being built (Friars Walk and Pinwell) to serve lines that came from the east, north and south. Lines used to exist here to Brighton, Burgess Hill, Newhaven, Eastbourne, East Grinstead and Uckfield, but today lines to these last two named destinations have closed. However, the Bluebell Railway has preserved the section between Sheffield Park and Kingscote on the former East Grinstead route. This preservation group is undertaking sterling work to reopen the line beyond Kingscote, with Imberhorne Cutting the last obstacle to be cleared.

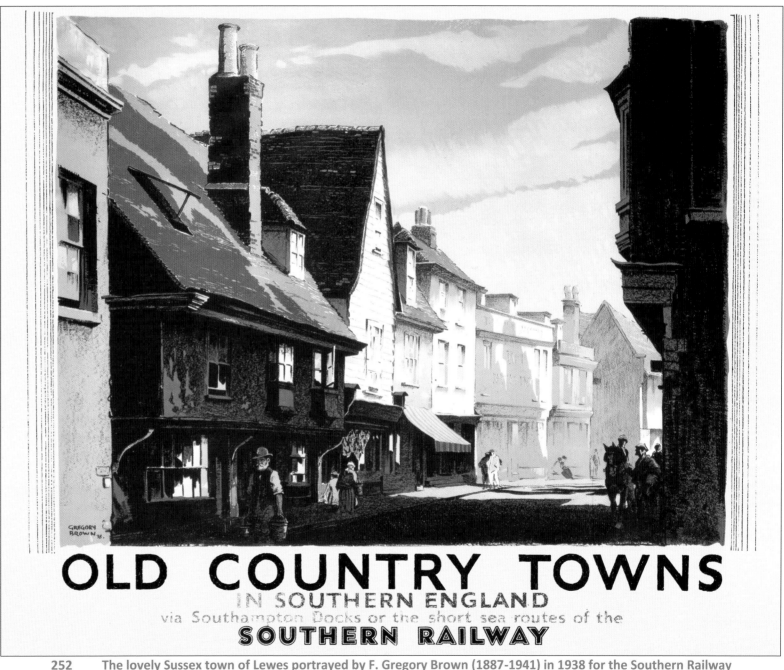

252 The lovely Sussex town of Lewes portrayed by F. Gregory Brown (1887-1941) in 1938 for the Southern Railway

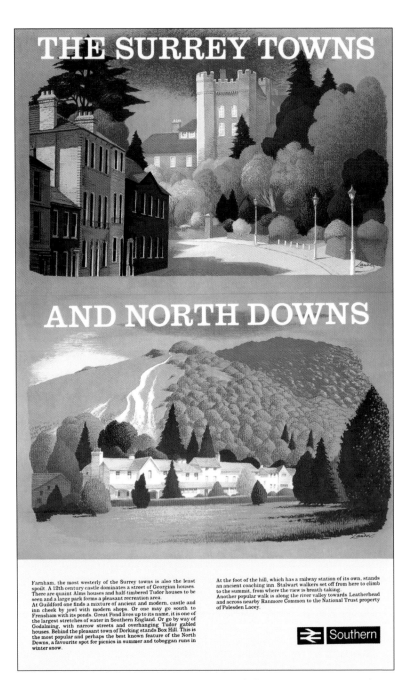

Within the image:
THE SURREY TOWNS

AND NORTH DOWNS

Farnham, the most westerly of the Surrey towns is also the least
spoilt. A 12th century castle dominates a street of Georgian houses.
There are quaint Alms houses and half-timbered Tudor houses to be
seen and a large park forms a pleasant recreation area.
At Guildford one finds a mixture of ancient and modern, castle and
inn cheek by jowl with modern shops. Or one may go south to
Frensham with its ponds. Great Pond lives up to its name, it is one of
the largest stretches of water in Southern England. Or go by way of
Godalming, with narrow streets and overhanging Tudor gabled
houses. Behind the pleasant town of Dorking stands Box Hill. This is
the most popular and perhaps the best known feature of the North
Downs, a favourite spot for picnics in summer and toboggan runs in
winter snow.

At the foot of the hill, which has a railway station of its own, stands
an ancient coaching inn. Stalwart walkers set off from here to climb
to the summit, from where the view is breath-taking.
Another popular walk is along the river valley towards Leatherhead
and across nearby Ranmore Common to the National Trust property
of Polesden Lacey.

≷ Southern

253 Reginald Lander's 1980 view of the Surrey countryside

North-west into Surrey

Crossing the High Weald we enter Surrey, an old traditional English county that borders onto London, Kent and Hampshire, as well as Sussex to the south. Its proximity to London has resulted in several boundary changes over the past 120 years, so that towns traditionally in Surrey (such as Croydon, Richmond and Kingston-upon-Thames) are now classified as Greater London. Indeed Surrey formerly extended some miles north of the pre-1965 London boundary, with Lambeth, Wandsworth and, to the east, Rotherhithe being in Surrey until 1889: Staines, now in Surrey, used to be in Middlesex until 1965. It is a much misunderstood county, being seen as both affluent and pretentious: affluent it may be, but pretentious, certainly not. It is true that the county is home to many wealthy and famous people, but the environment there is full of beauty, both natural and man-made. The poster alongside sums this county up rather well: in many places it is green and lush, with many areas of tended woodland, and the North Downs for walking and rambling. The towns are also well-kept, with a great deal of history and a general ambience that does reflect the general success of its residents over the past two hundred years. This makes it a desirable place to live and be able to travel easily up to the city. Public attractions are also few in numbers and therefore are the amount of railway posters produced.

Maps of the county show that the North Downs bisect Surrey. This chalk escarpment runs from near Farnham, ending as the celebrated white cliffs a little east of Dover, in Kent. At the Hog's Back between Farnham and Guildford, the escarpment gives way to a prominent ridge. The shape of the North Downs is the reverse of the South Downs in Sussex. On the south side of the North Downs the steep escarpment is found, while to the north the terrain slopes gently towards London and the Thames Valley. The high point is close to the Surrey-Kent border, while five rivers cut through in valleys, from the Wey in the west to the Stour in the east. Man has had a highly significant influence upon the landscape. Huge tracts of woodland have been removed, but in those places where the valley sides are steep (as in Lander's poster) the woodland remains. The top portion of his artwork features Farnham, in the west, and the lower portion is ancient woodland on the slopes of Box Hill, named after the scattering of box shrubs on the western slopes that face the River Mole. This hill is immensely popular with walkers, both local and from further afield, and in excess of 500,000 take to the slopes each year. Lander chose to illustrate the well-formed tracks from the Mole Valley up to the summit at Betchworth Clumps (735 ft or 224 m).

In 1978 the North Downs Way was opened, stretching from Farnham to Dover. It was never advertised on railway posters, though other walks in Surrey are listed. Within Kent it splits in two, with a northern section via Canterbury and a southern route via Wye. Within Surrey the North Downs Way takes in Godalming, Guildford, Dorking and Merstham, enabling ramblers to admire some of the most beautiful parts of the county: but why not advertise these locations? The historic county town was Guildford, however today, the Surrey County Council headquarters are in the far north, at Kingston-upon-Thames.

These two posters are excellent examples of why Surrey is such a desirable place to live. Imagine working in the City of London and yet living in places like these. Every weekday for over a century trains have carried commuters into Victoria, Waterloo and London Bridge stations. Guildford, for example, currently handles 7.8 million passengers annually with 7.1 million using Woking. The poster on the far side seems to say it all, although cramming like sardines into carriages is not my idea of happiness!

The poster alongside shows Oxshott Heath, a relatively small area of only 200 acres, fringed on its southern boundary by the main Waterloo to Guildford line. On the northern boundary of the Heath is the main A3 London-Portsmouth trunk road. An Oxshott Heath Conservation Board was provisionally set up in 1876 by a Westminster Order, which was later confirmed in 1904 by Act of Parliament. Both these posters show that Surrey's woodland is a mixture of native deciduous and planted conifer trees, with Oxshott Heath having beech, oak and silver birch shown in the distance, with Scots pine framing this 1932 scene. The earlier poster from Ethelbert White, dates from 1928, and shows the wooded scarp somewhere along the North Downs route.

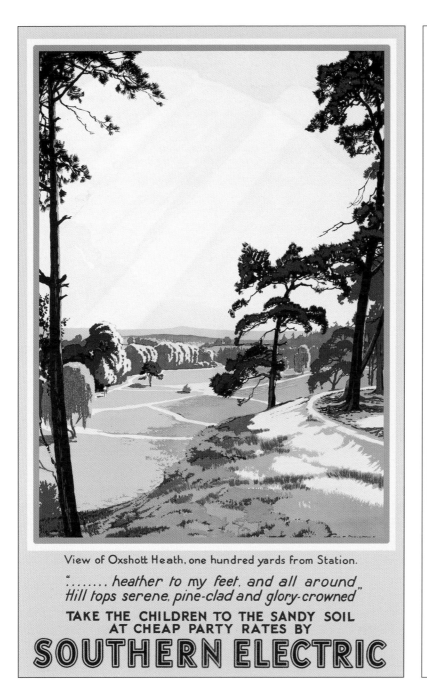

View of Oxshott Heath, one hundred yards from Station.

"........ heather to my feet, and all around Hill tops serene, pine-clad and glory-crowned"

TAKE THE CHILDREN TO THE SANDY SOIL AT CHEAP PARTY RATES BY

SOUTHERN ELECTRIC

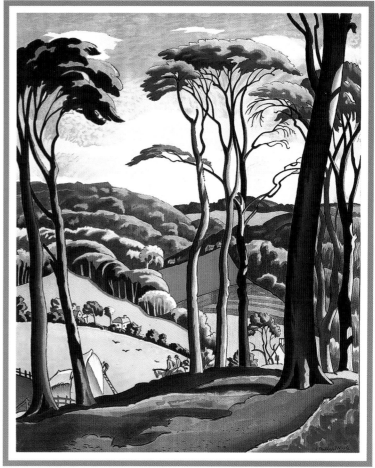

LIVE IN SURREY AND BE HAPPY!
FREQUENT ELECTRIC TRAINS DAY AND NIGHT.
"THE COUNTRY AT LONDON'S DOOR."
FREE AT ANY S.R. ENQUIRY OFFICE.

H. A. WALKER, GENERAL MANAGER.

254 & 255　　　The rolling hills of Surrey: artwork by Walter Spradbery (1889-1969:left) and Ethelbert Basil White (1891-1972:right)

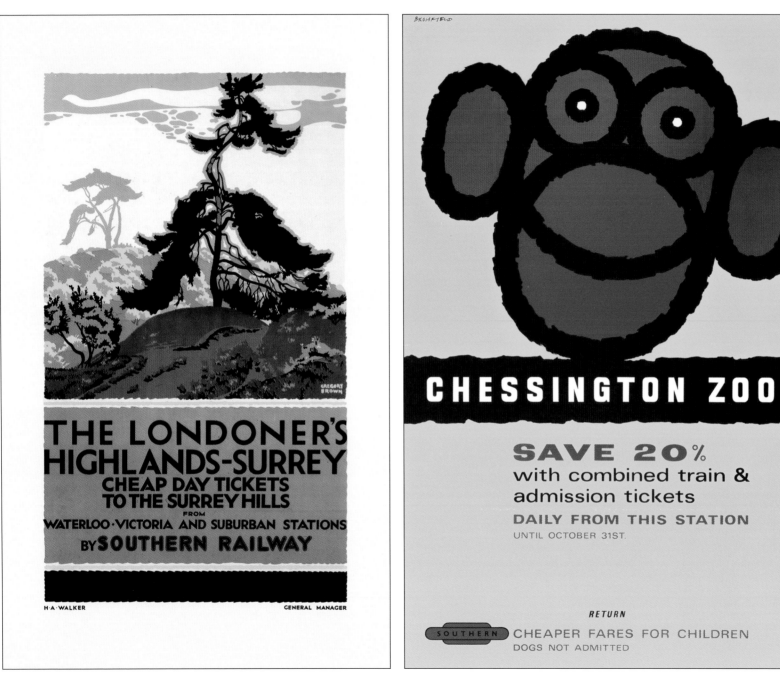

The Gregory Brown poster (far side) advertises cheap tickets to the Surrey Hills. This is an Area of Outstanding Natural Beauty designated in 1958. But even 30 years before that, it was touted as the 'Highlands of London' so that on weekends, people who lived nearby could walk and relax there. The Surrey Hills stretch from Farnham to around Oxted and extend south as far as Haslemere. The poster again shows pines on open heathland, but 40% of this area is covered in woodland. As well as Box Hill (see page 154) wonderful views can be found at Leith Hill, Newland's Corner, Gravelly Hill and the Devil's Punchbow, near Hindhead.

Time to go to the Zoo and Kew!

Chessington Zoo, near Surbiton in north-west Surrey, has always been popular. (Today it is advertised as 'London'). The zoo was founded in 1931 in the grounds of a large mansion house whose history goes back to the 14th century. At that time it was called Chessington Lodge. The original building became a Cavalier stronghold during the English Civil War, but was razed to the ground by Cromwell's troops. On rebuilding, it was named 'Burnt Stub' a name that it retains today. It was purchased by the Vere Barker family in the early 20th century.

256 and 257 Gregory Brown's 1929 depiction of days out in Surrey and Bromfield's 1961 poster for Chessington Zoo.

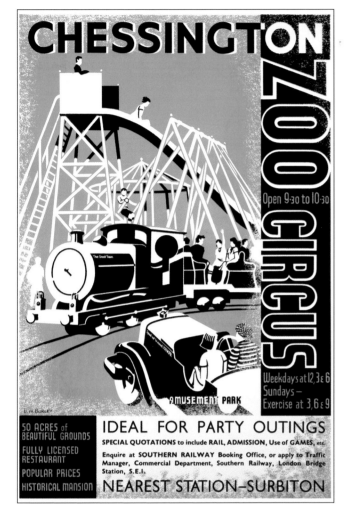 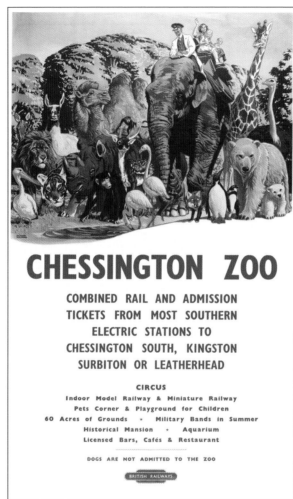 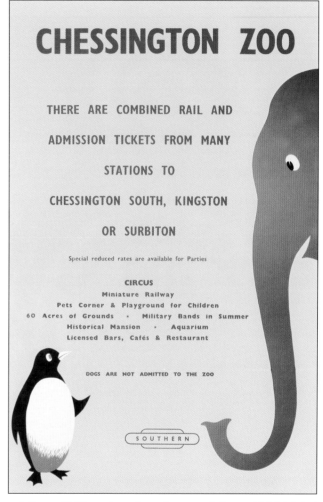

258, 259 and 260 Chessington Zoo Advertising: David Burley from 1935 (left), Raymond Sheppard (centre) from 1950 and unsigned artwork from 1956 (right)

Some years after the Vere Barkers took up residence, it was again ravaged by fire. Following refurbishment, it was put up for sale in 1931 and bought by a wealthy London businessman (R S Goddard) who decided to turn it into a zoo park to appeal to children. This opened in July 1931 and was an immediate success. Rides and attractions were added, and then a circus. Being so close to London, it had over 200,000 visitors in the first year and numbers rose thereafter. Naturally the railways wanted to be part of this success and began to advertise the attraction from 1935. The left-hand poster, above is one of a set of six issued that year to feature some of the animals and attractions on offer. David Burley, who was respected within the Southern Railway Publicity department, was commissioned to produce the six posters, which, when seen together, were quite colourful and would capture children's interest. This series was used up to the start of WWII, and it was not until 1950 that new advertising appeared. At that time, the best children's illustrator of animals was Raymond Sheppard; his artwork was produced in the form of a stock poster, with the picture above, and space left below where different station names could be printed for use in other areas of England. (The same artwork was used to advertise Dudley Zoo in the West Midlands). The detail in Sheppard's picture is quite remarkable - far better than that in the later poster from 1956 (right).

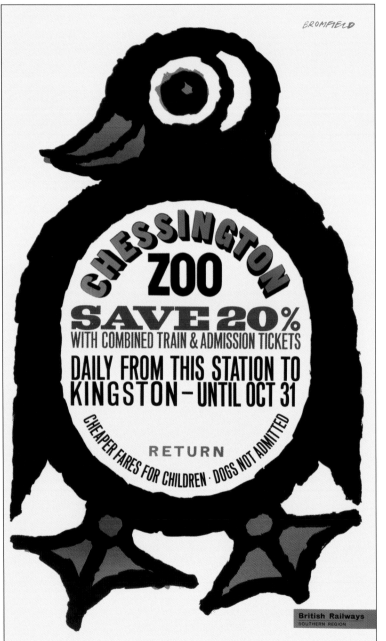

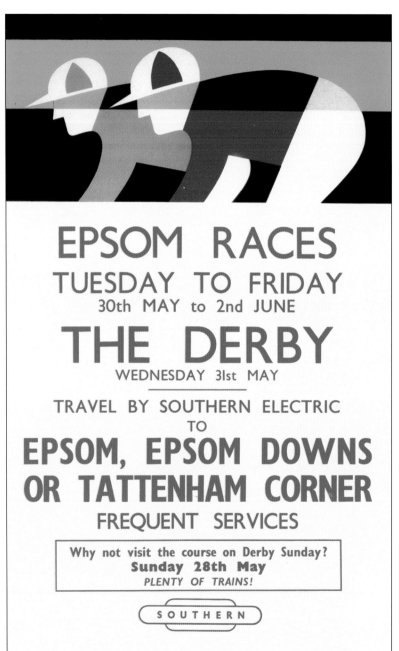

British Railways continued to promote Chessington until the mid 1960s, when advertising changed from artwork to photographs. Again the poster (far side) would attract children, but overall, the posters for Chessington were not the most striking. Even though it remained very popular, updating and new attractions were needed, and this occurred in the 1970s. In 1978 it was sold to the Madame Tussauds Group and the multi-million pound refit saw the park enlarged and greatly enhanced from 1981 onwards. In 1987 the whole attraction became Chessington World of Adventures, and in 2010 more than 1.4 million people passed through the entrances.

Surrey's second world-renowned venue is Epsom Racecourse, where the Derby has been run since 1780. Epsom Downs' first horse race was held in 1661, and it is home to several important events in the horse racing calendar, including the Oaks and the Coronation Cup. Each year the railway companies commissioned a new semi-letterpress poster, of which the nearer image is a representative example. Important artists were used - in this case the renowned Tom Eckersley in 1961 - and as shown here boldly coloured Art Deco type images featured on all the posters. The Derby, for 3-year-old horses, is the richest event in the racing calendar.

261 & 262 Two of Surrey's attractions: Chessington Zoo by Bromfield (1964:left) and Epsom Derby by Tom Eckersley (1961:right)

Surrey is also world-renowned for the fabulous Kew Gardens, where a unique collection of trees and plants has been steadily amassed since 1760. They were the brainchild of George III and his gardener, William Aiton, but Augusta, Dowager Princess of Wales, was also heavily involved. The plant collection is vast, with more than one in ten of all known species being held. The correct title is the Royal Botanic Gardens, but 'Kew Gardens' says everything.

Most of the travel posters publicizing the gardens were commissioned by London Transport and readers are referred to the excellent book by Jonathan Riddell *By Underground to Kew* published in 1995 (see Appendix C). I have therefore used only two railway posters to ensure Kew was on our itinerary. They also illustrate the huge change in style for the same location over a 50-year span. The 121 hectare site between Richmond and Kew is bounded by the Thames along its northern boundary. Within the grounds are numerous collections, both in glasshouses and outdoor gardens. Cacti, grasses, orchids, roses and rock gardens are found in all their glory and visiting throughout the year brings new colour and delights. It is simply a quite fabulous place for days out!

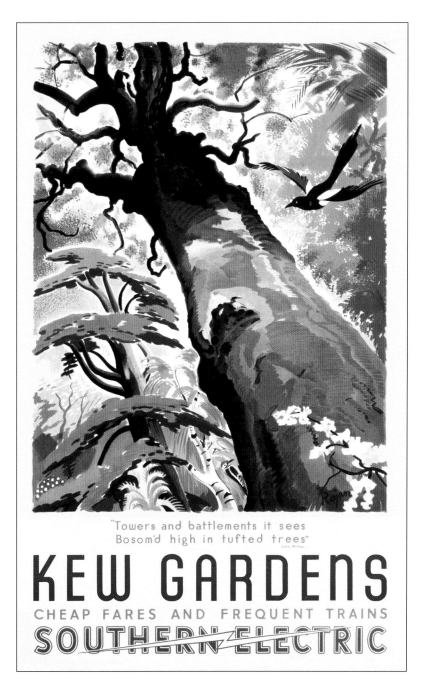

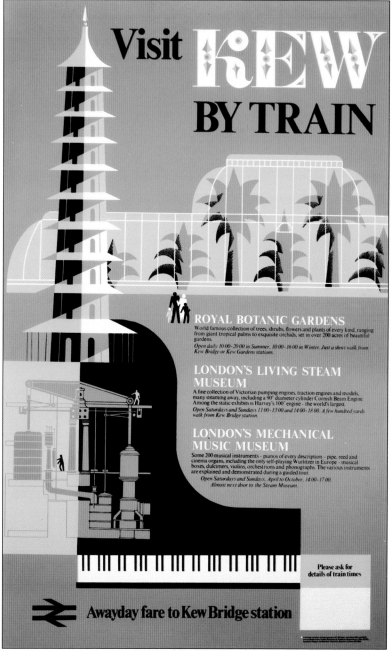

263 & 264 Surrey's world-famous gardens at Kew: *Rojan* from 1937 (left) and unsigned artwork from 1978 (right)

These three pieces of art see us on the old northern border of Surrey. Richmond Bridge features in two pictures, while market day in Kingston, with the Town Hall left of centre, is shown at the bottom. Since 1965, Richmond has been in Greater London. Richmond Palace was built here in the sixteenth century, thus naming the town. It is noted for its high quality of life and is only 8 miles (13km) from Charing Cross, and used to be part of Kingston-on-Thames. Initially landowners resisted the construction of a railway to their town, and the first station was built at Surbiton in 1838. By the 1860s Kingston had a station on the branch from Twickenham, which was later taken through to the main line at Surbiton.

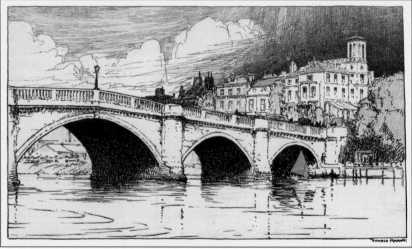

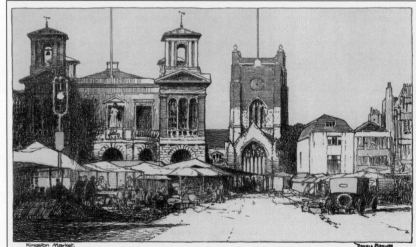

265 Colourful Richmond, Surrey by Verney Danvers in the 1930s

266 & 267 Prints for Richmond Bridge and Kingston by Donald Maxwell

The Guildford Area

From the fringe of London, it is time to move south-west to Worplesdon and one of the rarer posters in the National Railway Museum's collection. In 1936 it was commissioned to encourage the development of housing and commuting; the favoured railway artist David Burley provided the painting, with its striking use of colour. What is interesting is the impression it gives of man's effect on the environment, and in some places our interference has led to an improvement. The poster is also a social commentary on that time: plots of two acres or more! You might be lucky to find such investments today, but the price of land in Surrey is considerably elevated from three generations ago. It has the same feel today as that shown in the poster in the 1930s. In 1086, Worplesdon was listed in Domesday Book as *Werpesdune*, with an annual income of £10. It is three miles north of Guildford and the railway station, opened by the LSWR in 1883, is 1½ miles (2½ km) to the southwest of the village centre. Commuting to London Waterloo is catered for with a half-hourly service. On Sundays there are currently no services, so the target clientele is clear.

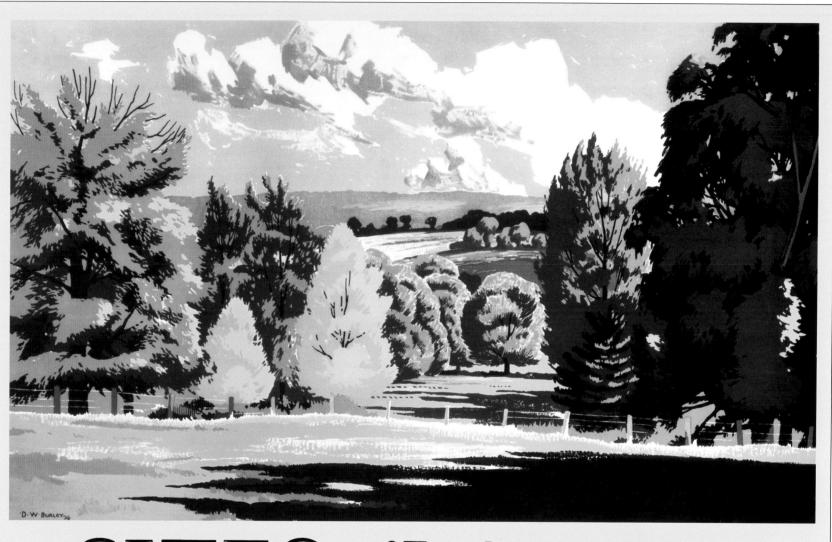

268 A rare 1936 poster in the National Collection: Worplesdon by David William Burley (1901-1990)

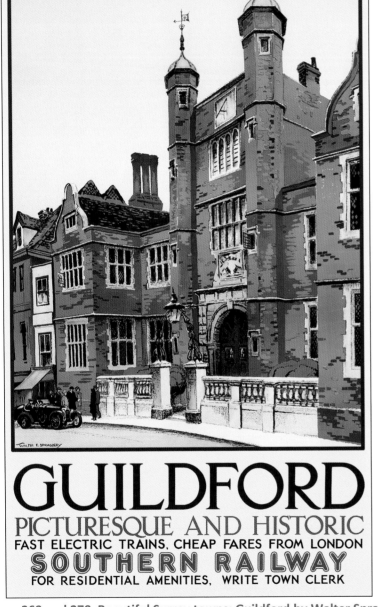

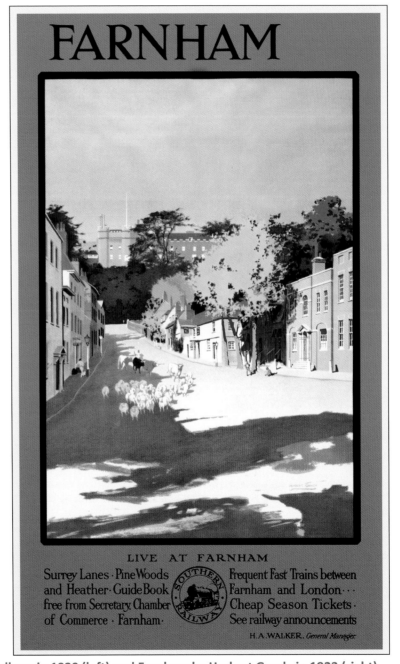

From Worplesdon, it is a short railway journey into Guildford, where our next poster advertises the town as 'Picturesque and Historic'. The town has Saxon roots, being built where the River Wey has carved a valley through the North Downs. The town's growth was slow but strong, so that by the tenth century, the Royal Mint was located here. It is listed in Domesday as *Geldeford,* and the owner is given as King William the Conqueror. As well as Guildford Castle, built by the king, the town has a notable Elizabethan Guildhall in the High Street that was extended in 1589. Of course the most distinctive building on the skyline at Stag Hill is the Cathedral, one of the few built during the 20th century. Unusually, the exterior is built in red brick rather than of stone. The diocese was formed in 1928, and by 1933 a design competition produced this building; the foundation stone was laid in 1936. Wartime and funding delays slowed progress and the nave was not started until 1955. The cathedral was finally consecrated in 1961. It is clearly modern in design and lofty; in bright sunlight the interior is impressive. The main LSWR line arrived here in 1845, and the station was essentially rebuilt and enlarged in 1880. It was completely rebuilt again in 1980 and currently serves over 750,000 people annually. From here we travel to Farnham to see our next poster.

269 and 270 Beautiful Surrey towns: Guildford by Walter Spradbery in 1930 (left) and Farnham by Herbert Gandy in 1923 (right)

Farnham is at the western edge of Surrey, close to the Hampshire border and 11 miles from Guildford. It is a most interesting town to visit, with many old buildings, including the elegant Georgian houses which Herbert Gandy has included in his poster. This artwork has richness and real warmth, harking back to former times, with sheep and cattle being driven down an urban street. East of the town the North Downs rise to form the prominent Hog's Back ridge. Nearby Waverley Abbey, dating from 1128, is England's earliest Cistercian foundation. In 1138 Farnham Castle was built by William's grandson, William de Blois. It is one of the few British castles where additions have created architectural awkwardness, but it is nevertheless important within the history of English buildings.

The poster here is also an unusual subject whose title must surely have commanded attention. Frensham Great Pond, and nearby Little Pond, are within Frensham Common. Although they look entirely natural the ponds were created in the Middle Ages to provide fish for the Bishop of Winchester's estate. They are a Site of Special Scientific Interest, with rare lizards, snakes and birds. The common extends over 922 acres (372 hectares) and is managed by the National Trust.

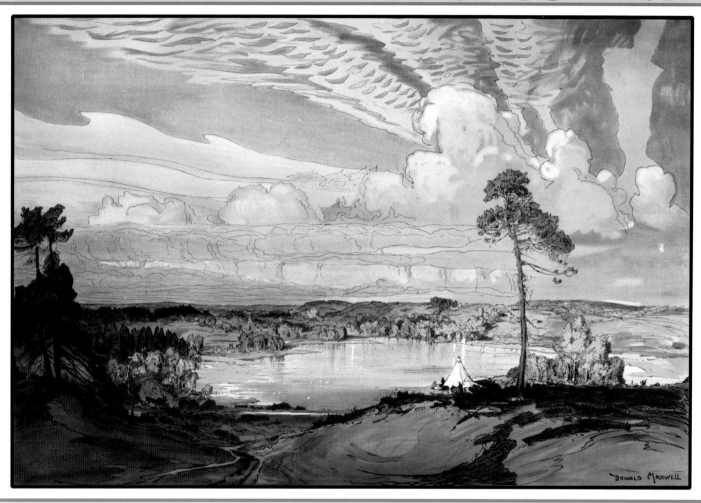

271 A strange Lake District: Frensham Great Pond, Surrey by Donald Maxwell for the Southern Railway in 1924

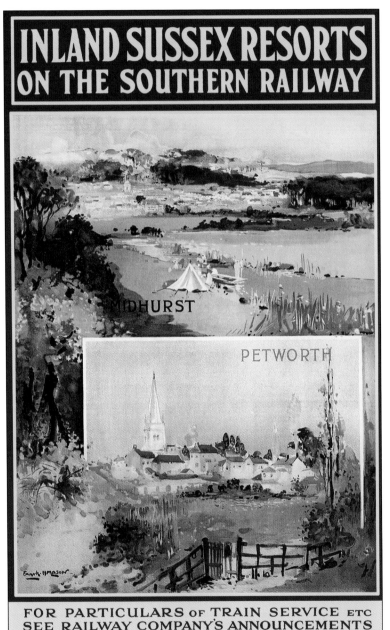

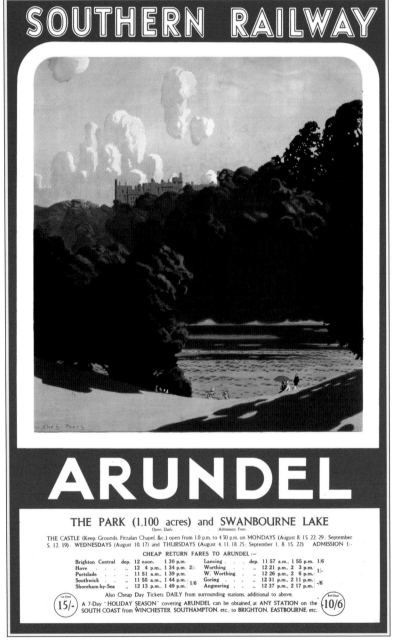

Back into West Sussex

In the final two pages in this chapter we stray across the southern border of Surrey to savour the delights of inland West Sussex.

This is a relatively unspoilt and lightly populated area, and the first poster (far side) is an uncommon Frank Mason offering for the Southern Railway, celebrating the countryside in this part of Sussex. The ruins of Tudor Cowdray House are close to Midhurst, alongside Cowdray Park, and its famous Polo Club. Midhurst itself is most picturesque and makes an excellent centre for exploring the local countryside. The same can be said of Petworth to the east, whose Georgian façades on Tudor houses have been sensitively preserved. Mentioned in Domesday, it is home to Petworth House, where the superb gardens are the work of Capability Brown: strangely, neither the house nor its gardens featured directly in any railway advertising. Good though Frank Mason was as a railway illustrator, this poster does neither town justice. Nearside is a brooding view of the imposing Arundel Castle. This wonderful structure appears on only one other poster (this is a 1978 poster painted by Reginald Lander).

272 and 273 Uncommon SR posters for inland West Sussex: Frank Mason from 1923 (left) and Charles Pears from 1932 (right)

Arundel was an important crossing point in the Arun Valley, shown beautifully here in Petherbridge's 1924 artwork for the Southern Railway. Small streams in the St Leonard's Forest combine and flow through Horsham, and are joined by streams from the Leith Hill area of Surrey. The river flows seaward to Arundel, reaching the coast at Littlehampton. Its length is a mere 25 miles (41 Km) but along most of its course it is fast flowing. The old ford at Arundel was strategic. The mouth was not always located at Littlehampton: in the late fifteenth century the river entered the sea at Lancing. The Arun Valley lies in a beautiful part of the South Downs, as our poster illustrates. The best known feature in the valley is the Norman castle at Arundel, built to protect northward routes through the Downs. Since the eleventh century it has been a stately home - and the seat of the Duke of Norfolk for over 400 years, - but the castle is currently owned and managed by a charitable trust. The view inside the quadrangle towards the Norman motte is simply wonderful: views of it from all sides are stupendous.

The final posters show the elegance of Edwardian Richmond, in Surrey, and the natural beauty of Sussex in the 1960s. These two counties have a lot to offer to the railway traveller.

274 An unspoilt part of England: SR Poster artwork from 1924 by Albert George Petherbridge (1882-1934)

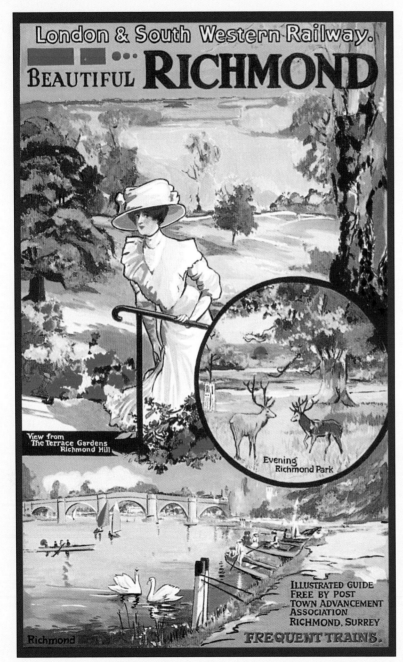

275 and 276 1909 elegance in Richmond (unsigned, left) and the beauty of the Sussex South Downs, Claude Buckle from the 1960s (right)

Chapter 7 Maritime Travels in Hampshire

Chapter 7 — Maritime Travels in Hampshire

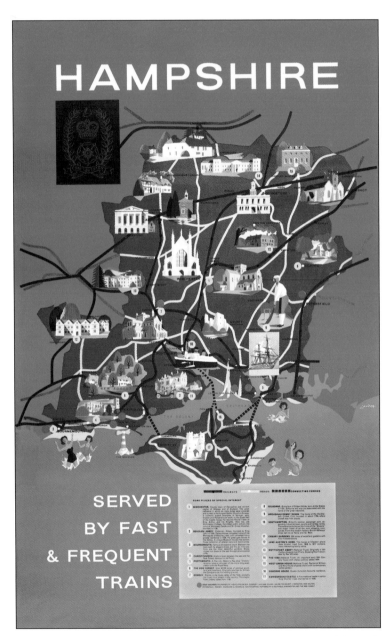

277 The delights of Hampshire: pictorial map by Reginald Lander

The County Overview

Hampshire is a large county, with a long proud history and exceptionally strong links with the sea. At its largest, it ranked fifth in size of the English counties and was one of the first recorded 'shire' counties. Winchester was once the capital of England, and Hampshire can lay claim to the birthplace of our armed forces. The geography ranges from ancient woodland in the west, a southern seashore that has changed over the centuries, downland in the north, and the chalk hills of the South Downs to the east. Clear, cool trout streams are paradise for the fisherman, while ramblers enjoy the superb New Forest and the Hampshire Downs. The boating and yachting fraternity is treated to a myriad of marinas, harbours and inlets in which to moor their vessels, when they are not racing up and down Southampton Water. The opening semi-pictorial poster announces that smooth, quiet electric trains can take visitors to attractions all over the county, and excellent links with the nearby Isle of Wight create the sense of a continental trip as we 'set sail' from England. The coastline is rather splendid, and the artwork below by Walter Langhammer shows houses nestling on the shoreline, with small dinghies to potter about in, and pines to offer protection. Hampshire has a pleasant climate, warmer and sunnier than the British average. We will travel roughly from east to west - with occasional detours inland.

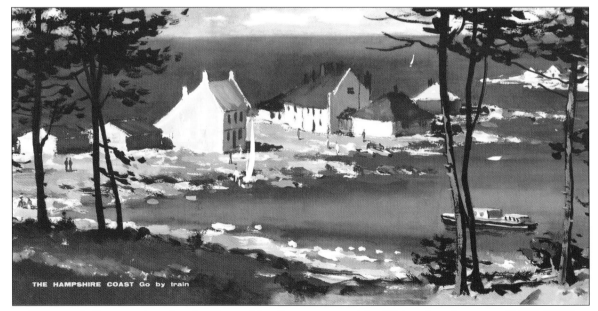

278 Railways advertise the Hampshire Coast: artwork by Walter Langhammer (1905-1977)

The 1980 poster by Reginald Lander shows the two parts of Hampshire. In reality the county can be divided into four distinct sections, plus the industrial seashore, with the cities of Portsmouth, Southampton and Bournemouth (now in Dorset) taking the traveller into a totally different world. Away from the coast, much of Hampshire is characterized by chalk uplands, dotted with sheep and tiny flowers. Skylarks soar above, singing their hearts out, looking down on wide open spaces. At the other extreme, there are dense parts of the New Forest, still tranquil save for birdsong, and the residents are old oak and beech trees with wide green canopies. This area cries out for leisurely exploration, with Lyndhurst, Brockenhurst and Lymington all needing time to view. In the north-east and south-west of Hampshire, we encounter the heathland, where purple and mauve clothe the landscape, but for most of the year, browns and greens intermingle. South of the chalk, the Itchen, Test and Avon meander through fertile valleys. While the clear waters of the Itchen and Test are swallowed up by the tidal flows in Southampton Water, the Avon reaches the sea at Christchurch Harbour, sheltered by Hengistbury Head.

The county has an area of around 1500 sq miles, excluding the Isle of Wight, which became a separate authority in 1974. For the purposes of the database however, posters from the island are listed at Hampshire (IOW). Bournemouth was in Hampshire until 1974. It is listed here as Hampshire, as most of its posters relate to their time of issue. However Bournemouth posters will appear in Volume 7, because there was such a wide choice for the present volume, and far less for the South-West; hence a re-balancing exercise was necessary.

Hampshire is also sometimes called the 'Gateway to the World'. This refers to those famous docks at Southampton where the great Cunarders and Union Castle liners used to sail to widely scattered destinations, and where the boat train from London ran straight onto the dockside to disgorge and collect eager passengers: those arriving to see London and those departing to see New York. I have vivid memories of my time there, going on board the QE2 when she was brand new, and marvelling at the size of a modern ocean liner. It was from here that the Pilgrim Fathers set sail for the New World, stopping in Plymouth before the Atlantic crossing. As well as the passenger terminal, the freight quays are significant and only Felixstowe in Suffolk has larger facilities. Along the coast, Portsmouth has been home to the Navy for centuries and today it is divided into the historical and working naval areas. Railways were essential to both ports, so that people and materials could be effectively moved. Indeed the first railway line of real importance in the south was built by the London & Southampton Railway Company to link port to capital. Proposals were discussed before 1830, but it was not until four years later that construction started. Numerous delays and the inevitable politics meant that the line did not fully open until May 1840; the London terminus was temporarily at Nine Elms. Four tunnels were needed, and the lovely valleys of the Itchen and Test proved the most difficult to cross. Railway posters throughout this chapter show just how important Portsmouth and Southampton are to Britain.

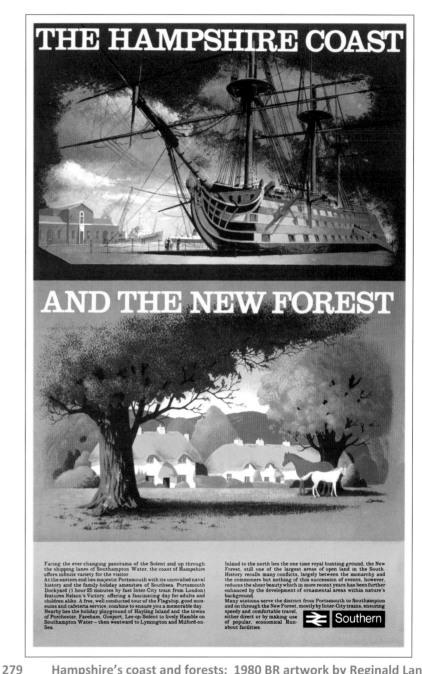

279 Hampshire's coast and forests: 1980 BR artwork by Reginald Lander

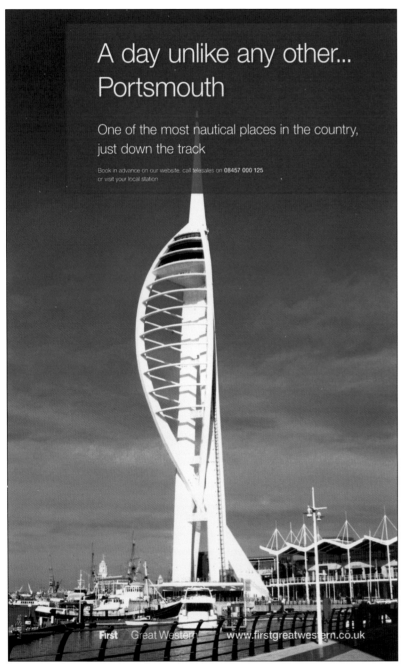

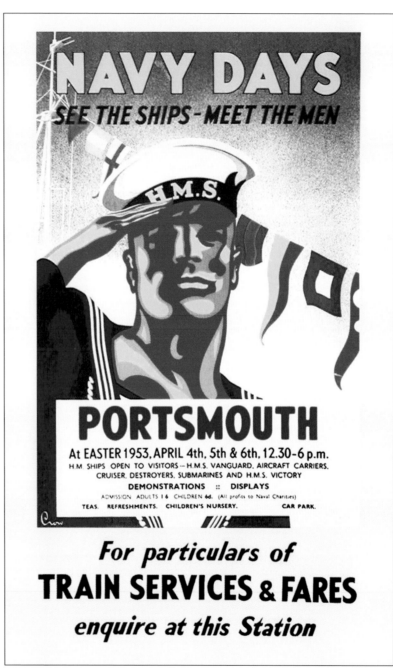

The Home of the Navy

Having set the scene, we begin travelling Hampshire at Portsmouth. The two faces of Hampshire in the previous poster are repeated here with two faces of Portsmouth in a trio of posters. 'Pompey' (to the Royal Navy) has been home to our fleet for more than 500 years. It has also developed important civilian cross-Channel links with France and northern Spain. But as well as significant history, it has a modern face, with the First Great Western (FGW) poster far side illustrating the Spinnaker Tower, built in 2005, overlooking the harbour. This is 560 ft high (170m) and offers spectacular views from three levels over the city.

In 1953, British Railways advertised day-trips to Portsmouth to see the ships over the Easter weekend, in the days when we had a significant fleet. Aircraft carriers, frigates, destroyers and other vessels were on display. The flagship then was *HMS Vanguard* a 44,000 tonne battleship, on which work was started during WWII, but was not commissioned until 1946. It must have been a wonderful sight, to see the vessel moored with flags aloft, and the crew on ceremonial duty. It was therefore a pity that only 14 years later she was scrapped.

280 and 281 Images of Portsmouth, new & traditional: photographic FGW from 2009 (left) and poster signed *Crow* from 1953 (right)

The face of Britain's navy is personified by just one ship, and the railway chose to honour *HMS Victory* in this 1937 quad royal. Think of the '*azure main*' and '*Rule Britannia*', and Nelson's flagship at Trafalgar immediately springs to mind. Posters that feature *Victory* are few in number, but this one is most striking. The SR often commissioned Kenneth Shoesmith between the late 1920s and late 1930s, and this is one of three Hampshire posters he produced. *Victory* was built at Chatham Dockyard between 1759 and 1765. She was a 104-gun fighting vessel that cost the equivalent of more than £7M in today's money. *Victory* distinguished herself at the Battles of Ushant, Cape Spartel and Cape St Vincent in the 18th century, before Nelson raised his flag as Captain in 1803.

In the Battle of Trafalgar, which took place in 1805, Nelson's tactic of using two columns to break the French line was decisive. Portsmouth has been home to this famous vessel since 1922, when she was moved to No. 2 dry dock and restored to her 1805 condition. She is a fantastic ship and worthy of a full quad royal. Some damage to *Victory* was inflicted during the bombing raids on Portsmouth, but this was repaired. In 1964 she underwent further restoration and yet more in 2005, so that for the bicentenary of the battle, she was in quite superb condition. No wonder more than 350,000 people now visit each year.

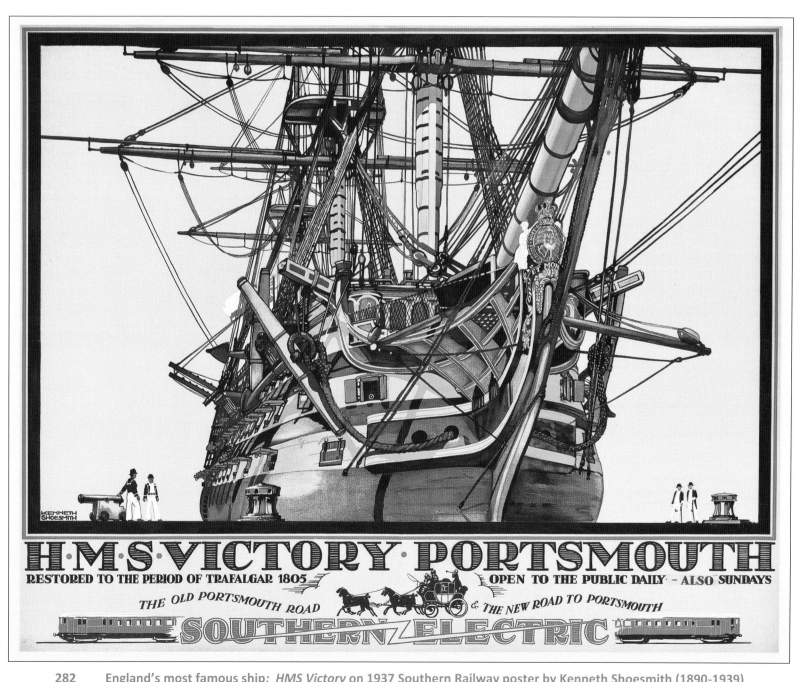

282 England's most famous ship: *HMS Victory* on 1937 Southern Railway poster by Kenneth Shoesmith (1890-1939)

These took place before and after WWII, with paddle steamers taking passengers around the fleet moored at Spithead. Leslie Carr's 1937 patriotic poster, below, shows the might of Britain's fleet before the ravages of WWII took their toll. By 1941, the battleships *Warspite*, *Barham*, *Iron Duke*, *Royal Oak*, *Revenge*, *Nelson*, *Rodney, King George V, Prince of Wales* plus others saw action all over the world as the global conflict grew. In the Naval reviews, ships from the fleets of our allies would also be included, and surprisingly, the new German pocket battleship *Admiral Graf Spee* (built 1936) was on view in 1937. This was also the final time HMY *Victoria and Albert III* was used before she was scrapped. Posters such as the one below were produced for each year that the Spithead Review took place, and SR steamers sailed in conjunction with special trains that ran from London into Portsmouth Harbour station. The next review was held in 1939, just before the outbreak of war, and the first full post-war review took place in Coronation Year, 1953, when hundreds of ships lined up to celebrate Queen Elizabeth's accession to the throne.

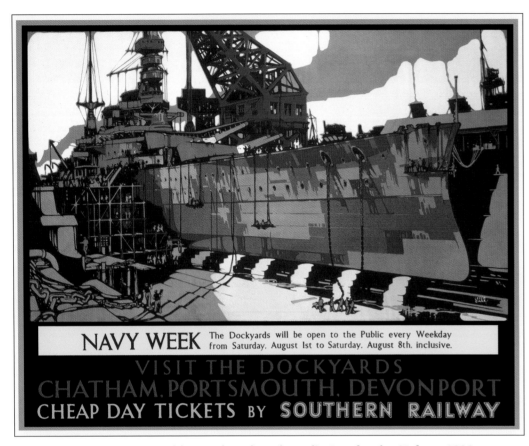

283 Portsmouth's Naval Dockyard: Leslie Carr for the SR from 1930

Portsmouth is one of the three strategic naval dockyards, and Leslie Carr's 1930 SR poster shows one of the navy's battlecruisers in dry dock. The Royal Navy used to have a string of facilities around the world, a few of which still support our shrinking fleet. Portsmouth was established in 1495 and used by Henry VIII. The dockyard was extended from the 1680s, when three development phases saw the harbour turn into Britain's most important naval base. By the start of Queen Victoria's reign it had trebled in size, with 62 acres of basin and 15 dry dock facilities covering more than 300 acres. It has seen some of our most famous ships over the years, and the historic section houses *HMS Warrior*, and *Mary Rose,* as well as *Victory* and the Royal Naval Museum. It used to hold the title of Royal Dockyard, but this was lost in 1984, when it became simply known as Portsmouth Naval Base. The former Royal Yacht *Britannia* was also based here until she too was 'retired'. The facilities have long been open to the public, and several Naval Reviews were also formerly held here.

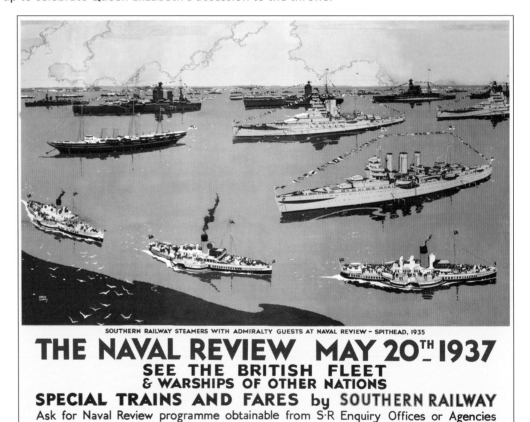

284 Displaying the fleet at Portsmouth in 1937: artist Leslie Carr

Portsmouth is not just about the Royal Navy and ships. The other half of the city is entirely different, and the second group of posters reveals a happy, social side. Moving a mile or so south from the harbour area we arrive in Southsea, whose 'seaside face' was on several of their posters in the first half of the 20th century. Southern Region station totems heralded arrival at Portsmouth & Southsea, but residents along the foreshore call it Southsea & Portsmouth! The posters reinforced the order of words. This part of town occupies the southern end of Portsea Island. Its character and appearance are quite unlike its larger neighbour to the north. Originally there was only a fort and lookout point, built in the time of Henry VIII to give early warning of impending attacks on the naval base. Buildings started to appear only in the early nineteenth century, and over the next 60 years steady development occurred. During WWII it was heavily bombed, as the whole island was a strategic target. Walking along the seafront today, watching the ships, or taking the sea air on the piers are some of the delights of modern Southsea. Posters here have always been colourful.

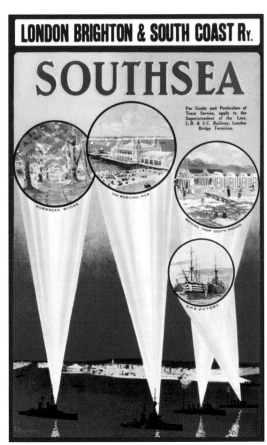

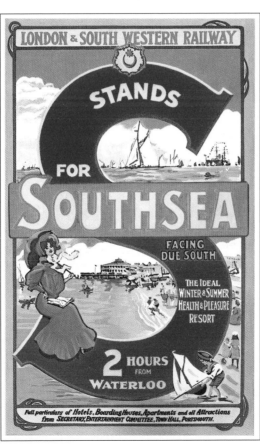

285 and 286 Early 20th century posters for Southsea; both are unsigned

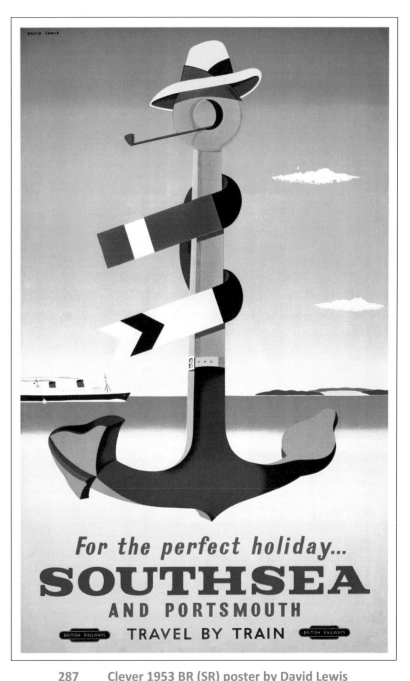

287 Clever 1953 BR (SR) poster by David Lewis

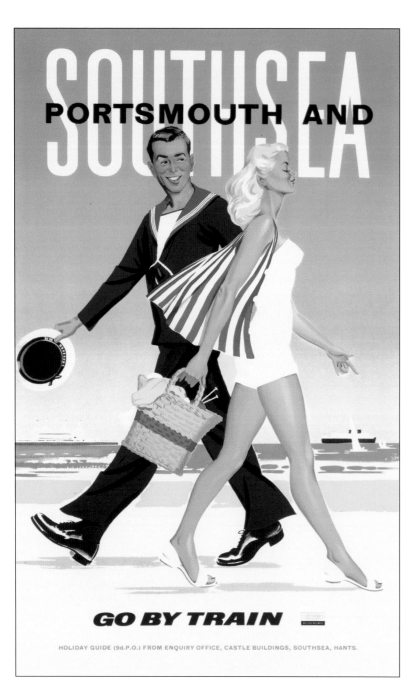

The two early 20th century posters show how rivals LBSCR and LSWR portrayed the town. One went for the naval side and the other featured holidays. David Lewis's rather clever poster and the Laurence Fish poster taken together reveal an insight into how BR choose to advertise the town. Both have Southsea more prominent and reveal nautical touches with a seaside bias and yet dwell on neither. While researching Laurence Fish's work as part of a forthcoming book, I was told that posters for Portsmouth and Southsea were decided by committee. Portsmouth wanted the navy, while Southsea preferred the beach. Both artists therefore made excellent compromises to satisfy all the committee members, and both are first-class examples of good poster art: bold and direct. In complete contrast, the two below could be a beach scene anywhere. In all three posters on this page, Southsea is emphasized as the holiday resort, even though the beach is mainly shingle, with sand only being uncovered at low tide. There are two piers: one large and active (Clarence Pier), the other dormant, pending restoration (South Parade Pier).

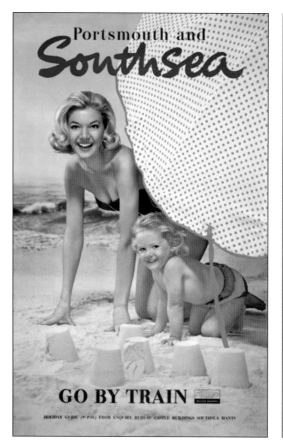

288 Superb 1960s railway poster art: Laurence Fish (1919-2009)

289 & 290 Holidays in Southsea anybody? John Dixon (left) and Mario Tempesti (right)

South Parade Pier features in Alker Tripp's early 1950s poster below. Pleasure ferries and the public tours for the naval reviews (see page 172) began from this pier. There is a large music hall, and the pier was famously featured in the highly acclaimed film *Tommy* directed by Ken Russell. It is currently awaiting complete restoration, having been purchased in 2010 following years of neglect. Nearby is Southsea Common, an area of land between the Clarence Pier and the site of Southsea Castle. This has some wonderful mature elm trees (Huntingdon Elms), planted almost 90 years ago: a rather unusual feature for a seaside promenade area. The most recent major gathering on the Common occurred in 2008, when Portsmouth FC brought home the FA Cup after their surprise Wembley victory. But it is sights such as those alongside right that have given this town its popular image

291 Uncommon early 1950s holiday poster for Southsea: Herbert Alker Tripp

292 Classic 'cheesecake' poster from mid 1950s: Alan Durman

England's former Capital

Moving away from the coast, we soon reach a small and lovely city. Winchester is the former capital of England and boasts a quaint, historic centre and a magnificent cathedral. Parliaments regularly met here, and kings were both crowned and buried within the city boundaries. The town began as a Roman settlement and for 300 years it developed as a regional capital. When the Romans left, the town had stone walls and good defences, but it soon declined and was abandoned until the Saxons 'rediscovered' it in the sixth century. They named the settlement *Venta Caester* after the Roman name of *Venta Belgarum*. In the eighth century this Saxon name mutated to *Uintancaester*, then to *Wintonia* by the ninth century, and later *Wintancaester*, before being shortened to Winchester.

King Alfred is the monarch most associated with Winchester but, even before those times, Winchester saw noble battles, Caedwalla defeating Atwald for example. Later King Egbert (771-839) made the city the capital of Wessex, but it was sacked by Danish invaders in 860. Alfred fought many battles against the Danes, and stories surrounding his reign are legendary. He was King of Wessex from 871 to 899, and he laid out the city much as we see it today, including defensive walls, some of which have survived. Alfred also took control of the Mercian city of London, after battles and then treaties saw him take part of the old Kingdom of Mercia. Winchester was capital of Wessex and then England until shortly after the Normans arrived, who promptly selected London as the capital. The unsigned British Railways poster from around 1960 shows some of Winchester's medieval streets. It has changed little over the years, and buildings such as the Guildhall, constructed in the 1870s in Gothic style, the 12th century Castle, 14th century almshouses, and 11th century Wolvesey Palace are also of interest. Much of the Old Town that escaped the Luftwaffe succumbed to 'planners' who permitted some real monstrosities to be erected – thankfully being replaced with buildings suited to Winchester's past.

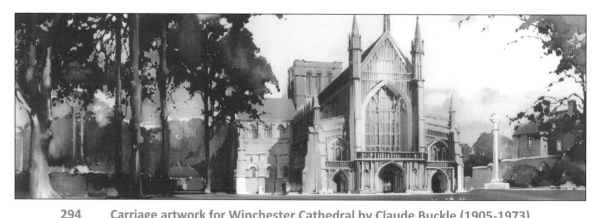

293 Rare unsigned BR (SR) Winchester poster from c1960

294 Carriage artwork for Winchester Cathedral by Claude Buckle (1905-1973)

The cathedral at Winchester is quite magnificent, as befits the place of worship for a former capital. The carriage print by Claude Buckle shows the west front, whilst the poster view looks east from the central nave. This site has been a place of worship for 1400 years, first as a small church, and today as one of our finest cathedrals. Railway posters are not plentiful, and those that have been produced do not show the internal beauty as well as they might. The nave is especially wonderful, very long, not so lofty, but awe-inspiring. It may be 550 ft (170m) long, but at 78 ft (23m) high, this is half that of Beauvais in France, for example. Consecrated in 1093, this cathedral was built from stones of an old Minster which had stood for 400 years. The arrival of the Normans triggered a huge building programme of castles, churches and official buildings throughout the land. The importance of Winchester was acknowledged by the grandeur of this structure. Money has been spent here down the years; every century remodelling and reshaping have taken place to produce the longest Gothic church in Europe. For example, the Gothic arches were altered in the 14th century and a great deal of ornamental detail was added in both 15th and 16th centuries. The Great East Screen dates from the 15th century, but suffered badly during the Dissolution.

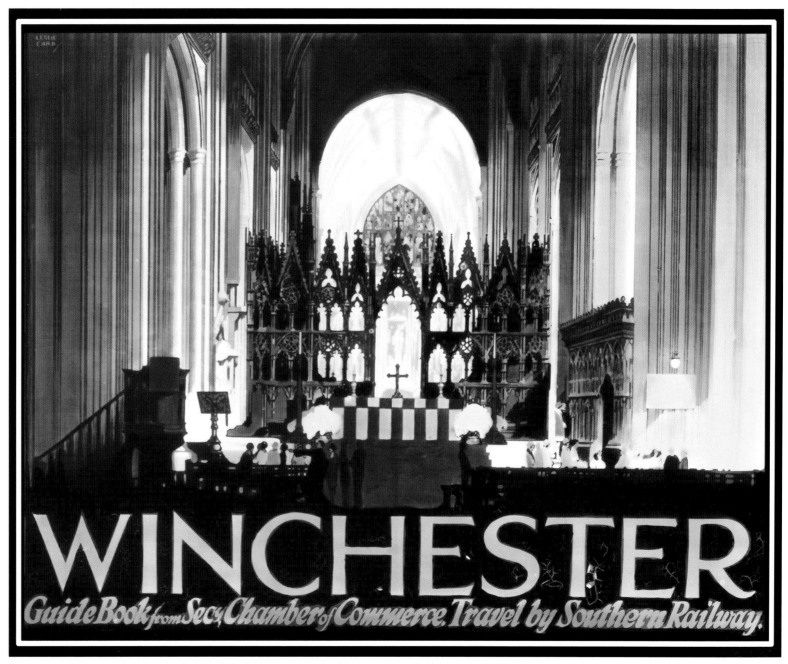

295 The beautiful altar area in Winchester Cathedral: 1929 SR poster by Leslie Carr (1891-1961)

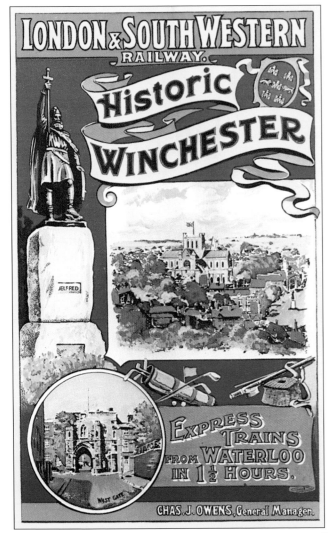

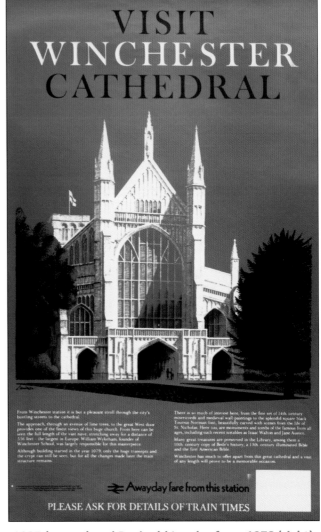

296-298 Winchester advertising through 20th century: unsigned from 1900s (left) Frederick Griffin from 1935 (centre) and Reginald Lander from 1978 (right)

The three posters above illustrate advertising for Winchester through the 20th century. The railways arrived here in 1839 (London & Southampton) so direct trains from Waterloo (above left) allowed easy travel to see the King Alfred legacy. The unsigned artwork features his statue, the cathedral and the West Gate. The interior of the cathedral is superb, so the central poster is somewhat disappointing. The same view from further down the nave would have shown the architecture to better effect, but when the sunlight streams through the southern windows, the effect is breathtaking. Much of the carved decoration, including the splendid craftsmanship of the choir stalls and misericords, and the corbels and roof bosses along the nave, is surprisingly secular, and in the Great East Screen, there is even a statue of Queen Victoria! But it is the view from the north-west corner of The Green towards the West Front which often appears in guide books, so the monochromatic poster from Reginald Lander shows the detail without the colour. The Buckle print is far, far nicer.

Apart from its wealth of architectural and historical possessions, the cathedral is also noted for an impressive array of famous connections: the shrine of St Swithun, from the 9th century; the burial of King Alfred the Great in AD899; several royal Coronations and marriages; and the grave of Jane Austen. It is time now to go south and continue our maritime travels.

City for the great ocean liners

Southampton is Hampshire's largest city and, over the years, home to some of the world's great ships. As a consequence, many railway posters were produced, depicting illustrious vessels that have brought the good, the bad and the famous to our shores for more than a century. It is a city I know well, and the imprint page painting by Norman Elford of the Ocean Terminal, with *The Cunarder* leaving for Waterloo, is a reminder of a great ship in a famous place served by a famous express. The Art Deco poster, alongside and made for the US market, is a superb example of graphic design: bold and sharp, and beautifully composed. The message is industrial, rather than for passengers, but it also informs everybody that one of the world's greatest dock complexes is owned and managed by England's Southern Railway Company.

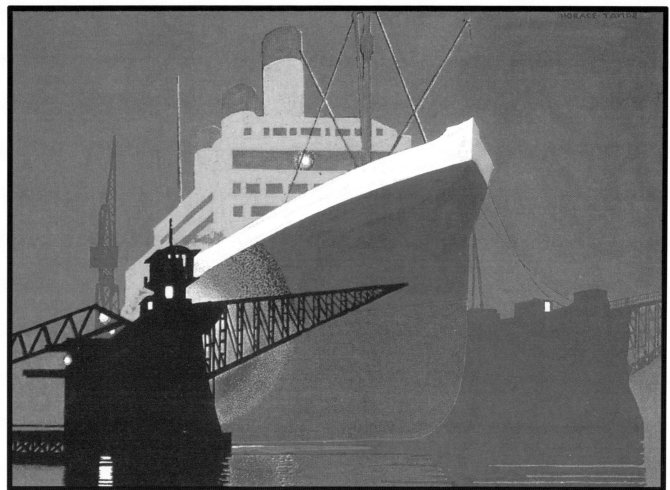

299 Definitive 1928 poster for Southampton Docks: artist Horace Weston Taylor (1881-1934)

These next few pages of posters show the maritime heritage of Southampton, with their text saying everything. Graphic design based images are intermingled with more artistically based images to illustrate the Railways' approach to advertising the docks. But it is not just a story of advertising. Herbert Walker (later knighted) worked tirelessly to expand the docks at Southampton and his clear vision of integrating all facets of transport earned him the respect of his colleagues and counterparts. He rightly publicised Southampton as a key port and city within the British economy. This pair of posters illustrates two of the great liners of the past (below) and depicts the stylised approach to the marketing of the enormous facilities that Walker's direction produced. The Southern Railway ran trains to see the great liners in dock, so this was the message in Leslie Carr's poster below.

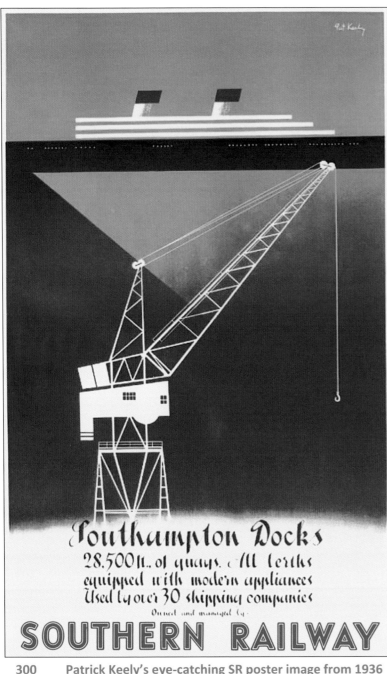

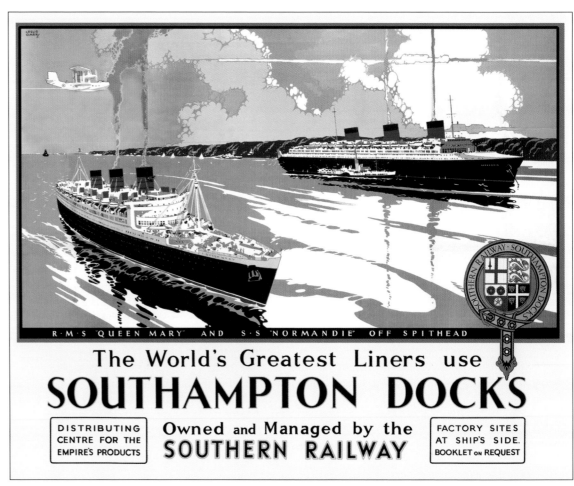

300 Patrick Keely's eye-catching SR poster image from 1936

301 Two famous liners at Southampton: SR Poster from 1936 by Leslie Carr (1891-1961)

This thought is carried on in the poster below, which, for the first sailing of a great ship such as *Queen Mary*, is rather disappointing. Built by John Brown at Clydebank, this well-proportioned vessel sailed the seas for over thirty years. She and her sister ship *Queen Elizabeth* were built to compete with the great American, French and German liners of the 1920s and 30s. She held the Blue Riband twice, from 1936 to 1937 (when the *SS Normandie* took it) and then from 1938 to 1952. That year, the *SS United States* took the title. The docks sit at the confluence of the Itchen and the Test that sees four high tides each day as a consequence of the geography of Southampton Water and the tidal flows within the English Channel. This gives a tidal variation of less than 6 ft (1.9m), allowing ships of all sizes to sail without having to wait for high tide. The extent of the dock facilities in 1938 is shown in the poster alongside, at a time when the Southern Railway was trying to encourage factories to move there. When air travel made journeying to New York a matter of hours instead of days, the number of trans-Atlantic trips fell, but Southampton adapted well and today is the centre of the world cruise industry.

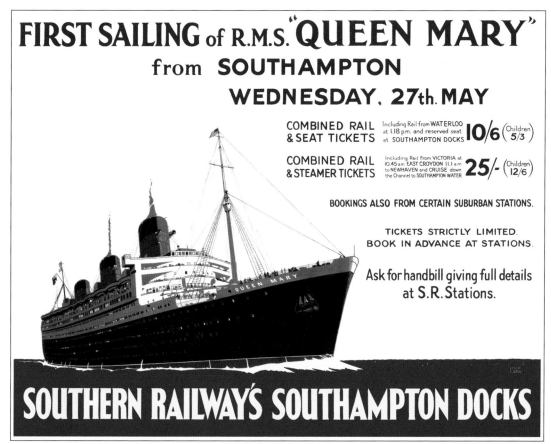

302 Maiden voyage of the *Queen Mary* in 1936: SR quad royal by Leslie Carr (1891-1961)

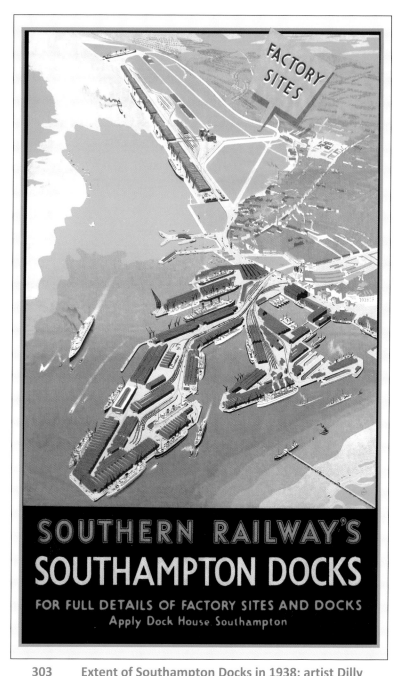

303 Extent of Southampton Docks in 1938: artist Dilly

The railways' arrival in 1840 transformed the docks, which up to that point had been served by paddle steamers plying across the English Channel, and where only small cargo ships were loaded and unloaded. Ferries had always been an unsung part of the port's operations, and the 1960 poster shows a vessel on the Southampton-Le Havre run, passing Fawley refinery as night falls. Within a decade many docks had been added, and over the next thirty years quays were added along the Itchen and Test, plus facilities out into the confluence. Of the main shipping lines, P&O came first, followed by the American Line, then White Star and finally Cunard. The eastern docks were completed by 1911, with the White Star Dock, but this became the Ocean Dock when both Cunard and Canadian Pacific started to use it. Even before this the LSWR, who had money to spare, became owner and operator of the docks. They successively expanded both the docks and the support infrastructure to meet the rising demands.

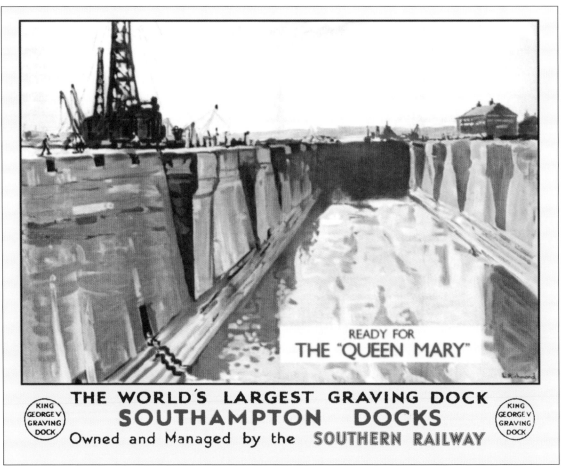

304 1960 Cross-Channel services from Southampton: artwork unsigned

305 Artist's impression of the enormous King George V dry dock: Leonard Richmond

However the size of ships increased faster than the size of the dry dock facilities, necessitating the development of the western docks. These opened in 1934 and contained the King George V dry dock, designed to take ships larger than anything that could be conceived for a century or more. Leonard Richmond's poster on the previous page and the Donald Maxwell poster below were two of a series commissioned in 1933 to show the development of shipping support infrastructure ahead of the opening of the western quays. These eventually became the container port and today are a hive of activity.

The famous Ocean Terminal, where *Queen Mary* and *Queen Elizabeth* docked, opened in 1950 and included a railway station, media centre, baggage and cargo handling, and of course luxurious passenger comforts. It was, sadly, demolished in 1983 as Southampton modernized to take the large cruise liners. Today there are four terminals, all upgraded this century, with the Queen Elizabeth II and Mayflower Terminals dating from the 1960s.

307 A famous Southampton Docks poster: Leslie Carr (1891-1961)

306 Opening of the Graving Dock in 1933: artist Donald Maxwell (1877-1936)

The years before World War II were a period of intense activity, when the title of 'Gateway to the World' appeared. In 1936 the docks handled 46% of all the UK shipping traffic and an impressive 90% of fruit imports from South Africa. The famous 1931 poster above shows the Canadian Pacific liner *'Empress of Britain'* moored in the eastern docks: she was sunk in the North Atlantic in 1940. A Cunarder (red funnels) is moored alongside. In 1936, more than half a million passengers passed through, with just as many sight-seers, and 100,000 people taking cruises. Poster 300 showed just one of the 140 cranes that serviced the vessels. It was a golden time for the UK and for the SR owners. They issued a guidebook each year to publicize their docks, and in 1938 this showed that almost 8,000 trains used the freight and passenger stations during the year. The tonnage of goods moved was colossal. Cross-Channel ferry services eventually moved to Portsmouth but, for a period in the 1960s, ships ran from Southampton to France, Spain and the Channel Islands.

Western Hampshire and the New Forest

Nearby is a beautiful part of Hampshire, a former royal hunting forest and the home to ancient boat-building on the Beaulieu River. Therefore the number of pieces of railway art found is surprisingly small, but this rare SR poster from the 1920s shows a typical scene in the New Forest. This is the largest unspoilt area of heathland and woodland in southern England. Like much of England, it was covered in deciduous woodland, but gradual clearing for fuel and agricultural purposes left all the surrounding areas largely free of trees. The area was declared a Royal Forest by William I around 1079, but the need for timber saw thousands of oak trees felled over the centuries. Many were replanted but, of course, usage always outstripped supply. Various statutes protected the rights of commoners, and, over the years, the whole area gradually became protected. The Crown still owns around 90% of the New Forest National Park, which covers nearly 220 sq miles (566 km^2).

308 Southampton's medieval Bargate: artist Donald Maxwell (1877-1936)

There is much more to Southampton than just the docks area. Its location close to Winchester and then London, plus easy access to the sea, saw it develop naturally as a port. In Roman times it was *Glausentum* and within easy marching distance of Chichester and Winchester. When the Romans left, the Anglo-Saxons moved the centre across the Itchen and named it *Hamtun*. By the eleventh century, records had it listed as *South Hamtun*. It suffered Viking raids, and King Canute the Great was crowned here in 1014. The coming of the Normans saw the start of city fortifications, work which was to continue for almost 300 years. The artwork above shows Bargate, the main gate into the port area from the north, which was constructed around 1180. The eastern walls came next, and it was not until after the French raids had ceased that the western walls were added around 1380. Much has survived of the many towers and gates which made the city appear impregnable. During the Stuart period, the *Mayflower* departed from there; later in the seventeenth century, during the Civil War it was a Parliamentary stronghold. The Georgian era saw spa facilities and rich merchants' homes added, but growth accelerated with the coming of the Industrial Revolution and then the railways. It was the home to the Spitfire, which transformed RAF Fighter Command, and through Vosper Thorneycroft, Southampton has strong Royal Navy links. Today, it is a bustling city with world-class Universities, which are strong in engineering, and home to the National Oceanography Centre and Ordnance Survey.

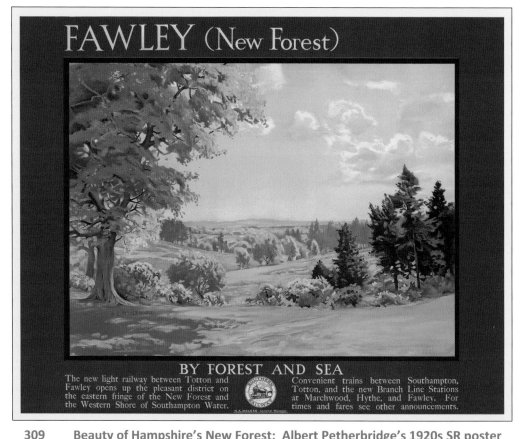

309 Beauty of Hampshire's New Forest: Albert Petherbridge's 1920s SR poster

Of this area one fifth is native woodland and the same amount is natural grassland and heathland. The forestry plantations account for another 15% of the protected space. The remainder is wet heathland, inhabited areas and some pine sections. Ponies are the best known residents of the New Forest, but this part of Hampshire is home to less common native birds, mammals, insects and plants. These two posters from around 1960 show how BR marketed the delights on offer. The final poster shows how the SR portrayed the area, using a quotation from the work of Shelley, but taking the opportunity to include reference to the new *Bournemouth Limited.* This ran between 1929 and 1939, often hauled by *'Schools'* Class locos, and featured here is engine 938 *St Olaves* built in 1934. This poster is dated 1938, so the use of the word 'new' is marketing propaganda – and the service had less than a year to run. No posters have yet surfaced to feature Beaulieu, Buckler's Hard, Brockenhurst, Lyndhurst or even Lymington; hopefully, this fact may cause uncatalogued items to surface. The Danvers poster (far side) shows how lovely this part of the Hampshire coast is: it is a walker's paradise. But it is now time to leave the mainland and make our final tour on the Isle of Wight.

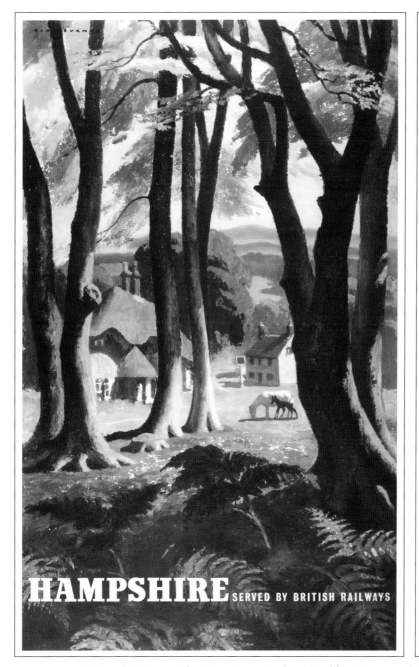
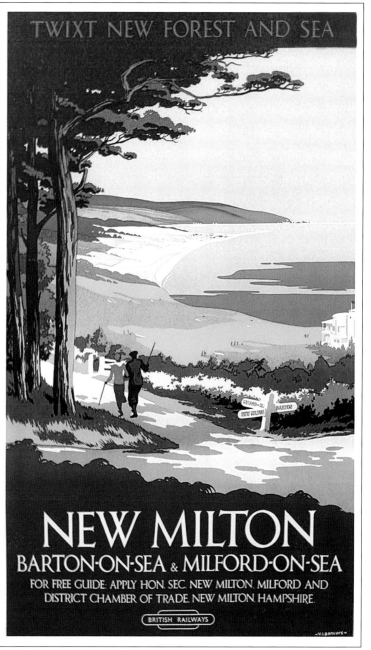

310 and 311 The New Forest advertised by BR around 1960: Alan Durman (left) and Verney Danvers (right)

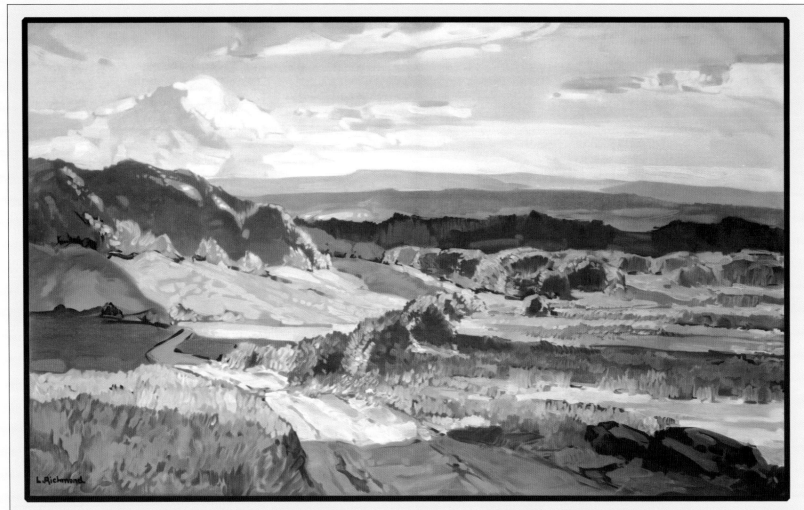

"We wandered to the Pine Forest that skirts the ocean's foam —"
Shelley.

TO HAMPSHIRE & THE NEW FOREST QUICKLY BY THE NEW "BOURNEMOUTH LIMITED"

SOUTHERN RAILWAY

312 The New Forest in 1938: artwork for the Southern Railway by Leonard Richmond (1889-1965)

Chapter 8 Off England's Southern Coast

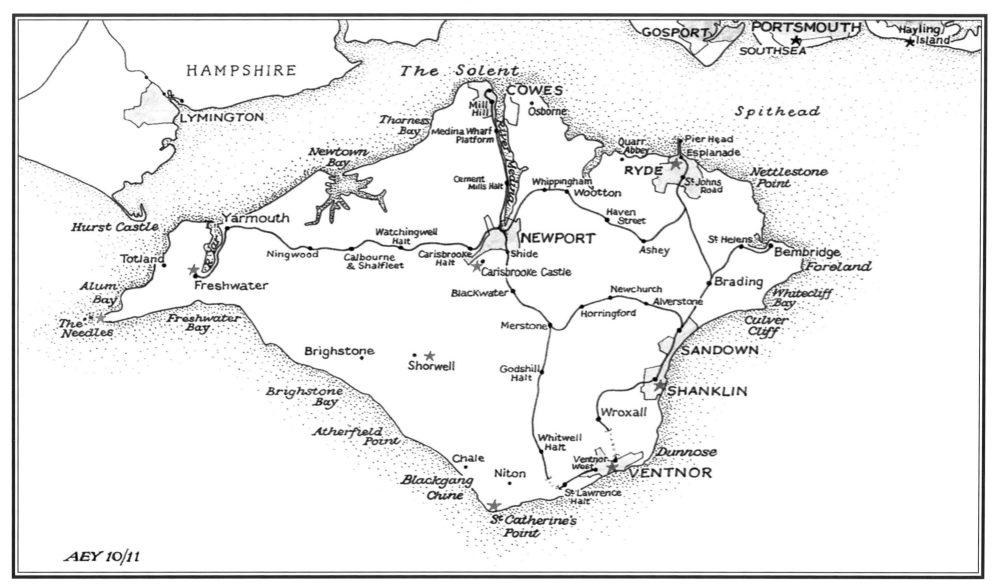

HAMPSHIRE

The Solent

GOSPORT

PORTSMOUTH

SOUTHSEA

Hayling Island

LYMINGTON

Spithead

COWES

Mill Hill

Osborne

Thorness Bay

Medina Wharf Platform

Quarr Abbey

Pier Head

Esplanade

Newtown Bay

Nettlestone Point

RYDE

St Johns Road

Cement Mills Halt

Whippingham

Hurst Castle

Yarmouth

Wootton

Haven Street

Watchingwell Halt

NEWPORT

St Helens

Totland

Ningwood

Calbourne & Shalfleet

Carisbrooke Halt

Shide

Ashey

Bembridge

Foreland

Carisbrooke Castle

Alum Bay

Freshwater

Blackwater

Newchurch

Brading

Whitecliff Bay

The Needles

Freshwater Bay

Merstone

Horringford

Alverstone

Culver Cliff

Brighstone

Shorwell

Godshill Halt

SANDOWN

Brighstone Bay

SHANKLIN

Atherfield Point

Wroxall

Whitwell Halt

Dunnose

Chale

Niton

Ventnor West

VENTNOR

Blackgang Chine

St Lawrence Halt

St Catherine's Point

AEY 10/11

313 The Isle of Wight portrayed by the Southern Railway in 1939: artist George Ayling (1887-1960)

England's Largest Island

In 1890 the Isle of Wight ceased to be part of Hampshire, but until 1974 it continued to have many links, both ceremonial and administrative, with its near neighbour. England's largest island was designated a non-Metropolitan county in April 1974. The railways always marketed it as 'The Garden Isle', an apt description and one which has encouraged people to visit since Victorian times. The poster, alongside, shows the island's geography, lying as it does a few miles from the Hampshire coast, with ferry links from Yarmouth in the west to Ryde in the east. Beaches ring the coast, so all the resorts partake of the sunshine, and offer scenery and the sports facilities that Ayling's poster advertises.

The island's dimensions are 23 miles (37km) east to west and 13 miles (21 km) north to south. Just before World War II, the island's Infrastructure was good, with roads giving access to the beaches, and railways linking the main ferry landing points with the major towns and the more popular resorts. This 1939 poster shows ferries from Lymington to Yarmouth in the west, Southampton to Cowes in the north, and Portsmouth to Ryde in the east, with an additional car ferry route from Portsmouth to Fishbourne. At this time, the Southern Railway operated the trains, though, from 1952 onwards, BR closures saw the railway system almost annihilated.

Considering the importance of the Isle of Wight as a holiday destination, and given that it was Queen Victoria's retreat from state duties, advertising and promotion by the railways was patchy at best, and few classic posters were produced. However an exception is the Air Service poster shown here, painted by Charles Pears in 1935. We will visit Railway Air Services (RAS) in more detail in Volume 8, but this poster illustrates the collaboration between a private company (Spartan Air Lines) and RAS in 1935. The plane is a Spartan III Cruiser, one of a fleet of 15 planes that the company ran from aerodromes in the London area to the Isle of Wight, and this aeroplane carried the RAS logo on the tail. The Cruiser range, of which three variants were constructed, was a three-engined plane designed to carry between six and ten passengers. They were built on the Isle of Wight at East Cowes by the Spartan Aircraft Company, and the Mark I first flew in 1932. The builders decided to form their airline in 1933. They ran services linking London with the Isle of Wight for two years before beginning a collaborative service with RAS, which lasted just one season. Many of the other RAS posters show route maps, but Pears chose to depict the Cruiser over the island, in a far more artistic than informative way. Note the prices for single and return fares at that time: even with a full passenger load of eight people on this aircraft, the total revenue per trip was only around £10. Cruising at around 115 miles per hour, the twice-daily journey from either Heston Aerodrome (1933 and 1935 seasons) or Croydon Aerodrome (1934 season) to Cowes or Bembridge, took a comfortable 40 minutes.

The Isle of Wight itself has a rich history, including a period in the fifteenth century when, for a time, it was an independent kingdom. As with many parts of England it had Roman, then Anglo-Saxon occupation, and was one of the last parts of England to become Christian. The Norman Conquest saw great structures such as Carisbrooke Castle appear, but the island did not come under full control of the Crown until 1293, when the last Lord of the Isle of Wight died. The island was an important lookout-point during the conflicts with Spain in and around 1588. Shortly thereafter, with Spanish threats remaining a possibility, Carisbrooke Castle saw the construction of the outer fortifications.

It was not until the Victorian years that the island's popularity grew. The Queen did not like Brighton, the traditional coastal retreat for the Royal Family, but she took straight away to the Isle of Wight. Osborne House was built as the summer home for Albert and Victoria. The house was designed by Prince Albert and it was here that Queen Victoria passed away in 1901. The royal presence on the island ensured that other eminent people of the time visited. Charles Dickens wrote much of *David Copperfield* there, and Alfred Lord Tennyson visited, before Victoria created him Baron Tennyson of Freshwater in 1884. The island also has the distinction of being home to the world's first radio station, created by Marconi in 1897 on the Needles. This was a continuation of the island's 'look-out heritage' that was to see it repeatedly bombed during WWII. The railways came here relatively late, with the line between Newport and Cowes opening in 1862. Newport to Ryde opened in 1875, and within 15 years the island had an extensive series of routes, as George Ayling's 1939 poster indicates.

314 Air travel to the Isle of Wight in 1935: Charles Pears (1873-1958)

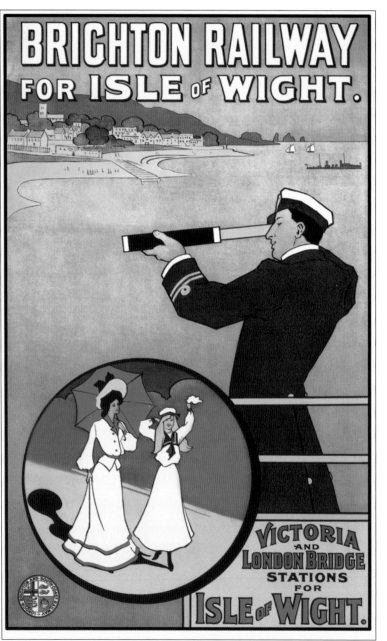

315 and 316 Unsigned LBSCR posters for the Isle of Wight from 1905 (left) and c1910 (right)

Early Isle of Wight advertising

This next group of images shows the early Edwardian posters designed to sustain visitor numbers after the Victorian era. The two mainland railway companies that served the island were rivals, as several of the English coastal destinations were served from London by both the LBSCR and LSWR. The former used Victoria and London Bridge stations, via Horsham and Chichester, as the poster, far side, shows, while LSWR services left from Waterloo via the more direct Guildford line, and thence to Portsmouth. The poster, near side, used 'Brighton Railway' as one of the shortened forms of LBSCR, the other being simply 'The Brighton Line'. The LBSCR traditionally had stronger links with the Isle of Wight, and carriage maps of their system in the NRM archives show the island lines as part of their system, as does the poster, far side. However, in 1880, they joined with the LSWR to take over the Portsmouth to Ryde ferry services. Together they built new pier facilities on the island as well as a short railway link to the existing St John's Road station. Both posters are social commentaries on the time, with smartly dressed people indicative of the clientele such advertising was intending to impress.

The poster, near side, shows a bolder approach adopted by the LSWR for Ryde, in contrast to the usual 'vignette type' image from the local railway company for the same period. Most Edwardian posters were noted for their fussiness, trying to place as many small images as possible on the poster. By this time, however, the popularity of the Isle of Wight was immense, especially with Londoners, primarily due to the regular presence of Queen Victoria in her later years, so there was really little need to advertise the island.

In the seventeenth century, Ryde was two small villages (Lower and Upper Ryde). As it grew, the architecture and nature of the villages changed; today the character of the main town and Esplanade area is strongly Victorian. Until Ryde Pier was built in 1814 boats from the mainland had difficulty in landing, At 1,730 ft (527m) in length, this was one of England's longest; within 20 years it had been extended to 2,234 ft (681m). A second pier opened in 1864, with tram connections to the Esplanade. The coming of the railways prompted the construction of a third pier in 1880 to provide a direct link from the ferry docking point to pier head. This was a joint venture between the LBSCR and the LSWR. The tramway pier is now partly dismantled and decaying, but the other two piers remain, and were 'listed' in 1976.

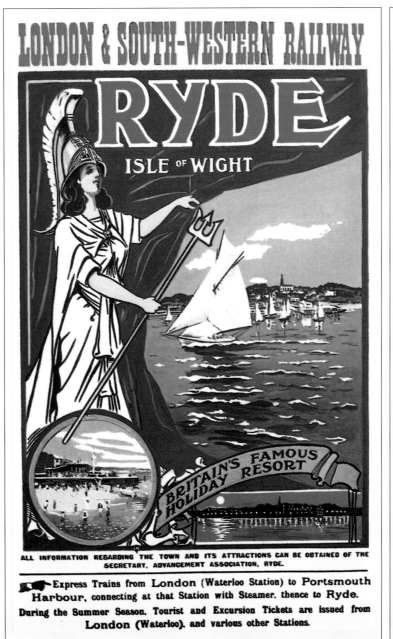

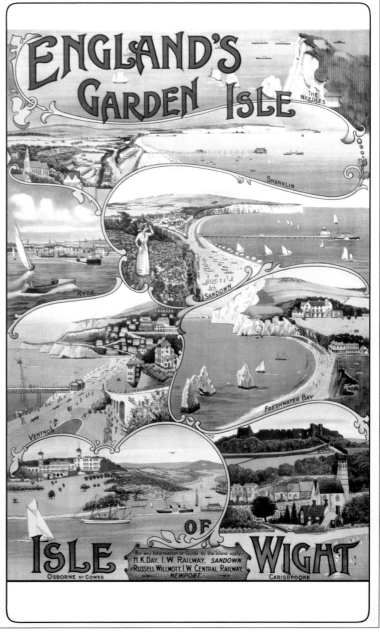

317 and 318 Unsigned LSWR poster from 1908 (left) and unsigned Isle of Wight Railway poster (right) from 1910

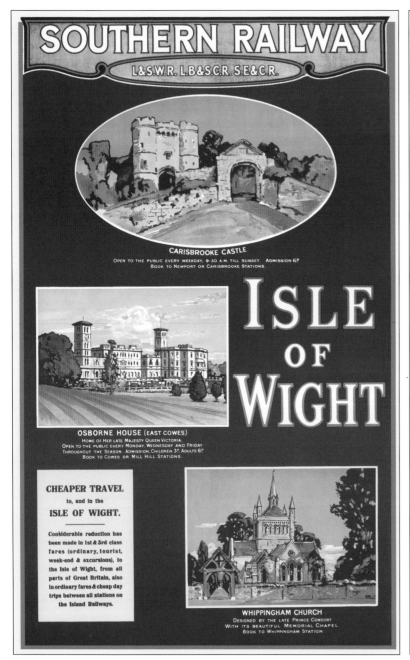

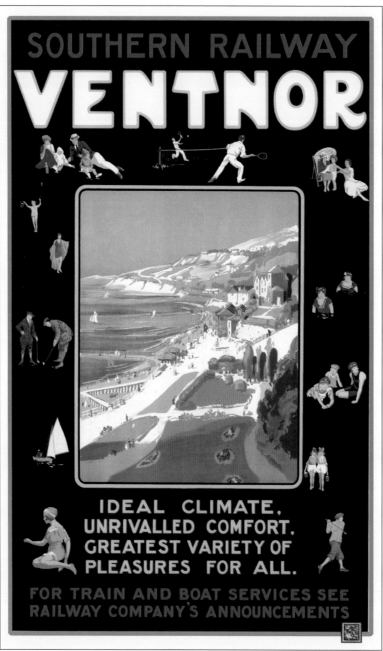

To the Sunny South of the Island

The north of the island may be more populous, but holidaymakers and day-trippers tended to flock to the southern part. When the Southern Railway was formed in 1923, they embarked on an advertising campaign covering most of the island. The poster, far side, is one of the first they ever issued for the Isle of Wight, and considering the date was 1923, the style is a throw-back to the Edwardian years. It is also one of the few SR posters where the constituent companies are listed below the new branding. Issued around the same time, the nearside poster for sunny Ventnor appears far more modern, with the holiday pleasures all depicted around a general view of the resort. The poster also carries reference to train and boat services as the SR consolidated their offerings.

Ventnor is built on a series of terraces below St Boniface Down, and the microclimate makes it one the island's sunniest spots. The Newbould poster, opposite, was produced for the Trust House hotels, who worked closely with the SR for mutual gain. In 1830, the benefits of Ventnor's mild climate on pulmonary diseases were recognized by physician Sir James Clarke, and over a short period the reputation and population of the resort increased.

319 & 320 Vignettes of the Isle of Wight: unsigned SR poster from 1923 (left) and unsigned poster from early 1920s (right)

The present site of Ventnor Botanic Garden was once the location of the Royal National Hospital for Chest Diseases, and the gardens contain plants that are more at home in the Mediterranean. The size and length of the south-facing cliffs, and the shelter they give to the town, are shown to good effect in this 1930 poster. At that time, Newbould was giving poster art classes for the British and Dominions School of Drawing, and his notes (in my collection) show that this poster was used to teach colour balancing, composition and the use of messages.

The Esplanade is fronted by a beach of sand and fine shingle, with family facilities that developed throughout the twentieth century. To the west of Bonchurch, a preserved Victorian village where Charles Dickens wrote a good part of his story *David Copperfield*, the tiny church of St Boniface can be found. This was built around 1070 by Benedictine monks. Ventnor station was the terminus of the line from Ryde, whilst Ventnor West was the end of the line from Cowes through Newport, as poster 313 on page 188 indicates. Ventnor station closed in 1966, Ventnor West having closed 14 years earlier. Today, this lovely resort can only be reached by road.

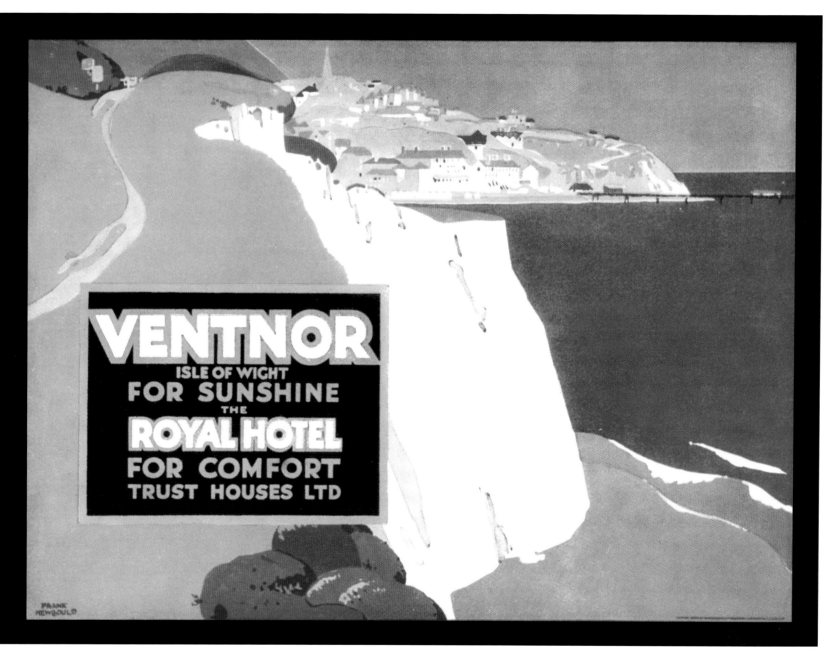

321 1930 hotel advertising for Ventnor, Isle of Wight by railway poster artist Frank Newbould (1887-1951)

Around 1930, steam packets from Southsea pier docked at Ventnor pier, and the town experienced its boom period. This was to last until WWII, and thereafter visitor numbers steadily declined. The closure of the railway was a significant loss to the local economy. A similar story applies to the resort of Shanklin, on the island's east coast, though it retains its railway connection. The artwork, below, by David Burley, a popular SR artist in the 1930s, shows the promenade and central beach. There is a historic gorge (Shanklin Chine) here that first opened to tourists around 1820, and the Old Village today has a wealth of thatched cottages. Both are shown as small vignettes in Burley's artwork, but the main part of the poster below shows the real attractions on which the local economy depends.

Shanklin railway station opened in August 1864 and used to be on the through line to Ventnor. When the southern section closed it became the Island Line terminus, and today it is used by over 330,000 people each year. The pier shown in this poster was destroyed in 1987 when a huge storm hit the island, so this is a historical view of the resort. The poets, Keats and Henry Longfellow stayed here during the nineteenth century, and the great singers Paul Robeson and Richard Tauber both performed in the pier theatre.

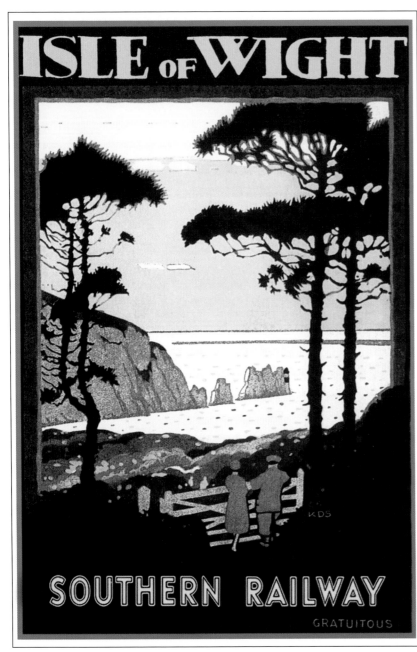

322 1930s poster for the western Isle of Wight: signed as *KDS*

323 David Burley's poster for Shanklin Council/Southern Railway from the mid 1930s

Central and Western Parts of the Isle of Wight

The artist Donald Maxwell was well respected within Southern Railway circles, and as well as producing full sized posters, he painted many carriage prints for Surrey, Sussex, Kent and Hampshire. Two for the Isle of Wight are shown here as, surprisingly, the railways chose not to produce posters for either of these locations. There has been a fortress at Carisbrooke since Saxon times, but the present structure dates from around 1100 when, following the Norman invasion, the island was given to the De Redvers family from Normandy, who assisted in William's conquest. It was not until around 1262 that extensive modifications to the first Norman castle by Countess Isabella de Redvers saw this very imposing structure grace the hill. In 1293 the Countess sold the castle to Edward I who, at that time, seemed to be building and collecting castles to cement his authority! The only serious threat came in 1377 when one of many French attacks around that time was easily repulsed. Much later it became 'home' to King Charles I, who was imprisoned here from 1647 to 1648, following defeat by Oliver Cromwell. It was the summer residence from 1914 of Princess Beatrice, the eldest of Queen Victoria's children (she was Governor of the Isle of Wight from 1896 to 1944). The castle is located south-west of Newport and today is managed by English Heritage.

325 Beautiful coastline at Freshwater, IOW: artist Donald Maxwell (1877-1936)

Maxwell's next painting shows the west of the island, and the beautiful coastline around Freshwater. Freshwater Bay is in the foreground, with the chalk cliffs that eventually lead to the Needles beyond. The main cluster of houses that make up 'the town' is off to the right. Since its discovery by Alfred Lord Tennyson it has become a popular destination. He lived at Farringford House, and much of his writing was completed there. Nearby is the unusual St Agnes thatched church, constructed on land donated by the Tennyson family early in the twentieth century. The other famous resident of Freshwater was scientist Robert Hooke FRS (1635-1703). He was born in the village, where his father was curate, but left for Oxford in 1653. A celebrated experimenter, Hooke's work on springs, particularly extension during loading, established important mechanical engineering principles.

Poster 313 on page 188 shows Freshwater was the western terminus of the island's railway on the line from Newport, from 1889 to 1953. Sadly, like many large former railway sites all over Britain, it is now home to a supermarket and garden centre. But it is the coastline that is so wonderful, and walking on the Tennyson Downs, shown in the picture above, is generally agreed to be an elixir. There are golden sands at Colwell Bay, and nearby Compton Bay is popular today with windsurfers: both would have made great posters.

324 Imposing Carisbrooke Castle: artist Donald Maxwell (1877-1936)

ISLE OF WIGHT

SERVED BY THE

SOUTHERN RAILWAY

326 The inland beauty of the Isle of Wight: 1946 Southern Railway poster by Adrian Paul Allinson

During the years when the railways issued artistic posters, the marketing phrase 'The Garden Isle' was often repeated. This is shown to good effect in Adrian Allinson's artwork issued just after the end of World War II. The rugged southern coastline, with imposing vantage points in the distance, contrasts with the lush greens, a feature of the island, when the harvest is being gathered in: this places the poster in late summer, though the image would have been painted early in 1946. It is therefore not surprising that most of the western part of the island is designated an Area of Outstanding Natural Beauty and, along with the South Downs, affords some of the best walking countryside in southern England. Flat it is not, the high point being on St Boniface Down (770ft - 241m) with steep, south-facing cliffs which support a diverse population of birds and other wildlife. The two main rivers (Medina and Yar) that flow to the north and north-east respectively rise in this higher ground. To ensure confusion reigns, there are actually two rivers on the island named the Yar. The Eastern Yar flows to the sea at Bembridge, while the Western Yar reaches the sea at Yarmouth, where the ferry crosses to Lymington. The temperate climate and lushness of landscape should have made poster marketing easy, but only this one shows the island's inland 'garden-like' beauty.

Final Isle of Wight Selection

A large proportion of the posters issued from 1930 onwards portrayed the island in maps, with small vignettes to show the key attractions. This does not do the Isle of Wight justice, and, to me, the overall quality of railway advertising is rather disappointing. The two shown here are functional rather than eye-catching, - like so many of today's station posters - so they have been deliberately placed opposite Allinson's work to show real marketing contrast. The island is one of the few places in southern Britain where red squirrels flourish and, had their decline been foreseen, this appealing creature, along with native flowers and birds, would have made a wonderful poster. It is, after all, one of the reasons why the Isle of Wight now attracts such strong protection and conservation interest. The small vignettes in the poster, far side, focus on holidays, sunshine, sports and families, whilst the nearside poster shows the ways to tour the island by public transport in 1960. Within six years, most of the railways shown on the map had closed: today around 14 miles (22km) remain.

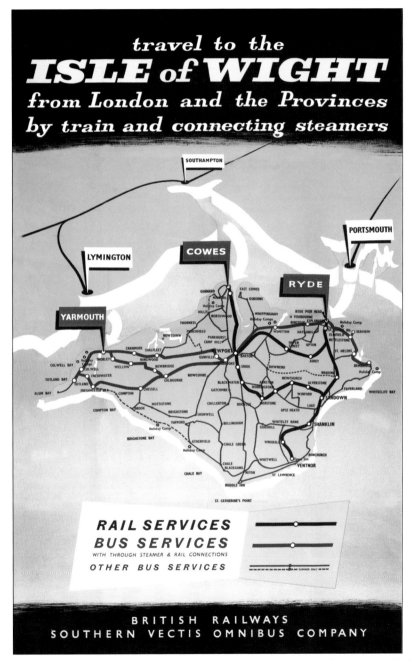

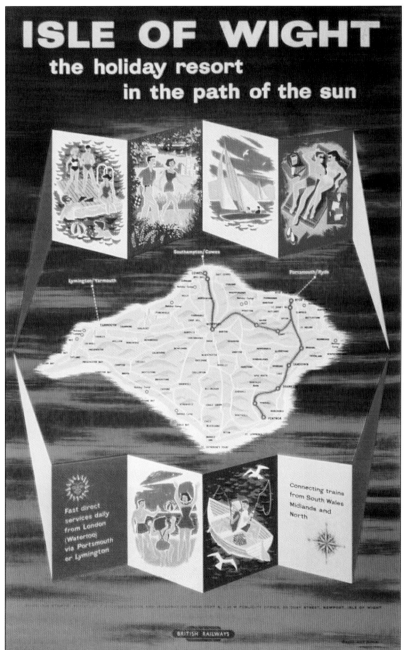

327 & 328 Unsigned BR artwork of transport links in 1960 (left) and holiday attractions in 1957 by Xenie (right)

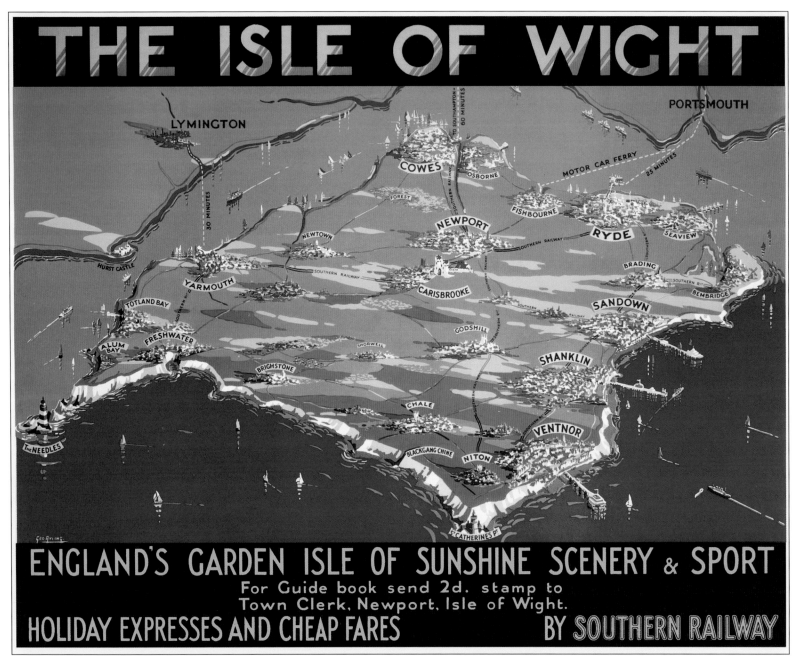

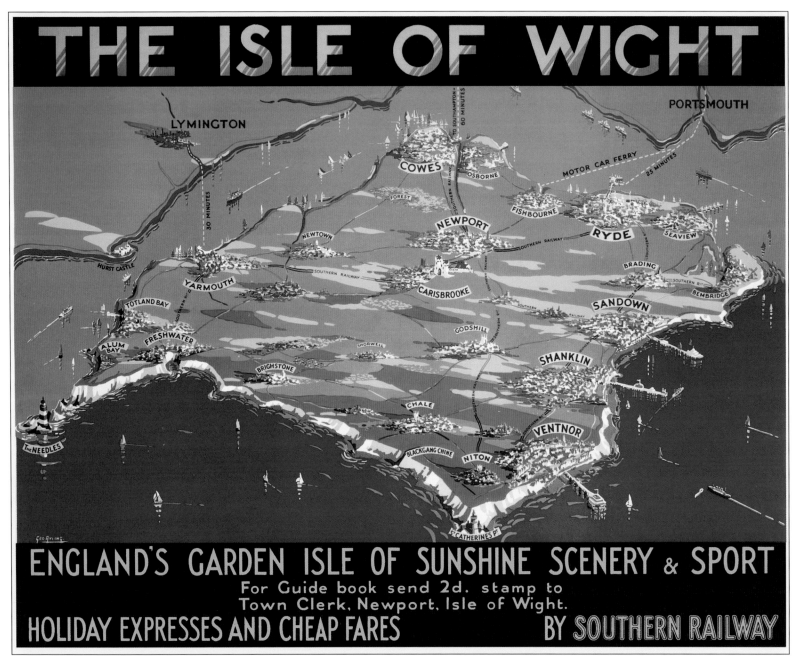

THE ISLE OF WIGHT

ENGLAND'S GARDEN ISLE OF SUNSHINE SCENERY & SPORT
For Guide book send 2d. stamp to Town Clerk, Newport, Isle of Wight.
HOLIDAY EXPRESSES AND CHEAP FARES BY SOUTHERN RAILWAY

329 1930 Southern Railway poster for the Isle of Wight by George Ayling (1887-1960)

Of the many map posters produced, this is probably the nicest and clearest, showing just how much open land there is. It also shows places for which posters could have been produced, such as Fishbourne, Chale, Godshill and Alum Bay. Fishbourne is the island terminus of the car ferry from Portsmouth and is often the first place visitors see, with fine views across the Solent to the mainland. Chale and nearby St Catherine's Down gave easy access to Blackgang Chine, a once-beautiful ravine that is now largely destroyed by land slips, but in Victorian times this was a popular destination. Godshill, lying south of Newport, is a really pretty village, boasting many thatched cottages and a model village (Godshill and Old Shanklin) and today it has a thriving tourist industry. It was not until 1960 that it featured on Lander's BR poster; sadly the rare image in our library was not good enough to reproduce in this chapter. But of all the locations on the Island, it is Alum Bay that would have made the nicest poster. Poster 322 on page 194 gives an indication of the bay where visitors can find multi-coloured sands, and the cliffs ooze colour in the sunshine. It is also the location of the Needles. Considering how many people actually visited this place over the years, a panoramic quad royal by Buckle or Sherwin, looking west, would have been a spectacular advertising addition.

The Needles, a line of spectacular chalk stacks which the sea is slowly demolishing, is one of the most recognized features on the island at the western end of Alum Bay. Today there are three rather squat stacks, but until 1764, a fourth slender and pointed stack existed, and it is from this natural structure that the name is derived. The 1983 poster, far side, shows the Needles, and BR persisted with this style of island marketing for three more seasons, so that the nearside poster from 1986 gives the illusion that they were issued in the same year.

We finish our travels with a quite stunning poster. In the 1950s some of the most amazing railway posters were produced which presented unsurpassable artistic views of Britain. This is my *golden expansive age* and throughout this series of books, it has been my pleasure to include some classics: poster 332 is one of these. We are now racing off Ryde, trying to catch the two dinghies in front of us. This, for many people, is the symbol of the Isle of Wight. Cowes Week, and all that the prestigious event entails, is wonderfully captured in a poster that hardly speaks of railways. It shows one of the finest examples of poster art, full of life, colour and energy: Oh, and by the way, the railways could take you there!

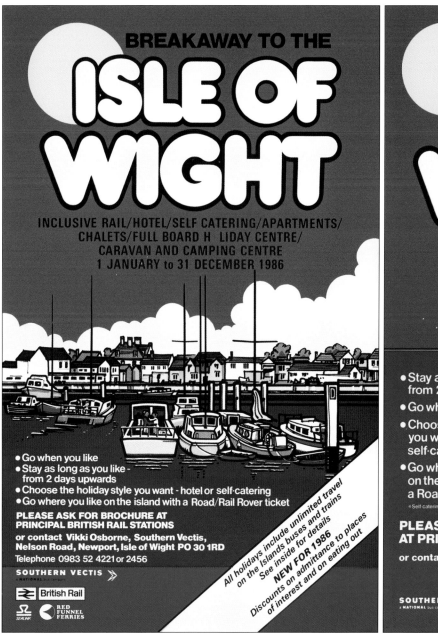
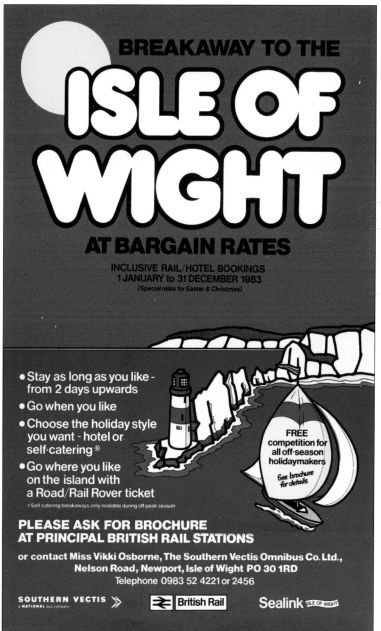

330 and 331 Isle of Wight marketing by British Rail in the 1980s: both posters are unsigned, but are likely to be agency-based

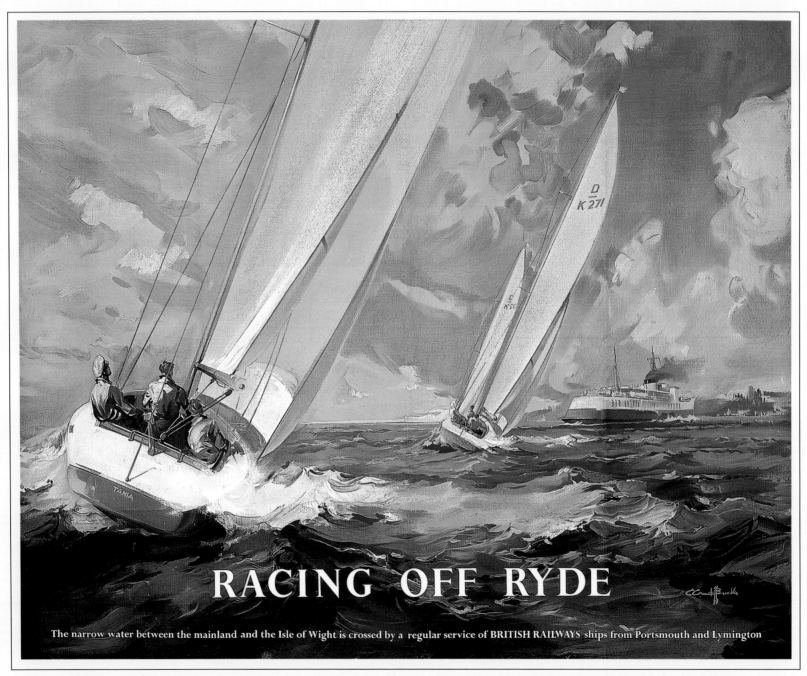

332 Quite superb railway poster art: BR Southern Region poster from the 1950s by Claude Buckle (1905-1973)

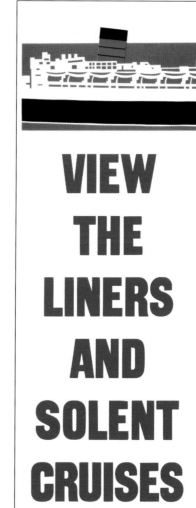

Posters 333 to 335: LMS Crystal palace from 1938 (artist Light, left), Day return tickets in 1950s (Kay Stewart, centre) and Viewing the liners in 1976 (unsigned, right)

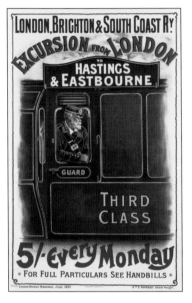
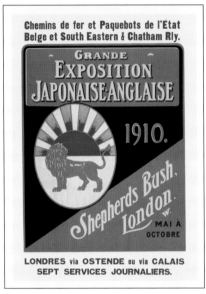
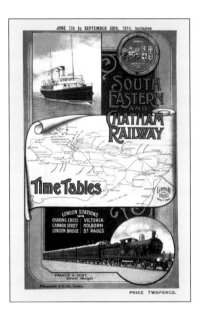

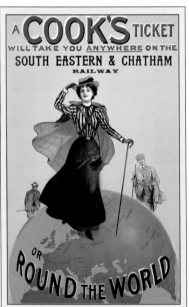
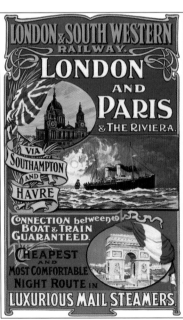
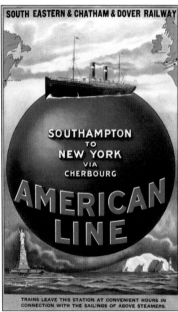

336-341 Fine selection of early posters from the three Southern Railway companies (see vii for detail)

The foundations of Southern Railway advertising

In order to appreciate the many posters included in this volume, it is necessary to go back to the early days of the companies in business in this region, to look at how they presented themselves to their customers. At first glance, the collage alongside of the three main rivals, LBSCR, LSWR and SECR, shows little difference; but closer inspection reveals their contrasting priorities at that time. The LBSCR was more in tune with passenger excursions, seaside visits and the early needs of the commuter, whilst the LSWR and SECR had extensive shipping and overseas links, and many of their Edwardian posters therefore portrayed images of ships and long-distance travel.

As early as 1862, the South Eastern Railway (SER) had already been publishing extensive national and international timetables and had formed rail partnerships throughout Europe. They clearly understood the importance of linking Dover and Folkestone to France, and in later years co-operated to add Southampton and Cherbourg to their service network. They were able to give guidance on passports, customers, goods shipments - indeed anything to do with foreign travel. Around the time that the SER joined with the London, Dover & Chatham Railway (LD&CR) to form the SECR, the lithographic colour printing technique was perfected. This development enabled the enlarged company to convert their extensive publicity material from mundane black and white letterpress posters and handbills into eye-catching pictures. The merger of the two companies took place in January 1899, so the majority of the early colourful posters in this book bear the name of the SECR. The timetable poster (top right) is an example of a railway company trying to portray transport integration, even at a time when World War I was imminent. Indeed, this poster covers the period from June to September 1914, and hostilities commenced in July of that year. But even a few years earlier they had international commitments, and the Japanese Exhibition at Shepherd's Bush London in 1910 was promoted both at home and on the continent (upper centre).

The Brighton Railway (LBSCR) also had very strong French links, and over a twenty-year period, they and their French partners produced many fine posters. Some had English wording, but others used French (top left) for display at stations in northern France. In many ways the LBSCR, like the NER and GNR (see volume 2 page 5), was visionary and innovative in its approach. Below left, there is a clever seasonal poster, designed to entice people into the capital to buy their Christmas gifts. They also produced tasteful, artistic works for the time (top centre and bottom centre) though the Health & Safety Executive today would undoubtedly view the Eastbourne poster with some concern. As a coastal image, however, it was ahead of its time. In the same way that the GER marketed Harlow (Volume 4 page 150) the LBSCR was keen to promote a healthy lifestyle, so the Selsey poster (bottom centre) had a double message: why just travel there when you could live there?

In contrast, the LSWR tried to include as much detail and as many pictures as possible on their posters. Poster 41 for Staines (page 21), 286 for Southsea (p173) and 317 for Ryde (p191) are examples of this style. So if we compare the three main southern companies just after the end of World War I, the messages, styles and imagery were quite different. Each of the three companies was actively involved in promotion, so when the grouping of the many small and large British railway companies occurred on 1st January 1923 to create the 'Big Four', one can only imagine the disagreements that ensued in this region, as the constituents tried to formulate a common identity and marketing policy for the new Southern Railway. The same was also true for the GWR, LMS and LNER (the three other Big Four companies) but these seemed to amalgamate more quickly and, very soon after 1923, the last two were going head-to-head to try to win the lucrative long distance traffic to Scotland.

The Southern Railway is formed

It was not just posters that the LBSCR, LSWR and SECR produced in copious amounts. Given the weather, the resorts, the influence of London and the foreign links, they had also produced guide books, handbills, pamphlets and joint leaflets with developers and town councils in their efforts to forge long-term links: all had to be amalgamated in style.

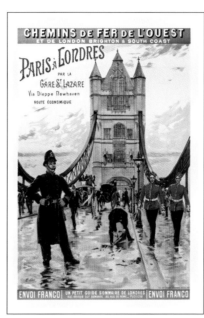 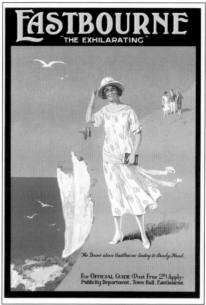 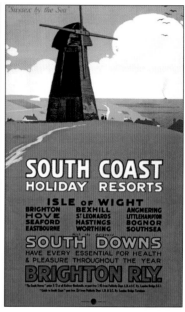
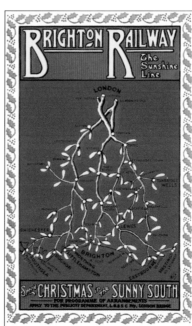 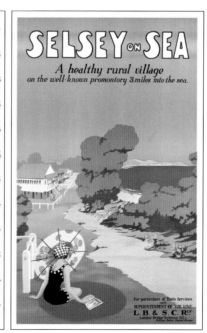 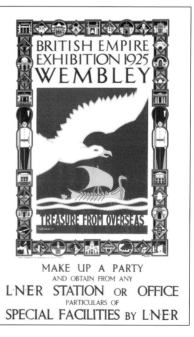

342-347　　Southern railway company poster transition styles up to the mid 1920s (see vii for detail)

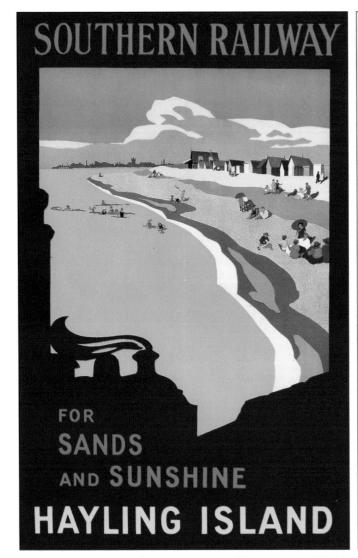 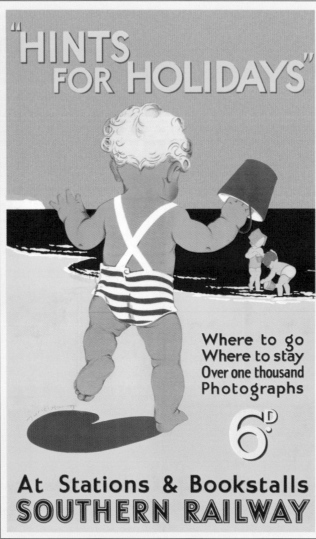 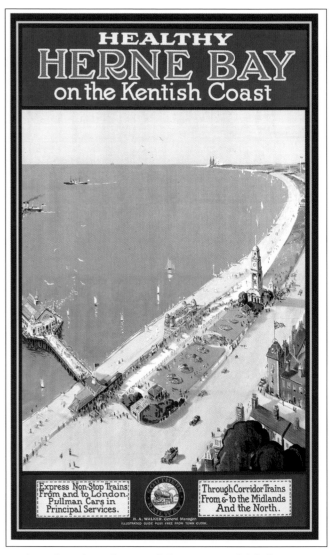

348, 349 and 350 Holidays on the SR: Margaret McIntosh in 1923 (left), Muriel Harris from 1939 (centre), and unsigned artwork from c1924 (right)

By the time the Southern Railway started their promotions, few places and even fewer topics had escaped being covered, so in order to generate their image, they took more time. They therefore appeared to be more lethargic than the other Big Four companies, which was actually far from the truth. Something that they and the GWR had in common was the publishing of yearly holiday guide books, and the centre image, above, is from a long line of posters that adorned Southern stations. These were highly influential, factual and often of artistic merit, using some of the best artists of the day. The end result was an enhancement of the strong links between the railway and town councils. This latter group jostled for prime positions both in railway publications and on station posters all over the south of England: as the GWR's attitudes were similar, collaboration was soon established between the two companies.

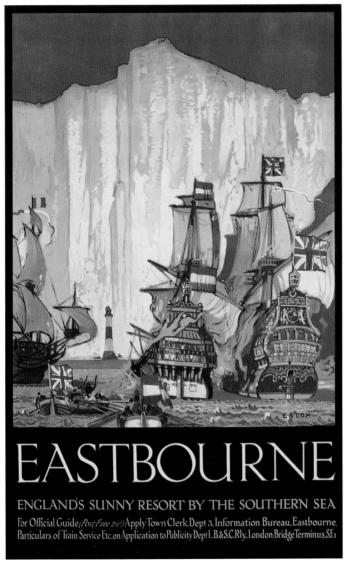
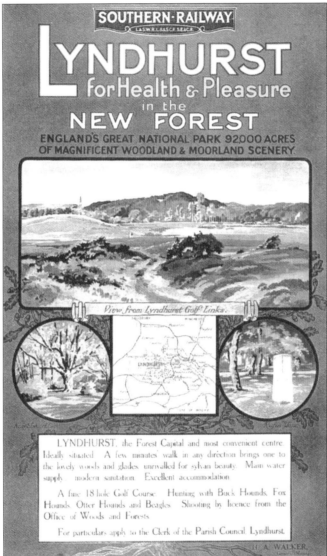
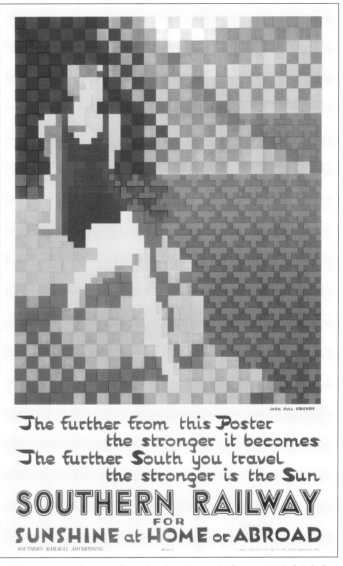

351, 352 and 353 The evolution of Southern Railway posters: Elijah A Cox for LBSCR from 1920 (left), unsigned from 1923 (centre) and John Grundy from 1933 (right)

The Southern had the fewest route miles of the 'Big Four' (2200 miles), but in terms of route density they ranked first. The LSWR contributed almost half, whilst the LBSCR's proportion was least, at about one fifth. These ratios were the reverse of the creativity shown in advertising before World War I, so that early SR advertising, driven from Waterloo, was mainly in the mould of the LSWR. The SR differed from their contemporaries in their vision regarding motive power, as they focused more on electric traction to serve the needs of their market. They had the fewest steam locomotives, so while the GWR, LMS and LNER fought over speed, the focus of the SR was on infrastructure development, reliability and frequent services.

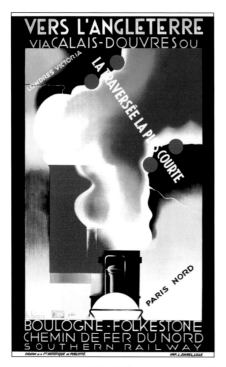
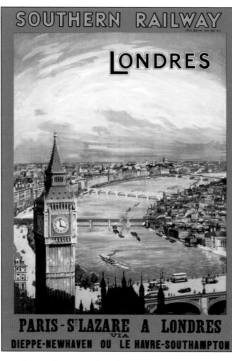
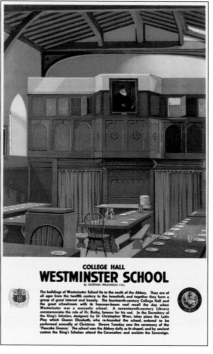
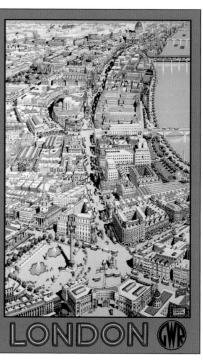

354-360 London and south-east destinations portrayed in the 1920s and 1930s (see page ix for dates and artist details)

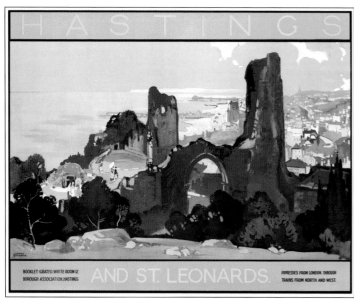
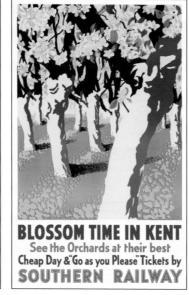
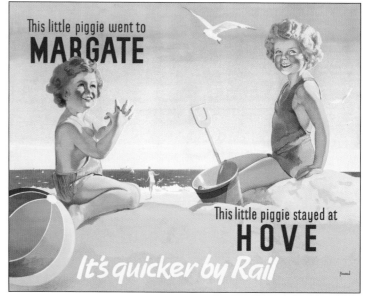

The Southern Railway was also different from the other three because it issued posters aimed directly at children. In 1930, they created *'Sunny South Sam'*, a friendly staff member who was there to help younger travellers in particular. A whole raft of posters was created by William Brealey, and the archives at York are home to the original artwork for the first one. This became a stock poster (nearside) so that local services from each station could be printed on, or below, the image. In 1947 the SR went a stage further with the Children's Own Poster (far side) in which a list of all events that would appeal to them was surrounded by colourful pictures of animals, cartoon characters, and historical events. This novel approach epitomised the clear thinking within the Southern Railway over many years. In 1923, the LMS and LNER planned major campaigns. The Publicity Manager for the LNER was William Teasdale, a person of huge vision. He built on the pedigree of the NER, GNR and GER, plus some ideas that London Transport had been executing, under Frank Pick's inspirational leadership. Teasdale's influence was to be felt for more than a generation by all of the companies.

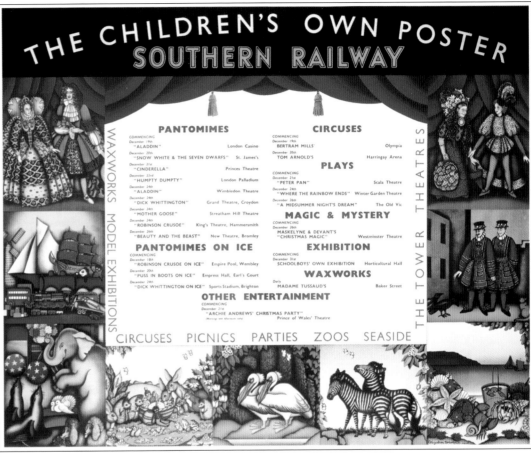

361 and 362 Southern Railway appeals to the younger generation: William Brealey in 1930 (left) and Elizabeth Skottowe in 1947 (right)

Furthermore, in General Manager Herbert Walker, the SR had stability and foresight at the top, and under his guidance, the SR moved in slightly different directions from the other three companies in services and technology. There was far less freight traffic and consequently more emphasis on passenger services, particularly commuting into London during the week and the exodus to the seaside in the opposite direction at weekends. They had also embarked on electrification programmes in the London area as early as 1909. By the time the SR was formed, stations with electric trains included Waterloo, Crystal Palace, Wimbledon, Hounslow, Hampton Court, Shepperton and Putney. By 1925, electric traction served Dorking, Leatherhead, Orpington, Guildford and many other towns, to allow quicker commuting, and thereby having a profound influence on suburban growth; this is why they forged ever stronger links with developers. Technology was driving society as journey times were dramatically reduced: commuters from Teddington in Middlesex found that electric trains slashed their travelling time to Waterloo by 35%, to just over half an hour. But it was not all good news, and by 1925, poor punctuality forced the SR to do something about their public image. Walker turned to John Elliott, whose job it became to turn around the poor reputation the railway had developed in its first two years: he reported progress directly to Herbert Walker.

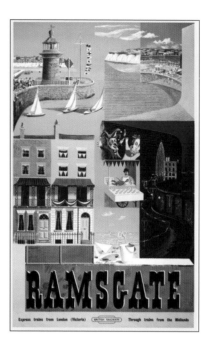

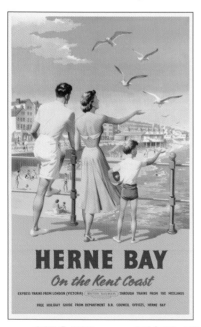

363 & 364 Post WWII posters: Norman Wilkinson from 1947 (left) and John Barker from 1953 (right)

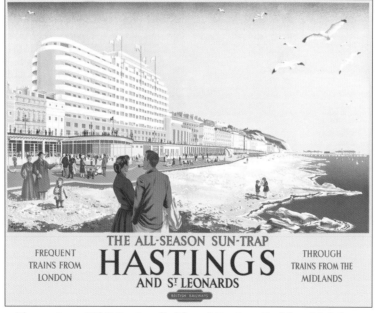

365 & 366 Mid-50s BR seaside posters: Whittington (left) and Daphne Padden (right)

With clever use of press conferences, advertising and image change, the SR deflected their criticism to give them time to build in more reliability and to streamline operations to improve punctuality. By 1939 their network had no counterpart in Britain, and their electrified route mileage was almost 700 compared with some suburban LMS and LNER electrification at 123 and 50 miles respectively. By 1939 over 30% of the Southern Railway system was electrified using a third-rail DC system. In contrast the GWR was only engaged in feasibility studies to look at reducing the cost of moving coal to Devon and Cornwall to service their engines. There is no doubt that the SR had the clearer vision: what would have happened if Herbert Walker's idea of electrified lines had been rolled out nationwide 30 years before it happened in other regions?

The SR also had major shipping interests, so transport integration for travellers' benefits was high on their agenda. They did recognize artistic talent, and occasionally used unknown artists, but in general their advertising tended to reflect a steady but cautious approach: this resulted in the Southern's identity taking time to develop. They had no poster 'design stars' such as Wilkinson or Purvis, and did not contemplate the use of Royal Academicians (as the LMS did for example), but what they did have was a sharper customer awareness: the likes of poster 353, for example, was never attempted by their contemporaries, and they embraced the Art Deco movement (poster 354 for example) with greater vigour. Of course many posters carried the 'Southern Electric' logo, and marketing phrases such as *'South for Sunshine'*, were used very successfully for several years.

Into the BR years

This different vision of advertising carried over into the BR years, so that this quartet of posters, all produced after WWII, does not look incongruous when shown together. The shipping poster by Norman Wilkinson showed they were not afraid to engage artists who were traditionally associated with other companies, and the former Southern Railway's friendly approach over the previous 20 years meant they had few enemies within the railway industry generally.

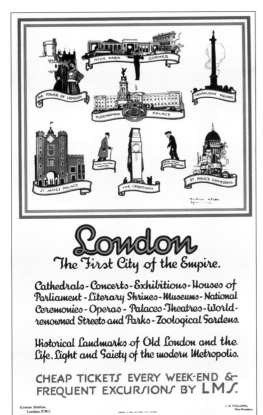

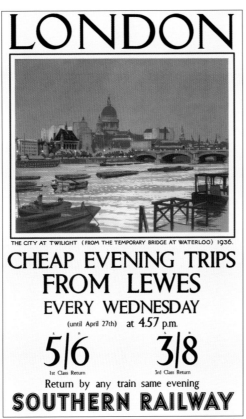

367 to 370 Poster style variations for London: LMS in 1929 (left), SR in 1937 (left centre), BR in 1953 (right centre) and BR/LT in 1960 (right)

British Railways faced the task of rapidly unifying the approach of disparate departments with differing publicity ideas. These four posters for London show the variations in style they had to cope with at the start, and how they approached the marketing of this unique city. Events such as the 1953 Coronation encouraged experimentation, but most of the really expansive artwork posters seemed to be of places outside the south-east (see the covers of the first three volumes for example), and London in particular never saw the wonderful quad royals, such as those presented in Chapter 3 by Wilkinson or Christopher Clark which were produced in the inter-war years. Indeed quite a few of these were simply reissued, as it was difficult to improve upon posters such as 88, 109,112 or 113. In the early BR years, investment was in hardware and infrastructure, and advertising became a secondary consideration.

The electrification of the east and west main lines from London to Scotland allowed BR to show it was moving with the times, but thirty years earlier the Southern Railway had done this in a programme of continuous upgrade: BR adopted a stop-start approach. During the BR upgrades, stations were rationalised and new rolling stock and motive power introduced. Some superb Cuneo quad royal posters were produced to communicate this, and there were a few informative offerings such as the Bank Station *Travolator* (above right), but, in general, the BR information campaigns were patchy. There were some new services with sleek new trains (such as the Blue Pullman and the HST) but the Southern Region did not benefit from these advances. They already had swift electric trains running at regular intervals on the main lines from London to the resorts and some of the ports, and the 1955 Modernisation Plan extended electrification to Ramsgate, Dover, Folkestone and Hastings in an apparently seamless process. Posters for these works did appear on the relevant stations. The Beeching Plan from the early 1960s had far less of an impact in this region; lines did close in Kent, Hampshire and Sussex, but there was nothing to compare with the ravages in South Wales.

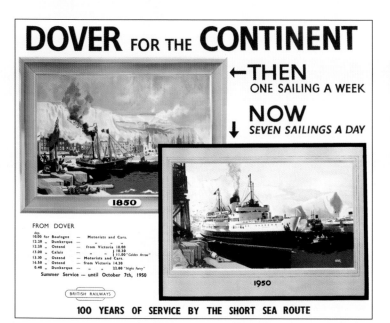
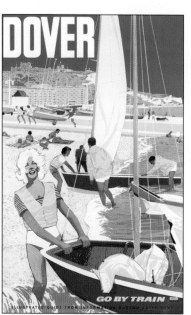

371 to 375 **BR marketing for Kent and East Sussex: Leslie Carr (top left) and unsigned (top right)**
 A trio of different styles for Folkestone, Hastings and Eastbourne by Reginald Lander

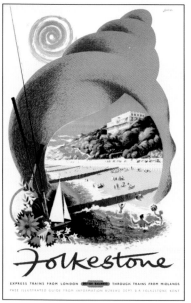
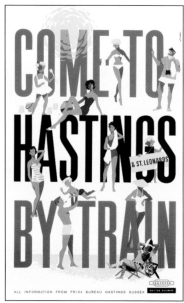
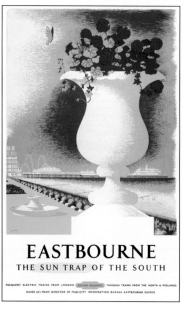

Beeching's plan was to concentrate on the key Inter-City routes and on linking the major cities with the major ports: thus the lines from London to Dover, Brighton, Portsmouth and Southampton were all earmarked for investment. Between 1962 and 1970 there was a massive reduction in locomotive numbers as steam was phased out, and diesel and electric traction was brought in. The Southern Region, much to the annoyance of many in the north, was relatively untouched. The Transport Act of 1968 saw massive financial assistance, particularly for operating the 11,000 route miles that remained after the Beeching cull, but little went into promotion and artwork, as photographic posters began to make their mark. This was the new image BR wanted to demonstrate, but the quality of advertising seemed to decline after this time.

Previously, in the 1950s and the early 1960s, Southern Region advertising brought in rich, colourful and often abstract posters, of which the selection here is representative. Again the cross-Channel services were updated and contrasts drawn with the past, but it seemed the seaside resorts were in strong competition with each other to use different imagery to attract tourists. Continued use of innovative commissions would have seemed logical, but most of these ideas were swept away. The 'old guard' had retired and new thinking was applied to promotional work. The railways commissioned fewer posters, preferring instead to send their work to outside agencies responsible for both their design and execution.

There were regular commissions for artists, such as Reginald Lander, whose trio alongside showed real flexibility of style that the railway advertisers admired. At this time each of the resorts was working ever more closely with BR and, indeed, some of the best seaside posters appeared at this time (posters 147, 153, 222, 231 and 288 for example). Several county collage posters were issued in the 1970s, again using Lander, with a good deal of colour (see posters 137, 194 and 253) and these were the last occasions when an artistic style was employed, until Arriva Wales and ScotRail revived artwork in their regions in the 1980s and 1990s.

The colourful Southern Region approach was continued until 1990, and this group of posters shows a mixture of photo, artwork and abstract styles. An interesting development is the regional approach to including modern rolling stock images on otherwise informative posters - below left; this extended, with remarkable insensitivity, to historic and beautiful places such as Leeds Castle (see poster 27) and Windsor (poster 32). In some cases there was retrogression to the fussy Edwardian style of posters, so that route maps such as those for Blackwater Valley (below left centre). This contained photo vignettes and lengthy text in an unstructured design.

Traditional tourist destinations, such as London, the southern cathedrals, Hampton Court and Portsmouth, continued to be promoted, but the classic seaside poster was consigned to history, as overseas locations proved to be more to the public taste. Posters for foreign destinations appeared at the main London termini as rail links with the continent grew stronger. Sealink in particular produced images with different languages for use both at home and abroad, and some of these will be displayed in Volume 8. The opening of the Channel Tunnel strengthened these links, and what we now see are posters of secondary importance, as direct e-marketing has come to the fore.

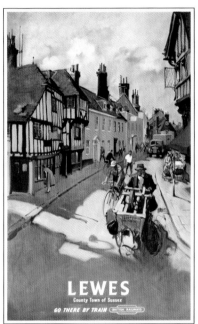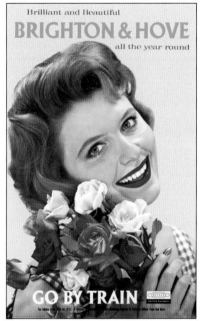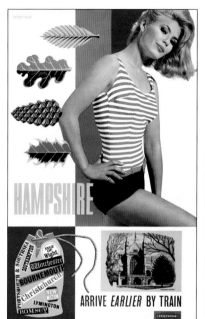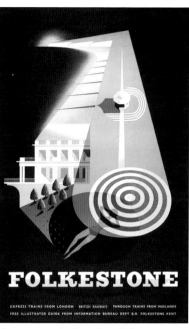

376 to 383 Evolution of poster advertising styles in the Southern Region from 1959 to 1989 (see page ix for details)

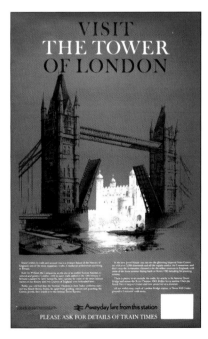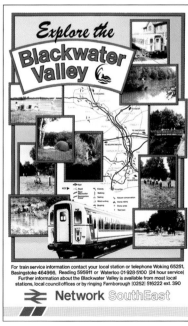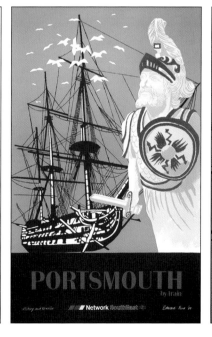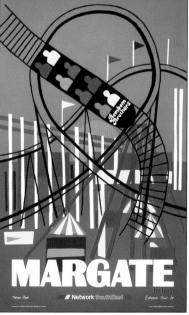

- 211 -

The final Southern Railway selection

In these closing pages, there is an opportunity to show a final batch of distinctive Southern advertising posters. As one travels south, the sunshine gets stronger and more persistent, and this was a cornerstone for many years of SR marketing. They had no real need to pursue freight business, so their core strategy was passenger service and comforts, using the promises of a warmer climate and attractive facilities at the resorts to fill their trains. The posters below sum up their long-term thrust: 'sunny' and 'holidays' are the key words.

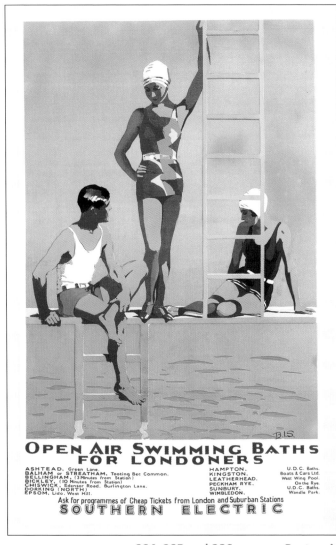 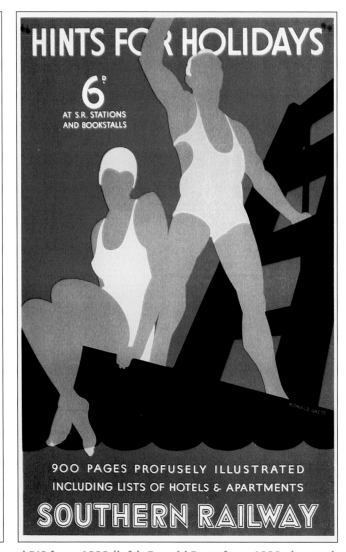 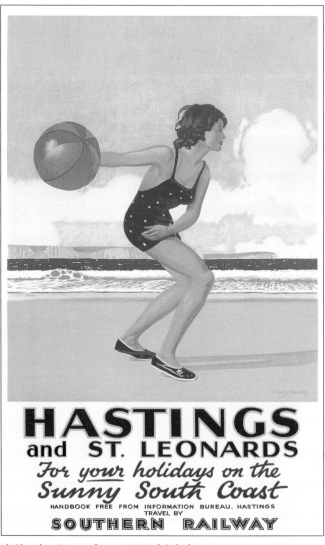

384, 385 and 386 Poster signed BIS from 1932 (left), Ronald Brett from 1930s (centre) and Charles Pears from 1939 (right)

Going south was all about families taking their hard-earned two weeks' holidays, hoping the sun shone and that the weather was kind. Before cars took over and the package holiday had developed, working class families spent their annual holiday at the seaside, so summer Saturdays were among the busiest days on the trains. This book is full of happy and bright images, with beaches thronged (as below) and the towns, pleasure steamers and, of course, the railways all packed and making money. It was a glorious time in our social history, and the southern railway companies through the twentieth century 'made hay while the sun shone'. The car and foreign holidays may have taken over, but what a heritage of posters remains!

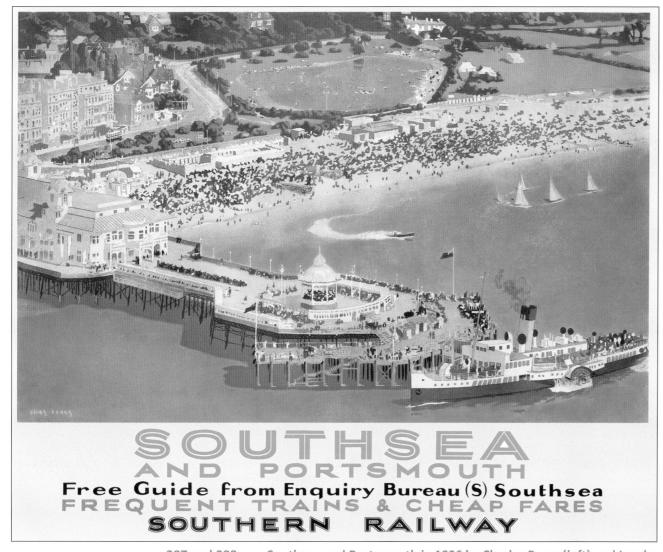 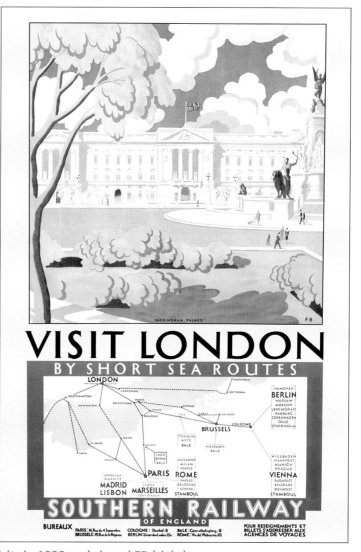

387 and 388 Southsea and Portsmouth in 1936 by Charles Pears (left) and London visits in 1929 and signed FB (right)

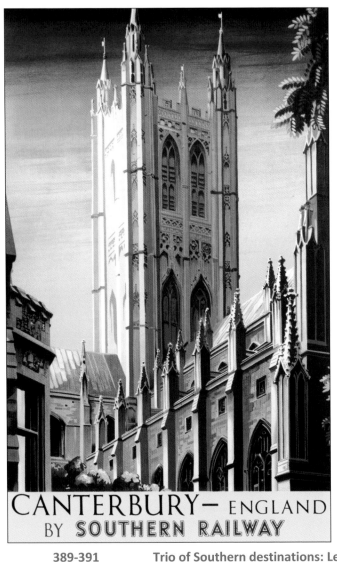

389-391 Trio of Southern destinations: Leslie Carr from 1939 (left), Edward Pond from 1989 (centre) and an FGW photographic image from 2009 (right)

ARTIST PORTRAITS

This section gives thumbnail sketches of the lives of the more prominent and influential poster artists, who appear throughout this series of books. Greg Norden has been of significant help in assisting with this. Data from his definitive book on carriage prints *"Landscapes Under the Luggage Rack"* forms part of the information presented here (see page 253). Other information was received from many sources, via research at the NRM and on the Internet.

Adrian Paul Allinson (1890-1959)

He was born in London 9/1/1890, the son of a doctor. He was educated Wycliffe College & Wrekin College, Wellington, and studied art at the Slade School under Tonks, Steer, Brown and Russell from 1910-12, and won the Slade scholarship. Allinson worked for a time in Munich and then Paris. He was a teacher of painting and drawing at Westminster School of Art. Whilst living in London, he became a notable landscape painter, sculptor and poster designer. He died on 20/2/1959, having produced posters for GWR, SR & BR. We will see more of his work in Volume 6.

Bruce Angrave (1914-1983)

Born in Leicester, Angrave studied at the Chiswick School of Art and London's Central School of Art. He worked as a freelance illustrator, designer and sculptor. Heavily influenced by both Eckersley and Games, his poster work is distinctive and sometimes a little bizarre. His concept was *'follow or discard'* after two seconds! He felt a good poster could be looked at time and time again, thus almost forcing the message home. After WWII, he undertook many commissions and his work was displayed at the 1951 Exhibition.

Mariano Armengol Torrella (1909-1995)

Mario Armengol was born on 17th December 1909 in San Juan de las Abadesas, Catalonia, Spain, the second of six children. His greatest love was painting and drawing and his extraordinary talent emerged from the age of seven. His mother encouraged him from the outset. By the age of 15, and after winning numerous local art competitions, he was commissioned by department stores to produce designs for posters and advertisements. 1920s Paris drew Armengol like a magnet. In 1926, he enrolled at an arts academy to continue studies but around 1930 returned to Spain. Shortly before General Francisco Franco came to power Armengol's parents and his siblings fled to Mexico, Armengol came back to Spain and tried through resistance movements to plot against Franco. In 1936 as a refugee, was granted official leave to stay in Britain. He was befriended by Francisco Madariaga, a restaurateur and leader Liverpool's long-established Spanish Basque community. His artistic career blossomed in the UK and over the next fifty years he proved to be a most competent poster artist, and quite revolutionary, when trying new media and new ideas.

Stanley Roy Badmin (1906-1989)

Badmin was noted as a detailed landscape watercolour artist, a lithographer and an illustrator & engraver. He was born Sydenham, London 18/4/1906, the son of a schoolmaster, and studied art at Camberwell School of Art and at RCA. He was art teacher and lecturer at Central School of Arts and Crafts, and was elected to the Royal Water Colour Society in 1939. He illustrated several books including 'British Countryside in Colour', 'The Seasons', 'Shell Guide to Trees and Shrubs' etc. Very elaborate in style. He lived in Bognor, Sussex for some time, and produced posters and carriage prints.

Frederick William Baldwin (1899-1984)

Frederick Baldwin was a Suffolk-born artist who lived in Beccles area, first at Westhall near Halesworth and later at Stoven, a few miles to the east. He was a pupil at the Sir John Leman Grammar School, Beccles and then went to work as a draughtsman for the Lowestoft boatbuilding firm of J.W. Brooke (now Brooke Marine Yachts). His finely drawn watercolours of the area show some of the same qualities that are also found in the work of the Ipswich artist Leonard Squirrel, his friend and painting companion. He undertook mainly carriage print artwork of his beloved Suffolk, some are found in chapter 5.

William H. Barribal (1873 - 1956)

Barribal was a London artist who began his career as a lithographer, before going on to study at the Paris Academie Julien. Becoming an accomplished painter and designer by the first quarter of the 20th century, Barribal created such memorable images as posters for the Schweppes advertising campaign, and the Waddingtons playing cards series, which are avidly collected today. He is also well-known for the bold Art Deco posters designed in the 1920s and 1930s for the London North Eastern Railway.

John Francis Bee (1895-19xx)

Designer of stage settings, posters and show-cards. Born in Wolverhampton. Studied art for four years in Europe and the Near East. Exhibited in Manchester and worked at Loughborough and Liverpool. He is known to have lived in Norfolk for a period. His work was illustrated in 'Commercial Art' and 'Posters and Publicity'. His posters normally bore a distinctive capital 'B' monogram, but the poster shown in chapter 2 and nearly his carriage panel artwork carried his normal signature. His place and date of death are not known.

Samuel John 'Lamorna' Birch (1869-1955)

Samuel Birch was born in Egremont, and educated at the Academie Colarrossi in Paris from 1896. His mother encouraged his art from an early age, and at 15 he exhibited at the Manchester City Art Gallery. He had moved to Cornwall in 1892 and, despite no formal training at that time, he became a professional artist. He was a keen fisherman, and his love of water always inspired his work. His nickname came from the fact that he lived at Newlyn in the Lamorna Valley. He is known for his expansive style of painting.

Montague Birrell Black (1884-1961)

Poster artist & illustrator, he was born Stockwell, London 29/3/1884. Educated Stockwell College, he first produced military and naval artwork, and was artist war correspondent for Toronto Star 1939-45. Black lived West Derby, Liverpool and Harrow, Middlesex. Was a White Star Line artist, and was renowned for his map posters for the railways over many years. He produced posters for LNWR, M&GN, LNER, LMS, SR & BR.

Stephen Bone (1904–58)

English painter, born in Chiswick, London, on 13th November 1904. His father, Sir Muirhead Bone (1876–1953), was a prestigious draughtsman and engraver. He trained from 1922 to 1924 at the Slade School of Art under Henry Tonks (1862–1937). He was awarded a gold medal at the International Exhibition in Paris. In 1929 he married the artist Mary Adshead (1904–95). By the time of the Second World War he was serving as a lieutenant in the Royal Naval Volunteer Reserve. He also worked for the War Artists' Commission. Many of his images were published in the *Illustrated London News*. His talent was recognised by his appointment as director of Hornsey College of Art in 1957. Sadly, he died only a year later in London, on 15 September 1958.

Sir Frank William Brangwyn (1867-1956)

Brangwyn was a Welsh artist, virtuoso engraver, water colour specialist and a truly progressive designer. Born in Bruges, where his father had been commissioned to decorate the Basilica, he returned to England in 1875 and received artistic guidance from both his father and the architect William Morris. With no formal training, his work was accepted for an RA summer Exhibition and he was determined to become an artist. Initially he used limited palettes in his posters, so they appeared dark and gloomy: later this changed as 'Orientalism' swept the art world. His work softened and brightened in his later years. Brangwyn received commissions from the East and from Africa. His work is very collectible.

F. Gregory Brown (1887-1948)

Began his artistic career as a metal worker, but turned to magazine illustration. He undertook work for all four of the main railway companies in addition to ICI, the Empire Marketing Board and MacFisheries. Gold Medal winner at 1925 Paris Exhibition of Art for textile design. Produced many posters for the London Underground.

Pieter Irwin Brown (1903-19XX)

Born in Rotterdam and grew up in Holland. He then travelled widely in Europe and Africa working as an artist. When he moved to London, he worked for Leigh Breton Studio and set up a design business with partner Rickman Ralph. He designed posters for the London Midland & Scottish Railway, Great Western Railway, London Transport and London County Council Tramways. In the 1930s he travelled to Indonesia, Japan and China, where he produced Japanese style woodblock prints. He moved to America in 1940, and worked under the name Pieter van Oort. In 1946 he settled in New York and little is known of his later life. Appears in the database as P Irwin Brown.

Claude Henry Buckle (1905-1973)

Buckle was a painter in oils & watercolour (particularly marine subjects) and poster designer. Born London 10/10/1905, he trained as an architect, specialising in industrial drawings, but turned to art in 1928. He was a member of Savages Art Club in Bristol. Produced commissioned artwork for the new nuclear power stations around the UK. He was a close friend of Terence Cuneo. He achieved a prolific output of artwork for the railways (GWR, LMS and BR). Painted many of his later subjects around the coast in France. Lived near Andover, Hampshire and died in 1973

Sir David Young Cameron (1865-1945)

Born in Glasgow and trained at both Glasgow and Edinburgh Schools of Art in the 1880s. He became known for his church interior drawings, and for his detailed etching work. Made Royal Academician in 1920, and was sought after until his work dried up in the Great Crash of 1929. Undertook poster work for the LMS at the request of Norman Wilkinson

Lance Harry Mosse Cattermole (ROI 1898-1992)

Painter in oils & watercolour. Born 19/7/1898, son of Sydney Cattermole, an artist, and grandson of George Cattermole (1800-68) - illustrator of *'The Old Curiosity Shop'* and other Charles Dickens works. Educated Worthing, Sussex and Odiham, Hants. Studied at Central School of Arts & Crafts 1922-23 and at the Slade School 1923-26. Lived near Worthing for many years. Represented in many museums and collections.

Christopher Clark (1875-1942)

Lived in London and better known initially as a historical and military subject painter. He worked for the LNER and LMS and several of his ceremonial London quad royal posters (see chapter 3) were reissued by BR.

Austin Cooper (1890-1964)

Born in Canada he trained and practised in Britain. He studied at the Cardiff School of Art from the age of 13, before winning a scholarship to the Allan-Frazer Art College, Arbroath from 1906 until 1910. In 1910 he moved to London, studying in the evenings at the City and Guilds School. He returned to Canada as a commercial artist, although this was interrupted by war service during the First World War in Europe. In 1922 he settled in London and received the first of many poster commissions from London Underground. Over the next two decades he established his reputation as a top poster designer. After the 1920s his work became increasingly pictorial, and he produced work for the Empire Marketing Board, LNER as well as the London Underground. In 1943 he turned from his career as a poster artist to become a full time painter.

Charles Ernest Cundall (1890-1971)

He was born in Stretford, Lancashire and studied at the Manchester School of Art, and then the Royal College of Art 1912-14. His studies were interrupted by WWI but he returned to RCA in 1918. Further studies at Slade Fine Art School and in Paris followed. He travelled widely; cityscapes and portraiture characterized his work, though he strayed into poster art and produced some good 'Big Four' and London Transport items. During WWII he was in Quebec as an official War Artist.

Terence Tenison Cuneo OBE (1907-1996)

One of the most famous of all poster artists, Cuneo was the son of Cyrus and Nell Cuneo, both well respected artists. He studied at Chelsea and Slade Art Schools. Known for railway subjects, he was also an accomplished portrait painter (including Royal and VIP subjects). Some of his engineering and technical work is also excellent. Appointed official painter to Queen Elizabeth II in 1953.

Laurence Fish (1919-2009)

He was born in London, and trained as an illustrator in Max Miller's studio at publishers Iliffe & Son, specialising in technical subjects - aircraft, yachts, motor cars - and acquiring the meticulous draughtsmanship required for publications like Yachting World, Autocar etc. During war service with the RAF, he was seconded to MI5 as a specialist in explosive devices. After the war he was a founder member of the Society of Industrial Artists and Designers, and became internationally known as a painter/illustrator. His work was commissioned and owned by most large industrial companies, (e.g. Shell, BP, Dunlop, Bristol Aeroplane Company, Hawker Siddeley, BOAC, MG Cars, British Rail and the Indian Air Force. His covers for Flight International and posters for British Railways are already collectors' items. He had a distinctive fine art style, quite different to his poster work. Died at Winchcombe, Gloucestershire in 2009.

Francis Murray Russell Flint (1915-1977)

Landscape & coastal painter in oils & watercolour. Born 3/6/1915, son of Sir William Russell Flint, the famous artist (who also produced posters for the railways). Educated at Cheltenham College and *HMS Conway*. Studied art at Grosvenor School of Modern Art, at the RA Schools and in Paris. Was art master at Lancing College. Lived in Burgess Hill, Sussex and Coffinswell, Devon and London W8. He was Vice President of RWS and died accidentally in Spain in 1977. Produced artwork for LNER Post-War, W Region series.

Abram Games (1914-1996)

Games learned his art at evening classes from 1932 onwards. He went to St. Martins School London, but left after two terms to pursue art. Worked in photography for his father, and then in a commercial design studio. In 1936 he won the London Olympic Games poster competition, and became a freelance artist full-time, securing commissions from Shell, L T and the Post Office. He was official War Office Designer during WWII. He had a 60-year career as an influential poster artist.

Konstantin Ivanovic Gorbatoff (1876-1945)

A Russian-born artist who fled the aftermath of the 1917 Revolution, going first to Italy and then to Berlin in 1926. Commissioned by LNER to paint his famous poster of Scarborough (see Vol2 p99, his only railway poster commission). He died two weeks after WWII ended.

Henry George Gawthorn (1879-1941)

He was born in Northampton and studied at Regent Street Polytechnic. He trained as an architect, but later turned to painting and art. He was a prominent LNER poster artist and wrote widely about poster design. He used to include himself in his posters, and 20 of his works are found at the NRM in York. Some of his seaside posters are absolute classics.

Charles Isaac Ginner (1878-1952)

He was born in Cannes, France and left school at 16 to go to sea. On his return he was briefly employed in an engineer's office before leaving for Paris, to work in an architect's office. In 1904 he left to study art at the Academie Vitti under Paul Gervais. His style of painting was not popular at the Academie and he left to go to the Ecole des Beaux-Arts and then to pursue his own career. Greatly influence by Van Gogh's bright style. Produced railway posters for the LNER.

John A Greene (ARCA)

Artist in oil and watercolour and lecturer. Studied art at the RCA. Lecturer at the Architectural Association School from 1946. Produced work for I.C.I. and the British

Transport Commission. The detail in some of his posters was astonishing. Lived at Bordon, Hants, but we know very little about his life.

Joseph Greenup (1891-1946)

Little is known about his early life, or where he was born, but he had been educated at the Birmingham School of Art, South Kensington College of Art and at the Royal Academy School. He worked as an illustrator for several newspapers, and also contributed to books and periodicals and earned part of his living as a portrait painter. In 1926, he married Frances May Greenup (1902-1998), the daughter of George Tuckwell, a police constable. They lived in London, during which time some of his best poster work was produced, until his death in 1946.

Maurice William Grieffenhagen (1862-1931)

Greiffenhagen was a British-born painter and illustrator despite his foreign sounding name. He studied at the Royal Academy Schools, and began to exhibit at the RA in 1884 and at the Society of British Artists shortly afterwards. His exhibits were mainly portraits and figures in the Pre-Raphaelite style. He was a prolific illustrator, best known for his work in the novels of H. Rider Haggard. He also worked for magazines such and the Daily Chronicle and the Lady's Pictorial. From 1900 onwards he increasingly turned to portrait work and for the next decade he exhibited his work at international exhibitions in Munich, Pittsburgh and Venice. In 1906 he taught at the Glasgow School of Art. In the 1920s, he produced important LMS posters such as the London on page 69, but also for Stirling and Carlisle. The Tate Gallery owns three of his works and more can be seen in St. John's Chapel at the church of St. Jude-on-the-Hill, Hampstead, North London.

Norman Hepple (1908-1994)

Born in London, Robert Norman Hepple produced posters for both BR and London Transport. He was educated at Goldsmiths College and the Royal Academy. His father and uncle were both well-known artists of their day. His work is owned by the Royal Family, and during WWII he was attached as official artist to the National Fire Service. Suffering ill health during his later life, he was killed in a road accident shortly after undertaking his commissions for London Transport.

Ernest William Haslehust (1866-1949)

He is a well known landscape painter chiefly in watercolour, illustrator. He was born Walthamstow East London on 12/11/1866 and was educated Manor House, Hastings and Felsted. Haslehust studied art at Slade School under Legros, and his work is represented in several public collections. (Principal works include *The Bridge nr Arundel* and *A Devon Estuary*). He illustrated the *'Beautiful Britain'* series of books. He was President of Midland Sketch Club and lived in South London for many years. He died on 3/7/1949 after having produced posters for LMS & LNER in a most detailed and wonderful style of painting.

John Hassall (1868-1948)

Hassall was born in Deal, Kent and during the first part of the 20th century became the best known of all poster artists. His GNR poster *Jolly Fisherman* for Skegness appeared in 1908 (volume 1 page 5) and subsequently he had many commissions. He was educated at Newton Abbot College then Neuenheim College, Germany before finishing at the Academie Julien in Paris. By 1900, Hassall was an established illustrator, cartoonist and poster designer. His most famous posters were for household products, theatre productions as well as for

the railways. He was an early member, and later President, of the London Sketch Club, he founded the New Art School (later the Hassall School of Art), which he ran for twenty years. Little is written about him in later life.

Allanson Hick (1898-1975)

Born in 1898, Allanson Hick was the son of a master mariner who sailed with Hull's Wilson Line. His mother also came from a seafaring family. His surviving earliest works are post card sized sketches produced in Scotland but these were followed by a flow of accomplished drawings and paintings dating from the 1920's and 1930's. Allanson Hick built a small but well chosen collection of pictures accepted by the Royal Academy Exhibition. A great friend of Allanson Hick was Henry Hudson Rodmell who was himself a notable marine painter and one of the great designers of shipping posters in the inter war period. In 1936 both men were elected to the Society of Graphic Artists and founded the Society of Marine Artists (RSMA).

Rowland Hilder OBE (1905-1993)

American-born landscape & marine painter, illustrator, author. He was born 28/6/1905 at Great Neck, Long Island, USA of British parents. Educated at Morristown, New Jersey. Settled in England 1915 and studied at Goldsmiths College School of Art under E. J. Sullivan 1922-25. His work was first selected for RA in 1923 when only 18. He married Edith Blenkiron, also a painter. Represented in several public collections here and abroad, and is renowned for his paintings of Kentish oast houses. Was President of Royal Institute for Painters in Watercolour 1964-74. He illustrated many books incl. 'Moby Dick' 1926, 'Treasure Island' 1930, 'The Shell Guide to Flowers of the Countryside' etc. Designed National Savings and Shell Oil posters. Hilder wrote

books on watercolour technique and an autobiography 'Rowland Hilder, Painter & Illustrator'. He was awarded the OBE in 1986. He lived in Blackheath, London and died April 1993 only nine months after the death of his wife, Edith.

Ludwig Holhwein (1874-1949)

Born in Wiesbaden, Holhwein also lived in London, Paris, Munich and Berchtesgaden. He trained as an architect, but began producing posters as early as 1906. Some of his early works are quite superb (restaurants, pavement cafes and buildings) and he was asked by the LNER to undertake some commissions. He worked as an illustrator for the Third Reich during WWII, where his bold style was suited to the messages required.

Eric Hesketh Hubbard (1892-1957)

Landscape & architectural painter, etcher & furniture designer. Born 16/11/1892 in London. Educated Felsted School. Studied art at Heatherleys, Croydon School of Art and Chelsea Polytechnic. Member of many art societies. Represented in many public collections, home and abroad. Published a number of books including *'Colour Block Print Making'* and *'Architectural Painting in Oils'*. Founder and director of Forest Press. Lived Croydon, Surrey; Salisbury, Hants and later in London. Died 16/4/1957. Produced posters for LMS, SR & GWR.

Edward McKnight Kauffer (1890-1954)

Born in Great Falls Montana, Kauffer became a most prolific and well known poster artist in Europe after studying first in San Francisco and then in Paris in 1913. WWI saw him move to London, becoming a London Transport artist for over 25 years. One very influential poster artists, he used surrealism, cubism and futurism in his work. Significant posters were produced for the GWR, Shell, Empire Marketing Board and the Post Office.

Ronald Lampitt (1906-19xx)

Painter of landscapes in oils & watercolour, poster designer, book illustrator (including children's books). Worked for Artists Partners Agency in London. Lived In Hampstead, London. Produced posters for GWR, LMS and SR, as well as many for BR.

William Lee-Hankey (1869-1952)

Painter and etcher of landscapes and portraits. Born 28/3/1869 in Chester. Studied at Chester School of Art under Walter Schroeder, at the RCA and also in Paris. Served with Artists Rifles 1915-19. Exhibited at most principal London galleries. President of London Sketch Club 1902-4. Represented in many public collections, home and abroad, and was a considerable contributor to RWS exhibitions. Won gold medal at Barcelona International Exhibition and bronze medal at Chicago. Lived and worked in France for some time, then in London. Became member of RWS in 1936, aged 67 and vice president in 1947. Died 10/2/1952. Produced LNER posters and had a lovely style painting.

Reginald Montague Lander (1913-19xx)

Born London 18/8/1913. Freelance commercial artist in gouache and watercolour, poster designer. Educated Clapham Central School and studied at Hammersmith School of Art. Chief designer and studio manager at Ralph Mott Studio (1930-9). He worked for Government Ministries and British Transport Commission. Lived New Malden, Surrey. Produced very many posters for all regions of BR and the Post Office. He is famous for his bold, almost modernistic style.

Sydney Lee (1866-1949)

Lee studied at Manchester School of Art and afterwards worked at the Atelier Colorossi in Paris. He first exhibited with the New English Art Club in 1903 and regularly at the Royal Academy from 1905, where he was elected Associate in 1922 and a Member in 1930. He lived in Kensington, from 1909. While he was first and foremost a painter, Sydney Lee was a versatile printmaker in a wide range of media, encompassing aquatint, drypoint, lithography, wood engraving and wood cut. He became widely known for his paintings and prints of mountainous landscape, town scenes, and architectural subjects in Britain and drawings from his tours in Spain, France, Switzerland, and Italy (Venice).

Alan Carr Linford (1926 -)

Alan Carr Linford is an eminent poster artist. He studied at the Royal College of Art 1943-47, gaining professional qualifications in art by the age of 20, and winning several prestigious scholarships. A student of Sir William Halliday, his work was seen in 1949 by the then Princess Elizabeth at Clarence House. Over the years Queen Elizabeth II has collected several of his drawings. He has painted for Royalty all over the world. One of my favourite posters of all is his depiction of High Street Oxford (Vol3 p62); it has quite superb artwork, depth and movement and is the natural choice for the cover of volume 3. See also his painting of York (Vol2, p223).

Freda Violet Lingstrom (1893-1989)

Freda Lingstrom was born 1893 in Chelsea, London, and educated at Heatherleys and the London School of Arts and Crafts. Her skills as an artist, illustrator and author gave her work on the editorial staff of a children's magazine. However in 1940 she joined the BBC and in 1947 she was promoted to Assistant Head of BBC Schools Broadcasting. At BBC Radio she created the lunchtime programme *Listen with Mother* in 1950. Soon afterwards she moved to television, and created *Andy Pandy* (with Maria Bird) and she was appointed Head of BBC Children's Television in 1951, and the following year

introduced *Watch with Mother* for pre-school children and created a different programme for each weekday, *The Flower Pot Men*, *Picture Book*, *The Woodentops*, *and Rag, Tag and Bobtail*. She designed posters for the Underground Group 1923-1933. Also produced posters around 1930 for the GWR and LNER Companies.

John Edmund Mace (1889-1952)

Produced more than a dozen railway posters, for all the 'Big Four' railways companies, but almost half of these for the LMS. Most active in the late 1920s and early 1930s. Specialized in watercolours but also painted in gouache. Known for his landscapes and pictures of British Cathedrals. Very little is known about his personal life.

Alasdair Macfarlane (1902-1960)

Born Ballymartin, Tiree 26/9/1902; Gaelic speaking, later bilingual, he was a self-taught artist. Moved to Glasgow 1922. Worked on ships for P Henderson & Co. Joined Clyde Navigation Trust in 1929. Drew ships for Evening Citizen newspaper, Glasgow from 1929. Exhibited 1932-7. Served with Ministry of War Transport in London 1940-45 and re-joined Clyde Navigation Trust. Produced private and commercial work latterly and ship drawings for Glasgow Evening Times 1950-60. Died from heart attack 1960. Produced posters for BR and Caledonian MacBrayne of Scotland.

Freda Marston (1895-1949)

Born Hampstead 24/10/1895 (nee Clulow). Painter & etcher of landscapes & figures. Educated, Hampstead, London. Studied art at Regent Street Polytechnic, in Italy and under Terrick Williams 1916-20. Married Reginald St Clair Marston in 1922. Now represented in several public collections. She was the only woman artist commissioned by the railway for carriage prints. Lived

Amberley, Sussex and later at Robertsbridge. Died 27/3/1949. Produced posters for LMS & BR.

Frank Henry Algernon Mason (1875-1965)

Marine painter in oil & watercolour, etcher, illustrator, author & poster designer. Born Seaton Carew, Co Durham 1/10/1875. Son of a railway clerk. Educated at *HMS Conway* and followed sea for a time as a ship engineer. Later engaged in engineering and shipbuilding at Leeds and Hartlepool. Travelled abroad extensively and painted many subjects in watercolour. Served 1914-18 as Lieutenant in the RNVR in North Sea and Egypt. Studied under Albert Strange at the Scarborough School of Art. Member of RBA 1904, RI 1929. Exhibited at the RA from 1900; prolific output of a railway artwork. Wrote the book *Water Colour Painting* with Fred Taylor. Lived at Scarborough, then London. Represented in several public collections. Produced posters for many UK areas. Many appear throughout this Volume. He was one of the LNER's 'Big 5' artists.

Fortunino Matania (1881-1963)

Born in Naples, Italy, he moved to London around the outbreak of World War I. He illustrated books and magazine, as well as his poster work for the railways. He created some of the most spectacular posters ever produced by any railway company (his Southport duo are magnificent) and his unique style lent itself well to portraying the 20s.

Jack Merriott (1901-1968)

Landscape & portrait painter in oil & watercolour, poster designer, author. Born 15/11/1901. Educated at Greenwich Central School. Studied at Croydon School of Art and at St Martins School of Art, both in London. Lectured in Royal Army Education Corps (1945-6). President of Wapping Group of artists 1947-60. Lived in

Shirley, Surrey; then Storrington, Sussex and later in Polperro, Cornwall. Illustrated some of the *'Beautiful Britain'* series of books by Blackies. Lectured widely on watercolour and produced the *'Pitman Guide to Watercolour'* and wrote *'Discovering Watercolour'*. Was Vice President of RI and achieved a prolific output of railway-related artwork. Produced posters for BR, several of which are found throughout this Volume.

Claude Grahame Muncaster (1903-1974)

Painter in oil & watercolour; etcher of landscapes, town scenes & marines, lecturer & writer. Born 4/7/1903 in West Chiltington, Sussex, son of Oliver Hall (RA). Educated at Queen Elizabeth School, Cranbrook. Elected a Member of RWS in 1936. In 1945, he adopted above name by deed poll, but had has used it at exhibitions un from 1923, and previously as Grahame Hall. First one-man show at the Fine Art Society 1926. Wrote book *'Rolling Round the Horn'*, pub.1933, about his four-month voyage from Australia. Represented in many public collections. Wrote several books on art. Lived near Pulborough, Sussex. Produced GW & LMS posters.

Bernard Myers (1925-2007)

Bernard Louis Myers, artist and teacher: born London 22 April 1925. He worked in instrument-making (radio location), and took a short course in Physics at London University before volunteering for the RAF at the age of 18. Royal College of Art 1961-80, Professor of Design Education 1979-80; Professor of Design Technology, Brunel University 1980-85; died London 30 September 2007. Known for his abstract style posters for British Railways, which today are very collectible (see p.47)

Brendan Neiland (b 1941-)

Born in Lichfield, Staffordshire he studied art at the Birmingham College of Art and then the Royal College of

Art in London. After winning numerous prizes and awards he was elected a Royal Academician in 1992 and a Fellow of the Royal Society of Arts in 1996. He is currently Professor at the University of Brighton. One of the UK's most distinctive painters, his modern renditions of British stations are real collectors' items. Has exhibited internationally, and his work is held in major public, private and corporate collections worldwide. His 1991 northern city station posters are found within volume 2 and his King's Cross poster appears on page 47.

Frank Newbould (1887-1951)

Born in Bradford, he became one of the 'Big Five' poster artists after studying art at the Camberwell School. Joined the war office in 1942 and was assistant under the famous Abram Games. His many posters were undertaken for the LNER, GWR, Orient Line and Belgian Railways. A great poster artist, he sadly died at too young an age. There are many examples of his fine poster artwork in Volume 2 and his superb Wye Valley is found in Vol3 p103.

Charles Oppenheimer (1875-1961)

Born in Manchester, this well known artist spent much of his life in Kirkcudbright and died there. Oppenheimer studied under Walter Crane at Manchester School of Art and in Italy. He settled in Kirkcudbright, and for 52 years painted views of the landscape in his local area. He was a keen fisherman, and many of his paintings dealt with rivers and the effect of light on water: he was also a fine painter of snow and an acute observer of weather conditions. He painted both oils and watercolours in a fresh, direct and realistic manner and his popularity is due to his great sensitivity to landscape and light. He retained a love of Italy and produced some excellent canvases of Florence and Venice. His expansive style produced some wonderful posters (e.g. Vol2, page 83).

Daphne Padden (1927-2009)

Daphne Padden was born on 21st May 1927, and was the daughter of Percy Padden ARCA who was both a fine artist and a poster designer himself (see below). She studied at Epsom & Ewell School of Art. She was a freelance artist for BPC, Post Office, BEA, P&O and other corporate firms. Undertook railway poster work for BR in the 1950s and 1960s. There are 9 entries for her in the JDF poster database, mainly for North Wales and the North-west areas. Exhibited her general artwork widely in the Surrey area and specialised in miniature paintings. Her work was accepted by Royal Society of Miniature Painters, Sculptors and Engravers in late 70s: she was first Associate then Member of the Society. Active as an artist well into later life, and died 21 September 2009.

Percy Padden (1885-1956)

Studied at the Royal College of Art and went on to become one of the foremost poster designers of the early 20th Century. He worked mainly for the post office producing sumptuous works advertising cruises on Mail Boats. His work is characterised by strong images with use of colour and form. He did work for London Transport and produced many LT posters in the 1920s. Also produced the lovely poster of Dovercourt Bay for the LNER in the mid 1930s.

James McIntosh Patrick (1907-1998)

Landscape & portrait artist in oil & watercolour, etcher. Born 4/2/1907 in Dundee, son of an architect. Studied at Glasgow School of Art under Grieffenhagen (1924-8) and in Paris. Worked for Valentines Cards. Received Guthrie award in 1935. Exhibited at the Fine Art Society and represented in many public collections, including the Tate Gallery. Based in Dundee for many years and died in April 1998. Produced posters for LNER & BR and his work today is very collectible.

Charles Pears (1873-1958)

Yorkshire-born Pears was a prolific railway poster artist and some of his classic posters are highly collectible. He was an Official Naval Artist during the First World War and also president of the Society of Marine Artists. He was 60 when he married Tiger in 1933, just two years after the death of his first wife, Miriam in 1931.

Tom Purvis (1888-1959)

Born In Bristol, the son of famous marine artists TG Purvis, Tom Purvis became one of the best poster artists of all. He studied at the Camberwell School of Art, and worked for six years at Mather and Crowther, before becoming a freelance designer. His bold style used blocks of colour in a two-dimensional manner and he largely eliminated detail. Worked under William Teasdale, the Marketing manager at the LNER and then his successor Dandridge, for 20 years and rose to prominence in the poster art field very quickly. The project database shows almost 100 posters, produced over his entire working life and several are featured herein. He tended to focus on places and the landscape rather than trains or people. His famous stand-alone sets of six posters for the LNER (Chapters 8 and 9) could also be placed together panoramically: way ahead of its time.

Gwen Raverat RE (1885-1957)

Gwen Raverat was born into a famous family. She was the daughter of Sir George Darwin, Professor of Astronomy at Cambridge University and the grand-daughter of Charles Darwin. She studied at the Slade from 1908-1911 and was self-taught as a wood engraver. In 1911 she married Jacques Raverat, a fellow art student. The pair were close friends of Eric Gill (of Gill Sans fame), Stanley Spencer and Andre Gide. In 1920 Gwen Raverat became a founder-member of the Society of Wood Engravers and an Associate of the Royal Society

of Painter-Etchers and Engravers. Gwen Raverat's role within the revival of wood engraving cannot be underestimated. She published books containing modern wood engravings from 1915 and illustrated a huge quantity of books throughout her life and became a teacher in this field. She undertook numerous etching-type posters because of her great skill in the art (see volume 4 page 54).

Harry Hudson Rodmell (1896-1984)

He was encouraged to pursue art as a career from a very young age. In 1912 he entered the Hull School of Art with a two year scholarship. It is not surprising that Hull-born Rodmell would find inspiration down at the docks. They were his favourite spots to take his sketchpad and so he developed a love of ships and an in-depth knowledge of many types of vessel. This interest revealed itself in his work and he began to produce work of an extremely high quality, even at this young age. Whilst still at college he painted a picture of *SS Eskimo*, which was of commercial poster quality. The design was bought by the owners (Wilson Line of Hull) of the vessel and loaned to hotels as an advertisement for the line. Whilst he was tempted to concentrate on maritime subjects he made sure to develop a range of skills. Rodmell excelled in many subjects including etching, lithography, carving and illustration. He produced posters for The P+O Steamship Company and British India Line and the tugboat company William Watkins Ltd. After wartime service with the ROC, he became well known for paintings of new vessels, produced prior to actual building, by using the official plans.

Gyrth Russell (1892-1970)

Printer, etcher of landscapes & marine subjects. Born Dartmouth, Nova Scotia on 13/4/1892. Son of Benjamin Russell, Judge of Supreme Court, Nova Scotia. Studied art at Boston USA, also in Paris at both the Academie Julian and Artelier Colarossi 1912-14. He represented in several public collections including Canada's National Gallery. Was official war artist with the Canadian Army during World War I. Lived in Topsham, Devon and later in Penarth, Glamorgan and Sussex. Died 8/12/1970 in Wales. Produced posters for GWR & BR. One of his best is found on volume 3 page 106 and several are in my own collection and will appear throughout this series.

Sir Henry George Rushbury (1889-1968)

Painter in watercolour, etcher & draughtsman of architectural subjects. Born 28/10/1889 at Harborne, Birmingham. Studied stained glass design and mural decoration at Birmingham College of Art 1903-09, later working as assistant to Henry Payne (RWS). Settled in London in 1912. First one-man show held at Grosvenor Gallery in 1921. Studied at Slade School for six months under Tonks. Became member of RWS in 1926. Worked home and abroad and represented in many public collections. Created CVO 1955, CBE 1960, KCVO 1964. Lived London, Sussex and Essex. Produced some truly outstanding posters for LMS, LNER & BR.

Hans Schleger (1898-1976)

German born Schleger, who signed his work 'Zero', was a major figure in the development of graphic design in Britain from the 1930s to the 1970s. Schleger studied and began his career in 1920s Berlin. He also spent five years in New York, where he was one of a small group of designers who helped to introduce modern design to the US. In 1932 he moved to London, where he stayed until his death. His advertising campaigns for British companies and public authorities have been influential both in Britain and abroad. He is best known for his design of the John Lewis Partnership symbol.

J. Charles M. Shepard (1892-19XX)

Signed his posters as 'Shep'. He also went under the name Captain Shepard. He studied art under Paul Woodroofe and later became Head of Design at the Baynard Press. He was commissioned to produce posters for the Southern Railway and several for London Transport. Well known for his iconic *expresses* series of posters (volume 2 page 241 for example). Little is known about his life, or when he died.

Raymond Sheppard (1913-1958)

Born in London, Raymond Sheppard was a hugely gifted artist and illustrator who studied and worked in and around the London area during the first half of the 20th Century. He was a very versatile painter who specialised in mostly animal subjects, spending many hours at the London Zoo researching and sketching. He illustrated books by Ernest Hemingway, Enid Blyton and Jim Corbett amongst others and was an active book artist in the 1930s. He was responsible for a few railway posters featuring animals (e.g. Dudley and Chessington Zoo). We know little about his later years.

Frank Sherwin (1896-1986)

Marine & landscape painter in oil & watercolour, poster designer. Born Derby 19/5/1896, son of Samuel S Sherwin (painter). Educated Derby and studied at Derby School of Art and at Heatherleys School of Fine Art in Chelsea 1920. He exhibited often from 1926 to 1940. Served in WWII as camouflage advisor around East Anglian airfields. He lived in Cookham, Berkshire for many years. Prints were produced from some of his artwork. Achieved a prolific output of poster art for the railways. producing images for three of the 'Big Four' companies (GWR, LMS, LNER) & many for BR regions, including the Southern Region. Died in Slough in 1986.

Kenneth Denton Shoesmith (1890-1939)

Though born in Halifax, he was brought up in Blackpool and in 1906 went as a cadet to the Conway training ship. She was then moored in the Mersey and Shoesmith spent most his spare time sketching passing ships. In 1909 he joined the Royal Mail Company until the end of the First World War, by which time, as a chief officer duties allowed him too little time to paint. He became a professional artist living in London and specializing in poster designs, mainly for shipping firms, and especially for the Royal Mail. He had his first one-man show in Belfast in 1921, and exhibited at the Royal Academy and the Paris Salon. Kenneth Denton Shoesmith was a member of the Royal Institute of Painters in Watercolours and of the British Society of Poster Designers. He died in London at just 48 years of age. A major collection of his work is held at The Ulster Museum, Belfast.

Ellis Luciano Silas (1883-1972)

Marine & landscape painter in oil & watercolour, poster and stained glass artist. Born London, son of Louis F.Silas, a decorative artist and founder member of the United Artists; and grandson of Edouard Silas, a composer. Studied art under his father and Walter Sickert. He was war artist for the Australian government 1914-18 and spent three years in Papua, painting and collecting curios which he described in his book 'A Primitive Arcadia'. President of the London Sketch Club in 1930. Lived in London for many years.

Walter Spradbery (1889-1969)

He was born in Dulwich, East London and educated at Walthamstow Art School. He specialized in landscapes showing the countryside around London, and regularly exhibited at the Royal Academy. His poster designs were produced mainly for London Transport, although he received some commissions for the LNER and British Railways. A lifelong pacifist, he served in the Royal Army Medical Corps during the First World War, and was also an official war artist. A memorial exhibition was held at the William Morris Gallery, London in 1970.

Leonard Russell Squirrell (1893-1979)

Painter & etcher of landscapes & architectural subjects, writer. Born Ipswich 30/10/1893. Educated at British School, Ipswich and studied at Ipswich School of Art under G. Rushton and at the Slade School. Won British Institution Scholarship in engraving 1915. Received gold medals at the International Print Makers Exhibitions in Los Angeles in 1925 & 1930, and silver in 1923. Represented in many collections, home and abroad. Transferred from the RI to the RWS during his career. Published 'Landscape Painting in Pastel' 1938, and 'Practice in Watercolour' 1950. Lived near Ipswich and was founder member of the Ipswich Art Club.

Kenneth Steel (1906-1970)

Printmaker, painter in watercolour and oils, poster and carriage print designer. Born Sheffield 9/7/06, studied under Anthony Betts at Sheffield College of Art. Started as metal and heraldic engraver. Produced over 40 line engraving & drypoint prints between 1932 and 1948. In 1940's worked producing architecture perspective drawings. Achieved a prolific output of art work for the railways, both carriage prints and posters because of a bold style ideal for advertising, he was one of the most prolific artists in the early days of BR. During 1950's travelled to Mediterranean, particularly Majorca and the Caribbean producing brightly coloured palette knife oil paintings, many published by Frost & Reed of Bristol as colour collotype prints. He married twice, in 1939 and 1953. Most work in private hands, very little in public collections. Died 7/7/1970 in Sheffield.

Fred Taylor RI (1875-1963)

Landscape & architectural painter in watercolour, poster designer. Born London 22/3/1875. Educated at St John the Evangelist. Studied art at Paris at the Academie Julian, at Goldsmiths College School (awarded gold medal for posters) and in Italy. Worked at the Waring & Gillow studio. He was a poster artist from 1908 to 40s. In 1930, he designed four ceiling paintings for the Underwriting Room at Lloyds, London. Worked on naval camouflage during World War II. Renowned for his topographical accuracy and prolific output, especially for the railways. He was one of Teasdale's favoured artists in early LNER days. Wrote the book 'Water Colour Painting' with Frank H Mason. Represented in several public collections and exhibited at the RA. Lived in London for many years. Produced posters for MR, GWR, LMS, LNER, BR, LT, EMB & several shipping companies.

Harry Tittensor (1887-1942)

Apprenticed to the Doulton ceramics factory in Stoke on Trent at the age of 14 in 1900, Tittensor became one of the company's most versatile and gifted artists. He was equally skilled as a modeller and painter, working in many different styles on all types of Burslem art wares. He excelled in Oriental subject matter and no doubt helped devise the exotic colourwashes for his famous Forty Thieves, which sell for between £3-5,000 each today. His eye for colour was spotted by the LNER, who commissioned him to produce several posters (see his Norwich poster on page 88 for example) and some carriage prints. He lived at Wolstanton near Stoke and later exhibited at the RA, RI & Fine Art Society late in life.

James Fletcher-Watson (1913-2004)

Born in Surrey July 1913, he was an architect and an outstanding watercolour artist. He was a member of the Royal Institute of Painters in Watercolour and the

Royal Society of British Artists. He exhibited widely in Britain, France, Australia and the Unites States, held regular exhibitions in his studio in the Cotswolds and was the author of several highly popular books. Painted several carriage prints for Norfolk, where he once lived. Moved to Windrush, Oxfordshire and died in June 2004.

Arthur Watts (1883-1935)

Arthur Watts (also known by the name Arthur George Watts), born 1883 in Chatham, the son of a surgeon in the Indian Medical Service. He studied at the Slade School of Fine Art. Later he travelled to Antwerp, Paris, Moscow and Madrid to further his studies. Watts was awarded the Distinguished Service Order in the First World War. He contributed illustrations to Punch, Pearson's Magazine, Pear's Annual, The Bystander and Radio Times in addition to illustrations for a number of books. Watts often drew views from an unusual overhead angle and his figures were sometimes somewhat elongated. Designed posters for the Underground Group 1924-1927 He sadly died in an air crash in 1935.

Edward Wesson RI RBA RSMA (1910-1983)

Wesson was born in Blackheath, London in April 1910. He developed into one of Britain's most outstanding 20th Century watercolourists. He started painting at the age of 20 and adopted his own pure and simple style, painting with a French polisher's mop and drawing with a matchstick or sharpened lollipop stick. He was elected a member of the RI (Royal Institute of Painters in Watercolour) in 1952 and public recognition was further enhanced by commissions for British Rail and the Post Office Savings Bank. Wesson was also a tireless teacher, writing articles for artists' magazines as well as tutoring painting holidays. He is also renowned for his coastal and rural views, townscapes and still life, applying his

watercolour to damp paper 'wet on wet' which suited his bold and simple style. He exhibited widely in the 1950s and 1960s, including at the Royal Academy.

Norman Wilkinson CBE (1878-1971)

Wilkinson was born in Cambridge and educated at Berkhamsted School then St Paul's Cathedral choir school. He had little formal training in art, and largely developed his style through his maritime career. Norman's greatest love in life was painting: his subjects were seascapes and landscapes, in both oil and watercolour. His early career as an illustrator for the Illustrated London News enabled him to develop his talents as both artist and entrepreneur. Norman made a contribution to WWI with the invention and development of *Dazzle Painting*, a novel form of ship camouflage. One of the finest marine painters of the century, he is well represented in many public collections, including Greenwich and the NRM York. During WWII he painted a record of the major sea battles and presented the series of 54 paintings to the Nation. They are kept at the National Maritime Museum. Norman's commercial work included many illustrated books and he initiated a revival in poster painting for LMS Railways. He was honoured with CBE in 1948.

Arthur Nigel Wolstenholme (1920-1982)

He was born in January 1920 and died in Watford – where it is believed he had lived for at least 40 years and possibly for his entire life – in June 2002 at the age of 82. He worked as a freelance technical illustrator in Watford, possibly from his home in Woodland Drive, and contrary to what had been assumed for many years by railway enthusiasts, covered subjects beyond transport. As well as railway posters, he also illustrated many Ian Allan ABC locomotive series books and was renowned for his meticulous artwork. Friend of artist Laurence Fish.

Wilfrid Rene Wood (1888-1976)

Wilfred Wood was born in Cheadle Hulme, and educated at Manchester Grammar School. His father was a cutler and part cotton mill owner; his mother was a good artist who had worked as a decorative painter at the Royal Doulton potteries. Wilfrid studied at the Manchester School of Art and the London Central School of Art. After WWI he resumed his training at the Slade School of Art, under Wilson Steer and Professor Tonks. In 1920 he moved to the London and painted local scenes, concentrating on areas that were threatened with development. In 1927 he produced a series of posters on Kew for London Underground and a series of town exhibitions, Oxford then Norwich, Cambridge and Tenby. In 1937 he moved to Stamford to record the town buildings and street scenes. He lived at Barnack with wife Joan, also an artist. 1937 saw his first exhibition in Stamford. He was later asked to paint vanishing scenes in Peterborough. A large permanent collection of his works is held by Peterborough Museum and Art Gallery and at Peterborough Cathedral.

Philip Zec (1909-1983)

Zec was born in Russia in 1909 to a family who was soon to flee Tsarist oppression, finally settling in London before the First World War. At the age of thirteen, he won a Scholarship to St Martin's School of Art, and on graduating he joined Arks Publicity an advertising agency. He later set up his own commercial art studio working for agencies including J Walter Thompson, which is when all his railway poster work was commissioned. In 1930's and during the Second World War he worked as the political cartoonist for the Daily Mirror, some of his wartime cartoons caused great embarrassment to the Government.

Anna Katrina Zinkeisen (1901-1976)

Born in Kilcreggan, Dunbartonshire, she was a pupil of the Royal Academy School, holding medals from there. She won scholarship to the Royal Academy from Harrow School of Art, winning the Landseer Prize in 1920 and 1921. She also worked for Wedgwood as a ceramics designer. She designed posters for the LNER and the SR.

Doris Clare Zinkeisen (1898-1991)

Elder sister of Anna, above, she also studied at the RA Schools. She lived in London, and as well as painting, she also undertook theatrical and set design work. Her classic poster of *'Coronation'* can be found in Vol2, p3, and her striking self-portrait on page 18 of volume 2. She worked as official artist to the St. John Ambulance during WWII, when she and younger sister Anna were nurses. Doris arrived in Belsen shortly after liberation and had recurring nightmares for over 40 years about the terrible camp conditions until she died.

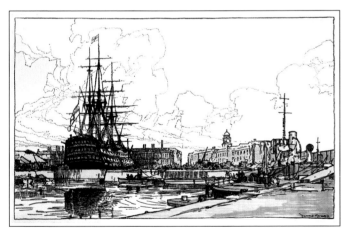

392 HMS Victory at Portsmouth: Donald Maxwell

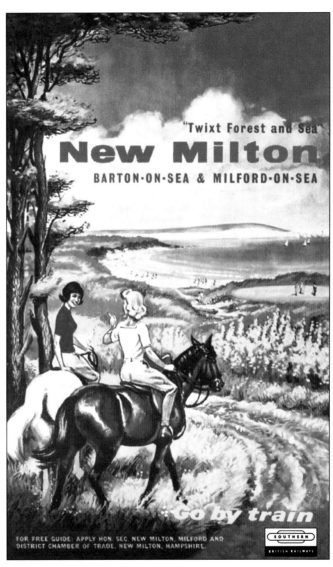

393 1952 Unsigned BR (SR) poster for New Milton

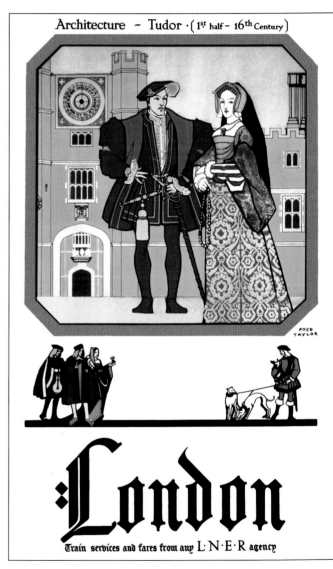

394 1930s LNER London poster by Fred Taylor

Speaking of **Middlesex**, this has a long proud history, the name being first recorded in 704 AD. The name simply derives from the territory of the Middle Saxons, with Wessex to the west, Essex to the east and Sussex to the south. The county town was Brentford, within the Borough of Hounslow, but this did not receive railway poster treatment, although in keeping with many places in this county, London Transport did issue some artwork. It was one of England's smallest counties (around 90 square miles), but one of the richest. The scenery is largely urban, and mainly flat, but vantage points such as Harrow-on-the-Hill, afford some unique cityscape views. This however was not taken up in railway advertising. The River Thames running through the centre affords superb riverside views, also largely neglected. The eleven posters listed focus strongly on Hampton Court, Staines and Harrow: in addition a lot of letterpress posters advertising Lords and the season's cricket fixtures were noted, some of which will feature in volume 8.

Surrey is a county name first listed in 722 AD, deriving from the Old English *'Suthrige'*, the region south of the Thames. Its county town was Kingston-Upon-Thames, but the 1965 boundary changes now place it in Greater London. The 24 different listings in the database pages represent a small number compared with the hundred plus issues by London Transport. The major attractions of Chessington Zoo, Kew Gardens and the Thames valley, plus Guildford and the Surrey Hills form the majority of the county's railway posters, but rather amazingly Runnymede was omitted, as were many of the well known beauty spots and pretty towns in this most wooded of the southern counties: Haslemere is a case in point, and Guildford Cathedral deserved more railway recognition. To counter these deficiencies, Box Hill, Leith Hill, Frensham Pond and Oxshott Heath are featured. Posters for these locations are found in chapter 6.

Sussex was extensively advertised by the railways: nearly 140 posters are listed in the database that follows. The name was first used at the same time as Surrey appeared, in 722 AD and its history and geography have largely been influenced by its coastline. It is one of the first places people from London travel to for some seaside fun. But other areas are equally appealing and the inland regions have a calm and beauty that the railways also portrayed. But it is the seaside town that saw the heaviest advertising investment, with Brighton (27 posters), Eastbourne (14), Hastings (24) and Bognor Regis (9) all featuring prominently. Bexhill, Chichester, Lewes, Littlehampton and Worthing are all featured in chapter 5, and some lovely quad royal posters of the South Downs show the beauty of this sunniest of English Counties. Battle and Midhurst, however were largely ignored, (almost a sin in the case of Battle with its huge significance in English history), and fine houses such as at Glynde and Petworth were similarly treated. Chapter 5 however is still awash with sunshine!

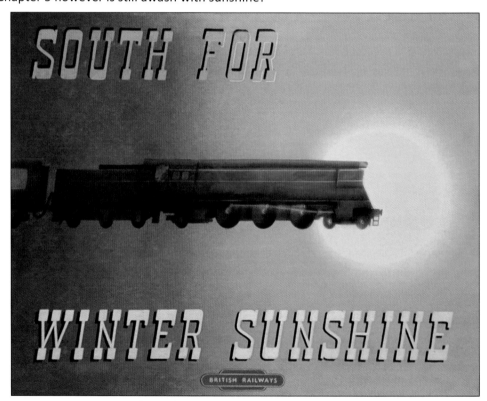

395 Edmond Vaughan's iconic poster from the 1960s

ARTIST	DATE	TITLE	LOCATION	COMPANY	SIZE	SOURCE	SOURCE DETAILS		IMAGE REF	NRM REF
Bateman, H.M.	1928	Season Tickets on the L.N.E.R. save time and money	Advert	LNER	DR	SSPL	10325494	Drawer D093	Advert0004	1978-9580
Michie	1950s	Golden Arrow Pullman Day Service to Paris	Advert	BR(SR)	DR	SSPL	10175384	Drawer D126	Advert0005	1978-0803
Barber	1953	Bournemouth Belle (stock poster bottom blank)	Advert	BR(SR)	DR	SSPL	10175323	Drawer D126	Advert0008	1978-0742
Brown, Charles E.	1937	London uber Ostende/Dover (famous child image)	Advert	SR	DR	SSPL	10174967	Drawer D101	Advert0011	1978-9811
Anon	1930	Eighth Exhibition of Poster Art: Gieves Gallery	Advert	LNER	DR	SSPL	10176036	Drawer D093	Advert0034	1988-8011
Keely, Patrick Cockayne	1930s	Signals Southern Railway	Advert	SR	DR				Advert0063	
Hammond, Aubrey	1930s	SR The Gateway to the Continent	Advert	SR	DR	Onslows	11/4/02 lot 390		Advert0072	
Vaughan, Edmond	1930s	Short Sea Routes	Advert	SR	DR	Onslows	21/11/01 lot 338		Advert0078	
Vaughan, Edmond	1929	South for Sunshine famous bluebird image	Advert	SR	DR	Onslows	21/11/2001 Lot 339		Advert0079	
Anon	1931	It's Time to Go South for Winter Sunshine	Advert	SR	DR	Christies	1/10/1993 lot 57 B+W image		Advert0113	
Cooper, Austin	1927	Liverpool Street Suburban Trains punctuality	Advert	LNER	DR	SSPL	10311579		Advert0129	1978-9582
Coventry, F.H.	1932	Winter Sunshine Holidays in Southern England	Advert	SR	DR				Advert0132	
Cusden, Leonard	1931	South for Sun-Bathing: seagulls resting	Advert	SR	DR				Advert0139	
Danvers, Verney L.	1933	Ensure a Good Morning: Travel by Southern Electric	Advert	SR	DR	SSPL	10176083	Drawer D103	Advert0140	1988-8058
Danvers, Verney L.	1933	Enjoy a Good Night: Travel by Southern Electric	Advert	SR	DR	SSPL	10176084	Drawer D103	Advert0141	1988-8059
Danvers, Verney L.	1926	South for Sunshine: The World's Finest Resorts	Advert	SR	QR				Advert0142	
Dull'ous, P.	1959	Night Ferry: through sleeping cars to Paris/Brussels	Advert	BR(SR)	DR	SSPL	10175113	Drawer D126	Advert0145	1978-9957
Dull'ous, P.	1959	Night Ferry: through sleeping cars to Paris/Brussels	Advert	BR(SR)	DR	SSPL	10175822	Drawer D126	Advert0145	1978-1246
Eckersley, Tom	1962	For London Football Travel by Southern Electric	Advert	BR(SR)	DR	SSPL	10175774		Advert0148	1978-1198
Fish, Laurence	1960	Bank Station Travolator; Waterloo & City Line	Advert	BR(SR)	DR	SSPL	10175373		Advert0152	1978-0792
Fish, Laurence	1960	Cross the Channel from Dover AD9061/1411/61	Advert	BR(SR)	DR	SSPL	10175160	Drawer D126	Advert0153	1978-0598
Brown, F. Gregory	1948	A Day in the Country: Frequent Electric Trains	Advert	BR(SR)	QR	SSPL	10173468	Drawer D025	Advert0157	1978-8930
Cobb, Charles David	1950	SS Maid of Orleans Now in Service AD6010	Advert	BR(SR)	DR	SSPL	10175305		Advert0159	1978-0724
Anon	1937	Be Sure to Visit Hastings for the Grand Carnival Week	Advert	SR	DR	SSPL	10174963	Drawer D101	Advert0171	1978-9807
Anon	1953	Coronation of Queen Elizabeth II Special Events	Advert	BR(SR)	DR	SSPL	10175434	Drawer D126	Advert0185	1978-0853
Anon	1963	Cross with Us to the Continent - Sailors and girl	Advert	BR(SR)	DR	SSPL	10175162	Drawer D126	Advert0186	1978-0600
Anon	1963	Cross with Us to the Continent - Sailors and girl	Advert	BR(SR)	DR	SSPL	10175768	Drawer D130	Advert0186a	1978-1192
Anon	1961	Explore the South Coast with a Day Tour Ticket	Advert	BR(SR)	DR	SSPL	10175695		Advert0192	1978-1119
Anon	1982	Get to know your London Connections	Advert	BR/LT	DR	SSPL	10172574		Advert0196	1983-8391
Anon	1946	Southern Railway: Map of System and Continental Connections	Advert	SR	QR	SSPL	10176082	Drawer D019	Advert0251	1988-8057
Wilkinson, Norman	1947	The New T.S. Falaise: Original Artwork	Advert	SR	QR	SSPL	10282912		Advert0258c	1976-9333
Zero (Hans Schleger)	1970s	The Museum of British Transport, Clapham	Advert	BR Exec	DR	SSPL	10171114		Advert0274	1992-7487
Anon	1935	Winter Sunshine: Southern Electric	Advert	SR	DR	SSPL	10171208		Advert0275	
Anon	1970s	All Stations: A journey through 150 years	Advert	Science Mus.	DR	SSPL	10172057		Advert0291	1981-7358
Vaughan, Edmond	1929	South for Winter Sunshine AD1072 Abstract train	Advert	SR	DR	SSPL	10172412	Drawer D103	Advert0293	1986-8773
Kerr, T.D.	1925	Progress Poster No. 1: Electrification	Advert	SR	DR				Advert0294	
JCV	1932	Southern Railway: Winter Sunshine: Businessman	Advert	SR	DR	SSPL	10172780		Advert0302	1983-8557
Vaughan, Edmond	1932	So Swiftly Home by Southern Electric: Night image	Advert	SR	DR	SSPL	10170810	Drawer D102	Advert0305	1991-7445
Molenaar, H.	1933	South for sunshine: Short sea routes AD2520	Advert	SR	QR	SSPL	10170955	Drawer D019	Advert0314	1990-7063
Keely, Patrick Cockayne	1947	Progress on the Southern Railway Electric and diesel locos	Advert	SR	DR	SSPL	10172948	Drawer D102	Advert0315	1985-8811
Shep (Charles Shepard)	1953	God Save the Queen - English heraldry PR 41	Advert	BR Exec	DR	SSPL	10173042	Drawer D116	Advert0316	1975-8390
Shep (Charles Shepard)	1953	God Save the Queen Scottish Heraldry	Advert	BR Exec	DR				Advert0316a	
Pears, Charles	1937	Summer Services for Winter Vistors: Portsmouth electrics	Advert	SR	QR	SSPL	10173058	Drawer D019	Advert0317	1975-8406
Carr, Leslie	1946	Southern Railway: Bullied Locomotive: Stock poster	Advert	SR	DR	SSPL	10174926	Drawer D102	Advert0345	1978-9770
Weber, Audrey	1935	Conducted Rambles: Autumn - Harvesting	Advert	SR	DR	SSPL	10174927	Drawer D101	Advert0346	1978-9771
Shep (Charles Shepard)	1938	Bournemouth Limited	Advert	SR	DR	SSPL	10174936	Drawer D101	Advert0349	1978-9780
Keely, Patrick Cockayne	1939	Conducted Rambles in Hants, Kent, Surrey & Sussex	Advert	SR	DR	SSPL	10174939	Drawer D101	Advert0351	1978-9783
Knebel, Elsie	1938	Cheap travel: On the Continent or at Home	Advert	SR	DR	SSPL	10174941	Drawer D101	Advert0352	1978-9785

ARTIST	DATE	TITLE	LOCATION	COMPANY	SIZE	SOURCE	SOURCE DETAILS		IMAGE REF	NRM REF
Keely, Patrick Cockayne	1938	SR Stock Poster: Horse racing jockey	Advert	SR	DR	SSPL	10174944	Drawer D101	Advert0353	1978-9788
Lee-Elliott	1938	SR Stock Poster: Horse racing art deco horses	Advert	SR	DR	SSPL	10174947	Drawer D101	Advert0354	1978-9791
Lee-Elliott	1938	SR Stock Poster: Rambling: Hikers in sunlight	Advert	SR	DR	SSPL	10174948	Drawer D101	Advert0355	1978-9792
Keely, Patrick Cockayne	1938	SR Stock Poster: Conducted Rambles hiker	Advert	SR	DR	SSPL	10174949		Advert0356	1978-9783
Chater, John	1937	Southern Electric: New extensions railway gang	Advert	SR	DR	SSPL	10174959	Drawer D101	Advert0358	1978-9803
Weber, Audrey	1936	Conducted Rambles: Spring: ploughing	Advert	SR	DR	SSPL	10174987	Drawer D102	Advert0368	1978-9831
Weber, Audrey	1936	Conducted Rambles: Summer; hay rick	Advert	SR	DR	SSPL	10174990	Drawer D102	Advert0370	1978-9834
Barber	1963	Brighton in 1 hour	Advert	BR(SR)	DR	SSPL	10175324	Drawer D126	Advert0395	1978-0743
Anon	1960s	The Southern Belles: To Brighton and Bournemouth	Advert	BR(SR)	DR	SSPL	10175349	Drawer D126	Advert0396	1978-0768
Lander, Reginald Montague	1950s	The All Pullman Bournemouth Belle	Advert	BR(SR)	DR	SSPL	10175361	Drawer D126	Advert0397	1978-0780
Keely, Patrick Cockayne	1950	Conducted Rambles in Kent, Surrey and Sussex Timetable	Advert	BR(SR)	DR	SSPL	10175385		Advert0399	1978-0804
Studio Seven	1959	Jobs on the Southern: Informative letterpress	Advert	BR(SR)	DR	SSPL	10175700		Advert0408	1978-1124
Marton	1936	Bournemouth Belle: Runs-Daily: N0 862 stock poster	Advert	SR	DR	SSPL	10307101		Advert0421	
Marton	1936	Bournemouth Belle: Runs Daily: Timetable	Advert	SR	DR	SSPL	10174972	Drawer D101	Advert0421a	1978-9816
Bagdatopolos, William S.	1920s	The Golden Arrow and Orient Express red dress version	Advert	CIE Wagon Lits	DR	SSPL	10171257	Drawer D103	Advert0428	1992-7729
Anon	1929	The Golden Arrow Limited:Paris in 6.5 hours AD 1088	Advert	SR	DR	SSPL	10171361	Drawer D101	Advert0432	1993-8141
Grundy, John Hull	1933	Sunshine at Home or Abroad: Pixcillated image	Advert	SR	DR	SSPL	10173054	Drawer D101	Advert0459	1975-8402
Brown, Charles E.	1936	I'm taking an early holiday classic child and train image	Advert	SR	DR	SSPL	10173056		Advert0460	1975-8404
Goddard, F.A.	1947	The Southern Railway brings the Countryside nearer	Advert	SR	DR	SSPL	10173150	Drawer D101	Advert0461	1977-5589
Brearley, William Ramsden	1939	Why do they call me Sunny South Sam?: famous Guard	Advert	SR	QR	SSPL	10173406	Drawer D019	Advert0463	1978-8875
Shep (Charles Shepard)	1937	Suspension and Alteration of IOW steamboat services	Advert	SR	DR	SSPL	10174935	Drawer D101	Advert0466	1978-9779
Keely, Patrick Cockayne	1939	SR Stock Poster: Football	Advert	SR	DR	SSPL	10174943		Advert0472	1978-9787
Wolstenholme, A.N.	1950s	The Bournemouth Belle: 70007 loco stock poster	Advert	BR Exec	DR				Advert0473	
Wolstenholme, A.N.	1950	The Bournemouth Belle: stock poster AD 6350/A1	Advert	BR(SR)	DR	SSPL	10175359		Advert0473	1978-0778
Ayling, George	1938	Southern Coastal Resort Artwork/trimmed	Advert	SR	DR	SSPL	10324068	Drawer D102	Advert0477	1998-11684
Knebel, Elsie	1938	Keep Fit Holidays: Camping on the Southern	Advert	SR	DR	SSPL	10308295	Drawer D101	Advert0487	1995-7033
Shep (Charles Shepard)	1925	Your Cue for Summer Sunshine snooker table map	Advert	SR	QR				Advert0509	
McDowell, William	1925	Cross the Atlantic by White Star via SR	Advert	SR/Cunard	DR				Advert0514	
Tomkin, William Stephen	1906	Coast Line Rail Motor Services	Advert	LBSCR	DR				Advert0516	
WCL	1910s	Brighton Railway: The Sunshine Line Mistletoe map	Advert	LBSCR	DR				Advert0528	
Ralph & Mott (Pub)	1937	Happy Thought: Text in Christmas Tree Image	Advert	GW/LM/LN/SR	DR				Advert0531	
Cort, John	1958	Excursions from London to the Continent	Advert	BR(SR)	DR	SSPL	10170925		Advert0560	1989-7021
Anon	1987	Intercity savers from London 4th October 1987	Advert	BR Intercity	DR				Advert0564	
Anon	1992	Discover Kent & East Sussex	Advert	NSE	DR				Advert0570	
Brown, Pieter Irwin	1930	There is Sunshine in the South	Advert	SR	DR	SSPL	10305956	Drawer D103	Advert0578	1996-7431
Wentworth-Shields, F.W.	1932	Spring Radiance: Go-as-you-please-tickets Ad 1878	Advert	SR	DR	Onslows	3/11/1999 lot 308		Advert0594	
Kerr, T.D.	1932	Golfing in Southern England and on the Continent	Advert	SR	DR				Advert0600	
Bromfield, Kenneth	1960s	London to Paris in Pullman Comfort: Golden Arrow	Advert	BR(SR)	DR	Christies	14/09/2006		Advert0612	
Brown, Charles E (Photo)	1924	South for Sunshine Famous child image	Advert	SR	DR	Christies	13/09/2007 Lot 31		Advert0615	
Durman, Alan	1950s	Golden Arrow: The All-Pullman Service to Paris	Advert	BR(SR)	DR	Christies	14/10/2004 REF. AD 6518B15/26353		Advert0617	1978-1443
Photographic	1960s	Switch to Blue Pullman: Sonning Cutting	Advert	BR(WR)	QR				Advert0628	
Kerr, T.D.	1925	Rolling-Stock: Progress Poster Number 4	Advert	SR	DR				Advert0631	
Taylor, Horace	1931	Seaside excursions To Littlehampton Bognor Regis Portsmouth	Advert	SR	DR				Advert0650	
Brown, F. Gregory	1930s	Winter Sunshine Holidays: Southern Railway	Advert	SR	QR				Advert0681	
Black, Montague Birrell	1930s	Southern Railway to the Continent: Relief Map	Advert	SR	QR				Advert0691	
Keely, Patrick Cockayne	1948	SR New fleet 1948; Ship Launch Image	Advert	BR(SR)	DR				Advert0695	
Anon	1915	Happy Hours on the South-East Coast	Advert	SECR	DR	SSPL	10316905		Advert0698	
Anon	1970s	Getting to Heathrow is Plane Simple	Advert	Network SE	DR	NRM	1996-8268 Drawer D083		Advert0707	1996-8268

ARTIST	DATE	TITLE	LOCATION	COMPANY	SIZE	SOURCE	SOURCE DETAILS	IMAGE REF	NRM REF
Bromfield, Kenneth	1950s	Take Your Car by Train to London: Avoid the Jams	Advert	BR(SR)	DR	NRM	1978-0732 Drawer D158	Advert0743	1978-0732
Anon	1960s	Travel Bargains from Victoria: Bognor, Dover,Ramsgate	Advert	BR(SR)	DR	NRM	1978-0794 Drawer D159	Advert0756	1978-0794
Anon	1960s	Travel Bargains from Waterloo: Portsmouth, Ryde	Advert	BR(SR)	DR	NRM	1978-0795 Drawer D159	Advert0757	1978-0795
Anon	1960s	Travel Bargains from Victoria: Brighton, Littlehampton	Advert	BR(SR)	DR	NRM	1978-0796 Drawer D159	Advert0758	1978-0796
Anon	1960s	Travel Bargains from Charing Cross: Folkestone, Hastings	Advert	BR(SR)	DR	NRM	1978-0797 Drawer D159	Advert0759	1978-0797
Anon	1960s	Cheap Trips from this Station: Brighton, Arundel, Bexhill	Advert	BR(SR)	DR	NRM	1978-0798 Drawer D159	Advert0760	1978-0798
Cooper, Royston	1960s	Cheap Trips from this Station: Pevensey, Bexhill, Portsmouth	Advert	BR(SR)	DR	NRM	1978-0799 Drawer D159	Advert0761	1978-0799
Anon	1960s	Bargain Trips by the New Kent Coast Electrics	Advert	BR(SR)	DR	NRM	1978-0800 Drawer D159	Advert0762	1978-0800
Turner, Derek	1960s	Rail Trips from Waterloo: Portsmouth, Ryde, Bournemouth	Advert	BR(SR)	DR	NRM	1978-0809 Drawer D159	Advert0764	1978-0809
Turner, Derek	1960s	Rail Trips from Victoria: Brighton, Bognor, Eastbourne	Advert	BR(SR)	DR	NRM	1978-0811 Drawer D159	Advert0765	1978-0811
Turner, Derek	1960s	Rail Trips from Victoria: Margate, Broadstairs, Ramsgate	Advert	BR(SR)	DR	NRM	1978-0817 Drawer D159	Advert0766	1978-0817
Anon	1960s	Travel Bargains from Charing Cross, Waterloo, Victoria	Advert	BR(SR)	DR	NRM	1978-0812 Drawer D159	Advert0767	1978-0812
Anon	1960s	Cheap Trips by Train from Charing Cross (Pier image)	Advert	BR(SR)	DR	NRM	1978-0818 Drawer D159	Advert0769	1978-0818
Anon	1960s	Cheap Trips by Train from Victoria and London Bridge (Pier image)	Advert	BR(SR)	DR	NRM	1978-0819 Drawer D159	Advert0770	1978-0819
Anon	1960s	Cheap Trips by Train from Victoria (Pier image)	Advert	BR(SR)	DR	NRM	1978-0820 Drawer D159	Advert0771	1978-0820
Bromfield, Kenneth	1960s	So Near to the Sea by Train	Advert	BR(SR)	DR	NRM	1978-1095 Drawer D160	Advert0772	1978-1095
Anon	1960s	Day Tickets to the Coast from this station: Bexhill	Advert	BR(SR)	DR	NRM	1978-1105 Drawer D160	Advert0777	1978-1105
Bromfield, Kenneth	1961	Night Ferry: Sleep your way to Paris and Brussels	Advert	BR(SR)	DR	NRM	1998-10092 Drawer D160	Advert0784	1998-10092
Shep (Charles Shepard)	1930s	Golden Arrow: London-Paris Pullman	Advert	SR	DR			Advert0796	
Anon	1960s	Waterloo & City Line: only a 5-minute train journey	Advert	BR(SR)	DR	NRM	1978-0761 drawer D157	Advert0838	1978-0761
Studio Seven	1960s	Southern Electrics for the Kent Coast from June 15	Advert	BR(SR)	DR	NRM	1978-0763 Drawer D157	Advert0840	1978-0763
Anon	1960s	Special Sunday Excursion from this station	Advert	BR(SR)	DR	NRM	1978-0787 Drawer D157	Advert0842	1978-0787
Studio Seven	1960	Cheap Trips from Charing Cross: Hastings Folkestone	Advert	BR(SR)	DR	NRM	1978-0788 Drawer D157	Advert0843	1978-0788
Anon	1980	London and South East Passenger Network Route Map	Advert	BR Exec	QR	NRM	1980-7319 Drawer D026	Advert0862	1980-7319
Weber, Audrey	1924	Hints for Holidays: 960 page brochure SR	Advert	SR	DR			Advert0878	
Sherwin, Frank	1947	Hints for Holidays: where to go; where to stay	Advert	SR	DR			Advert0879	
McKie, Helen Madeleine	1947	Camping on the Southern 1947	Advert	SR	DR			Advert0880	
Ayling, Geoffrey	1925	Winter Holidays in Southern England	Advert	SR	DR			Advert0881	
Anon	1937	Winter 1937-8 Principle Services	Advert	SR	DR			Advert0882	
Anon	1932	Main Line Electrification: Opening July 17 1932	Advert	SR	DR			Advert0883	
Anon	1930s	London-Paris by Ferry Boat & Sleeping-Cars	Advert	SR	DR			Advert0884	
Anon	1934	Cheap LMS Trips from St. Pancras during April	Advert	LMS	DR	NRM	1977-5627 Drawer D092	Advert0888	1977-5627
Anon	1937	Winter 1936-7 Principle Services	Advert	SR	DR			Advert0895	
Anon	1935	New Extensions: Eastbourne, Bexhill, Seaford, Hastings	Advert	SR	QR			Advert0898	
Anon	1935	London-Sevenoaks service	Advert	SR	DR			Advert0913	
Barber	1953	The Golden Arrow Pullman Service: Pictorial timetable	Advert	SR	DR			Advert0914	
Brown, F. Gregory	1932	To the country quickly	Advert	SR	QR			Advert0915	
Reilly, Michael Leeds-Paine	1930s	Live in Metroland	Advert	Met. Rly	DR			Advert0922	
Anon	1930s	Live in Metroland+ Countryside from the carriage	Advert	Met. Rly	DR			Advert0923	
Shep (Chas Shepherd)	1930s	Spend a day in Metroland Brambles image	Advert	Met. Rly	DR			Advert0924	
Constable, S. Douglas	1930s	Fishing in Metroland: Leaping trout	Advert	Met. Rly	DR			Advert0925	
Anon	1911	Metropolitan Railway timetables 3rd July 2011	Advert	Met. Rly	DR			Advert0926	
Anon	1930s	Metro-land: Country House and Garden	Advert	Met. Rly	DR			Advert0927	
Hassall, John	1910	The Met: The Best Way: Policeman image	Advert	Met. Rly	DR			Advert0928	
Reilly, Michael Leeds-Paine	1930s	Metro-land: The Woodland Scene	Advert	Met. Rly	DR			Advert0929	
Stewart, Kay	1930s	Spring flowers (stock poster)	Advert	SR	DR			Advert0948	
Pinney, Betty	1939	In Winter: To your recreations by Southern Electric	Advert	SR	DR	SSPL	10308299	Advert0962	1995-7034
Wolstenholme, A.N.	1950	The Golden Arrow: London-Paris Pictorial timetable	Advert	BR(SR)	DR			Advert0963	

ARTIST	DATE	TITLE	LOCATION	COMPANY	SIZE	SOURCE	SOURCE DETAILS	IMAGE REF	NRM REF
Anon	1910s	Weekends at the Sunny South Coast	Advert	LBSCR	DR		Private Collection	Advert0972	
Anon	1933	Rail and Road Routes of Southern England: Map	Advert	GWR/SR	QR			Advert0974	
Shep (Chas Shepherd)	1936	Coronation Day: Train Alterations and special services	Advert	SR	DR	NRM	1978-9778 Drawer D101	Advert0991	1978-9778
Anon	1935	London Eastbourne Extension of Southern Electric in Progress	Advert	SR	QR	Pub Rec Off	Official SR Poster	Advert1006	
Keely, Patrick Cockayne	1935	Sunshine Recorded	Advert	SR	QR	Pub Rec Off	Official SR Poster	Advert1007	
Pears, Charles	1935	There's nothing to equal the Southern sun after all	Advert	SR	QR	Pub Rec Off	Official SR Poster	Advert1008	
Anon	1935	Southern Railway for the Continent Art deco image	Advert	SR	QR	Pub Rec Off	Official SR Poster	Advert1009	
Anon	1934	You can Sun-bathe on the Southern Coast	Advert	SR	QR	Pub Rec Off	Official SR Poster	Advert1012	
Anon	1932	Warm South Coast?: Quickest Southern Expresses	Advert	SR	QR	Pub Rec Off	Official SR Poster	Advert1014	
Anon	1923	Southern England for winter holidays or residence	Advert	SR	QR	Pub Rec Off	Official SR Poster	Advert1018	
Anon	1934	South Coast: Supreme for Sunshine: Sunny South Sam	Advert	SR	QR	Pub Rec Off	Official SR Poster	Advert1020	
Anon	1933	Rail and Road Routes of Southern England: Map	Advert	SR	QR	Pub Rec Off	Official SR Poster	Advert1021	
Anon	1932	The Sunny South: pictorial map	Advert	SR	QR	Pub Rec Off	Official SR Poster	Advert1024	
Anon	1905	Xmas Excursions from London: train in snow	Advert	GNR	DR	SSPL	10289067	Advert1025	
Anon	1987	Progress Report No. 1: Bournemouth Electrification	Advert	NSE	DR	NRM	1996-8214 Drawer D193	Advert1029	1996-8214
Anon	1987	Dairy Crest International, Portsmouth	Advert	Network SE	DR	NRM	1996-8215 Drawer D193	Advert1030	1996-8215
Photographic	1987	London Waterloo- Hounslow-Staines-Woking	Advert	Network SE	DR	NRM	1996-8233 Drawer D193	Advert1032	1996-8233
Photographic	1970s	Link Line: Reading-Guildford-Gatwick Airport	Advert	Network SE	DR	NRM	1996-8234 Drawer D193	Advert1033	1996-8234
Anon	1980s	Gatwick City Link	Advert	Network SE	DR	NRM	1996-8237 Drawer D193	Advert1035	
Wentworth-Shields, F.W.	1936	Southern for the Basking AD 3800	Advert	SR	QR	Onslows	16/10/1996 Lot 412	Advert1050	
Photocrom	1932	Take the Southern This Year: Photo montage	Advert	SR	QR	Onslows	16/10/1996 Lot 264	Advert1051	
Vaughan, Edmond	1930	South for Sunshine AD1149 art deco image	Advert	SR	DR	Onslows	01/04/1998 Lot 447	Advert1052	
Fish, Laurence	1960s	South for sun by train original artwork	Advert	SR	sm.			Advert1056	
Anon	1930	Autumn in the woods by Southern Rail	Advert	SR	DR			Advert1058	
Weber, Audrey	1936	Conducted Rambles: Winter Horse rider	Advert	SR	DR	Onslows	30/06/2010 Lot 332	Advert1068	
Freese, Cyril	1940s	The Link Between London and the Sunny South	Advert	SR	DR			Advert1080	
Anon	1953	For London Football Travel by Southern Electric	Advert	BR (SR)	DR	SSPL	10175782	Advert1095	1978-1206
Anon	1930	Sunny Side Up: British Isles upside down	Advert	SR	DR	Christies	12/05/2011 Lot 106	Advert1134	
Anon	1914	The Sunshine Line	Advert	LBSCR	DR	SSPL	10172241	Advert1137	1986-8831
Pears, Charles	1937	Add a day to your holiday in France	Advert	SR	DR	SSPL	10171363	Advert1138	1993-8143
Anon	1910s	The Best Way to Paris	Advert	LSWR	DR	Pub Rec Off	Official LSWR Poster	Advert1138	PRO
Anon (signed)	1925	Now Autumn is Here	Advert	SR	QR	Pub Rec Off	Official SR Poster	Advert1139	PRO
Anon	1928	Comfort in the South at Southern Railway Hotels	Advert	SR	QR	Pub Rec Off	Official SR Poster	Advert1140	PRO
Anon	1929	Here through Long Unhampered Days	Advert	SR	QR	Pub Rec Off	Official SR Poster	Advert1141	PRO
Anon	1929	Sunshine Guidebooks: sixpence each	Advert	SR	QR	Pub Rec Off	Official SR Poster	Advert1142	PRO
Anon	1929	7-day season tickets for holiday or business travel	Advert	SR	QR	Pub Rec Off	Official SR Poster	Advert1143	PRO
Anon	1929	Why Not Spend the Weekend on the Warm South Coas	Advert	SR	QR	Pub Rec Off	Official SR Poster	Advert1144	PRO
Anon	1929	Schools for Your Boys and Girls	Advert	SR	QR	Pub Rec Off	Official SR Poster	Advert1145	PRO
Anon	1930	Speedways to the Continent	Advert	SR	QR	Pub Rec Off	Official SR Poster	Advert1146	PRO
Anon	1930	SR For The Continent	Advert	SR	QR	Pub Rec Off	Official SR Poster	Advert1147	PRO
Aon (signed)	1930	South for Sunshine: Hints for holidays	Advert	SR	QR	Pub Rec Off	Official SR Poster	Advert1148	PRO
Anon	1930	Sunny South Sam: Look for me in the papers	Advert	SR	QR	Pub Rec Off	Official SR Poster	Advert1149	PRO
Anon	1930	Travel by Southern Electric: Takes Less time	Advert	SR	QR	Pub Rec Off	Official SR Poster	Advert1150	PRO
Anon	1931	Sunny South Sam and his Marionettes	Advert	SR	QR	Pub Rec Off	Official SR Poster	Advert1151	PRO
Anon	1931	South for Sunshine : I Told you So	Advert	SR	QR	Pub Rec Off	Official SR Poster	Advert1152	PRO
Aon (signed)	1931	South for Sunshine SR Train image	Advert	SR	QR	Pub Rec Off	Official SR Poster	Advert1153	PRO
Anon	1931	Spring South for Sunshine	Advert	SR	QR	Pub Rec Off	Official SR Poster	Advert1154	PRO
Anon	1931	Winter on the Sunny South Coast	Advert	SR	QR	Pub Rec Off	Official SR Poster	Advert1155	PRO

ARTIST	DATE	TITLE	LOCATION	COMPANY	SIZE	SOURCE	SOURCE DETAILS		IMAGE REF	NRM REF
Anon	1932	Rambles on the South Downs	Advert	SR	QR	Pub Rec Off	Official SR Poster		Advert1156	PRO
Anon	1932	Buy British Sunshine this Year says Sunny South Sam	Advert	SR	QR	Pub Rec Off	Official SR Poster		Advert1157	PRO
Anon	1932	Holiday Tickets and a fare and a third	Advert	SR	QR	Pub Rec Off	Official SR Poster		Advert1158	PRO
Anon	1933	Better than Ever says Sunny South Sam	Advert	SR	QR	Pub Rec Off	Official SR Poster		Advert1159	PRO
Anon	1924	The Sunny South	Advert	SR	QR	Pub Rec Off	Official SR Poster		Advert1160	PRO
Anon	1926	South for Sunshine: The Worlds Finest Resorts	Advert	SR	QR	Pub Rec Off	Official SR Poster		Advert1161	PRO
Anon	1927	Live Further out in the Surrey or Kentish Hills	Advert	SR	QR	Pub Rec Off	Official SR Poster		Advert1162	PRO
Anon (Signed)	c1930	The South Coast is the Sunny Coast	Advert	SR	DR		Private Collection		Advert1163	
Weber. Audrey	1933	Take them to the Seaside: Fairground image	Advert	SR	DR	Pub Rec Off	Official SR Poster		Advert1164	
Anon	1932	South For Sunshine: Punch and Judy Show	Advert	SR	DR	Pub Rec Off	Official SR Poster		Advert1165	PRO
Brown, Charles E.	1927	South for the Sunshine: Cheap tickets from SR	Advert	SR	DR	SSPL	10173292	Drawer D103	Advert1180	1986-9122
Rice	1930s	South For Winter Sun	Advert	SR	DR				Advert1181	
Molenaar, Heinrich	1933	Bournemouth Belle: All-Pullman Express Sundays	Advert	SR	DR	SSPL	10176085	Drawer D103	Advert1182	1988-8060
Johnson, Andrew	1936	Bournemouth Belle: Pullman Express - Sundays	Advert	SR	DR				Advert1183	
Fish, Laurence	1960s	The Brighton Belle: The Bournemouth Belle	Advert	BR(SR)	DR	SSPL	10175366	Drawer D126	Advert1184	1978-0785
Adelman	1960	The Brighton Belle: The Bournemouth Belle	Advert	BR(SR)	DR	SSPL	10175350		Advert1185	1978-0769
Cassandre, A. Mouron	1926	Victoria London-Dunkerque	Advert	Ala/CdfNord/SR	DR				Advert1186	
Anon	1977	Go and See Somewhere Soon with Awayday	Advert	BR Exec	DR	NRM	2003-7817 Drawer D323		Advert1187	2003-7817
Photographic	1993	Discover Historic Maritme Greenwich by Train	Advert	Network SE	DR	NRM	1997-8174 Drawer D037		Advert1188	1997-8174
Rob	1952	The Counties and Coastline of Southern England: Sussex Kent	Advert	BR(SR)	QR	SSPL	10173760	Drawer D025	Advert1189	1978-9133
Keely, Patrick Cockayne	1933	Southern for the Continent: Channel view	Advert	SR	DR	SSPL	10172944	Drawer D102	Advert1190	1985-8807
Lee-Elliott	1937	Navy Week letter press type poster	Advert	SR	DR	SSPL	10174953	Drawer D101	Advert1192	1978-9797
Weber, Audrey	1938	Riviera: trees on foreshore	Advert	SR	DR	SRA	12/12/2011 lot 164		Advert1193	
Anon	1963	Newhaven -Dieppe Services Paris (Black)	Advert	BR (SR)	DR	Onslows	09/12/2011 Lot 80		Advert1205	
Anon	1962	Newhaven-Dieppe Services Paris (Blue)	Advert	BR (SR)	DR	Onslows	09/12/2011 Lot 81		Advert1206	
Anon	1960	No Passport excursions to Boulogne	Advert	BR (SR)	DR	Onslows	09/12/2011 Lot 218		Advert1208	
Anon	1959	The Newhaven and Dieppe Route re-opens 1959	Advert	BR (SR)	DR	Onslows	09/12/2011 Lot 222		Advert1209	
Adams, J	1950s	To London by Train: Nelson's column image	Advert	BR (SR)	DR	Onslows	09/12/2011 Lot 226		Advert1211	
Anon	1960	No Passport excursion to Dieppe	Advert	BR (SR)	DR	Onslows	09/12/2011 Lot 234		Advert1212	
Peaty	1960s	Cheap Trips from this station: Margate, Bognor Regis Folkstone	Advert	BR(SR)	DR	SSPL	10175728	Drawer D126	SRAdvert01	1978-1152
Praill, R.G.	1915	South Coast Holiday resorts: Sussex by the sea	Advert	LBSCR	DR	SSPL	10176002		SRAdvert02	1988-8074
Vaughan, Edmond	1960s	South for Winter Sunshine: train image	Advert	BR(SR)	QR	SSPL	10266306		SRAdvert03	1995-7762
Vaughan, Edmond	1932	South for Winter Sunshine: rain and sun image	Advert	SR	DR	SSPL	10276292		SRAdvert04	1995-7761
White, Ethelbert Basil	1928	Kentish Hills & Surrey Dales: Go as You Please	Advert	SR	DR	SSPL	10176044	Drawer D102	SRAdvert06	1988-8019
Tripp, Herbert Alker	1937	Fresh Air for Health: Ploughing on South Downs	Advert	SR	QR	SSPL	10174132	Drawer D019	SRAdvert07	1978-9315
Anon	1905	Picturesque Tours: Bournemouth, Plymouth etc.	Advert	LSWR	DR	Christies	23/09/1999 lot 24		SRAdvert08	
Anon	1937	Signal successes: Portsmouth Southsea 90 mins	Advert	SR	DR					
Forgan, Winifred A.P.	1929	South for Winter Sunshine: Impressionist palms	Advert	SR	DR					
Kauffer, Edward McKnight	1935	Royal Windsor	Berkshire	GWR	DR	SSPL	10170725	Drawer D090	Berkshire01	1991-7106
Spradbery, Walter Ernest	1946	Thames Valley	Berkshire	GWR/SR	QR	SSPL	10173665	Drawer D019	Berkshire02	1978-9063
Keely, Patrick Cockayne	1954	Ascot Races June 17-20th Return Fare 12/9d	Berkshire	BR(SR)	DR	SSPL	10175413		Berkshire03	1978-0832
Lee-Elliott	1938	Royal Ascot June 14-17 from London	Berkshire	SR	DR	SSPL	10174937	Drawer D102	Berkshire04	1978-9781
Nicoll, Gordon	1962	Windsor: See Britain by Train Royal Barge	Berkshire	BR(WR)	DR	SSPL	10170941	Drawer D116	Berkshire05	1990-7049
Taylor, Fred	1950s	Royal Windsor PW72	Berkshire	BR(LMR)	QR	SSPL	10172482	Drawer D021	Berkshire06	1983-8335
Anon	1897	Ascot Races	Berkshire	GWR	DR	NRM	2000-7507		Berkshire07	
Anon	1920	Riverside Excursions: Windsor	Berkshire	LSWR	DR				Berkshire08	
Anon	1908	Royal Windsor: State Apartments Open to Visitors	Berkshire	GWR	DR				Berkshire09	
Paton, D.	1929	The Derby: Book Your Bus Early!!	Berkshire	Lon. Gen. Co.	QR				Berkshire10	

ARTIST	DATE	TITLE	LOCATION	COMPANY	SIZE	SOURCE	SOURCE DETAILS	IMAGE REF	NRM REF
Anon	1980s	Winchester: Catch the train to cat up on your history	Hampshire	Intercity	DR			Hampshire40	
Durman, Alan	1950s	For Happy Holidays: Portsmouth and Southsea	Hampshire	BR(SR)	DR	SSPL	10175128 Drawer D157	Portsmouth01	1978-9972
Durman, Alan	1950s	For Happy Holidays: Portsmouth and Southsea	Hampshire	BR(SR)	DR	SSPL	10175758 Drawer D130	Portsmouth01a	1978-1182
Shoesmith, Kenneth Denton	1937	HMS Victory: Portsmouth: Southern Electric	Hampshire	SR	QR	Christies	03/11/2011 Lot 165	Portsmouth02	
Tempesti, Mario	1958	Portsmouth and Southsea	Hampshire	BR(SR)	DR	SSPL	10316630	Portsmouth03	1978-1079
Carr, Leslie	1930	Visit the Dockyards: Chatham, Portsmouth, Devonport: Navy Week	Hampshire	SR	QR	SSPL	10174840 Drawer D019	Portsmouth05	1987-9155
Fish, Laurence	1962	Portsmouth and Southsea: Go by train AD9033	Hampshire	BR(SR)	DR	SSPL	10175132	Portsmouth06	1978-9976
Crow	1953	Navy Days: See the ships Meet the men	Hampshire	BR Exec	DR	Onslows	19/12/06 Lot 253	Portsmouth07	
Photographic	1962	Portsmouth and Southsea: Go by train mother and child	Hampshire	BR(SR)	DR	NRM	1978-0659 Drawer D157	Portsmouth09	1978-0659
Tempesti, Mario	1950s	Portsmouth and Southsea Bather on swing	Hampshire	BR (SR)	DR	Onslows	25/03/1997 Lot 206 original artwork	Portsmouth10	
Photographic	2009	A Day Unlike any Other - Portsmouth	Hampshire	First GW	DR	FGW	Poster Listing from Swindon	Portsmouth11	
Maxwell, Donald	1933	Southampton Docks: King George V Graving Dock	Hampshire	SR	QR	SSPL	10175886 Drawer D019	SouthamptonDocks01	1987-9160
Carr, Leslie	1931	Southampton Docks: The Gateway to the World	Hampshire	SR	QR	SSPL	10173308 Drawer D019	SouthamptonDocks02	1986-9138
Taylor, Horace	1928	Southampton: Great Britain's Premier Docks	Hampshire	SR	QR	Pub Rec Off	Poster postcard collection	SouthamptonDocks03	
Carr, Leslie	1936	The World's Greatest Liners use Southampton Docks	Hampshire	SR	QR	SSPL	10173471 Drawer D019	SouthamptonDocks04	1978-8933
Carr, Leslie	1936	First Sailing of the RMS Queen Mary: Southampton	Hampshire	SR	QR	SSPL	10173472 Drawer D019	SouthamptonDocks05	1978-8934
Keely, Patrick Cockayne	1935	Southampton Docks: 28500 ft of Quays	Hampshire	SR	DR		Private collection	SouthamptonDocks06	
Carr, Leslie	1935	Southampton Docks: New Extension	Hampshire	SR	QR		Private collection	SouthamptonDocks07	
Anon	1930s	La Voie D'Acces en Grande-Bretagne	Hampshire	SR	DR			SouthamptonDocks08	
Dilly	1930s	Southern Railway's Suthampton Docks: aerial view	Hampshire	SR	DR		Private collection	SouthamptonDocks09	
Richmond, Leonard	1933	Southampton Docks: Worlds largest graving dock	Hampshire	SR	QR		Private collection	SouthamptonDocks10	
Anon	1934	The Worlds Largest Liner in the World's Largest Dock	Hampshire	SR	QR	Pub Rec Off	Official SR Poster	SouthamptonDocks11	
Anon	1931	Southampton Docks: The Gateway to the World	Hampshire	SR	QR	Pub Rec Off	Official SR Poster	SouthamptonDocks12	
Williamson, Harold Sandys	1938	Southampton Docks Magnificent Shed Accomodation	Hampshire	SR	QR	Swann NYC	Sales 2201 Lot 370	SouthamptonDocks13	
Anon	1926	To The Sea in Ships; Southampton Docks	Hampshire	SR	QR	Pub Rec Off	Official SR Poster	SouthamptonDocks14	PRO
Anon	1924	Southampton Docks Owned and Managed by SR	Hampshire	SR	QR	Pub Rec Off	Official SR Poster	SouthamptonDocks15	
Lipscombe, Guy	1912	Southea 4 ships showing spotlights	Hampshire	LBSCR	DR	SSPL	10170964	Southsea02	1990-7072
Anon	1930s	Sunny Southsea and City of Portsmouth	Hampshire	SR	DR			Southsea03	
Tripp, Herbert Alker	1950s	Southsea and Portsmouth	Hampshire	BR(LMR)	QR	Onslows	21/11/01 lot 328	Southsea04	
Lewis, David	1953	Southsea and Portsmouth: Anchor with signal arms	Hampshire	BR(SR)	DR	NRM	1978-0662 Drawer D158	Southsea05	1978-0662
Brown, F. Gregory	1930s	Southsea on the Silvery Solent	Hampshire	SR	QR	Christies	6/02/1997 lot 135	Southsea06	
Pears, Charles	1936	Southsea and Portsmouth (Ferry at the pier)	Hampshire	SR	QR	Onslows	02/04/09 Lot 298 Ref AD 3869	Southsea08	
Anon	1930s	Southsea for family holidays: HMS Victory	Hampshire	SR	DR			Southsea09	
Walker, John Hutton	1905	Southsea and Portsmouth	Hampshire	Council Ad	DR			Southsea10	
Wylie, W.L	1928	"For ever England": Come to Southsea: HMS Victory	Hampshire	SR	QR	Onslows	02/04/2009 Lot 295 AD 643	Southsea11	
Shoesmith, Kenneth Denton	1932	Southsea and Portsmouth for Every Attraction	Hampshire	SR	QR	Pub Rec Off	SRPublicity.com	Southsea13	Pub Rec Off
Anon	1925	Sunny Southsea	Hampshire	SR	QR	Pub Rec Off	Official SR Poster	Southsea14	PRO
Anon	1988	Farnborough 88: Multi transport air/bus and train	Hampshire	BR NSE	DR				
Allinson, Adrian Paul	1950s	Bournemouth: Coastline and Chine	Hampshire	BR(SR)	DR				
Anon	1920s	Ventnor: Ideal Climate, Unrivalled Comfort	Hampshire (IOW)	SR	DR	SSPL	10276078 Drawer D103	Isle of Wight01	1995-7775
Pears, Charles	1935	London & Isle of Wight: In 40 minutes daily services	Hampshire (IOW)	Rly. Air Ser.	DR	SSPL	10175889 Drawer D102	Isle of Wight02	1987-9163
Buckle, Claude Henry	1950s	Racing off Ryde	Hampshire (IOW)	BR(SR)	QR	SSPL	10173467 Drawer D025	Isle of Wight03	1978-8929
Buckle, Claude Henry	1950s	Racing off Ryde	Hampshire (IOW)	BR(SR)	QR	SSPL	10174126 Drawer D025	Isle of Wight03a	1978-9309
Ayling, George	1930	The Isle of Wight: England's Garden Isle	Hampshire (IOW)	SR	QR	SSPL	10173713 Drawer D019	Isle of Wight04	1978-9111
Lander, Reginald Montague	1960	The Isle of Wight by train and ship: Godshill	Hampshire (IOW)	BR(SR)	DR		RefAD8631/a3/21960	Isle of Wight05	
Allinson, Adrian Paul	1946	Isle of Wight: Served by the Southern Railway	Hampshire (IOW)	SR	QR	SSPL	10171334 Drawer D019	Isle of Wight06	1993-8114
Smith, Tom	1949	The Isle of Wight: "The Garden Isle"	Hampshire (IOW)	BR(SR)	QR	SSPL	10173716 Drawer D025	Isle of Wight07	1978-9114
Ayling, George	1939	The Garden Isle for sunshine, scenery & sport	Hampshire (IOW)	SR	QR	SSPL	10173711 Drawer D019	Isle of Wight08	1978-9109

ARTIST	DATE	TITLE	LOCATION	COMPANY	SIZE	SOURCE	SOURCE DETAILS	IMAGE REF	NRM REF
Anon	1923	The Isle of Wight: three vignettes	Hampshire (IOW)	LBSCR/LSWR	DR	SSPL	10172143 Drawer D102	Isle of Wight09	1986-8774
Legard, Helen and Alice	1903	Brighton Railway for the Isle of Wight	Hampshire (IOW)	LBSCR	DR	SSPL	10317487	Isle of Wight10	1998-11346
Newbould, Frank	1930	Ventnor for sunshine. The Royal Hotel for comfort	Hampshire (IOW)	Trust Houses Ltd	QR	Christies	2/4/1997 Lot 89	Isle of Wight11	
Tripp, Herbert Alker	1930s	The Isle of Wight: Not only August but all year round	Hampshire (IOW)	SR	QR	Christies	05/11/1987 Lot 167	Isle of Wight12	
Steel, Kenneth	1950s	Isle Of Wight: Sandown Bay original artwork	Hampshire (IOW)	SR	QR			Isle of Wight13	
Xenie	1950s	Isle of Wight: The holiday resort in path of the sun	Hampshire (IOW)	BR(SR)	DR			Isle of Wight14	
Pond, Edward	1989	Isle of Wight by Train: sand castle & the Needles	Hampshire (IOW)	BR NSE	DR		Private Collection	Isle of Wight15	
Lander, Reginald Montague	1950s	Isle of Wight: Go there by British Railways	Hampshire (IOW)	BR(SR)	QR		Private Collection	Isle of Wight16	
Baylis and Adam (Pubs)	1957	Isle of Wight: The holiday resort in path of the sun	Hampshire (IOW)	BR(SR)	DR	Onslows	20/06/06 Lot 352 AD 7284/57-58	Isle of Wight17	
Anon	1923	The "Garden Isle": photo-vignettes	Hampshire (IOW)	SR	QR			Isle of Wight18	
Shep (Charles Shepard)	1960s	Isle of Wight for sunny Days (Pictorial letterpress)	Hampshire (IOW)	BR(SR)	DR			Isle of Wight19	
Anon	1986	Breakaway to the Isle of Wight	Hampshire (IOW)	BR Exec/Vectis	DR	NRM	1996-9314 Drawer D83	Isle of Wight20	1996-8314
Anon	1960	Travel to the Isle of Wight from London and Provinces	Hampshire (IOW)	BR(SR)/Vectis	DR	NRM	1978-0735 Drawer D157	Isle of Wight21	1978-0735
Anon	1983	Breakaway to the Isle of Wight: The Needles	Hampshire (IOW)	BR Exec/Vectis	DR	NRM	1983-8350 Drawer D159	Isle of Wight22	1983-8350
KDS	1930s	Isle of Wight: Southern Railway; Gratuitous	Hampshire (IOW)	SR	DR		Private Collection	Isle of Wight23	
Anon	1908	Ryde: The Isle of Wight: Britannia	Hampshire (IOW)	LSWR	DR		Private Collection	Isle of Wight24	
Anon	1923	The Isle of Wight for health and sunshine	Hampshire (IOW)	SR	QR			Isle of Wight25	
Whiting, Chris	1976	Isle Of Wight Steam Railway: Pictorial timetable	Hampshire (IOW)	IOW Steam Rly	DR	Onslows	11/04/2002 Lot 382	Isle of Wight26	
Burley, David William	1930s	Shanklin I O W: Short sea cruises	Hampshire (IOW)	SR	QR	Bloomsbury	31/03/2010 Lot 17 NYC Sale	Isle of Wight27	
Anon	1910	England's Garden Isle: vignettes on stock poster	Hampshire (IOW)	IOW Steam Rly	DR	SSPL	10172320	Isle of Wight28	1983-8228
Anon	1905	The Garden of England: map and couple	Hampshire (IOW)	LBSCR	DR	SSPL	10316235	Isle of Wight29	1999-7215
Anon	1910s	Sunny Scenes by the Sea - Isle of Wight	Hampshire (IOW)	LSWR	QR	Pub Rec Off	Official LSWR Poster	IsleofWight30	PRO
Anon	1910s	Sunny Scenes for the Winter - Isle of Wight	Hampshire (IOW)	LSWR	QR	Pub Rec Off	Official LSWR Poster	IsleofWight30a	PRO
Anon (Signed)	1927	The Isle of Wight: Englands Garden Isle	Hampshire (IOW)	SR	QR	Pub Rec Off	Official SR Poster	IsleofWight31	PRO
Shoesmith, Kenneth Denton	1933	The Royal Yatch Victoria and Albert: Cowes Week	Hampshire (IOW)	SR	DR	Pub Rec Off	Official SR Poster	Isle of Wight32	1979-7895
Shoesmith, Kenneth Denton	1933	The Royal Yatch Victoria and Albert: Cowes Week	Hampshire (IOW)	SR	DR	SSPL	10171850 Stock poster for Cowes week	Isle of Wight32a	1979-7895
Smitch, Tom	1955	The Isle of Wight - Pic. Map; Ref AD 5855	Hampshire (IOW)	BR(SR)	QR	SRA	5/6/02 Lot 167 ebay 260232236825 24/4/0	Isle of Wight33	
Lander, Reginald Montague	1950s	Broadstairs: The Resort with Charm of its Own	Kent	BR(SR)	DR	Christies	09/09/09 Lot 45	Broadstairs01	
Durman, Alan	1960	Broadstairs family on beach AD8215/60-62	Kent	BR(SR)	DR	SSPL	10175764 Drawer D130	Broadstairs02	1978-1188
Burley, David William	1920s	Broadstairs, original artwork	Kent	SR	sm.	SRA	17/10/92 Lot 64A 10"x15"	Broadstairs03	
Mace, John Edmund	1929	Broadstairs: Sea. Sands. Sunshine	Kent	SR	DR	SSPL	10170743	Broadstairs04	1991-7126
Lasham, William	1909	Sunny Broadstairs: The Children's Elysium	Kent	SECR	DR			Broadstairs05	
Buckle, Claude Henry	1952	Canterbury: where history lingers: visit of Queen Elizabeth	Kent	BR(SR)	DR	SSPL	10175652 Drawer D127	Canterbury01	1978-1076
Griffin, Frederick	1927	Canterbury Cathedral: frequent trains cheap fares	Kent	SR	DR	SSPL	10170754	Canterbury02	1991-7137
Coventry, F.H.	1948	Canterbury Cathedral- The Nave looking East	Kent	BR(SR)	QR	SSPL	10171250 Drawer D025	Canterbury03	1992-7722
Carr, Leslie	1928	Canterbury: A view of the cathedral	Kent	SR	QR			Canterbury04	
Shep (Charles Shepard)	1938	Canterbury by Southern Railway AD4525	Kent	SR	QR	Onslows	1/11/02 lot 303	Canterbury05	
Shep (Charles Shepard)	1938	Canterbury - England by Southern Railway	Kent	SR	QR	SSPL	10175983 Drawer D101	Canterbury06	1988-7958
Anon	1960s	Conducted Tour to Canterbury (blue image)	Kent	BR(SR)	DR	NRM	1978-0815 Drawer D159	Canterbury07	1978-0815
Anon	1960s	Conducted Tour of Canterbury (red image)	Kent	BR(SR)	DR	NRM	1978-0816 Drawer D159	Canterbury07a	1978-0816
Lander, Reginald Montague	1960s	Canterbury: 13th cent. Stained glass window	Kent	BR(SR)	DR	NRM	1978-1935 Drawer B1	Canterbury08	1978-1935
Lander, Reginald Montague	1960s	Canterbury Stained glass window	Kent	BR(SR)	DR			Canterbury08a	
Studio Seven	1958	Dover: Express trains from London	Kent	BR(SR)	DR	SSPL	10175212	Dover01	1978-0649
Carr, Leslie	1950	Dover for the Continent: Then and now 1850-1950	Kent	BR(SR)	QR	SSPL	10173653 Drawer D025	Dover03	1978-9051
Anon	1950s	Dover: Go by train - woman pulling boat	Kent	BR(SR)	DR	Christies	14/09/2006 lot43	Dover04	
Thomas, Walter	1936	The New Train Ferry Boats: Dover-Dunkerque	Kent	SR	QR	SSPL	10173661 Drawer D020	Dover06	1978-9059
Zinkeisen, Anna Katrina	1930s	The White Cliffs of Dover	Kent	SR	QR	SSPL	10172977	Dover07	1985-8840
Shoesmith, Kenneth Denton	1934	The "Golden Arrow" and the "Motorists" service	Kent	SR	QR	SSPL	10173969 Drawer D019	Dover08	1987-8814

ARTIST	DATE	TITLE	LOCATION	COMPANY	SIZE	SOURCE	SOURCE DETAILS	IMAGE REF	NRM REF
Griffin, Frederick	1959	Dover: Go by train: beach and cliff view	Kent	BR(SR)	DR	SSPL	10175649 Drawer D158	Dover09	1978-1073
Richmond, Leonard	1930s	Dover : red-sail boat and Dover Castle	Kent	SR	DR	Christies	Sept 2000 Lot 60	Dover10	
Pond, Edward	1989	Dover By Train: Dovers cliffs and castle	Kent	Network SE	DR	NRM	1996-8226 Drawer D193	Dover11	1996-8226
Anon (signed)	1912	Red Star Line: Dover New York Weekly Service	Kent	SECR	DR	SSPL	10171754	Dover12	1979-7799
Lander, Reginald Montague	1978	Visit Dover Castle: Constables Tower and Gate	Kent	BR(SR)	DR	NRM	1978-7526 Drawer D159	Dover13	1978-7526
Lampitt, Ronald	1956	Folkestone: aerial view of resort ref AD 6356	Kent	BR(SR)	DR	SSPL	10174334 Drawer D136	Folkestone01	1987-8854
Danvers, Verney L.	1947	Folkestone: Cliffs Palace Hotel	Kent	SR	DR	SSPL	10174970 Drawer D102	Folkestone02	1978-9814
Lander, Reginald Montague	1950s	Folkestone: beach through shell	Kent	BR(SR)	DR	SSPL	10175428 Drawer D130	Folkestone03	1978-0847
Anon	1910	Fashionable Folkestone Kent: Vignettes	Kent	SE+CR	QR	NRM	1989-7202 Drawer D001	Folkestone04	1989-7202
Danvers, Verney L.	1929	Folkestone: The Gem of the Kentish Coast	Kent	SR	QR	Onslows	17/05/2001 Lot 942 and 03/2006	Folkestone05	
Anon	1960s	Folkestone: express trains from London	Kent	BR(SR)		NRM	1978-1128 Drawer D158	Folkestone06	1978-1128
Anon	1959	Folkestone Go by Train	Kent	BR(SR)	DR	NRM	1978-0670 Drawer D157	Folkestone07	1978-0670
Ayling, George	1926	Folkestone: The Gem of the Kentish Coast	Kent	SR	DR	Christies	01/10/1998 Lot 72	Folkestone08	
Anon	1930s	Folkestone: Cliffs Pavilion Hotel	Kent	SR	QR			Folkestone09	
Richmond, Leonard	1936	Folkestone: The All-the-year-round Resort	Kent	SR	DR			Folkestone11	
Lander, Reginald Montague	1960s	Folkestone: Express Trains from London: Abstract	Kent	BR(SR)	DR	NRM	1978-0651 Drawer D130	Folkestone12	1978-0651
Danvers, Verney L.	1934	Folkestone: Corridor Expresses and Cheap Fares	Kent	SR	DR			Folkestone13	
Thomas, Walter	1948	The Continent via Folkestone-Calais	Kent	BR(SR)	QR	SSPL	10173400 Drawer D025	Folkestone14	1978-8869
Bromfield, Kenneth	1950s	Herne Bay on the Kent Coast: man jumping deck chair	Kent	BR(SR)	DR	SSPL	10175124 Drawer D160	Herne Bay01	1978-9968
Fish, Laurence	1959	Herne Bay: On the Kent Coast couple on yatch	Kent	BR(SR)	DR	SSPL	10175091 Drawer D130	Herne Bay02	1978-9935
Durman, Alan	1952	Herne Bay: Single female image	Kent	BR(SR)	DR	SSPL	10175220 Drawer D126	Herne Bay03	1978-0657
Sherwin, Frank	1948	Herne Bay: For your holiday: seafront panorama	Kent	BR(SR)	DR	SSPL	10172257 Drawer D127	Herne Bay04	1986-8847
Tempesti, Mario ?	1961	Herne Bay on the Kent Coast: Go by Train: white bikini belle	Kent	BR(SR)	DR	SSPL	10175127 Drawer D159	Herne Bay05	1978-9971
Anon	1920s	Healthy Herne Bay on the Kentish Coast	Kent	SR	DR	Christies	12/09/2002 lot 70	Herne Bay06	
Whittington	1955	Herne Bay On the Kent Coast: family feeding gulls	Kent	BR(SR)	DR	Christies	14/10/2004 Lot 80	Herne Bay07	
H.L.	1950s	Herne Bay on the Kent Coast: woman canoeist	Kent	BR(SR)	DR			Herne Bay08	
Anon	1920	Herne Bay's Industry is "Health Making"	Kent	Nord/SE+CR	DR	SSPL	10172240	Herne Bay09	1986-8830
Sherwin, Frank	1955	Kent -The Garden of England: See Britain by Train	Kent	BR(SR)	QR	SSPL	10173465 Drawer D025	Kent01	1978-8927
Maxwell, Donald	1930s	The Weald of Kent Southern Railway	Kent	SR	QR	SSPL	10175885 Drawer D019	Kent02	1987-9159
Wilkinson, Norman	1946	TS Invicta leaving Dover: Golden Arrow Sea Route	Kent	SR	QR	SSPL	10174014	Kent03	1978-9197
Roberts, N. Cramer	1928	Dungeness: By the RH+D Railway	Kent	RHDR Co.	DR	SSPL	10174642	Kent04	1978-9615
Tripp, Herbert Alker	1930s	Deal frequent expresses & cheap fares	Kent	SR	DR	SSPL	10170903 Drarwer D103	Kent05	1989-7140
Brown, F. Gregory	1929	The Londoner's Garden - Kent	Kent	SR	DR	SSPL	10175984 Drawer D102	Kent06	1988-7959
Buckle, Claude Henry	1960	Whitstable: Kent's Garden by the Sea	Kent	BR(SR)	DR	Christies	23/9/1999 lot 43	Kent07	
English, E.	1920	Invest in a Holiday at Deal	Kent	LSECR	DR			Kent08	
Cuneo, Terence Tenison	1957	Port to Port: SS Invicta Ref AD 7660 B25/191257	Kent	BR(SR)	QR	SSPL	10173689 Drawer D025	Kent09	1978-9087
Danvers, Verney L.	1930s	Isle of Thanet: served by restaurant-car expresses	Kent	SR	QR	Morphets	15/10/2010 Lot 145	Kent10	
Sherwin, Frank	1952	Deal and Walmer: Sunny and bracing	Kent	BR(SR)	DR	SSPL	10171207 Drawer D136	Kent11	1992-7666
Brett, Ronald	1937	Great Britain's Fleet in the Thames May 7-13th	Kent	SR	DR	SSPL	10308301 Drawer D103	Kent12	1990-7082
Photographic	1960	See Britain by Train: Penshurst Place, Kent	Kent	BR(SR)	DR	SSPL	10171685	Kent13	1979-7730
Anon	1961	Explore East Kent with a Rail Tour Ticket: letterpress	Kent	BR(SR)	DR	SSPL	10175738 Drawer D126	Kent14	1978-1162
Sherwin, Frank	1955	Kent - The Garden of England artwork for Kent01	Kent	BR(SR)	QR	SSPL	10282622	Kent15	1989-7155
Carr, Leslie	1937	Drive you car direct on to the Train Ferry Boat	Kent	SR	QR	Onslows	19/12/06 Lot 368 AD4223/37	Kent16	
Anon	1927	Romney, Hythe and Dymchurch Rly: Romney Marsh	Kent	RHDR	DR			Kent17	
Keely, Patrick Cockayne	1930s	Deal: express Pullman services 2 hours from London	Kent	SR	DR	Christies	14/09/2000 Lot 62 Drawer D101	Kent18	2000-8432
BUP	1937	Blossom Time in Kent: See the orchards at their best	Kent	SR	DR	Christies	13/09/2007 Lot 98	Kent19	
Sparrow, Clodagh	1937	Live in Kent and be Content - Southern Electric	Kent	SR	DR			Kent20	
Lander, Reginald Montague	1970s	Kent Coast Heritage and Inland Charm	Kent	BR(SR)	DR	SSPL	10172817 Drawer D127	Kent21	1983-8594

ARTIST	DATE	TITLE	LOCATION	COMPANY	SIZE	SOURCE	SOURCE DETAILS	IMAGE REF	NRM REF
Lander, Reginald Montague	1978	Visit Rochester Cathedral	Kent	BR(SR)	DR		Private Collection	Kent22	
Lander, Reginald Montague	1978	Visit Rochester Cathedral Ref Stock Poster	Kent	BR(SR)	DR	NRM	1979-7535 Drawer D159	Kent22a	1979-7535
White, Ethelbert Basil	1928	Live in Kent and be Content Oast house in autumn	Kent	SR	DR	Christies	05/11/2010 Lot 35	Kent23	
Maxwell, Donald	1930s	The Devil's Chimney ref 177 Beach Head	Kent	SR	DR		Private collection	Kent24	
Constable, S. Douglas	1920s	Bodiam Castle: A Perfect Mediaeval Relic	Kent	SR	DR	Swann NYC	4/08/2004 Lot 196	Kent25	
Lander, Reginald Montague	1978	Visit Canterbury Cathedral Ref AD998/B3/12178	Kent	BR(SR)	DR	NRM	1979-7534 Drawer D157	Kent26	1979-7534
Anon	1960s	Maidstone The County Town of Kent	Kent	BR(SR)	DR			Kent27	
Buckle, Claude Henry	1952	Deal Castle and Port original artwork	Kent	BR(SR)	DR			Kent28	
Buckle, Claude Henry	1960s	Kent: Served by British Railways Oast houses	Kent	BR(SR)	DR	Christies	03/06/2008 lot 133	Kent29	
Photographic	1993	Leeds Castle Maidstone in Kent	Kent	Network SE	DR	NRM	1997-8069 Drawer D085	Kent30	1997-8069
Shine, P	1924	Deal for your holidays	Kent	Belgian Rail	DR	Onslows	22/11/05 lot 394	Kent31	
Roberts, N. Cramer	1927	Greatstone: RH+D railway	Kent	RHDR	DR	Onslows	29/06/2007 Lot 337	Kent32	
Lander, Reginald Montague	1962	Kent: Served by fast & frequent trains Pictorial map	Kent	BR(SR)	DR	NRM	1978-9931 Drawer D159	Kent33	1978-9931
Lander, Reginald Montague	1970	Kent: Some places of special interest	Kent	BR(SR)	DR	NRM	1979-7783 Drawer D159	Kent35	1979-7783
Anon	1900s	Summer & Winter Resorts: Victoria Holborn St. Pauls	Kent	LC&DR	DR	SSPL	10327633 Drawer D001	Kent36	2001-7650
Anon	1930s	Hythe The Pride of Kent	Kent	SR	DR			Kent37	
Burley, David William	1930s	Allhallows-on-Sea: Healthy homes for Londoners	Kent	SR	DR		Private collection	Kent38	
Carr, Leslie	1920s	Southern Electric Still growing: Rochester, Maidstone	Kent	SR	DR			Kent39	
Photographic	1922	Places of Interest on the SE&CR: Rochester	Kent	SE%CR	DR	SSPL	10171109	Kent40	1992-7749
Spradbery, Walter Ernest	1933	Birchington: Sun Sea and Sand	Kent	SR	DR	Christies	14/10/2002 Lot 78	Kent41	
Anon	1987	The Biggin Hill International Air Fair 25th anniversary	Kent	Network SE	DR	NRM	1996-8217 Drawer D193	Kent42	1996-8217
Black, Montague Birrell	1925	Half an Hour From London: Kent Garden of England	Kent	SR	QR	Pub Rec Off	Official SR Poster	Kent43	PRO
Anon	1925	Fair Land of Kent map and vignettes	Kent	SR	QR	Pub Rec Off	Official SR Poster	Kent44	PRO
Phillips, Graham	1913	The Breezy Kent Coast: Caesar's Choice	Kent	SECR	DR	SSPL	10173057	Kent45	1975-8405
Anon	1949	North Kent Line 1849-1949	Kent	BR (SR)	DR	SSPL	10172785	Kent46	NRM83/38326
Bromfield, Kenneth	1963	Arrive earlier by train on the Kent Coast: clock	Kent	BR(SR)	DR	SSPL	10175161	Kent47	1978-0599
Bromfield, Kenneth	1963	Kent: Arrive earlier by train: pin-up	Kent	BR(SR)	DR			Kent48	
Stewart, Kay	1950s	Conducted Rambles: To Kent locations (floral)	Kent	BR(SR)	DR			Kent49	
Anon	1960s	Kent Coast Electrification: Do you know?	Kent	BR(SR)	DR	NRM	1978-0731 Drawer D158	Kent50	1978-0731
Studio Seven	1961	Explore Kent with New South Eastern tourist ticket	Kent	BR(SR)	DR	NRM	1978-1111 Drawer D160	Kent51	1978-1111
Hubner, Paul	1907	Magical Margate: Finest Sands in England	Kent	Town Hall	DR			Margate01	
PG	1961	Margate: Britain's finest resort: AD8694/61	Kent	BR(SR)	DR	Christies	09/09/09 Lot 49 1978-0844 drawer D158	Margate02	1978-1330
Baldwin	1950s	Margate: For the holiday of your life; swimming belle	Kent	BR(SR)	DR			Margate03	
Black, Montague Birrell	1925	Margate (Angleterre): colourful sky and pier	Kent	SR	QR	Guido Ton	Zurich Auctions 18 March 2006 Lot 170	Margate04	
Pond, Edward	1989	Margate by Train: abstract fairground	Kent	BR (NSE)	DR	NRM	1996-7327 Drawer D059	Margate05	1996-7327
Lampitt, Ronald	1950s	Margate: Fast frequent trains from London Ref. 6337/B37.5	Kent	BR(SR)	DR			Margate06	
Padden Percy	1938	This Little Piggie went to Margate: Its Quicker by Rail	Kent	LNER/Council	QR	Christies	09/09/2009 Lot 54 AD4474	Margate07	
Anon (SIGNED)	1928	Margate	Kent	SR	QR	Pub Rec Off	Official SR Poster	Margate08	PRO
Anon	1910s	Margate-Folkestone: Looking into the Future	Kent	SECR	DR			Margate09	
Anon	1961	Choose Ramsgate: and come by train: family beach	Kent	BR(SR)	DR	NRM	1978-0680 Drawer D158	Ramsgate01	1978-0680
Durman, Alan	1958	Ramsgate: couple back-to-back ;AD7414/58/59	Kent	BR(SR)	DR	NRM	1978-1172 Drawer D160	Ramsgate02	1978-1172
Durman, Alan	1960	Ramsgate: Go by Train couple holding child aloft	Kent	BR(SR)	DR	NRM	1978-1171 Drawer D160	Ramsgate03	1978-1171
Shoesmith, Kenneth Denton	1939	Ramsgate for Jolly Holidays: harbour AD4910	Kent	SR	QR	SSPL	10174337 Drawer D019	Ramsgate04	1987-8857
Pears, Charles	1932	Ramsgate: On the Sunshine Coast of Kent	Kent	SR	QR			Ramsgate05	
Richmond, Leonard	1930s	Ramsgate: Bracing breezes: Lido and beaches	Kent	SR	QR			Ramsgate06	
Barker, John	1953	Ramsgate: Express trains from London: Montage	Kent	BR(SR)	DR	NRM	1978-0718 Drawer D157	Ramsgate07	1978-0718
Durman, Alan	1950s	Ramsgate: single bathing belle in red bikini	Kent	BR(SR)	DR	Christies	13/09/2007 Lot 99 Drawer D159	Ramsgate08	1978-0609
Anon	1908	Sunny Ramsgate: Promenade: timetable from Paris	Kent	SECR/CdeFN	DR	Christies	14/09/2006 Lot 40	Ramsgate09	1997-8472

ARTIST	DATE	TITLE	LOCATION	COMPANY	SIZE	SOURCE	SOURCE DETAILS	IMAGE REF	NRM REF
Hubbard, Eric Hesketh	1950s	Ramsgate: Southern sunshine Bracing Breezes	Kent	BR(SR)	QR		Private Collection	Ramsgate10	
Anon	1930	Ramsgate: Sands Sunshine: Red sail boat	Kent	SR	DR			Ramsgate11	
Buckle, Claude Henry	1950s	Ramsgate for holidays view of harbour	Kent	BR(SR)	DR			Ramsgate12	
Anon	1926	Ramsgate: Sands Sunshine	Kent	SR	QR	Pub Rec Off	Official SR Poster	Ramsgate13	PRO
Johnston	1960s	Royal Tunbridge Wells: sunniest inland resort	Kent	BR(SR)	DR	SSPL	10170968 Drawer D103	TunbridgeWells01	1990-7076
Durman, Alan	1957	Royal Tunbridge Wells: 1 Hour from London: pub sign design	Kent	BR(SR)	DR	SSPL	10175263 Drawer D158	TunbridgeWells02	1978-0682
Shep (Charles Shepard)	1930s	Royal Tunbridge Wells: Pantiles: crest top left	Kent	SR	DR	eBay		TunbridgeWells03	
Sparrow, Clodagh	1947	Royal Tunbridge Wells: Country scene;couple foregrour	Kent	SR	DR	Onlows	20/06/06 Lot 354	TunbridgeWells04	
Dawson, B.H.	1959	Royal Tunbridge Wells: Georgian period	Kent	BR(SR)	DR			TunbridgeWells05	
Carr, Leslie	1925	Royal Tunbridge Wells: where Beau Nash reigned	Kent	SR	DR			TunbridgeWells07	
Sherwin, Frank	1950s	Royal Tunbridge Wells: sunniest inland resort	Kent	BR(SR)	DR	Christies	13/09/2007 Lot 96	TunbridgeWells08	
Anon	1910s	Royal Tunbridge Wells: "Ye Pantyles"	Kent	LNWR	DR			TunbridgeWells09	
Richmond, Leonard	1930s	Royal Tunbridge Wells: The Sunny inland resort	Kent	SR	DR	Swann NYC	12/11/07 item 2128090	TunbridgeWells10	
Anon	1935	Royal Tunbridge Wells The Sunny inland Resort	Kent	SR	DR			TunbridgeWells11	
Fish, Laurence	1959	Whitstable: yachting AD7927/1959	Kent	BR(SR)	DR	SSPL	10175095	Whitstable1	1978-9939
Mace, John Edmund	1929	Whitstable and Tankerton: promenade and beach	Kent	SR	DR	Christies	6/02/1997 Lot 157	Whitstable2	
King, Cecil	1936	Whitstable & Tankerton sunset image	Kent	SR	DR	SSPL	10174969 Drawer D101	Whitstable3	1978-9813
Anon		Meet the Navy: Go by train to Gillingham Kent	Kent	BR Exec	DR		Private Collection		
Light	1938	Crystal Palace: Road circuit	London	LMS	DR	SSPL	10170927 Drawer D091	CrystalPalace01	1990-7033
Anon	1921	Crystal Palace Grand International Show; Poultry & pigeons	London	SE&CR	DR	SSPL	10171753	CrystalPalace02	1979-7798
Huveneers + Lander	1958	Greenwich: Cutty Sark National Maritime Museum	London	BR(SR)	DR	SSPL	10171115	Greenwich01	1992-7488
Anon	1986	150th Anniversary London and Greenwich Railway:	London	BR Exec	DR	SSPL	10173876	Greenwich02	1986-9375
Morduant, Myles	1933	Greenwich Night Pageant	London	London Advert	DR	Onslows	19/12/06 lot 265	Greenwich03	
Lander, Reginald Montague	1977	Visit Greenwich: Naval College and Cutty Sark AD295/6.5/22677	London	BR(SR)	DR	NRM	7-5657 Drawer D159 ref AD295/6 1/2/22	Greenwich04	1977-5657
Cooper, Austin	1920s	King's Cross for Scotland LNER Shortest-quickest	London	LNER	DR	SSPL	10173902 Drawer D096	Kings Cross01	1987-8747
Cooper, Austin	1920s	King's Cross for Scotland: Shortest- quickest	London	LNER	DR	Christies	4/2/99 lot 33	Kings Cross02	
Cooper, Austin	1920s	King's Cross for Scotland: Clan tartans	London	LNER	DR	SSPL	10174618 Drawer D097	Kings Cross03	1978-9591
Bradshaw, Laurence	1920s	King's Cross for Scotland: Art deco image	London	LNER	DR	SSPL	10176038 Drawer D095	Kings Cross04	1988-8013
Myers, Bernard	1950s	Northward Bound: King's Cross for Scotland	London	BR(ER)	DR	SSPL	10171739	Kings Cross05	1979-7784
Neilland, Brendan	1996	London Kings Cross	London	Intercity	DR	SSPL	10308304	Kings Cross06	1997-8438
Alexeieff, Alexander	1932	The Night Scotsman	London	LNER	QR	Christies	20/10/1988 Lot 112	Kings Cross07	
Alexeieff, Alexander	1932	To London by Sleeper	London	LNER	QR			Kings Cross08	
Lingstrom, Freda Violet	1930s	Kings X for Scotland	London	LNER	DR	Onslows	19/12/06 Lot 279	Kings Cross09	
Blake	1960	London: See Britain by train PP1169 montage image	London	BR(LMR)	DR			London001	
Berry, J.	1951	London: Cheap Travel facilities: Lord Mayor's Procession	London	BR(LMR)	DR	SSPL	10306020 Drawer D118	London002	1997-7385
Nicoll, Gordon	1953	Visit London in Coronation Year	London	BR(LMR)	DR	SSPL	10173043	London004	1975-9381
Buckle, Claude Henry	1955	London: Trafalgar Square: See Britain by Rail	London	BR(LMR)	DR	SSPL	10170742 Drawer D078	London005	1991-7124
Clark, Christopher	1932	London by LMS - Trooping the Colour, Whitehall	London	LMS	QR	SSPL	10173224 Drawer D004	London006	1986-9089
Mason, Frank Henry Algernor	1947	London "Afloat upon ethereal tides" PW18	London	GWR	DR	SSPL	10174176 Drawer D076	London007	1978-9359
McCorquodale Studios	1930s	Charing Cross Hotel & Restaurant in the Heart of London	London	LT Image	DR	Onslows	11/6/04 lot 282	London008	
Pean, S. Rene	1910	Paris a Londres: Beefeater, Tower bridge from Gare St Lazare	London	CdFL'Ouest	DR	Christies	8/2/01 Lot 193	London009	
Clark, Christopher	1930s	London for State Occasions	London	LMS	QR	SSPL	10173088 Drawer D004	London010	1976-9231
Brown, G. Massiot	1937	While you sleep: London Paris by train + ferry	London	SR	DR	Onslows	11/04/02 Lot 326	London011	
Clark, Christopher	1932	London: St. James's Palace: military band	London	LMS	QR	SSPL	10172484 Drawer D004	London013	1983-8336
Clark, Christopher	1937	London: The Horse Guards	London	LMS	QR	SSPL	10173237 Drawer D004	London014	1986-9096
Taylor, Fred	1925	Why not visit London for a few days: Eros in Piccadilly Circus	London	LNER	QR	SSPL	10173374 Drawer D018	London015	1986-9188
Sims, Charles	1924	London cartoon type image	London	LMS	QR	SSPL	10171844 Drawer D004	London016	1979-7889
Zinkeisen, Anna Katrina	1934	London by LNER: Its quicker by rail: Rotten Row 1895	London	LNER	QR	SSPL	10173587 Drawer D008	London017	1978-9013

ARTIST	DATE	TITLE	LOCATION	COMPANY	SIZE	SOURCE	SOURCE DETAILS		IMAGE REF	NRM REF
Anon	1950	London Town; Travel by train: pictorial map	London	BR Exec	QR	SSPL	10171846	Drawer D025	London018	1979-7891
Taylor, Fred	1930s	London: 16th Architecture - Tudor 16th century	London	LNER	DR	SSPL	10171245	Drawer D100	London019	1992-7713
Anon	1938	London Town map (heraldic shield border)	London	SR	QR	SSPL	10170787	Drawer D019	London020	1991-7269
Spradbery, Walter Ernest	1936	London: Cheap evening trips from Lewes	London	SR	DR	SSPL	10174966	Drawer D102	London021	1978-9810
Bateman, James	1935	London: Travel by Rail - Midweek if you can	London	LNER	DR	Onslows	20 June 06 Lot 365		London022	
Bateman, James	1939	London: Its Quicker by Rail St Paul's Cathedral	London	LNER	DR	SSPL	10174375	Drawer D095	London022a	1987-8895
Harris, Edwin Lawson James	1952	London: See England by Rail: Hyde Park	London	BR(LMR)	DR	SRA	15/03/08 Lot 323 ref. PP1127		London023	
Clark, Christopher	1951	The Tower of London: See Britain by rail: befeeters	London	BR(LMR)	QR	SSPL	10170779	Drawer D022	London024	1991-7254
Toussaint, Maurice	1907	Paris a Londres: Scots pipers in London	London	CdfOuest/LBSCR	DR	SSPL	10173949		London025	1987-8794
Anon	1927	London by LMS on Friday Night: Art upper half text below	London	LMS	DR	Christies	21/5/96 lot 55		London026	
Pryse, Gerald Spencer	1924	British Empire Exhibition 1924: Cattle image	London	Govt Poster	QR	Christies	5/2/98 Lot 73		London027	
Beard	1925	British Empire Exhibition: Wembley London	London	Govt Poster	QR	Christies	9/02/1995 Lot 181		London028	
Nicoll, Gordon	1954	Visit London: Travel by Train ref. PR/40	London	BR(WR)	DR	SSPL	10175473	Drawer D116	London029	1978-0892
Clark, Christopher	1951	British Army Ceremonial	London	BR(LMR)	QR	Christies	09/09/2009 Lot 40 LM5551		London030	
Taylor, Fred	1935	London: Lord Mayor's procession Its Quicker by Rail	London	LNER	DR	SSPL	10174220	Drawer D100	London031	1978-9403
Coffin, Ernest	1936	London aerial view of Central london	London	GWR	DR	SSPL	10172227	Drawer D090	London032	1986-8817
CHS	1920	The Gateway to Health & Pleasure: Waterloo Station	London	LSWR	DR	SSPL	10327530		London033	1999-8245
Mason, Frank Henry Algernor	1930s	London Via Harwich	London	LNER	DR		Private Collection Disclosed		London034	
Mason, Frank Henry Algernor	1938	London Tower of London: Tower bridge	London	GWR	DR	SSPL	10174171	Drawer D076	London035	1978-9354
Mason, Frank Henry Algernor	1946	London Pride Ref. PW 15	London	GWR	QR	SSPL	10173997 +10174015 Drawer D002		London036	1978-9180
Blake, Frederick Donald	1950s	London: See England by Rail; Trafalgar Square	London	BR(ER)	QR	SSPL	10173757	Drawer D023	London037	1978-9131
Shepherd, David	1955	Service by Night. Trains leaving Kings Cross	London	BR(ER)	QR	SSPL	10170978	Drawer D023	London038	1990-7086
Wilkinson, Norman	1938	St. Paul's School	London	LMS	DR	SSPL	10323827	Drawer D091	London039	1999-7126
Wilkinson, Norman	1938	Westminster School: College Hall	London	LMS	DR	Christies	12/9/2002 Lot 272		London040	
Wilkinson, Norman	1948	The Thames: Tower Bridge	London	BR(LMR)	QR	Christies	14/10/2004 Lot 294		London041	
Wilkinson, Norman	1925	London by LMS: The Tower	London	LMS	QR	Christies	09/09/2009 Lot 39		London042	
Wilkinson, Norman	1930	London: Whitehall from St. James's Park	London	LMS	QR	Christies	2/10/1997 Lot 114		London043	
Cooper, Royston	1950s	Visit London: There are cheap tickets from this station	London	BR(SR)	DR	SSPL	10175665	Drawer D160	London044	1978-1089
Cuneo, Terence Tenison	1946	The Day Begins	London	LMS	QR	SSPL	10173083	Drawer D004	London045	1976-9228
Danvers, Verney L.	1924	Where it is warm and bright: smog street scene	London	LTU	DR				London046	
Davies, G.H.	1960s	Improving Euston	London	BR(LMR)	DR	Morphets	21/07/2010 Lot 58 LM6652		London047	
Davis, G.H.	1953	New stations for old: Carpenders Park/Gospel Oak	London	BR(LMR)	DR	SSPL	10172263	Drawer D104	London048	1986-8853
Dowd, Leo	1950	At your Service: couple and ticket collector	London	LT advert	DR				London049	
Fenton, E.W.	1952	The Garden (urn in foreground)	London	LT advert	DR				London050	
Anon	1930	Londres: View of Tower bridge	London	CdefE/LBSCR	DR	SSPL	10171371		London051	1994-7170
Brown, F. Gregory	1950	London Excursions from this station	London	BR Exec	DR	SSPL	10170958		London052	1990-7066
Newbould, Frank	1937	The Coronation The First Streamline Train 60010	London	LNER	DR	SSPL	10406816 Booklet cover		London053	
Newbould, Frank	1939	London: Heart of the Empire: Life Guard	London	GWR	DR	SSPL	10170855		London054	1989-7090
Payne, Stanley	1936	Londres: heraldic montage for French market	London	SR	DR	SSPL	10170959	Drawer D103	London055	1990-7067
Navarro, J	1953	London by Train: Horse Guard, Eros collage	London	BR(ER)	DR	SSPL	10172255		London056	1986-8845
Lander, Reginald Montague	1980	London's Monuments and Royal Parklands	London	BR(SR)	DR	SSPL	10172818	Drawer D127	London057	1983-8595
Photographic	1966	The Lights of London are just a train-ride away	London	BR Inter City	DR	SSPL	10172876		London058	1984-8199
Wilkinson, Norman	1938	Mill Hill School	London	LMS	QR	SSPL	10172981	Drawer D006	London059	1985-8844
McKie, Helen Madeleine	1947	Waterloo station - Peacetime AD5416/1500-1947	London	SR	QR	SSPL	10173130	Drawer D019	London060	1976-9262
McKie, Helen Madeleine	1947	Waterloo station - Wartime	London	SR	QR	SSPL	10173129	Drawer D019	London061	1976-9261
Skottowe, Elizabeth	1947	The Children's own Poster AD5548/2000/1947	London	SR	QR	SSPL	10173399	Drawer D019	London062	1978-8868
Toussaint, Maurice	1932	Visitez L'Angleterre State occasion	London	CdFL'Etat/SR	DR	SSPL	10173948	Drawer D102	London063	1987-8793
Anon	1913	Londres: Paris St. Lazare a Londres	London	SR	DR	SSPL	10173951	Drawer D102	London064	1987-8796

ARTIST	DATE	TITLE	LOCATION	COMPANY	SIZE	SOURCE	SOURCE DETAILS		IMAGE REF	NRM REF
Wilkinson, Norman	1925	London by LMS: St Paul's Cathedral	London	LMS	QR	SSPL	10174009	Drawer D006	London065	1978-9192
Shep (Charles Shepard)	1925	British Empire Exhibition, Wembley May-Oct 1925	London	LNER	DR	SSPL	10174449	Drawer D079	London067	1987-8969
Shep (Charles Shepard)	1925	British Empire Exhibition, Wembley	London	LNER	DR	SSPL	10174450	Drawer D077	London068	1987-8970
Shep (Charles Shepard)	1925	British Empire Exhibition, Wembley May-Oct 1925	London	LNER	DR	SSPL	10174452	Drawer D079	London069	1987-8972
Shep (Charles Shepard)	1925	British Empire Exhibition, Wembley May-Oct 1925	London	LNER	DR	SSPL	10174453	Drawer D079	London070	1987-8973
GH	1924	Wembley Torchlight Tattoo	London	LNER	DR	SSPL	10174455	Drawer D077	London071	1987-8975
Brown, F. Gregory	1925	The New Wembley: Better and Brighter than ever	London	LNER	DR	SSPL	10174456	Drawer D079	London072	1987-8976
Photographic	1977	Here's the latest on clearing the throat	London	BR(ER)	DR	SSPL	10174689		London073	1978-9662
Shep (Charles Shepard)	1939	Back Again! Cheap day tickets to London Stock letterpress	London	SR	DR	SSPL	10174945	Drawer D101	London074	1978-9789
Shep (Charles Shepard)	1939	Back Again! Cheap day tickets to London stock poster	London	SR	DR	SSPL	10174945	Drawer D101	London074	1978-9789
FB	1927	Visit London Horseguard's Parade and map	London	SR	DR	SSPL	10173953	Drawer D102	London075	1987-8798
Anon	1966	Visitex La Grande Bretagne par le Train	London	BR(SR)	DR	SSPL	10175147		London076	1978-9991
Keely, Patrick Cockayne	1957	Cricket at the Oval 1957	London	BR(SR)	DR	SSPL	10175408		London077	1978-0827
Anon	1960s	The New Euston - The Parcels Depot	London	BR(LMR)	DR	SSPL	10175533	Drawer D104	London078	1978-0952
Anon	1965	The New Euston - Reconstruction Begins	London	BR(LMR)	DR	SSPL	10175534	Drawer D111	London079	1978-0953
Anon	1971	Browse and buy at Collectors' Corner	London	BR(LMR)	DR	SSPL	10175555	Drawer D111	London080	1978-0974
Lander, Reginald Montague	1962	Cricket Fixtures at the Oval	London	BR(SR)	DR	SSPL	10175642		London081	1978-1066
Stewart, Kay	1950s	Enjoy the Countryside: London area day return tickets	London	BR(SR)	DR	SSPL	10175643		London082	1978-1067
Fish, Laurence	1960	Visit Britain by Rail and Sea Ceremonial Guard	London	BR(SR)	DR	SSPL	10175656	Drawer D158	London083	1978-1080
Lander, Reginald Montague	1961	For London Rugby Travel by Southern Electric	London	BR(SR)	DR	SSPL	10175775		London084	1978-1199
Keely, Patrick Cockayne	1959	For London Football Travel by Southern Electric	London	BR(SR)	DR	SSPL	10175785		London085	1978-1209
Hasler	1955	Steam Locomotive - A Valedictory Exhibition at Euston Station	London	BR(LMR)	DR	SSPL	10175857		London086	1978-1281
Greiffenhagen, Maurice Willia	1926	London by LMS: Piccadilly Circus by night - artwork	London	LMS	QR	SSPL	10282857		London087	1976-9279
Greiffenhagen, Maurice Willia	1926	London by LMS: Piccadilly Circus at night	London	LMS	QR	Christies	09/09/09 Lot 38 (Best Way No. 80)		London087a	
Wilkinson, Norman	c1930	Ready for the Road: Camden Shed original artwork	London	LMS	QR	SSPL	10282997		London088	1976-9416
Wilkinson, Norman	1930s	Ready for the Road: Camden Shed	London	LMS	DR				London088a	
Photographic	1970s	Meet London face to face: Photo collage	London	BR Intercity	DR	SSPL	10314015		London089	
Anon	1960	Be Budget-wise!: Buy a shopping ticket to London	London	BR Exec	DR	SSPL	10316350	Drawer D160	London090	1998-10099
Photographic	1947	Great Western Royal Hotel, Paddington	London	GWR	DR	SSPL	10172144	Drawer D090	London091	1986-8775
Photographic	1947	When in London stay at the Great Western Royal Hotel	London	GWR	DR				London091a	
Colb, H.	1910s	Paris a Londres par La Gare St Nazaire: Police on bridge	London	CdefO/LBSCR	DR	SSPL	10172264		London092	1986-8854
Wilkinson, Norman	1927	"Royal Scot" leaves Euston	London	LMS	QR	SSPL	10173244	Drawer D006	London093	1986-9098
Connard, Philip	1935	Spring on Wimbledon Common	London	Underground	QR	SSPL	10173402	Drawer D020	London094	1978-8871
Nicoll, Gordon	1929	Great Eastern Hotel: Liverpool St. station London	London	LNER	QR	SSPL	10175952	Drawer D015	London095	1986-9318
Nicoll, Gordon	1929	Great Eastern Hotel: Liverpool St.station London	London	LNER	QR	SSPL	10324283	Drawer D015	London095a	1986-9318
Neilland, Brendan	1996	Waterloo International	London	Railfreight	QC	SSPL	10308307		London096	1997-8442
Roberts, Bruce	1951	Festival of Britain: Excursions to London from this station	London	BR(NER)	DR	SSPL	10327502		London097	1999-7099
Coffin, Ernest	1936	London: View looking east along the Strand	London	GWR	DR	Morphets	14/01/2010 Lot 276		London98	
Studio Seven	1960	By Train to London	London	BR(SR)	DR	SSPL	10316272	Drawer D136	London099	1998-10095
Roberson, Peter	1962	London Centenaries 1962	London	LT	DR	Onslows	19/12/06 Lot 343		London100	
Herry=Perry (Heather Perry)	1929	London: Thou Art the Flower of Cities All	London	GWR	DR	Christies	14/9/2006 Lot 150		London101	
BIS	1932	Open Air Swimming Baths for Londoners	London	SR	DR	Christies	14/9/2006 Lot 154		London102	
Cooper, Richard T.	1924	British Empire Exhibition 1924	London	LCC	QR	Christies	14/9/2006 Lot 155		London103	
Newbould, Frank	1924	Tour the Empire at Wembley	London	LCC	QR	Christies	14/9/2006 Lot 156		London104	
Cooper, Royston	1928	The Londoner's Transport throughout the Ages: AD327	London	LT	QR				London105	
Anon	1912	London: Piccadilly Circus at Night	London	GWR	DR				London106	
Clark, Christopher	1930	Opening of Parliament State coach	London	LMS	QR	NRM	1986-9097	Drawer D004	London107	1986-9097
Fix-Masseau, Pierre	1980	Venice Simplon Orient Express: Victoria station	London	VSOE	DR	NRM	1984-8161	Drawer D109	London109	1984-8161

ARTIST	DATE	TITLE	LOCATION	COMPANY	SIZE	SOURCE	SOURCE DETAILS	IMAGE REF	NRM REF
Lefevre	1900	Paris a Londres: Beefeater and montages	London	CdefO/LBSCR	DR		Private Collection disclosed	London112	
Taylor, Fred	1914	Victoria Station	London	SR	QR		Private Collection disclosed	London113	
Anon	1909	Piccadilly Circus station	London	LT advert	QR		Private Collection disclosed	London114	
Brown, Douglas George	1905	Best Night Trains to Liverpool, Manchester etc	London	LNWR	DR		Private Collection disclosed	London115	
Lloyd, John Henry	1911	Lightning Parcel Express	London	CLTR	DR		Private Collection disclosed	London116	
Anon	1920s	Charing Cross Hotel: Restaurant poster	London	SR	DR		Private Collection disclosed	London117	
Fraipont, Gustave	1890s	Paris Nord a Londres tower bridge night scene	London	CdeFN	DR		Private Collection disclosed	London118	
Toussant, Maurice	1908	Paris a Londres: Life guards on parade	London	CdefO/LBSCR	DR		Private Collection disclosed	London119	
Pears, Charles	1930	The Musician travels Underground	London	LT	DR	LTM237	London Transport Museum	London120	
Brown, F. Gregory	1929	The Londoner's Leisure - The Thames	London	SR	DR			London121	
Williamson, H.S.	1927	Harringay Park: view of dog track	London	LT	QR	LTM354	London Transport Museum	London122	
James, Margaret Calkin	1935	Chelsea Flower Show May 22-23-24	London	LT	QR	LTM366	London Transport Museum	London123	
Zinkeisen, Anna Katrina	1934	Trooping the Colour June 4	London	LT	QR	LTM599	London Transport Museum	London124	
Anon	1923	London's Tramways: Polo at Avery Hill	London	LT	DR	LTM633	London Transport Museum	London125	
Wilkinson, Norman	1925	London by LMS: The Houses of Parliament	London	LMS	QR			London126	
Cuneo, Terence Tenison	1962	Clapham Junction ref. AD 9126/A1.5 /22162	London	BR(SR)	QR	SSPL	10176097 Drawer D025	London127	1988-8072
Blake, Frederick Donald	1960s	British Railways London; Ask for details of cheap tickets	London	BR Exec	DR	NRM	2000-7599 Drawer D154	London128	2000-7599
Wilkinson, Norman	1925	Willesden Box No. 7 - original artwork	London	LMS	QR	SSPL	10171852 Drawer D007	London129	1979-7897
Ungeriese		The Zoo Aquarium	London	LT Advert	DR			London130	
Burningham, John	1961	Zoo Ahoy: Noah's Ark	London	LT Advert	DR			London131	
BF	1929	Visit London by Short Sea Routes: Buckingham Palace	London	SR	DR	Christies	12/09/2002 Lot 140	London132	
Zero (Hans Schleger)	1936	Victorian London 1850: 1800 George III's London	London	LT	DR	Christies	14/09/2000 Lot 239	London133	
Goetz, Walter	1936	Boat Race April 4	London	LT advert	QR	Christies	14/09/2000 Lot 243	London134	
Cooper, Richard T.	1929	The Boat Race Centenary Saturday 25th March 1929	London	LT Advert	QR	Christies	14/09 2000 Lot 244	London135	
Spradbery, Walter Ernest	1944	The Proud City: St Clements Danes after raid	London	LTPBoard	DR	Onslows	29/06/2007 Lot 317	London136	
Spradbery, Walter Ernest	1944	The Proud City: St Thomas Hospital and Parliament	London	LTPBoard	DR	Onslows	29/06/2007 Lot 318	London137	
Spradbery, Walter Ernest	1944	The Proud City: Tower of London across Water Lane	London	LTPBoard	DR	Onslows	29/06/2007 Lot 316	London138	
Spradbery, Walter Ernest	1944	The Proud City: St. Pauls Cathedral	London	LTPBoard	DR	Onslows	29/06/2007 Lot 315 London Folder	London139	
Spradbery, Walter Ernest	1944	The Proud City: The Temple Church after bombing	London	LTPBoard	DR	Onslows	11/6/04 lot 321 London folder	London140	
Photographic	1977	At Kings Cross we call this the Throat	London	BR(ER)	DR	SSPL	10174635	London141	1978-9608
Kauffer, Edward McKnight	1922	At the Museum of Science South Kensington	London	London Advert	DR	Christies	14/09/2000 Lot 221	London142	
McKie, Helen Madeleine	1954	Day Excursion to London Scottish locations	London	BR(ScR)	DR	Christies	28/06/2007 Lot 118	London143	
McKie, Helen Madeleine	1954	Day Excursion Bookings London -- Wales locations	London	BR(WR)	DR		Private collection	London144	
McKie, Helen Madeleine	1954	Day Excursion Bookings from Met & Great North lines	London	BR(ER)	DR			London144a	
McKie, Helen Madeleine	1954	London: Wed and sat until 12th June: east locations	London	BR (ER)	DR			London144b	
Shep (Charles Shepard)	1925	British Empire Exhibition 1925: Wembley	London	LNER	DR	SSPL	10174451 Drawer D079	London145	1987-8971
Tripp, Herbert Alker	1936	Westminster Abbey original artwork	London	LTU	DR	LTU Museum	record 6 of 9 held	London146	
Tripp, Herbert Alker	1936	Houses of Parliament original artwork	London	LTU	DR	LTU Museum	record 7 of 9 held	London147	
Spradbery, Walter Ernest	1944	The Proud City: Chelsea Power House from Meek St.	London	LTPBoard	DR	Onslows	18/06/2004 Lot 323	London149	
Lander, Reginald Montague	1978	Visit Royal London ref. AD846/B9/10578/CodeC	London	BR (NSE)	DR			London150	
Hick, Allanson	1950s	London Easter Sunday 2nd April REF PP9415	London	BR(ER)	DR		Private collection PP/94/93(B531)	London151	
Neilland, Brendan	1996	London Paddington: GW Trains	London	Railfreight	DR		private collection	London152	
Nevison, Christopher Richard	1925	1925 Wembley: Make up a Party	London	LNER	DR	SSPL	10174454 Drawer D079	London153	1987-8974
Baker, Charles H.	1924	London's newest underground wonder: Camden	London	LT advert	DR		Private Collection	London154	
Bainbridge	1953	A Guardsman - stock poster	London	LT advert	DR		Private Collection	London155	
Anon	1925	Londres: Londres et L'Angleterre	London	SR	DR		Private Collection	London156	
Coffin, Ernest	1910s	England by short sea routes: Westminster Abbey	London	SE+CR	DC			London157	
Taylor, Fred	1920s	The Pool of London: aerial view	London	Ltransport	QR	Onslows	25/06/2008 Lot 245	London158	

ARTIST	DATE	TITLE	LOCATION	COMPANY	SIZE	SOURCE	SOURCE DETAILS	IMAGE REF	NRM REF
Lander, Reginald Montague1!	1978	Visit the Tower of London	London	BR Exec	DR	NRM	2003-7190 Drawer D318	London159	2003-7190
Anon	1968	The New Euston Station is now open	London	BR(LMR)	QR	NRM	1998-11324 Drawer D022	London160	1998-11324
Ralph & Mott (Pub)	1930s	London calling: semi pictorial letter press	London	GWR	DR			London161	
Anon	1931	Londres: Routes maritimes les plus courtes	London	SR French copy	DR			London162	
Shep (Charles Shepard)	1953	British Railways: God save the Queen	London	BR(WR)	DR			London163	
Anon	1993	Chelsea Flower Show 1993 Blue background: floral arrangement	London	Network SE	DR	NRM	1997-8078 Drawer D085	London164	1997-8078
Anon	1965	The New Euston: Progress continues: ticket offices	London	BR(LMR)	DR	NRM	1978-0954 Drawer D104	London165	1978-0954
Anon	1965	The New Euston: The New Signalbox	London	BR(LMR)	DR	NRM	1978-0955 Drawer D104	London166	1978-0955
Anon	1965	The New Euston: Reshaping Progresses	London	BR(LMR)	DR	NRM	1978-0968 Drawer D104	London167	1978-0968
Anon	1965	The New Euston: Changes in Drummond Street	London	BR(LMR)	DR	NRM	1978-0972 Drawer D111	London168	1978-0972
Taylor, Fred	1923	Aerial view of Palace of Westminster	London	LNER	QR	Onslows	25/06/2008 Lot 244	London169	
Anon	1906	The Best Route for Comfortable Travel and Picturesque Scenery	London	MR	DR			London170	
McKie, Helen Madeleine	1957	Choisissez La Grande Bretagne pour vos vacances	London	BR Exec	DR			London171	
Maxwell, Donald	1930s	Visitez Londres Southern Railway of England	London	SR	DR	Onslows	11/04/02 lot 405	London172	
Anon	c1930	Theatre-land from Metro-land and back	London	Met Rly.	DR			London173	
Anon	1923	Travel by "Metro" to the Cup Final 1s 0d	London	London Tra	DR			London174	
Sommerville, Howard	1904	Cook's Excursions to London: Chelsea Pensioner	London	Midland Rly	DR	Pub Rec Off	Official MR Poster	London176	
Fitzsimmons, Dennis	1904	Cook's Excursions to London: Eros statue stock poster	London	Midland Rly	DR	Pub Rec Off	Official MR Poster	London177	
Burley, David William	1939	Artwork: Travelling particulars in London + SE	London	SR	sm.			London178	
Brown, F. Gregory	1965	London for the Day stock poster	London	BR Exec	DR	NRM	1978-1140 Drawer D102	London181	1978-1140
Anon	1951	Festival of Britain: Day Return Tickets	London	BR(SR)	DR	NRM	1978-0807 Drawer D126	London182	1978-0807
Buckle, Claude Henry	1935	London: The Bank of England waiting room poster	London	GWR	sm.			London183	
Photographic	1987	The 1987 Royal Tournament, Earls Court	London	Network SE	DR	NRM	1996-8216 Drawer D193	London184	1996-8216
Anon	1938	London by LNER: Sights Shops Shows	London	LNER	DR			London185	
Coffin, Ernest	1925	British Empire Exhibition: Bridge across the Lake	London	LMS	DR	Onslows	01/04 1998 Lot 478	London186	
Coffin, Ernest	1925	British Empire Exhibition: The Palace of Industry	London	LMS	DR	Onslows	01/04 1998 Lot 480	London187	
Coffin, Ernest	1925	British Empire Exhibition: HM Government Building	London	LMS	DR	Onslows	01/04 1998 Lot 481	London188	
Coffin, Ernest	1925	British Empire Exhibition: Walled City of West Africa	London	LMS	DR	Onslows	01/04 1998 Lot 483	London189	
Watts, Arthur George	1929	London: The First City of the Empire	London	LMS	DR	SSPL	10324156 Drawer D091	London190	1995-7045
Anon	1951	London and Suburbs: Main line Railways	London	BTC	QR			London191	
Brown, F. Gregory	1927	Zoo: Regents Park Camden Town Kangaroos	London	L.Trans U	DR		Private Collection	London192	
Gardiner, Clive	1930s	At London's service: woodland scene	London	LT advert	DR			London193	
Anon	1930s	Ideal Home Exhibition Earl's Court April11 to May 6	London	LNER	DR		Private Collection	London194	
Newbould, Frank	1938	London Stock Poster: Tower and tower bridge top	London	LNER	DR		Private Collection	London195	
Games, Abram	1976	London Zoo Regent's Park tiger image	London	LT advert	DR		Private Collection	London196	
Anon	1924	Closing of Waterloo Bridge	London	SR	QR			London203	
Anon	1897	The Salvation Army 32nd Anniversary Pageant	London	GWR	DR	GCRA	08/11/2011 Lot 46	London204	
Greiffenhagen, Maurice Willia	1920s	The Visit to Town	London	LMS	QR			London205	
Snowdon, Douglas	1910	London to Paris: Luxurious Mail Steamers	London	LSWR	DR			London206	
Nicoll, Gordon	1953	Visit London Travel by Train	London	BR (WR)	DR	SSPL	10175473	London029	
Nicoll, Gordon	1953	Visit London in Coronation Year	London	BR (WR)	DR		Privata Collection	London029a	1975-8391
Taylor, Fred	1910	Going North? St. Pancras	London	Midland Rly	QR	SSPL	10174037 Drawer D001	St. Pancras1	1978-9220
Taylor, Fred	1910	Going to London?: Yes - Midland (St Pancras)	London	Midland Rly	QR			St. Pancras2	
Coffin, Ernest	1925	British Empire Exhibition: Palace of Engineering	London	LMS	DR	Onslows	01/04 1998 Lot 482		
Coffin, Ernest	1925	British Empire Exhibition: The North East Collande	London	LMS	DR	Onslows	01/04 1998 Lot 479		
Coffin, Ernest	1925	British Empire Exhibition: The North Entrance	London	LMS	DR	Onslows	01/04 1998 Lot 477		
Pears, Charles	1932	London Enquire for Cheap GWR Ticket Facilities	London	GWR	DR	NRM	GWR Poster Index page 53		PRO
Taylor, Fred	1937	London: Coronation of George VI	London	LNER	DR				

ARTIST	DATE	TITLE	LOCATION	COMPANY	SIZE	SOURCE	SOURCE DETAILS	IMAGE REF	NRM REF
Buckle, Claude Henry	1935	London: The Heart of the Empire (see above)	London	GWR	DR	NRM	GWR Poster Index page 63		PRO
Adcock, A.A.	1928	See the Wonders of London	London	GWR	DR	NRM	GWR Poster Index Page 46		PRO
Wilson, Duncan	1985	The Lord Mayors Show: Montage of event	London	BR(SR)	DR				
Taylor, Fred	1920s	Hampton Court by Tram	Middlesex	Lon. Tramways	DR		Private Collection Disclosed	HamptonCourt1	
Herrick, Frederick	1926	Hampton Court: Romance and Gaiety	Middlesex	Lon. Tramways	DR			HamptonCourt2	
Pond, Edward	1989	Hampton Court by Train: Heraldry on gates: Palace beyond	Middlesex	BR (NSE)	DR	NRM	1996-7330 Drawer D059	HamptonCourt3	1996-7330
Wilkinson, Norman	1927	Harrow School	Middlesex	LMS	QR	SSPL	10174005 Drawer D006	Middlesex01	1978-9188
Anon	1929	Book to Colindale or Hendon Central Station	Middlesex	LT	QR	LTM361	London Transport Museum	Middlesex02	
Allinson, Adrian Paul	1934	Hampton Court: Stock poster	Middlesex	GWR	DR	Christies	12/09/2007 Lot 154	Middlesex03	
Kauffer, Edward McKnight	1930s	The Colne River at Uxbridge	Middlesex	LT image	DR	Onslows	11/6/04 lot 277	Middlesex04	
Lander, Reginald Montague	1978	Visit Hampton Court Palace Ref AD999/B5/12178	Middlesex	BR(SR)	DR		Private collection	Middlesex05	
Anon	1912?	Staines The Unrivalled Riverside Resort	Middlesex	LSWR	DR			Middlesex06	
Gardiner, Cliff		Hampton Court	Middlesex	LT advert				Middlesex07	
Buckle, Claude Henry	1950s	Hampton Court: Where history lingers	Middlesex	BR(SR)	DR			Middlesex08	
Anon	1930s	Riverside Palace, Gardens and Maze	Middlesex	SR	DR	Pub Rec Off	Official SR Poster	Middlesex09	
Photographic	1929	Brentford Docks Additional Warehousing Accomodation	Middlesex	GWR	DR	NRM	GWR Poster Index Page 48		PRO
Maxwell, Donald	1924	The 'Lake District' of Surrey: Frensham Pond	Surrey	SR	QR	SSPL	10172198 Drawer D019	Surrey01	1986-8796
Burley, David William	1925	Chessington Zoo Circus: Ideal for party outings	Surrey	SR	DR	SSPL	10177032 Drawer D101	Surrey02	1991-7114
Eckersley, Tom	1961	Epsom Races: The Derby Wednesday31st May	Surrey	BR(SR)	DR	SSPL	10175736	Surrey03	1978-1160
Anon	1956	Chessington Zoo: Combined rail/admission tickets	Surrey	BR(SR)	DR	SSPL	10175721 Drawer D157	Surrey04	1978-1145
Sheppard, Raymond	1950	Chessington Zoo: Stock poster collage of animals	Surrey	BR(SR)	DR	SSPL	10174154	Surrey05	1978-9337
Sheppard, Raymond	1950	Chessington Zoo: Combined rail tickets collage	Surrey	BR(WR)		NRM	1978-9292 Drawer D117	Surrey05a	1978-9292
Gandy, Herbert	1923	Farnham: Live at Farnham	Surrey	SR	DR	SSPL	10321713	Surrey06	
Anon	1978	Visit Kew by Train Royal Botanic Gardens	Surrey	BR(SR)	DR	SSPL	10171483	Surrey07	1979-7528
Brown, F. Gregory	1929	The Londoner's Highlands - Surrey	Surrey	SR	DR	SSPL	10170967 Drawer D103	Surrey08	1990-7075
Rojan	1937	Kew Gardens: Cheap fares and frequent trains	Surrey	SR	DR	SSPL	10171212 Drawer D103	Surrey09	1992-7680
Lander, Reginald Montague	1980	The Surrey Towns and the North Downs	Surrey	BR(SR)	DR	SSPL	10172820 Drawer D127	Surrey10	1983-8597
Bromfield, Kenneth	1961	Chessington Zoo: Save 20% with Combined rail tickets	Surrey	BR(SR)	DR	SSPL	10175691	Surrey11	1987-1115
Bromfield, Kenneth	1964	Chessington Zoo Save 20% with combined train admission tickets	Surrey	BR(SR)	DR	SSPL	10175731	Surrey12	1978-1155
Spradbery, Walter Ernest	1932	Oxshott Heath by Southern Electric Autumn heather	Surrey	SR	DR	Christies	10/9/2003 Lot 116	Surrey13	
Anon	1928	Richmond Royal Horse Show June 14. 15. 16	Surrey	LT	QR	LTM501	London Transport Museum	Surrey14	
Lander, Reginald Montague	1978	Visit Guildford: blue Ref AD7252/B3/29769	Surrey	BR(SR)	DR			Surrey15	
Lander, Reginald Montague	1978	Visit Guildford: green Ref AD7252/B3/29769	Surrey	BR(SR)	DR	NRM	2003-7176 Drawer D318	Surrey15a	2003-7176
Anon (signed)	1930s	Godstone; chalk cliffs building silhouette	Surrey	SR	DR	Christies	27/05/99 Lot 1	Surrey16	
Danvers, Verney L.	1930s	Richmond: The Garden of London	Surrey	SR	DR	Onslows	17/5/01 lot 941 image in folder	Surrey17	
Anon	1909	Beautiful Richmond	Surrey	LSWR	DR			Surrey18	
White, Ethelbert Basil	1928	Live in Surrey and Be Happy!	Surrey	SR	DR	Christies	05/11/2010 Lot 36	Surrey19	
Burley, David William	1936	Sites of Two Acres or more at Worplesdon	Surrey	Building Poster	QR	SSPL	10311567	Surrey20	1995-7039
Black, Montague Birrell	1925	Half an Hour From London: Woods and Commons of Surrey	Surrey	SR	QR	Pub Rec Off	Official SR Poster	Surrey22	PRO
Spradbery, Walter Ernest	1930	Guildford: Picturesque and historic	Surrey	SR	DR	Onslows	1/11/02 lot 374	Surrey24	
Photographic	2009	A Day Unlike any Other - Guildford	Surrey	First GW	DR	FGW	Poster Listing from Swindon	Surrey23	
Keely, Patrick Cockayne	1957	Epsom Races The Derby 5th June	Surrey	BR(SR)	DR	SSPL	10175414	Surrey26	1978-0833
Burley, David William	1935	Chessington Zoo Circus: Bubble the penguin	Surrey	SR	DR			Surrey27	PRO
Burley, David William	1935	Chessington Zoo Circus: George the Clown	Surrey	SR	DR			Surrey28	PRO
Burley, David William	1935	Chessington Zoo Circus: Dicky the Sealion	Surrey	SR	DR		Public Records Office: SR poster	Surrey29	PRO
Burley, David William	1935	Chessington Zoo Circus: Jill the bear	Surrey	SR	DR		Private Collection	Surrey30	PRO
Burley, David William	1935	Chessington Zoo Circus: Rosie the Elephant	Surrey	SR	DR		Private Collection	Surrey31	PRO
Anon	1930s	Chessington Zoo: Fun for everyone	Surrey	SR	DR		Private Collection	Surrey32	PRO

ARTIST	DATE	TITLE	LOCATION	COMPANY	SIZE	SOURCE	SOURCE DETAILS	IMAGE REF	NRM REF
Anon	1930s	New Station now open: Chessington South for Zoo	Surrey	SR	DR		Private Collection	Surrey33	
Anon	1960s	Bognor Regis: red poster bathing belle ref. AD 7004/B1114	Sussex	BR(SR)	DR	NRM	Inventory Number 1978-0702 drawer D157	Bognor01	1978-0702
Mamlok	1960s	Bognor Regis: Go by Train girl jumping over sandcastle	Sussex	BR(SR)	DR			Bognor02	
Durman, Alan	1950s	Bognor Regis: frequent electric trains from London Victoria	Sussex	BR(SR)	DR	SSPL	10175116 Drawer D130	Bognor03	1978-9960
Angrave, Bruce	1925	Bognor Regis : art deco ladies - stock poster	Sussex	SR	DR	Christies	21/5/1996 Lot 53	Bognor04	
Brett, Ronald	1950s	Bognor Regis: mother and son in beach pool	Sussex	BR(SR)	DR	Christies	13/09/2007 Lot 134	Bognor05	
Anon	1910	Bognor: The Place in the Sun sun-based image	Sussex	LBSCR	DR	SSPL	10317486	Bognor06	1999-7127
Johnston	1952	Bognor Regis: frequent electric trains from London Feeding gulls	Sussex	BR(SR)	DR			Bognor07	
Deseth	1970	Bognor Regis: frequent trains from London (Victoria)	Sussex	BR(SR)	DR	NRM	1978-0691 Drawer D158	Bognor08	1978-0691
Anon	1986	Clowns' Convention 2nd International Bognor Regis	Sussex	Intercity	DR	NRM	1996-8193 drawer D193	Bognor09	1986-8193
Johnson, Andrew	1931	Brighton and Hove: very fit-and you? Wonderful!!	Sussex	SR	QR			Brighton01	
Pears, Charles	1935	Brighton and Hove: sea scene. canoes foreground	Sussex	SR	QR	SSPL	10172269 Drawer D019	Brighton02	1986-8859
Tidmarsh, G.D.	1935	Brighton and Hove: modern route map	Sussex	GW/LMS/SR	QR	SSPL	10173712 Drawer D020	Brighton03	1978-9110
Shoesmith, Kenneth Denton	1938	Brighton and Hove seafront: west and palace piers	Sussex	LMS	QR			Brighton04	
Wentworth-Shields, F.W.	1950	Brighton & Hove: Always in Season AD6248	Sussex	BR(SR)	QR	Onslows	20/06/06 lot 341C	Brighton05	
Wentworth-Shields, F.W.	1950s	Brighton and Hove for Sea and Downs: windmill image	Sussex	BR(SR)	QR	Guido Ton	18 March 2006 Lot 240	Brighton06	
Dixon, John (photo)	1959	Brighton & Hove: Brilliant and Beautiful all year round	Sussex	BR(SR)	DR	SSPL	10175108	Brighton07	1978-9952
TF	1920s	Brighton: For Health & Pleasure all the year round	Sussex	Brighton BC	DR	SSPL	10173276	Brighton08	1986-9113
McKeown, Joseph (photo)	1961	Brighton & Hove Brilliant and Beautiful Go by Train	Sussex	BR(SR)	DR	SSPL	10175169 Drawer D157	Brighton09	1978-0607
Barber	1958	The Brighton Belle: All-Pullman Train Pic. timetable	Sussex	BR(SR)	DR	SSPL	10175175 Drawer D130	Brighton10	1978-0613
Barber	1953	The Brighton Belle (stock poster bottom blank)	Sussex	BR(SR)	DR			Brighton10a	
Bramwell, Southby	1950s	Brighton: yellow centre collage of local images	Sussex	Brighton Corp	DR	Christies	14/9/2006 Lot 65	Brighton11	
Cox, E.A.	1920	Brighton: For health & pleasure all the year round	Sussex	LBSCR	DR			Brighton12	
Lander, Reginald Montague	1960	Regency Brighton & Hove multiple vignettes	Sussex	BR(SR)	DR	Christies	13/09/2007 Lot 136 Drawer D158	Brighton13	1978-9959
Gawthorn, Henry George	1926	Brighton: Fame & Fashion Seafront view	Sussex	SR	QR			Brighton14	
Pond, Edward	1989	Brighton by Train : Sketch of the Royal Pavilion	Sussex	BR NSE	DR	NRM	1996-7322 Drawer D059	Brighton15	1996-7322
Fish, Laurence	1957	Brighton and Hove: Brilliant and beautiful	Sussex	BR(SR)	DR	NRM	1978-0692 Drawer D158	Brighton16	1978-0692
Photographic	1960s	Escape this winter to Brigton and Hove	Sussex	BR(SR)	DR	Morphets	21/07/2010 Lot 54 Drawer D158	Brighton17	1978-0701
Anon	1930	Brighton	Sussex	SR	QR			Brighton18	
Anon	1950s	Brighton: frequent electric trains from London Victoria	Sussex	BR(SR	DR			Brighton19	
Anon	1960s	Brighton & Hove: The Regency Resorts (9 vignettes)	Sussex	BR(SR)	DR			Brighton21	
Carr, Leslie	1920s	Brighton is bright by Day and Night	Sussex	Brighton Corp	QR		Private Collection Picture	Brighton22	
Anon	1920s	Brighton La Plus Charmante Station	Sussex	French Poster	DR			Brighton23	
Anon (signed)	1928	Brighton	Sussex	SR	QR	Pub Rec Off	Official SR Poster	Brighton24	PRO
Anon	1900s	A Sea Voyage on Wheels at Brighton (Volks Rly)	Sussex	B&RSECR	DR	SSPL	10289065	Brighton25	1977-0395
Hubbard, Eric Hesketh	1957	Brighton and Hove: Royal Pavilion	Sussex	BR (SR)	DR		Private collection disclosed	Brighton26	
Anon	1957	Brighton and Hove: Couple on Balcony	Sussex	BR (SR)	DR		Private collection disclosed	Brighton27	
Shoesmith, Kenneth Denton	1925	Eastbourne - bandstand and beach	Sussex	SR	DR			Eastbourne01	
Cox, A.E.	1920	Eastbourne: England's sunny resort by the Southern Sea	Sussex	Town Council	DR	Christies	10/9/2003 Lot 92	Eastbourne02	
Bromfield, K & Pulford, E.	1961	Eastbourne: Suntrap of the South: blue mermaid	Sussex	BR(SR)	DR	SSPL	10175767 Drawer D130	Eastbourne03	1978-1191
Anon	1951	Stay at Eastbourne: Sun Trap of the South	Sussex	EBCouncil	DR			Eastbourne04	
Anon	1951	Eastbourne for glorious holidays	Sussex	EBCouncil	DR			Eastbourne05	
Spradbery, Walter Ernest	1948	Eastbourne: seafront and coat of arms	Sussex	BR(SR)	DR	Christies	14/09/2006 Lot 62	Eastbourne06	
Tripp, Herbert Alker	1950s	Eastbourne: suntrap of the south: cliff view of town	Sussex	BR(SR)	QR		Ref. AD6344/A2	Eastbourne07	
Lampitt, Ronald	1950	Eastbourne: crowded beach bandstand and pier	Sussex	BR(SR)	DR	Private	Disclosed collection (8/12/07)	Eastbourne08	
Photographic	1959	Eastbourne: Sun-trap of the south: bather purple costume	Sussex	BR(SR)	DR	NRM	1978-0666 Drawer D157	Eastbourne09	1978-0666
Anon	1910s	Eastbourne: "The Exhilarating": Beach Head	Sussex	LBSCR	DR	Christies	10/09/2008 Lot 173	Eastbourne10	
Lander, Reginald Montague	1960	Eastbourne: The Suntrap of the South: Flower urn image	Sussex	BR(SR)	DR	NRM	1978-0845 Drawer D160	Eastbourne11	1978-0845

ARTIST	DATE	TITLE	LOCATION	COMPANY	SIZE	SOURCE	SOURCE DETAILS	IMAGE REF	NRM REF
Anon	1927	Eastbourne	Sussex	SR	QR			Eastbourne12	
Anon	1935	Eastbourne Beachy Head	Sussex	SR	QR			Eastbourne13	
Bromfield, Kenneth	1960s	Eastbourne: Sun-trap of the south: Stick of rock	Sussex	BR(SR)	DR	NRM	1978-0703 Drawer D158	Eastbourne14	1978-0703
Wentworth-Shields, F.W.	1959	Hastings and St. Leonards: pier image	Sussex	BR(SR)	QR	SSPL	10170642 Drawer D025	Hastings01	1990-7153
Anon	1961	Hastings and St. Leonards: Go by train	Sussex	BR(SR)	DR	NRM	1978-0711 Drawer D157	Hastings02	1978-0711
Pears, Charles	1931	Follow their lead and go to Hastings - artwork	Sussex	SR	QR	SSPL	10173502 Drawer D019	Hastings03a	1989-8961
Pears, Charles	1933	We always go to - Hastings & St. Leonards	Sussex	SR	QR	SSPL	10173304 Drawer D019	Hastings04	1986-9134
Cox, A.E.	1920	Hastings & St. Leonards	Sussex	Town Council	DR			Hastings05	
Durman, Alan	1952	Hastings and St. Leonards: Fisherman	Sussex	BR(SR)	DR	SSPL	10175301 Drawer D127	Hastings06	1978-0720
Anon	1950	Hastings and St. Leonards: Sun-spot of the Sussex Shore	Sussex	BR(SR)	DR	SSPL	10175679 Drawer D157	Hastings07	1978-1103
Leighton, Alfred Cocker	1930	Hastings & St. Leonards: People on cliffs over beach	Sussex	SR	QR	Christies	14/9/05 lot 63	Hastings08	
Adelman	1950s	Hastings and St. Leonards: For a warm and sunny winte	Sussex	BR(SR)	DR	SSPL	10175308 Drawer D130	Hastings09	1978-0727
Cooper, Royston	1960s	Hastings & St. Leonards Go by Train	Sussex	BR(SR)	DR	NRM	1978-0663 Drawer D158	Hastings10	1978-0663
Edwards, Nowell M.	1930s	Hasting to Hastings: Southern Electric	Sussex	SR	QR			Hastings11	
Pond, Edward	1989	Hastings by Train: Boats, net drying sheds, beach: graphic design	Sussex	BR NSE	DR	NRM	6-7326 Drawer D059 Ref. B00496/B75/1	Hastings12	1996-7326
Lander, Reginald Montague	1962	Come to Hastings by Train	Sussex	BR(SR)	DR	SSPL	10175182 Drawer D130	Hastings13	1978-0619
Richmond, Leonard	1927	Hastings and St. Leonards: Cliff-top ruins	Sussex	SR	QR	Christies	14/9/2006 Lot 61	Hastings14	
Fish, Laurence	1956	Hastings & St. Leonards couple white costume	Sussex	BR(SR)	DR	NRM	1978-1173 Drawer D158	Hastings15	1978-1173
Anon (Colourflex)	1950s	Hastings - For the Perfect Holiday in England	Sussex	Rly Exec (SR)	DR	SSPL	10305954	Hastings16	1990-7040
Durman, Alan	1952	Hastings and St. Leonards: Small boy on beach	Sussex	BR(SR)	DR	NRM	1978-1132 Drawer D160	Hastings17	1978-1132
Anon	1927	Hastings & St. Leonards (Angletere) The Resort of History and Romance	Sussex	Council Ad	QR	Guido Ton	Zurich Auctions 2 October 2004 Lot 358	Hastings18	Pub Rec Off
Pears, Charles	1939	Hastings and St. Leonards: For your holidays on the sun	Sussex	SR	DR	Christies	10/09/2008 Lot 175	Hastings19	
Anon	1932	Hastings & St. Leonards Britains Best Tonic	Sussex	SR	QR			Hastings20	
Anon	1905	Hastings: American Car Trains	Sussex	SECR	DR	SSPL	10171332	Hastings21	1993-8112
Padden, Daphne	1950s	Hastings and St. Leonards: Seafront Hotel	Sussex	BR (SR)	QR	Christies	03/11/2011 Lot 150	Hastings22	
Pryse, Gerald Spencer	1934	The Famous bathing pool at Hastings & St. Leonards	Sussex	LMS	QR	SSPL	10176055 Drawer D004	Hastings23	1988-8030
Pryse, Gerald Spencer	1934	The Famous bathing pool at Hastings and St. Leonards	Sussex	SR	QR		LMS Version of SR poster	Hastings23a	
Bromfield, Kenneth	1970	Grasp the winter sun at Hastings and St. Leonards	Sussex	BR(SR)	DR	NRM	1978-0698 Drawer D160	Hastings24	1978-0698
Eckersley, Tom	1950s	Hastings & St. Leonards	Sussex	BR (SR)/Council	DR			Hastings25	
Allinson, Adrian Paul	1950s	Downland Rambles: Beachy Head Eastbourne	Sussex	BR(SR)	QR	SSPL	10173490 Drawer D025	Sussex01	1978-8951
Buckle, Claude Henry	1960	Sussex: Served by British Railways	Sussex	BR(SR)	DR	Christies	14/9/2006 Lot 60	Sussex02	
Shoesmith, Kenneth Denton	1938	Eastbourne - two flags and view of town	Sussex	SR	DR	SSPL	10170731	Sussex03	1991-7112
Carr, Leslie	1930	Seaford Southern Railway	Sussex	SR	DR	SSPL	10170720 Drawer D101	Sussex04	1991-7101
Buckle, Claude Henry	1955	Chichester: The County Town of West Sussex: The Butter Cross	Sussex	BR(SR)	DR	SSPL	10175651 Drawer D127	Sussex05	1978-1075
Spradbery, Walter Ernest	1946	The South Downs Ref. AD 5484/4000	Sussex	SR	QR	SSPL	10173542 Drawer D019	Sussex06	1978-8986
Spradbery, Walter Ernest	1934	The South Downs: I'm tired of crowded places	Sussex	SR	QR	SSPL	10176015 Drawer D019	Sussex07	1988-7990
Mills, Arthur G.	1935	The South Downs	Sussex	SR	DR			Sussex08	
Cuneo, Terence Tenison	1955	Lewes: County town of Sussex	Sussex	BR(SR)	DR	SSPL	10175166 Brawer D127	Sussex09	1978-0605
Danvers, Verney L.	1928	Bexhill-on-Sea: An Old Town - and a New	Sussex	SR	DR	SSPL	10175898 Drawer D102	Sussex10	1987-9172
Lampitt, Ronald	1947	Bexhill-on-Sea: East Parade and Pavilion	Sussex	SR	DR	SSPL	10175173 Drawer D102	Sussex11	1978-0611
Eckersley, Tom	1964	Goodwood: Travel by train to Chichester	Sussex	BR(SR)	DR			Sussex12	
Petherbridge, A. G.	1924	The Valley of the Arun: Easily reached by Southern Rly.	Sussex	SR	QR	SSPL	10175959 Drawer D019	Sussex13	1988-7934
Pears, Charles	1960s	Arundel: view of castle from Swanbourne Lake	Sussex	SR	DR	SSPL	10175999 Drawer D101	Sussex14	1988-7974
Merriott, Jack	1957	The South Downs AD6657/A3	Sussex	BR(SR)	QR	SSPL	10173492 Drawer D025	Sussex15	1978-8953
Lander, Reginald Montague	1979	Visit Arundel Festival 15 August to 2 September 1979	Sussex	BR (SR)	DR	SSPL	10172814 Drawer D127	Sussex16	1983-8591
Anon	1987	Gatwick Airport: Where trains meet planes	Sussex	Network SE	DR	SSPL	10173981	Sussex17	1987-8826
Joseph, Agnes	1903	Victoria and London Bridge stations for Sussex Downs	Sussex	LBSCR	DR	HMSO	Bon Voyage Book Plate 18	Sussex18	
Secretan, Murray	1922	The Southern Belle "One hour of luxurious travel"	Sussex	LBSCR	DR			Sussex19	

ARTIST	DATE	TITLE	LOCATION	COMPANY	SIZE	SOURCE	SOURCE DETAILS	IMAGE REF	NRM REF
Richmond, Leonard	1920s	Sunny Worthing Pier Pavilion	Sussex	BR(SR)	DR	Bloomsbury	31/03/2010 Lot 125 NYC sale	Sussex20	
Danvers, Verney L.	1930s	Seaford: Frequent Electric Trains Cheap Fares	Sussex	SR	DR	Onslows	3/11/1999 Lot 324	Sussex21	
Brown, F. Gregory	1938	Old Country Towns in Southern England: Lewes	Sussex	SR	QR	SSPL	10170976	Sussex22	1990-7084
Cox, E.A.	1920	Worthing	Sussex	LBSCR	DR	Onslows	1/11/2000 Lot 62	Sussex23	
Skelton, John	1962	Visit Lewes: pictorial map	Sussex	BR(SR)	DR			Sussex24	
Anon	1950s	Bexhill-on-Sea in Sunny Sussex: Go by train	Sussex	BR(SR)	DR	Morphets	21/07/2010 Lot 104	Sussex25	1978-1390
Anon	1960s	Bexhill on Sea: Go by Train family foreground stock poster	Sussex	BR(SR)	DR	NRM	1978-1390 Drawer B1	Sussex25a	1978-1390
Sherwin, Frank	1950s	Seaford: On the Sussex coast	Sussex	BR(SR)	DR	Morphets	15/10/2010 Lot 443	Sussex26	
Durman, Alan	1959	Sunny Worthing the 'All the Year round' resort	Sussex	BR(SR)	DR	Christies	12/09/2002 Lot 120	Sussex27	1978-0684
Anon	1920	Selsey on Sea: A healthy rural village	Sussex	LBSCR	DR	Christies	12/9/2002 lot 117	Sussex28	
Anon	1961	Sunny Worthing: Go by train	Sussex	BR(SR)	DR	Christies	3/09/07 Lot 140 ref AD 8733/A2/61/6	Sussex29	1978-0841
Brown, F. Gregory	1930s	Come see and admire Lewes: Historic County Town	Sussex	SR	DR	Christies	14/10/2004 Lot 136	Sussex30	
Pears, Charles	1930s	Chichester: Historic City of the South Downs	Sussex	SR	DR	Christies	14/10/2004	Sussex31	
Mason, Frank Henry Algernon	1923	Inland Sussex Resorts on the Southern Railway	Sussex	SR	DR	Christies	27/05/1999 Lot 64	Sussex32	
Lander, Reginald Montague	1980	The Sussex Coast and Rolling Downs AD/2903/13/11/4280	Sussex	BR(SR)	DR	SSPL	10172816 Drawer D127	Sussex33	1983-8593
Lander, Reginald Montague	1978	Visit Chichester: Ref AD991/B2/1/2/12178	Sussex	BR(SR)	DR	NRM	1979-7532 Drawer D1579	Sussex34	1979-7532
Lander, Reginald Montague	1962	Sussex: Served by Fast and Frequent Trains	Sussex	BR(SR)	DR	Onslows	19/12/06 Lot 358	Sussex35	1978-9998
Studio Seven	1959	Littlehampton: Frequent Electric Trains harbour view	Sussex	BR(SR)	DR	Morphets	21/07/2010 Lot 101	Sussex36	1978-0665
Studio Seven	1957	Littlehampton: Go by Train: colourful harbour view	Sussex	BR(SR)	DR	NRM	1978-9936 Drawer D160	Sussex36a	1978-9936
Lander, Reginald Montague	1978	Visit Battle Ref. AD993/B2 1/2 12178	Sussex	BR(SR)	DR	NRM	1979-7537 Drawer D159	Sussex37	1979-7537
Lander, Reginald Montague	1978	Visit Arundel Castle: Blue image, black trees	Sussex	BR(SR)	DR	NRM)-7527 Drawer D159 Ref AD997/B2 1/2 1	Sussex38	1979-7527
Lander, Reginald Montague	1978	Visit Arundel Castle: Green image, black trees	Sussex	BR(SR)	DR	NRM	1977-5656 Drawer D159	Sussex38a	1977-5656
Lecomte, Paul-Emile	1910s	Brighton: Medmenham Abbey	Sussex	CdfE/LBSCR	DR			Sussex39	
Pond, Edward	1989	Chichester by Train The Butter Cross	Sussex	BR (NSE)	DR	NRM	1996-7823 Drawer D059	Sussex40	1996-7823
Sherwin, Frank	1950s	Littlehampton for Sands and Sunshine AD6707B37 1/2	Sussex	BR(SR)	DR	Morphets	15/01/2010 Lot 450 Ref AD 6343/B37	Sussex41	
Anon	1910s	Seaford at the foot of the South Downs	Sussex	LBSCR	DR	Onslows	09/11/2004 Lot 206	Sussex42	
Lander, Reginald Montague	1970s	Sussex: Some places of special interest	Sussex	BR(SR)	DR	NRM	1978-9925 Drawer D159	Sussex43	1978-9925
Anon	1930s	Sunny Worthing: The Municipal Orchestra	Sussex	SR	DR		RAF Private collection	Sussex44	
Anon	1960s	Explore Sussex with a new day tour ticket	Sussex	BR(SR)	DR	NRM	1978-1102 Drawer D160	Sussex45	1978-1102
Sherwin, Frank	1950s	Bexhill on the Sunny Sussex Coast: De La Warr Pavilion	Sussex	BR(SR)	DR			Sussex46	
Danvers, Verney L.	1930s	Bexhill-on-Sea for ideal holidays	Sussex	SR	QR		Private Collection	Sussex47	
Anon	1935	Sunny Worthing pier entrance	Sussex	SR	DR		Private Collection	Sussex48	
Anon	1920s	Southern Electric: Hastings + 6 destinations	Sussex	SR	QR			Sussex49	
Wolstenholme, A.N.	1953	The Brighton Belle: Timetable poster: train at top	Sussex	BR(SR)	DR	SSPL	10175364 Drawer D126	Sussex50	1978-0783
Lander, Reginald Montague	1950s	The All Pullman Brighton Belle	Sussex	BR(SR)	DR	NRM	1978-0759 Drawer D126	Sussex51	1978-0759
Anon	1933	Southern Electric helps you to live in Country: Ouse Valley	Sussex	SR	QR	Pub Rec Off	Official SR Poster	Sussex52	
Burley, David William	1930	Bexhill-on-Sea Seafront view	Sussex	SR	QR	Pub Rec Off	Official SR Poster	Sussex53	
Anon	1980s	Worthing on the Sussex Coast colourful montage	Sussex	BR NSE	DR		private collection image	Sussex54	
Bromfield, Kenneth	1963	Arrive earlier by train on the Sussex coast	Sussex	BR(SR)	DR			Sussex55	
Anon	1950	Sunny Worthing the 'All the year round resort'	Sussex	BR (SR)	DR			Sussex56	
Durman, Alan	1960s	Sunny Worthing: Sunshine Music Flowers Sport	Sussex	BR(SR)	DR			Sussex57	
Anon	1925	Sussex Two ancient Towns: Winchelsea and Rye	Sussex	SR	QR	Pub Rec Off	Official SR Poster	Sussex58	PRO
Black, Montague Birrell	1925	Where the South Downs Slope to the Sea	Sussex	SR	QR	Pub Rec Off	Official SR Poster	Sussex59	PRO
Anon (Signed)	1925	The Sussex Hills	Sussex	SR	QR	Pub Rec Off	Official SR Poster	Sussex60	PRO
Anon	1929	Sussex by the Sea for Happy holidays	Sussex	SR	QR	Pub Rec Off	Official SR Poster	Sussex61	PRO
Joseph, Agnes	1903	Sussex Downs	Sussex	L&BR	DR			Sussex62	
Anon	1931	London Brighton Worthing	Sussex	SR	QR	Pub Rec Off	Official SR Poster	Sussex63	PRO
Bromfield	1960	Sussex Arrive earlier by train: girl at top Buttercross below	Sussex	BR (SR)	DR	NRM	Inventory number 1978-9989	Sussex64	1978-9989

ARTIST	DATE	TITLE	LOCATION	COMPANY	SIZE	SOURCE	SOURCE DETAILS		IMAGE REF	NRM REF
Shep (Charles Shepard)	1934	Brighton Belle One hour Victoria-Brighton	Sussex	SR	DR	SSPL	10175986	Drawer D103	Sussex65	1988-7961
Spradbery, Walter Ernest	1948	The Sussex Downs	Sussex	BR (SR)	QR	Pub Rec Off	Official SR Poster		Sussex66	
Carr, Leslie	1930s	Bexhill-on-Sea	Sussex	SR	QR		Private Collection		Sussex67	
Anon	1920s	Bodiam Castle now Open to the Public	Sussex	SR	DR	Pub Rec Off	Official SR Poster		Sussex68	

Updated to 25 April 2012	PRO = Public Record Office, Kew

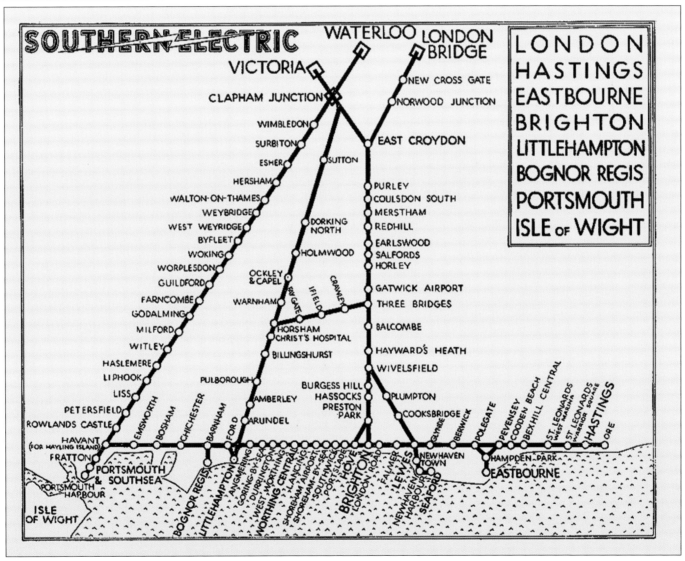

Southern Electric's Hampshire and Sussex Route Map in the late 1930s

Posters and Prints

- Barman, Christian (1979). *The Man who Built London Transport – A biography of Frank Pick*. David & Charles Publishing, Newton Abbott, Devon.
- Bownes, D and Green, O. (Eds.) (2008): *London Transport Posters – A Century of Art and Design*. Lund Humphries (Publishers), Aldershot, Hampshire GU11 3HR. ISBN 978-0-8533198-4-9
- Callo, Max: (1974): *The Poster in History*. Hamlyn Publishing Group, Feltham Middlesex ISBN 0-600-37118-2
- Cole, B and Durack, R (1992). *Railway Posters 1923-1947*. Laurence King Publishing, 361-373 City Road London EC1V 1JJI. ISBN 978-1-85669-014-0
- Edelstein, Teri J. (Ed) (2010): *Art for All – British Posters for Transport.* Yale University Press, New Haven and London. ISBN 978-0-300-15297-5
- Favre, Thierry: (2011). *Railway Posters*. Antique Collectors Club, Woodbridge Suffolk IP12 4SD. ISBN 978-1-8514967-2-3
- Furness, R A: (2009): *Poster to Poster Volume 1; Scotland*. JDF and Associates Ltd, Gloucestershire GL2 2AT. ISBN 978-0-9562092-0-7
- Furness. R A: (2010): *Poster to Poster Volume 2; Yorkshire and the North-East*. JDF and Associates Ltd, Gloucestershire GL2 2AT. ISBN 978-0-9562092-1-4
- Furness, R A: (2011): *Poster to Poster Volume 3; Midlands and Wales*. JDF and Associates Ltd, Gloucestershire GL2 2AT. ISBN 978-0-9562092-4-5
- Furness, R A: (2011): *Poster to Poster Volume 4; The Eastern Counties*. JDF and Associates Ltd, Gloucestershire GL2 2AT. ISBN 978-0-9562092-3-8
- Green, O. (1990): *Underground Art: London Transport Posters 1908 to Present*. Laurence King Publishing London. ISBN 1-85669-166-7
- Hillier, Bevis (1974): *Posters*. Hamlyn Publishing Group, Astronaut House, Feltham Middlesex. ISBN 0-600-37001-1
- Hillman, T and Cole, B (1999). *South for Sunshine – SR Publicity and Posters 1923-1947*. Capital Transport Publishing, London. ISBN 185414-213-5.
- Norden, Greg (1997). *Landscapes under the Luggage Rack*. GNR Publications, Northampton, UK. ISBN 0-9529602-0-6
- Palin, M (1987): *Happy Holidays*. Pavilion Books, ISBN 1-85145-130-7
- Rennie, P (2010): *Modern Railway Posters: Art, Design and Communication*. Black Dog Publishing, London ISBN 978-1-906155-97-1
- Riddell, J and Stearn, W T: (1994). *By Underground to Kew.* Studio Vista, Cassell Group, 125 Strand, London WC2R 0BB. ISBN 0-289-80141-9
- Shackleton, J T (1976). *The Golden Age of the Railway Poster*. Chartwell Books Inc. 110 Enterprise Ave. Secaucus, NJ 07094 USA. ISBN 0-89009-212-8
- Timmers, M (1988): *The Power of the Poster*. V&A Publications, Brompton Road London SW3 1HW. ISBN 1-85177-2405

Railways

- Atterbury, Paul: (2010: *Life along the Line: Railways and People*. Pages 46-61: David and Charles Inc, Brunel House, Newton Abbott, Devon. ISBN 978-0-71533628-1
- Awdry, Christopher :(1990): *Encyclopaedia of British Railway Companies*. Guild Publishing, London. Book reference CN8983
- Brennand, D and Furness R A (2002). *The Book of British Railways Station Totems*. Sutton Publishing Group, Phoenix Mill Thrupp GL5 2BU. ISBN 0-7509-2997-9
- Carter, E.F: (1959): *A Historical Geography of the Railways of the British Isles.* Cassell & Company, Red Lion Square, London WC1
- Edwards, C. (2001): Railway records; A guide to Sources. Public records Office, Richmond. Cromwell Press Trowbridge. ISBN 1-899597-12-3
- Esau, M: (1996): *The Southern – Then and Now*. Ian Allan Publishing Ltd. Station Approach Shepperton, Surrey TW17 8AS. ISBN 0-71110-2464-2
- Glover, John: (1999): *Railways in and Around London - Then and Now*. Ian Allan Publishing Ltd. Station Approach Shepperton, Surrey TW17 8AS. ISBN 0-7110-2671-9

- Jowett, A: (1989): *Jowett's Railway Atlas.* Guild Publishing London. Ref CN2155
- Moody, B: (1992): *Southampton's Railways*. Waterfront Publications, 463 Ashley Road, Parkstone, Poole BH14 0AX. ISBN0-946184-63-1
- Simmons, J. and Biddle, G: (1997): *The Oxford Companion to British Railway History*. Oxford University Press, Oxford. ISBN 0-19-211697-5
- Thomas, D. St John and Whitehouse, P: *SR 150 – A century and a Half of the Southern Railway*. David & Charles (Publishers) Brunel House Newton Abbot Devon UK ISBN 0-7153-9148-8
- White, H. P: (1982). *Regional History of the Railways of Great Britain – Vol2 Southern England*. David & Charles Newton Abbot. ISBN 0-7153-8365-5
- White, H. P: (1971). *Regional History of the Railways of Great Britain – Vol3 Greater London*. David & Charles Newton Abbot. ISBN 0-7153-5337-3
- White, H.P: (1994): *Railways South East – The Album*. Capital Transport Publishing, 38 Long Elmes, Harrow Weald, Middlesex. ISBN 185414-165-1
- Wignall, C.J (1985): *British Railways Maps and Gazetteer 1825-1985*. Oxford Publishing Company. ISBN 0-86093-294-X

Miscellaneous

- Boumphrey, G.(1964) *Shell and BP Guide to Britain*. Ebury Press: George Rainbird Ltd London W2
- Grant, Russell. (1996). *The Real Counties of Britain*. Virgin Publishing Ltd, 332 Ladbroke Grove, London W10 5AH. ISBN 1-85227-497-4
- Hadfield, John (1970). *The Shell Guide to England*. Rainbird reference Books Ltd, Edgware Road, London W2. ISBN 7181-4032-X
- Hadrill, John: (1999): *Rails to the Sea*. Atlantic Publishers, Atlantic House, Penryn, Cornwall TR10 8HE ISBN 0-9066899-86-9
- Hinde, Thomas (Ed) (1995). *The Domesday Book – England's Heritage Then and Now*. Crescent Books New Jersey NJ 07001 USA. ISBN 0-517-14075-6
- Roe, Sonia, (Ed) (2006). *Oil Paintings in Public Ownership in North Yorkshire*. TPC Foundation, St Vincent Street, London WC2H 7HH. ISBN 1-904041-23-5
- Wood, Donna (Ed). (2010). *Britain the Ultimate Guide*. AA Publishing, Fanum House, Basingstoke Hampshire RG21 4EA. ISBN 978-0-9558666-0-9

Poster Image Sources	**All images (see pages iii to ix for details) courtesy SSPL/NRM National Collection except for:**
Author's Collection	2, 15, 22, 31, 36, 40, 82, 93, 94, 104, 123, 136, 175, 177, 205, 214, 219, 235, 244, 251, 280, 295, 321, 332, 352, 391, 393
Bridgeman Art Library	48, 51, 73, 95, 96, 99, 113, 120, 141, 143, 159, 163, 185, 188, 198, 201, 212, 240, 241, 250, 254, 255, 269, 272, 276, 282, 309, 346, 348, 350, 356, 358, 359, 360, 365, 366, 372, 384, 386, 387, 388
First Great Western	280, 391
Guido Ton, Zurich	150, 226
GWRA Railwayana Auctions	88, 207
John Bertram	265
Kilvington Collection	3, 37, 39, 41, 107, 131, 186, 208, 210, 213, 221, 275, 286, 303, 340, 380, 390
Laurence Fish Estate	117, 142, 146, 171, 222, 288, 370
Morphets of Harrogate	67, 121, 148, 311, 357, 389
Norden Collection	Acknowledgements, 133, 158, 169, 183, 266, 267, 278, 294,
Onslows Poster Library	13, 17, 43, 44, 54, 119, 132, 136, 172, 181, 195, 200, 217, 220, 281, 291, 293, 299, 300, 305, 322, 328, 385, 395
Solent Railwayana Auctions	236
Swann NYC	38, 232, 323

<u>Authors Note:</u> Strict copyright protection exists for all the images in this book. Copying and reproducing by any means is expressly forbidden under existing copyright laws. The Author acknowledges the help of **Wendy Burford**, **Debbie Jones** and **Jasmine Rodgers** at the Science and Society Picture Library, **Charlotte Heyman** at the Bridgeman Art Library, **Patrick Bogue** at Onslows, **Jean Bray** from the Laurence Fish Estate and **Greg Norden** from the Travelling Art Gallery in helping to source image copyright. During the preparation of this volume, the Publishers wish to state that all care, attention and due diligence has been employed with regard to traceability and copyright ownership.

SSPL Prints

Most of the posters included in this volume in their 'pre-cleaned' state are available from SSPL prints at www.ssplprints.com, the official website for the National Railway Museum, York. They are available in sizes A0 down to 8" x 6", framed or unframed. Other licensed poster suppliers include the Newcastle Poster Company, Newcastle upon Tyne. For more information on their 'cleaned' images, contact Steve Whittle at newcastlepostercompany@gmail.com.

Recommended Websites	www.postertoposter.co.uk,	www.railway-posters.com,	
	www.nrm.org.uk,	www.scienceandsociety.co.uk,	www.ssplprints.com
	www.onslows.co.uk,	www.bridgemanart.com,	www.christies.com
	www.travellingartgallery.com,	www.ltmuseum.co.uk,	www.southernposters.co.uk

NB: Please note the website details for the travelling Art Gallery: this was erroneously given as co.uk in volume 4

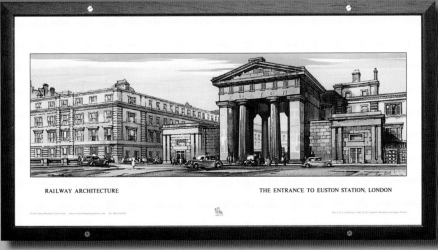
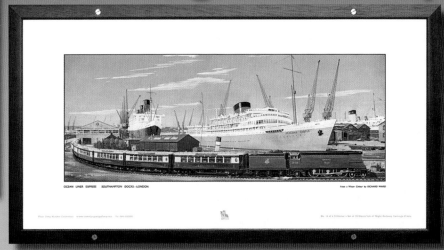

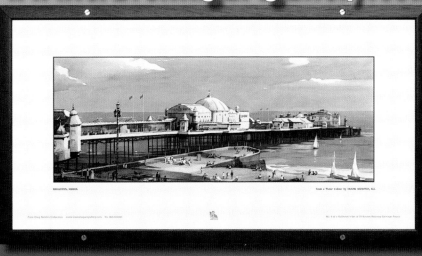
- 253 -

Forthcoming Volumes

This series of poster books eventually eight in total eight and averaging around 250 pages with more than 300 images per book, allows many previously unpublished posters from Victorian to Modern Times to be seen as intended – an inducement to travel. Each volume has a regional focus (the first time this has been attempted) and the locations will be based on the older British county names rather than the modern administrative areas.

The next volume to appear will be Volume 6, covering the British North-West. This 250+ page volume will feature a journey around the northern half of the Irish Sea, taking in England, North Wales, Northern Ireland and the Isle of Man. Volume 6 begins in the Lake District, a popular target for advertising. Travelling south we enter the 'Red Rose' county and the industrial centres of Liverpool and Manchester. Then it is into North Wales, before we take the ferry from Holyhead to tour Northern Ireland. This country also has a strong poster heritage. The final leg sees us cross eastwards to end the journey on the Isle of Man. The Foreword has already been written by famous travel personality Michael Palin. The front cover features a classic inter-war years poster of the now-demolished lido at Southport, painted by Alfred Lambart in 1923 (below left).

Vol.6: THE BRITISH NORTH-WEST

Vol. 7: THE GLORIOUS SOUTH-WEST: Somerset, Wiltshire, Dorset, Devon, Cornwall, Scilly & Channel islands

The areas covered by Volume 7, with its proposed covers are shown above right. The expected publication for this eagerly awaited book is late summer/early autumn 2013, with the Foreword being written by TV Book Club personalities Richard Madeley and Judy Finnigan (TV's Richard and Judy). This will be a poignant reminder for many of happy childhood holidays in the West Country at a time of real change in this country after WWII. The poster journey begins in the City of Bristol and will end in Guernsey: this allows advertising from the GWR, SR and Western Region of BR to feature strongly, with a few early LSWR posters promoting selected locations.

Already Available

The first volume in the series (Scotland) was published in July 2009. It has received critical acclaim since publication, being named as Scotland's 'Non-fiction Book of the Year' in December 2009. The volume features some 330 Scottish posters in a book of 250 pages total. The book ISBN number is 978-0-9562092-0-7 and it can be ordered directly from **JDF and Associates Ltd, Unit 19, Space Business Centre, Quedgeley, GLOUCESTER GL2 4AL**. It can also be ordered on the Internet from www.postertoposter.co.uk.

Review Comments Included:

"Evocative, comprehensive and stunningly illustrated, this Magnum Opus is destined to become a classic"	**Railway Antiques Gazette**
"Some books just sell themselves and none more so perhaps than Richard Furness's Poster to Poster"	**Edinburgh Evening News**
"Dr Furness has done a superb job in recording for posterity, the significance of these National Treasures"	**Friends of the National Railway Museum, York**
"A hitherto neglected subject is well served by this, undoubtedly definitive, work"	**Scottish Railway Preservation Society**
"It is a lovely book that is also an important and fascinating reference: Recommended"	**Editor: Steam Railway**
"A stunning artistic guide as well as a comprehensive look at Scotland's railway poster heritage"	**The Scotsman**
"A great book that should appeal to everyone, not just railway enthusiasts. Well worth the cover price"	**Editor: Railways Illustrated**
"This book is astounding: If you love Scotland and her railways, this is a MUST for the collection"	**Editor: West Highland News**

The second volume in the series covered Yorkshire and the North-East of England, and was published in July 2010. It featured over 380 posters and will soon go out of print. It was followed early in 2011 by the third volume for Central England and Wales with over 300 posters. With the fourth volume published in 2011, the series has now included some 1370 images from many sources. The complete series will eventually span 120 years of railway poster development via 2,700 posters. The covers for volumes 2-4 are illustrated below.

Foreword written by Paul Atterbury

Foreword written by Pete Waterman

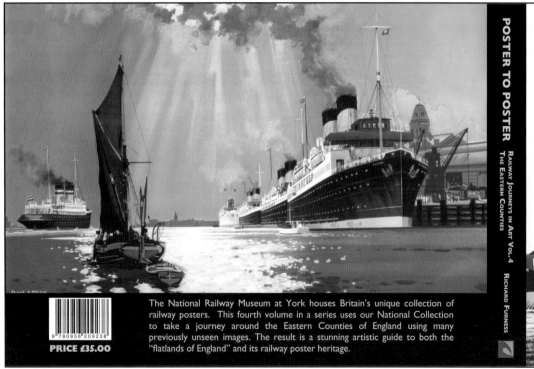

Foreword written by Rt. Hon Michael Portillo